NARRATING THE THIRTIES

Narrating the Thirties

A Decade in the Making:
1930 to the Present

John Baxendale
Principal Lecturer in Social and Cultural History
Sheffield Hallam University

and

Chris Pawling
Principal Lecturer and Subject Leader in Communications
Sheffield Hallam University

First published in Great Britain 1996 by
MACMILLAN PRESS LTD
Houndmills, Basingstoke, Hampshire RG21 6XS
and London
Companies and representatives
throughout the world

A catalogue record for this book is available
from the British Library.

ISBN 0–333–62299–5 hardcover
ISBN 0–333–62300–2 paperback

First published in the United States of America 1996 by
ST. MARTIN'S PRESS, INC.,
Scholarly and Reference Division,
175 Fifth Avenue,
New York, N.Y. 10010

ISBN 0–312–12898–3

Library of Congress Cataloging-in-Publication Data
Baxendale, John.
Narrating the thirties : a decade in the making. 1930 to the
present / John Baxendale and Chris Pawling.
p. cm.
Includes bibliographical references and index.
ISBN 0–312–12898–3
1. Great Britain—History—George V, 1910–1936—Historiography.
2. Great Britain—History—George VI, 1936–1952—Historiography.
3. Great Britain—History—Edward VIII, 1936—Historiography.
4. English Literature—20th century—History and criticism.
5. Arts, Modern—20th century—Great Britain—History. 6. Great
Britain—In literature. 7. Narration (Rhetoric) I. Pawling,
Christopher. II. Title.
DA578.B35 1996
941.08—dc20
 95–26254
 CIP

10 9 8 7 6 5 4 3 2 1
05 04 03 02 01 00 99 98 97 96

Printed and bound in Great Britain by
Antony Rowe Ltd, Chippenham, Wiltshire

To our parents, who lived through
the Thirties and helped build the better world in which
we grew up

Contents

Acknowledgements

Those who write cultural history are under more obligation than most to acknowledge their debts: this we do with great pleasure, though without seeking to shift the blame in any way. This book arises out of interdisciplinary teaching and research in the stimulating environment of the School of Cultural Studies at Sheffield Hallam University. We are grateful to colleagues for maintaining that environment despite the manifold pressures and panics of modern academic life, and for facilitating our sabbatical leave to get this book written; to students for their tolerance and interest as we developed our ideas about the Thirties; to colleagues in the school administration and the University Library for their invaluable help over the years; to Rosalind Brunt, Chas Critcher, Van Gore, Peter Hartley and Mick Worboys for practical help and encouragement in the early stages of this project; and to Gerry Coubro, Chris Goldie, Martin Jordin and Tom Ryall for intellectual stimulus, encouragement and friendship during its writing, as well as at other times. Special mention should go to those crucial sites of cultural exchange, the Union Hotel on Thursday evenings and Bramall Lane on Saturday afternoons. Finally, we thank Elaine, Sally, Cathy, Kieran, Anne and Tom, not just for practical and emotional support, but for sparing the time from the equally absorbing pursuits of their own lives to show an encouraging interest in what we were up to.

JOHN BAXENDALE
CHRIS PAWLING
Sheffield

1

Introduction: A Decade under Construction

Let us begin by saying what this book is not. The reader will not find here yet another account of the events and conditions of 1930s Britain – the economic and social impact of the Slump, the literary politics of the 'Red Decade', the rise of Fascism and the drift into war. All these themes are thoroughly dissected and argued over elsewhere, in a large body of reputable and rewarding historical work. Instead, this book deals with the way in which all these themes – and others – have formed part of a cultural object, shifting and changing over time, and held together by varying degrees of coherence and consensus, which we call 'the Thirties'.

Our understanding of both the past and the present is so firmly organised around large historical objects – 'Western civilisation', 'the Cold War', 'the working class' – that it is easy to miss the fact that history does not make us a free gift of these landmarks: we have to invent them. However useful they may be – and it is difficult to see how we would make our way without them – and however adequately they encapsulate actual historical experience, they are still constructs of the imagination: the collective, cultural imagination.

Decades are a particularly tricky case. We know that they are in some ways a banal illusion – the arbitrary product of our system of measuring time – with far less 'real' existence than, say, 'the Second World War' or even 'the reign of George V'. Nevertheless, we find it useful to believe that a decade of history contains some underlying principle of unity, an essential character or focus which is specific to it and different from others.

The mere mention of a decade ('the Sixties'; 'the Twenties') evokes powerful shared (or sometimes contested) meanings. We may argue about what these meanings are, but it is pointless to dispute their existence on the plausibly rational grounds that history during a particular period of ten years is complex, contradictory, multi-layered, with innumerable overlapping narratives

1

few of which begin or end neatly on the turn of the decade. The fact is that, although such crude signposts may mislead, without them we are lost altogether. Decades work for us because, like all the other grand historical unities, they rescue history from being an unstructured jumble of 'one thing after another'. Their function is to pick out from the cacophony one specific rhythm of historical change – just as centuries ('long' or 'short')[1] identify a different and longer rhythm. The special character of decades lies, perhaps, in the relation between their particular historical tempo and the timescale of individual memory: they measure out our own lives as well as that of the nation and the world. If it requires massive simplification to make this resonance work, so for that matter does any other device for making structured sense of human experience.

For a work of cultural history, though, it is enough that 'the Thirties' exists and has meaning for posterity, for it to become an object worthy of study. Those meanings have been manifold, contra-dictory and ever-changing. This is the 'red decade' of political com-mitment, Communist poets and the Spanish Civil War. It is the 'devil's decade' of mass unemployment and hunger marches, of Blackshirts and street-fighting. It is the decade of appeasement, be-trayal and the complacent drift towards war. It is the first age of mass high consumption, of mechanised homes, family cars and suburbia, of Hollywood, the *Daily Express* and dance-bands on the radio. It is the last age of high-spending luxury, of Brideshead, art deco night-clubs and transatlantic liners. It is the moment of capitalism's crisis, and/or of its renewal. All these different meanings are the outcome of a continuous and often hotly contested process of construction and reconstruction, beginning in the 1930s, in which not only professional historians but journalists, novelists, film-makers, politicians and social investigators have brought their public discourses to bear on our private memories and beliefs. This continual re-presentation of 'the Thirties', we shall argue, owes more to forces at work in the present than to any improvements in our knowledge of the past. At its heart is the aim of making a particular sense not just of the 1930s, but of what went before and came after, linking them together in narratives which give meaning to historical experience.

IN THE THIRTIES: A CULTURAL CRISIS?

If 'the Thirties' is a cultural construct, it is produced not just from the mentality of a particular era, but within certain specific patterns

of social and cultural relations. It is not innocent of the play of power and interest. The process of constructing the inner meaning of the decade began, naturally enough, in the 1930s themselves; case-studies of this contemporary self-examination form the next three chapters of the book. But what of the culture that gave rise to these self-representations? We are aware that to characterise 1930s society and culture at all is to offer yet another cultural construct, which narrativises the Thirties in one manner rather than another; nevertheless, as there is no final escape from history's hall of mirrors, this is what we must now attempt to do.

The interwar period in Britain was a time of crisis and transformation, not just in the society that was being represented, but even more so in the status and situation of those who were doing the representing.[2] In the nineteenth century, British intellectuals had been a small, compact and closely-linked group, often with social and family connections amongst key elements in the upper bourgeoisie and aristocracy.[3] As such, they were part of a widely-understood structure of class and cultural authority, addressed a coherent and powerful educated minority, and were able to conduct the political and ideological controversies of the time with confidence that they would be heard.

Crucial changes, beginning in the late nineteenth century and accelerating in the interwar period, seriously eroded this position, leaving the intellectuals of the 1930s in a state of increasing impotence and detachment. The widening of the franchise in stages from 1867 to the achievement of universal adult suffrage in 1928 vastly expanded the sphere of public debate beyond an educated minority, and seriously undermined their claims to ideological and cultural authority. Following on the heels of democratisation came a process of massive cultural expansion: universal literacy and the growth of the education system, and the creation of new sectors of cultural production in the popular daily press, radio and cinema. New cultural professions such as broadcasting and advertising, and old ones such as journalism and teaching, grew rapidly (for example, from 9500 secondary teachers in 1909 to 23 000 in 1934; and from 6000 'authors, editors and journalists' in 1891 to 19 000 in 1931 – a rate of increase six times that of the whole population).[4] However, these were cultural producers of a new kind: dependent on mass markets and corporate or state employers, and often less highly-educated and well-connected than the traditional intellectuals. While cultural producers grew in numbers, then, they lost group coherence and authority. The response of many traditional

intellectuals was to seek a professionalisation of their own, retreat-
ing from the disintegrating bourgeois public sphere into academic
life and specialist discourses.[5]

The new media also undermined established cultural authority
in a more direct way: they flooded the public sphere with the 'de-
graded' popular taste which earlier reformers had sought to sup-
press or improve, and they 'corrupted' British culture with
American influences. Hence, in 1927, the British state for the first
time acted to protect the national culture against both foreign incur-
sions and market forces. The BBC became a public corporation
under Royal Charter, and the Cinematograph Films Act was
passed, introducing quota protection against imported (i.e.
American) films. But the declining authority of the old cultural élite
was not replaced with anything like a common national–popular
culture. For one thing, there was the influence of Hollywood. But
even nationally-based cultural power still seemed to rest in the
hands of a public-school and Oxbridge group which in cultural
terms was neither populist nor properly élitist. The 'national voice'
of the BBC was all too audibly theirs, and they also held the key po-
sitions in the faltering British film industry. Not surprisingly, both
radio and cinema were criticised for failing to reflect national life.
As J. B. Priestley put it, echoing a widespread view, British films
tended to be thin in social texture compared to French or
Hollywood products, showing an England 'taken from a few issues
of the *Sketch* and *Tatler* and a collection of Christmas cards'.[6] Polite
good taste reigned, and the British tradition of popular vulgarity –
what Alan Lovell has called 'News of the World culture'[7] – was dis-
dained along with Hollywood commercialism. Though 'insiders' in
metropolitan class terms, these cultural gatekeepers were 'out-
siders' in relation to mainstream national life: exceptions such as
Priestley and Alfred Hitchcock were few and far between. The
result was that, in general terms, British audiences tended to find
the films and popular fiction of the USA more relevant and realistic
than their own culture's stumbling and class-ridden attempts at
self-representation.[8]

Culturally, then, interwar Britain was an increasingly fragmented
society. Traditional intellectuals responded to the crisis in their cul-
tural authority in a number of ways. Some sought to use the new
state mechanisms to shore up the ruins of the old cultural paternal-
ism, and raise or defend 'standards'. Elements of this response can
be seen in the quasi-Arnoldian project of John Reith at the BBC, and

in the attempts of the British Board of Film Censors to banish distasteful or subversive material from the screen.[9] A second response was to retreat into cultural pessimism, and the defence of an increasingly embattled minority culture against the incursions of mass civilisation. This stance characterised the group which gathered around the journal *Scrutiny*, and its leading light F. R. Leavis.[10] In some ways, this was a logical development of the professionalism and specialisation of the traditional intellectuals – of which Leavis himself was a leading protagonist in the field of literary studies. Academic specialisation, like literary modernism, rendered much intellectual discourse inaccessible to the general educated readership, whose predecessors had lapped up Dickens, Tennyson and Macaulay, and thus opened up the gap between civilisation and culture that the professionals now bemoaned. The gap was filled, not by Leavis and his colleagues, but by among other things the middle-class journalism and 'middlebrow' novels which they so ardently deplored (see Chapter 3).

A third response to the crisis was in the direction of commitment: to try to make some contact with the working-class mainstream of national life, either by investigating it – the 'documentary impulse', discussed in Chapter 2 – or by allying with it politically, in the much-publicised intellectual swing towards Marxism. During the Thirties, these two movements had only limited success in overcoming social and cultural divisions: both remained movements of detached intellectuals looking in from outside, and never really made contact with broader social movements. Public-school Communists, indeed, seemed more in tune with the European fight against Fascism than with working-class struggles in Britain.[11] In the longer term, however, the 'documentary impulse' in particular did contribute to the stronger sense of social unity which arose during and after the Second World War (see Chapter 2). Significantly, however, neither grouping managed to free themselves from dominant orientalist discourses and engage radically with what now seems the major question hanging over British identity in the early twentieth century: the Empire (see Chapter 4).

Contemporary responses to the 1930s were therefore shaped not just by broad events and experiences of the time, but by this complex crisis of representation, with its impact on relations of cultural production and the position of the intellectuals. The studies in the first part of the book, while not attempting a comprehensive overview, investigate the way in which a range of observers, di-

versely situated in terms of personal situation, relations of production, chosen medium and intended audience, grappled with the problems of representing Britain and the Empire to itself during the 1930s.

AFTER THE THIRTIES: CONSTRUCTING THE PAST

At the point when events are no longer contemporary but have become part of the past, a different kind of cultural process begins: the construction and reconstruction of historical memory. In the years since the Thirties ended, they have been made and remade, investigated and analysed, fantasised and fought over, according to the changing needs and perceptions of succeeding generations. Hindsight does not guarantee that the past will be seen any more clearly than the present, or that there will be any greater agreement about its meanings. To imagine that it does would be to mistake the purpose of our continual engagement with history, which is not to get at its essential underlying truth, but to use it to make sense of our own situation. As the present changes, the relationship between past and present changes also, and with it the meaning the past – and the Thirties – has for us.

The process of making and remaking the past is therefore not so much cognitive as creative: less about 'finding out', and more about attributing meanings. The work of the professional historian is of course vital to this process in modern society: like most other functions, knowing about the past has become a specialised and professionalised role. But it is important to remember that it is a historically contingent one; most societies have engaged with the past quite effectively without having academic historians, and even in modern times their role has continually changed and different definitions of it are strenuously contested.[12]

It is important also to remember that professional historians are not the only people who engage with the past. Unlike, say, nuclear physics or molecular biology, history is an open game in which all manner of people can play. Our sense of the past is constructed by the interplay of a very wide range of cultural forces. At the most fundamental level is private memory: what individuals themselves remember, or what has been passed on by relatives and friends. At a somewhat more public level lies a thriving 'voluntary sector' of historical production: local history groups, family history societies,

WEA classes, history workshops and women's history groups, and a wide audience for 'serious' history books and TV documentaries. The past is a source of commercialised pleasure: in fictional forms from romantic novels to period film and TV drama; in popular documentary, biography, books of photographs; in historical theme parks and 'heritage tourism'; in the continual 'reference back' to the past in popular styles, songs, advertisements. Finally, the state itself is actively involved in constructing and reconstructing the past for us, through the school curriculum, university degree courses and research funding bodies, historical museums and ancient monuments, the preservation of old buildings, and the panoply of historically-based national traditions and ceremonies through which the state legitimises itself. In all kinds of public discourse, political or journalistic, the past is continually brought up and put before us, its lessons read and re-read as evidence of progress or decline.[13]

This obsessive concern with the past is something we have in common with virtually all known societies, past and present. Even in non-literate cultures, historical narratives in the shape of orally-transmitted myths and stories play a crucial role in shaping social relations and legitimating the social order.[14] Aspiring nations in the nineteenth and twentieth centuries built their cultural identity on the shared narratives of folklore, literature and history. In our own society, politicians debate what version of the national past schoolchildren should be given, and national identity is constructed, reconstructed and contended over through competing versions of key national experiences such as the Empire and the Second World War, while subordinate groups develop oppositional narratives to support their own struggles: women's history, black history, working-class history. Out of all this jumble of agencies, practices and discourses comes a body of impressions and beliefs which constitute our collective memory of the Thirties – not a single story, but a contradictory and contested field, crossed by many competing ideas and interests, in which no one view is guaranteed dominance – while some 'achieve centrality and luxuriate grandly ... others are marginalised or excluded or reworked' – and in which even our private memories can be shaped and reshaped by changing circumstances and the shifting winds of dominant historical discourse.[15]

How does the academic historian relate to this maelstrom of popular memory? One conventional answer, to which lip-service is frequently paid even by the most populist of historical producers, is that academic history is simply the 'true story' – at least to the best

of our present knowledge – against which competing versions can be checked: the still, small voice of historical truth, striving to make itself heard against the hubbub of political rhetoric, romantic fantasy and commercialised excess. This claim is not entirely without foundation. The professional practices of historians, their research methods, their conditions of work, and their commitment to producing rational and verifiable versions of the past which are open to debate, undoubtedly give their pronouncements a special authority. But this authority has strict limits.

The eminent Tudor historian Geoffrey Elton, a staunch defender of methodological orthodoxy, described historical method as 'a recognised and tested way of extracting from what the past has left the true facts and events of that past, and so far as possible their true meaning and interrelation'.[16] Even overlooking the obvious questions, 'recognised and tested by whom?' and 'which facts and events?', and accepting for the sake of argument that historians can tell us fairly unproblematically 'what happened', there are still insurmountable problems with the claim that they can tell us with authority what those events *mean*. And this is a serious matter, because it is meanings, rather than factual accuracy, that the present looks for when it contemplates the past. Events may be part of a fixed past, but their meanings are part of the changing present, and cannot therefore be settled for good by the authority of professional experts. Walter Benjamin reminds us that the meaning of a historical event can be determined

> posthumously, as it were, through events that can be separated from it by thousands of years. A historian who takes this as his point of departure stops telling the sequence of events like the beads of a rosary. Instead, he grasps the constellation which his own era has formed with a definite earlier one.[17]

Benjamin's words, as we shall see, apply very aptly to the events of the Thirties. The task of 'grasping the constellation' is one which historians must share with everyone else who has an investment in the relationship between past and present: otherwise, it will go ahead without them.

Our case-studies in Chapters 5 to 8, dealing with 'the Thirties after the Thirties', therefore bring in a range of different discourses which have sought to construct and reconstruct the decade posthumously – professional history among them, but also journalism, politics and fiction. Our purpose is not merely to make the somewhat banal

point that each age interprets the past in its own way, but to try to show why and how this is so: and in particular, how narratives about or including the Thirties have not only been shaped by subsequent history, but also have been used to shape it, to influence subsequent events and give them particular meanings. These meanings, like the meaning of episodes in a novel, arise less from the intrinsic nature of historical events than from their position in the story – in Elton's phrase, their 'interrelations' with other events. As we shall see, disagreements about the history of the Thirties have rarely been about factual matters, but more often about the way the elements of the story have been emplotted, and thereby given meaning.

About what these elements are in the case of 1930s Britain, there has been quite wide consensus – so much so that it is easy to forget that the Thirties we all recognise is a highly selective construction, guided by the chosen focus of historians and the preoccupations of posterity. Central to this received version of the Thirties are two themes: the Slump, its social and political effects and responses to it; and the rise of Fascism, and in particular the foreign policy of appeasement. In histories of the period, the Slump tends to dominate the early part of the decade; appeasement the later.[18] These themes dominate not merely because they were self-evidently important in the 1930s themselves, but because of their continuing resonances in the post-Thirties world – the Slump pointing towards a new postwar order of economic management and the Welfare State; appeasement towards the dangerous confrontations of the Cold War, and Britain's declining world-power status as highlighted by the Suez adventure of 1956.

Other, lesser, issues are given canonical status, as it were, in so far as they can be linked to these dominant themes and orchestrated around them. The Abdication Crisis of 1936, for example, when not presented as soap-opera, has usually been discussed in terms of the political strengths of Baldwin and Churchill, rather than as an episode in constitutional history;[19] perhaps the current travails of the House of Windsor will lead to its repositioning. The rise of 'mass culture' and the new communication media, which had long-term importance of their own, are discussed for their impact on the way politicians handled the two main problems of the day.[20] Cinema becomes an object of investigation because historians think it might have been effective in promoting political stability.[21] Health, poverty and welfare policy are treated as aspects of the Slump; popular political movements as responses to unemploy-

ment and the rise of Fascism; domestic lifestyles and leisure as a contrast and counterweight to the experience of the depressed areas. In the process, issues which might otherwise be considered important in their own right – for example, gender, the Empire, and the patterns of cultural change – are either sidelined because they are difficult to articulate to the dominant themes, or treated selectively to make them fit.

However, this powerful consensus about what the issues are is accompanied by a stubborn failure, despite an ever-increasing volume of historical research, to resolve any of the major debates that have gone on around them. Indeed, as we shall see, rather than converging on an agreed truth, the tendency has been to find new ways of disagreeing. This, we maintain, is because such conflicts are not about the facts, but about the way they, and the dominant themes of the Thirties, are turned into narratives – stories which by implication come up to the present day and thus give a particular twist to our own contemporary concerns. The same underlying themes can be turned into narratives in numerous different ways, differently structured, and starting and finishing at different points. What narratives of the Thirties are available, and what gives them their coherence and relevance at any particular moment?

NARRATIVES, JOURNEYS AND SOCIAL DEMOCRACY

As Roland Barthes pointed out, as a means of conveying meaning and understanding, narrative is ubiquitous: 'myth, legend, fable, tale, novella, epic, history, tragedy, drama, comedy, mime, painting, stained glass windows, cinema, comics, news items, conversations ... there nowhere is, nor has been, a people without narrative'.[22] Narrative structures our perception of everyday events, our sense of personal identity (as we each write and rewrite our inner autobiography) – even, through the narratives of science, our understanding of the natural world. Historical narratives have strong affinities with fictional ones, but their particular power is that they link our personal sense of selfhood – the here and now – with the broader collectivities and longer timescales which give it a wider meaning, allowing us to situate our own experience of change, which in the modern world might be vertiginous and alienating, as part of an ongoing story.

Perhaps one of the reasons why the Thirties is seen as such a recognisable and distinct period is that it is able to generate narratives which are self-contained and internally coherent. In part, this is due to the fact that it is bound by certain 'watersheds' – the Wall Street Crash of 1929 and the onset of unemployment at one end of the decade and the outbreak of war at the other. Thus, it is possible to construct a narrative of events with a certain structure: we start with a disruption/destabilisation of the social and political order; we move to a struggle between contending forces which climaxes in the middle of the decade with the Spanish Civil War; we conclude with a resumption of order, based on a nation united in a common purpose – the defeat of Fascism – although, paradoxically, this unity is constructed in wartime. Finally, the demons of depression and unemployment are banished by the Labour victory of 1945, which acts as a coda to the narrative by supposedly announcing a new state where there will be 'no return to the Thirties'.

By highlighting certain features of the social and political landscape, it is possible to produce a narrative with a progressive outcome, in which a 'stagnant' society is transformed as a result of both internal conflict and contact with rejuvenating forces in the outside world (e.g. international socialism in Spain), so that the Left can finally triumph over the forces of 'reaction'. (What might be seen as the Branson and Heinemann 'story' of the Thirties.)[23] Here we have a potent narrative which seems to offer a way of imposing coherence on the facts and making sense of the period by means of a particular narrative *structure* (stasis, disruption, climax, denouement). Of course, there are variations on the theme. So, Julian Symons' study of the Thirties, from the point of view of the largely middle-class literary intelligentsia, presents it as a decade of betrayed idealism, in which writers such as Auden and Isherwood quickly see through the lies of Stalinism. (The sub-title of Symons' book is 'A Dream Revolved'.) In this packaging of the decade there is no projection forward to the war, let alone 1945, because it is important to demonstrate that the Thirties is the last period in which it is possible to embrace 'ideologies', such as Marxism, in an idealistic manner. This 'myth' is shattered in Spain (the 'heart of the dream' in Symons' version of events) with the growing awareness that communism is just another variant of 'totalitarianism' and, hence, socialism itself is tainted. So the decade ends with Auden and Isherwood sailing off to America, away from communism to

Christianity, and the intelligentsia who remain back home redis-
cover the 'English' virtues of liberalism and tolerance.[24]

Such narratives have many variations, but each has a diachronic
structure and a *learning curve* for its participants (and, of course, by
implication, the reader), similar to that of the classic *'Bildungsroman'*
of the nineteenth century, in which the hero (whether individual or
collective) receives an education in the lessons of life and comes
away a wiser person.[25] The 'crisis' and disruption of life can, of
course, be solved in different ways, with different implications. So,
for example, in Symons' narrative (and in the more complex
version provided by Stevenson and Cook[26]), British society is dis-
rupted by a socio-economic crisis which provokes an 'unnatural'
polarisation of society and threatens to undermine the normal
'organic' growth of its central institutions. By contrast, in Branson
and Heinemann's version, the Thirties is the 'Red Decade', in which
capitalism is in terminal crisis, and the social body requires major
surgery. It is revived through the ministrations of the Communist
Party (Gramsci's 'Modern Prince') and the heroic actions of the
people, particularly the industrial working class (the alliance of the
British and Soviet states in the war). But, despite the underlying
differences in political ideologies, in both accounts a better, more
secure social order emerges as a result of the 'testing' of the collec-
tive 'hero', the British people, under fire – a testing which can also
be presented (for example by C. L. Mowat)[27] as an act of redemp-
tion for the shame of appeasement and the Depression.

Thus, one might argue that the Thirties exists as a potential object
of study because it is able to generate narratives with formal coher-
ence, rhetorical power and a diachronic structure. Ultimately, we
are fascinated by a particular historical period because it makes
sense as a narrative of 'progress' in which we can find stability and
security, and which fits with a certain 'archetypal' structure of what
we expect from life – one which has been passed down from gener-
ation to generation and from culture to culture. The identity of a
period derives, then, less from 'what actually happened', than from
a set of discursive effects which are the products of signifying
processes and narrative structures. This is a powerful argument
and one which requires attention, for the recent impact of post-
structuralism and narrative theory, through the work of the 'new
historicists', such as Hayden White, has provoked a radical, and
controversial, reassessment of the assumptions that underlie histo-
riography.[28] We are now no longer so ready to believe – if we ever

were – in the 'transparency' of historical periods whose meanings simply deliver themselves up to the historian in a common-sense fashion. It is narratives and their structures which help to guide us through the morass of facts and help to impose some order on historical events. At the same time, we have to remember that history does not *just* consist of preformed narratives or 'tropes', and we should concentrate on the 'uses' which are made of these narratives, rather than just fetishising their timelessness or universality.[29]

So, what themes underlie our own particular narrative, and what uses are we making of it? As the reader will not fail to notice, this book has a theme, which is argued out in different ways through all its chapters, and which like all historical themes owes much to the preoccupations of the time when we are writing. That theme could be summed up as 'social democracy': the particular historical moment, signalled by the Labour victory of 1945, which gave rise to the Welfare State, economic management for full employment, and the broader project of the democratisation of British society. Others have described the political, economic and administrative origins of this watershed: our concern is with its discursive construction (before, during and after the event) through historical narratives in which the Thirties played a central part – beginning with the attempts made in the Thirties to heal the nation's divisions through discourses about the 'condition of England', and continuing through the populist constructions of the nation, reinforced by the theme of 'never again!' which carried all before them in 1940–45. We also chart the way in which changing narratives focused on the Thirties signalled the Left's loss of initiative during the postwar boom, and the eventual disintegration of the postwar settlement, leading to the accession of the Thatcher government in 1979.

Narratives of social democracy dominated the self-image of the postwar period – during what Eric Hobsbawm has provocatively labelled the 'Golden Age'.[30] The 1930s origins of both the narratives and the moment of social democracy have, however, been somewhat eclipsed, from both Left and Right. Literary-based cultural histories of the Thirties have been dominated by the Communist Party, various Popular Front organisations such as the Left Book Club and working-class writing on the one hand, or the trajectory of the literary avant-garde, the Auden generation, *New Writing*, and so forth, on the other. Attention has also been paid to the construction in popular and middlebrow culture of right-wing conceptions of nation, empire and home.[31] Missing from these accounts are the

very elements which most seemed to prefigure the dominant
pattern of the wartime and postwar era: the social democratic and
middlebrow culture (not necessarily coterminous, but quite often
so) represented in such writers as J. B. Priestley, Winifred Holtby,
A. J. Cronin (and, to a lesser extent, George Orwell), and the paral-
lel thrust of the documentary movement, which turned the ideas
and experiments of the European avant-garde to a particularly
British project. One aim of this book is to resurrect interest in this
discourse, showing how it emerges from within the Thirties rather
than just being a product of war-time conditions, and exploring the
way in which it helps to pave the 'road to 1945' and beyond. At the
same time, we seek to explore some of the contradictions of
this social democratic discourse, particularly around questions of
political/cultural 'authority' and attitudes to 'the masses' (e.g.
Griersonian documentary and Mass Observation), its weak analysis
of the workings of capitalism (J. B. Priestley), and its vulnerability
to discourses of imperialism and 'orientalism' (Orwell, and Basil
Wright's documentary, *Song of Ceylon*).

A powerful trope around which these narratives are organised is
that of the 'journey': the expeditions of documentarists and mass-
observers from London into the provinces; Orwell's earlier trajectory
to the colonies and back again, and later to Wigan and back; the
wanderings of Priestley's hero Charlie Habble from the Midlands to
the corrupt metropolis and the derelict north-east; Gracie Fields'
shorter but equally transformative round-trip to Blackpool;
Priestley's own looping survey of England; the post-Thirties fictional
journeys of Arthur in *Pennies from Heaven* and Stevens in *Remains of
the Day*; the epic transatlantic passage (literal and metaphorical) of
C. L. R. James from Trinidad to England to Harlem and back again
to Brixton. Through this recurrent theme, we can explore the spatial
as well as the diachronic aspects of Thirties narratives.

Most literary-based accounts have picked up on the importance
of travel and travel writing in the Thirties.[32] However, they have
tended to interpret the journey as a *metaphysical* movement through
a 'landscape without maps', a quest for values which rewrites the
universal archetype of the Fall. Europe in the Thirties is seen as a
land without God, whose more 'aware' inhabitants, the intelli-
gentsia, are embarked on a voyage 'out of Utopian notions of inno-
cence into a kind of Christian awareness of sin'.[33]

By contrast, our analysis emphasises the concrete socio-political
dimensions of the journey: the way in which the documentary film

movement and Mass Observation articulate a felt need on the part of progressive middle-class intellectuals to move out of the metropolis and discover the 'provinces', or the reciprocal journey from the regions to the metropolitan 'centre' which is part of Priestley's project to articulate another version of 'Englishness'. Such travellers – unlike, for example, the interwar favourite H. V. Morton – are not looking for an identity that is already there, an essential 'England', deeply rural and deeply historical, simply waiting to be revealed.[34] They are *constructing* identity, not *revealing* it. Through spatial narrative, organised around geographical movement and social encounters across class lines, they are seeking to link together the fragments of a broken society, remapping the co-ordinates of the nation as a social and political entity, and reversing its dominant spatial logic, so that instead of the metropolitan 'centre' – the City and West End of London – we are given the regions; in place of the rural shires we get the industrial centres; as an alternative to the nation state of the English ruling class we are offered 'the people', organised in mutually-supporting, co-operative, sharing communities, which are not confined to one particular location, but are dotted throughout the British Isles. In this way, the writings of Priestley, and documentary films such as *Coalface* and *Night Mail*, sought to reconstruct the notion of community, and thus helped to lay the foundations of the social democratic Britain that was to arise during and after the Second World War.

The social democratic narrative of the Thirties thus attempts to foreground a different national 'space', but it does so purely from within the boundaries of the nation. However, there is another 'journey' in the Thirties: the movement 'outwards' and 'inwards' of an imperial culture which is also in the process of change, albeit in contradictory ways and only at a partially conscious level. So, older discourses of jingoism and world power are rejected, for example in Priestley's celebration of 'little Englandism' against the 'big Englanders ... red-faced, staring, loud-voiced fellows, wanting to go and boss everybody about all over the world'; there is a sense here of a 'return home' after the temporary aberration of Empire.[35] On the other hand, a film such as Basil Wright's *Song of Ceylon*, whilst ostensibly sympathetic to the native Ceylonese culture which it is attempting to document, still displays the attitudes of a western 'orientalist' discourse in its underlying cultural assumptions. The native people and their culture are treated in a respectful manner, but they are ultimately part of what Raymond Durgnat

has described as an 'imperialist pastorale' which acts as an exotic
space into which the western intellectual can escape without ques-
tioning his/her own power/knowledge relationship to that 'other'
world.[36] So, it is necessary to chart the emergence of an alternative
narrative perspective on the Empire, here expressed in the writings
of the Caribbean intellectual C. L. R. James, who made the journey
to the metropolitan 'centre' in the early Thirties and whose works
such as *The Black Jacobins* help to connect prewar Britain with that
hybrid, multicultural nation of the Nineties which is obviously the
product of a myriad other journeys 'inwards' since that time.

Both social democratic and post-imperial narratives take us up to
our own time. We argue in this book that the shifts and turns of
British social and political life during and since the postwar era can
be charted through the changing reputation of the Thirties, and the
ways in which the decade has been presented and re-presented by
historians, politicians, journalists, novelists, playwrights, and all the
manifold forms of public discourse. It was with the decline of the
postwar consensus that narratives of the Thirties once again became
publicly contested – culminating, perhaps, when Norman Tebbit fa-
mously held up the example of his father, who in the depths of the
Slump got on his bike and looked for work instead of resting back
on state benefits. Tebbit was not telling an untruth, or denying the
experience of unemployment; he was rearticulating the story of the
Thirties from one of injustice and systemic crisis to one of pre-
welfare state self-reliance, thereby undermining the narrative which
linked the Thirties to the postwar settlement and underpinned the
welfare capitalism which the Thatcher government was seeking to
dismantle. It was this act of narrative aggression, as much as
Tebbit's apparent insensitivity, which so stung the Left, aware that
their stake in the political consensus was unravelling along with the
version of history that had helped to carry it to power.

At the moment of writing, it is the Thatcherite story which seems
to be unravelling, and a new social-democratic project may be, for
the first time in decades, a practical possibility. No such political
sea-change, we would argue, can be carried through without accom-
panying narratives, comparable to those of 1945 and 1979, rearticu-
lating past, present and future in a new way, and showing how the
story can be carried through to its desired resolution. We await with
interest the emergence of the new narratives of social democracy.

2

Representing the People: The Documentary Film Movement and Mass Observation in the Thirties

To throw some light on discussions about the 'people' and the 'popular', one need only bear in mind that the 'people' or the 'popular'...is first of all one of the things at stake in the struggle between intellectuals.

Pierre Bourdieu, 'The uses of the "people"', in *In Other Words: Essays Towards a Reflexive Sociology* (Cambridge, 1990), p. 150

It is, I know only too well, difficult to be sure of one's attitudes in a decade like this. Can we heroicize our men when we know them to be exploited? Can we romanticize our industrial scene when we know that our men work brutally and starve ignobly in it? Can we praise it – and in art there must be praise – when the most blatant fact of our time is the bankruptcy of our national management? Our confidence is sapped, our beliefs are troubled, our eye for beauty is most plainly disturbed: and the more so in cinema than in any other art. For we have to build on the actual. Our capital comes from those whose only interest is in the actual. The medium itself insists on the actual. There we must build or be damned.

John Grierson, 'Flaherty' (1932), in *Grierson on Documentary* (ed. Forsyth Hardy, (London, 1979), p. 30

INTRODUCTION: INTELLECTUALS AND THE PEOPLE

One of the assumptions often made about the Thirties is that it is a decade when the social and political exigencies of the time in-

17

evitably propel men and women into action. This is the period of the Slump and hunger marches, of Fascism and the Spanish Civil War, when the 'objective circumstances' of history force individuals to take sides and act in the 'real world'. As Auden explains in his own inimitable, if somewhat melodramatic fashion:

> *To-morrow for the young poets exploding like bombs,*
> *The walks by the lake, the weeks of perfect communion;*
> > *To-morrow the bicycle races*
> *Through the suburbs on summer evenings. But to-day the*
> > *struggle.*
>
> *To-day the deliberate increase in the chances of death,*
> *The conscious acceptance of guilt in the necessary murder;*
> > *To-day the expending of powers*
> *On the flat ephemeral pamphlet and the boring meeting.*[1]

In his essay, 'Inside the Whale', Orwell comments that the main difference between the Twenties and the Thirties is that the 'Olympian' attitude of writers in the former gives way to a growing awareness of politics in the latter, both at home and abroad. Whereas the Twenties is the era of 'irresponsibility' and 'disillusionment', its successor witnesses the genesis of political commitment and a 'serious purpose'.[2] Thus the Thirties is the decade of realism in literature and the arts in general, producing documentary film, reportage, the *Living Newspaper*, proletarian fiction, workers' newsreels, the 'pylon poets' and a myriad of responses to the growing crisis which put their faith in the power of the 'actual' to act as an antidote to the myths of Fascism and the 'illusions' of a 'dying culture'. It is the moment, then, when the 'ordinary people' start to invade the spheres of politics and culture, partly as the objects of concern for a liberal, reforming middle class, but also as the subjects of a new discourse, documentary realism, which articulates a new attitude to popular culture.

Whilst the above account has much to recommend it, in recent years a number of critics have questioned some of the assumptions which lie behind this construction of the 'people' and their culture, both during the Thirties and subsequently. Pierre Bourdieu has pointed out that the people and popular culture are not simply the well-springs of a hidden truth or reality which radical intellectuals can tap at will in their attempts to excoriate the *status quo*. The 'actuality' of people's lives is not just transmitted through the filter of

political discourse or the camera lens, when politicians or journalists or documentary film-makers 'go out' to the people. Rather, the discourses which concern themselves with the people and their culture are mediations of reality which codify the social and political relations of the observer to the observed. As a consequence, the Thirties cannot just be understood as a moment when ordinary people and the real world suddenly come into their own and 'speak' for themselves, for the people and their culture are, as Bourdieu argues, 'one of the things at stake in the struggle between intellectuals.'[3]

This means that when one examines the role of what has been termed the 'documentary impulse' in the thirties,[4] and its relationship to the life of 'the people', one needs to recognise that what is 'at stake' here is not simply a progressive attitude on the part of intellectuals, or a new way of recording reality. Documentary film, Mass Observation and 'pylon poetry' do not just constitute new formal responses to a changing political and cultural climate, nor are they simply the by-products of developments in the apparatuses and institutions of cultural production (government-sponsored film units, magazines of photo-journalism such as *Picture Post*, left-inspired journals, such as *Left Review* and *New Writing*, etc.). The urge to document is also a socio-cultural phenomenon, what Stuart Hall has termed a 'public social rhetoric' which encodes a range of social relations between the people and a variety of social groups (intellectuals, cultural workers, political organisations, etc.).

Consequently, a number of different attitudes are enshrined in this discourse of the people and the 'subjects' of this discourse tend to appear in a variety of different guises. If you are a reforming social democrat, such as the documentary film-maker John Grierson, they can be the heroes of history, as the epigraph at the beginning of this chapter suggests, although they can also be a source of potential dangers too if they are seduced by 'romantic' Socialist dreams of workers' control. To a Communist, or self-styled Communist such as the younger Auden, the people can be the 'salt of the earth' and revolutionary comrades, but they may also be the 'dupes' of an Americanised mass culture, as Auden's poem *A Communist to Others* rather naively demonstrates:

Comrades who when the sirens roar
From office shop and factory pour

> 'Neath evening sky;
> By cops directed to the fug
> Of talkie-houses for a drug
> Or down canals to find a hug
> Until you die:[5]

Thus, the interpellation of the people, in and through the discourse of intellectuals, is a process which encodes a number of social and political assumptions. Auden's 'comrades' are recognisable to other intellectuals of a similar persuasion because the rhetorical devices of the poem enunciate them in a certain way, producing a 'type' which we, the progressive intellectual readers, can recognise (the worker as a potential force for change if given proper leadership but, at present, an automaton, 'directed' by the state and 'drugged' with the modern opiate, the movies). Similarly, in the case of the documentary, the particular corner of the world to which the 'social eye' of the camera is directed, the organisation of the shot, the editing and dramatisation of the resulting frames, are also bound up with the mobilisation of a certain 'point of view'. For even the simplest news photograph to be 'meaningful', it has to be codified in a certain way and linked with a caption which 'anchors' it for the viewer. These textual strategies are not merely formal mechanisms for the extraction of meaning, but social and discursive channels of communication – semiotic realisations of particular social and political positions. Realism and the documentary are not just transparent windows on the 'real world' of the people, but *encodings* of meaning which actively construct the object of their gaze, as well as recording it. Hence one of the reasons why the working class and the industrial scene of the thirties can still exist for us is because documentary film makers *chose* to record them and make their images available. It is the motivations behind the particular selection of images which require our attention as much as the images 'themselves'.

THE CULTURE INDUSTRIES: A NEW INTELLIGENTSIA?

The 'documentary impulse' should, then, be understood as a discursive relationship between one social grouping (the intelligentsia, including various sub-sets of cultural producers, such as documentary film makers, writers of reportage, etc.) and another ('the

people' at work or at play). In order to understand the high profile of documentary forms in the thirties, we need to examine the changing character of the intelligentsia and its relationship to the people, particularly the working class, as mediated through a developing 'culture industry'. Francis Mulhern points out that there was a major recomposition of the 'traditional' intelligentsia in the inter-war years, particularly the Thirties, which had profound effects on the 'national culture':

> Historically, Britain's intellectuals had been a small and compact group, linked from birth by myriad ties of kinship and formed in the socially and culturally homogeneous milieu of England's public schools and older universities. The political and ideological controversies of later Victorian England did no grave or lasting damage to this remarkably cohesive bloc, but from that time onwards, changes of a less dramatic character began gradually to erode the foundations of its cultural monopoly. The relative decline of the public schools and Oxbridge within an expanding educational system, the amelioration of the educational prospects of lower-middle-class children, the growth and diversification of State activity, the expansion of whole sectors of cultural production and the creation of new ones (publicity and the cinema, for instance) together induced the formation of an intellectual stratum which, although still dominated by the old Victorian bloc, was necessarily of a different character. By the early 1930s, the national intelligentsia was more numerous, more disparate in social origin and occupational composition, and culturally less homogeneous than ever before.[6]

By the Thirties a growing sector of the intelligentsia was employed in the expanding culture industries, such as radio, film, the press and advertising and an important part of its function was to monitor, evaluate and shape public opinion. The developing advertising industry was concerned with analysing behaviour and consumer response through the application of methods derived from the social sciences, particularly psychology, and phenomena such as Mass Observation or the documentary film movement cannot be understood in isolation from the demand for market research and surveys of public opinion which were increasingly common in the Thirties. Newspapers such as the *Daily Mirror* employed market research to elicit information about their readers' preferences and it has been argued that the *Mirror's* ability to predict Labour's victory

in the 1945 election was not just a product of the correct political 'instincts', but was also due to the development of strategies for listening to its readers which started in a 'non-political' way when it turned to market research in the late Thirties.[7]

DOCUMENTARY AND THE STATE: GRIERSON AT THE EMB AND GPO

The documentary film unit which John Grierson established at the Empire Marketing Board in the late Twenties is an illuminating example of the way in which organisations interested in influencing public opinion provided a new point of articulation between intellectuals and the people in the inter-war years. The EMB had been set up in 1926 to promote imperial products to the British market and it recognised that it could only achieve this aim by 'bringing the Empire alive'.[8] In the shape of an intelligent civil servant, Sir Stephen Tallents, it found an able supporter who, as Stephen Constantine remarks, 'translated the message of the advertising profession into a language of government service.'[9]

> It was, he argued, essential in a modern mass democracy, in which the functions of government were increasing, for departments of state to keep the public informed of government services, educate them in their use, persuade them to comply.[10]

Tallents' positive approach to advertising, publicity and the new mass media meant that he was sympathetic to approaches from Grierson and the suggestion that the EMB might be interested in financing a film on the Scottish herring industry, which was released as *Drifters* in 1929. Grierson, who had studied moral philosophy at Glasgow University, had been engaged in postgraduate research on the film industry and public opinion under the guidance of Walter Lippmann at Chicago University on a Rockefeller Scholarship, before returning to England in the late Twenties. Grierson's own account of how he came to work with the EMB highlights the way in which the new media were being seen increasingly as a vital mediating link between the state and its citizens:

> It is worth recalling that the British documentary group began not so much in affection for film *per se* as in affection for national

education. If I am to be counted as the founder and leader of the movement, its origins certainly lay in sociological rather than aesthetic aims. Many of us after 1918 (and particularly in the United States) were impressed by the pessimism that had settled on Liberal theory. We noted the conclusion of such men as Walter Lippmann, that because the citizen, under modern conditions, could not know everything about everything all the time, democratic citizenship was therefore impossible. We set to thinking how a dramatic apprehension of the modern scene might solve the problem, and we turned to the new wide-reaching instruments of radio and cinema as necessary instruments in both the practice of government and the enjoyment of citizenship. It was no wonder, looking back on it, that we found our first sponsorship outside the trade and in a Government department, for the Empire Marketing Board had, from a governmental point of view, come to realize the same issue. Set to bring the Empire alive in contemporary terms, as a commonwealth of nations and as an international combine of industrial, commercial, and scientific forces, it, too, was finding a need for dramatic methods. For the imaginative mind of Sir Stephen Tallents, head of that department, it was a quick step to the documentary cinema.[11]

Grierson had become interested in the work of the Soviet film directors during his period of residence in the United States and the influence of techniques derived from Pudovkin, Vertov and Eisenstein (particularly the latter's use of montage and superimposition of images) is visible in *Drifters*. The critical success which greeted the screening of *Drifters* at the London Film Society in 1929 was important in establishing a radical British film form, the documentary, which, whilst hardly revolutionary in the Soviet sense, did utilise film to explore the dynamics of social existence. Grierson's break with the rather theatrical tradition of British cinema, and its hidebound attitude to working-class and provincial life, offered a model which inspired a number of young film makers who were keen to employ the new medium as an instrument of social reform. Figures such as Paul Rotha, Stuart Legg, Edgar Anstey, Arthur Elton, Harry Watt and Basil Wright joined the EMB film unit, or its successor at the GPO when the former collapsed in 1933. Moreover, such was Grierson's magnetic attraction that internationally-known directors such as Robert Flaherty and Alberto Cavalcanti could be persuaded to work with the unit, as

well as national figures of artistic renown, such as the poet
W. H. Auden, the composer Benjamin Britten and the painter
William Coldstream.

Grierson's imposing presence in the EMB and his persuasive
manner helped him to develop a measure of autonomy for himself
and his collaborators, both in matters of artistic control and bud-
getary decisions.[12] He was adroit at negotiating with the Treasury,
appealing to the ideology of the artist as individual creator as a
way of wresting control from his sponsors over the form and
content of his 'creations'. At the same time, he was adept at dealing
with attempts to impose political censorship on the film unit and
his reputation helped to keep at bay suspicious members of the
government and the secret services. (Harry Watt recalls their politi-
cal complexion as being 'left-wing to a man. Not many of us were
Communists, but we were all socialists.' For a while a Special
Branch agent, who had been smuggled in under the guise of a
trainee film editor, kept watch on the unit, albeit with what
seems to have been limited effect.[13] Nevertheless, this gives some
indication of how the 'secret state' viewed this, hardly subversive,
operation.)

Although the function of Grierson's film unit was to provide pub-
licity for its sponsors, he and his colleagues managed to exploit a
number of contradictions in their relationship with the state and ef-
fectively produced an agenda for themselves which was more akin
to the politics of social democracy than those of the national gov-
ernment. According to Grierson, *Drifters* had been designed to high-
light 'the high bravery of upstanding labour'.[14] Other 'epics of steam
and steel' such as *Coalface* [1935: directed by Alberto Cavalcanti] and
Night Mail [1936: directed by Harry Watt and Basil Wright] took this
project further by celebrating the centrality of the industrial working
class to the economic and social life of the nation.[15]

Thus, the opening statement of *Coalface* – 'Coal is the basic indus-
try of Britain' – made it clear that this staple industry was vital to
the economic existence of Britain and the welfare of its citizens. The
dangers of the miner's life were emphasised by the enumeration of
basic facts about accident rates in the industry and then this narra-
tive was set, contrapuntally, against a Brechtian chorus which
voiced the miners' own experience of the reality behind these facts:
'trapped underground....rescue efforts abandoned....cannot
account for 200 lads'. Finally, the miners' dependence on the pit
and, by implication, the pit owners, was hinted at in a passage

which has a poignant ring once again, after the virtual de-nationalisation of the industry: 'The miner's life is bound up with the pit. His home is often owned by the pit. The life of the village depends on the pit.'

In *Drifters, Coalface, Night Mail* and other documentary explorations of working life, Grierson and his collaborators elaborated what Robert Colls and Philip Dodd have termed a 'national-collectivist' myth of Britain which celebrated the interconnectedness of the nation and, by implication, called for more planning, integration and state involvement in the economic life of the country.[16] Grierson spelt this out in the essay, 'First Principles of Documentary', where he argued that individualism was dead, both as a social philosophy and as an aesthetic attitude and claimed that some form of collectivism must, inevitably, take its place:

>you may feel that in individualism is a yahoo tradition largely responsible for our present anarchy....In this case you will feel that you want your drama in terms of some cross-section of reality which will reveal the essentially co-operative or mass nature of society.[17]

Coalface highlighted the centrality of a national resource and workforce which were under private ownership, implying that they were so vital to the nation's interests that they demanded greater public concern and state involvement. *Night Mail* dealt with an already existing public utility and employed the trope of a journey on the night mail through the heartlands of industrial Britain to emphasise the collective and interdependent nature of the nation at a number of levels (the metropolis and the regions, workers and middle-class commuters, agriculture and industry, male drivers and female canteen workers, etc.) This was, in essence, the 'social patriotism' of war-time Britain being rehearsed at an earlier stage, but under a Tory-dominated National Government. As Grierson was to recall with the benefit of hindsight, documentaries such as *Coalface* and *Night Mail* were the films of 'a Tory government gradually going Socialist.'[18]

SOCIAL DEMOCRACY IN THE WINGS?

In attempting to unite the interests of the documentary film-makers with those of their government sponsors at the EMB and GPO,

Grierson seemed to feel that it was possible to create a new 'public sphere' which would act as a forum for enlightened debate. The aim was to articulate values and strategies which would replace the unbridled individualism which he and others of a centre-left persuasion so despised. Grierson argued that it was possible to distinguish between the government of the day, which for most of the Thirties was largely dominated by the Tory party, and the *state*, which was an entirely different entity. He maintained that the longterm interests of state corporations such as the EMB were not necessarily coterminous with a Conservative commitment to the free market and 'business as usual'. Potentially, these corporations embodied a new vision of the state, based on a planned, socialised economy. By appealing to enlightened state functionaries such as Sir Stephen Tallents one could virtually bypass the government of the day whose bankrupt *laissez-faire* policies had prevented it from recognising the long-term imperatives of a state capitalism in crisis.[19]

When he looked back on the Thirties from the vantage point of 1941, in an essay entitled 'Education and the New Order', Grierson argued that the lesson to be learned from the recent past was that Britain and other *laissez-faire* capitalist countries had been locked in a mind-set which had prevented them from adjusting to a changed economic order. Individualism had 'created its own Frankenstein', unleashing forces which it was 'of all philosophies, least fitted to coordinate and control.'[20] The spirit of competition which had been 'so great a breeder of initiative yesterday' had become 'a disturber of peace today'. On the home front, the experience of the depression had taught the simple lesson that a philosophy 'in which nobody is his brother's keeper' had become impossible 'when a decision by a board of directors hundreds of miles away will wipe out a town overnight.' In the sphere of international affairs it was clear that irresponsible competition, governmental *laissez-faire* and failure to plan had landed 'not towns but nations and continents in the deepest disaster in the history of mankind.'[21]

Grierson's analysis of the crisis in capitalism had much in common with more Marxist critiques, such as Christopher Caudwell's *Studies in a Dying Culture*, in that both saw the decline of individualism as the necessary outcome of an inevitable 'historical process'.[22] Although Grierson did not share the Marxist commitment to revolutionary socialism, he argued that *laissez-faire* capitalism could not resist the tide of history and the movement

towards some form of collectivism, whether Fascist, Soviet or, as far as he was concerned, the ideal solution of democratic socialism. As an educationalist, Grierson felt that he and others in his profession must recognise that 'the individualist dream is over and done with in a world which operates in terms of large integrated forces'. If they failed to face up to this challenge and provide guidance 'in terms of what is happening and what is most needed in the world', then the people would find 'other more realistic leadership'.[23]

In making his point about the need for educationalists to address the 'new order' of politics, Grierson recalled the experience of his father, 'a good dominie of the old school', who had been a schoolmaster in a Scottish village on the Perthshire–Stirlingshire border. Grierson senior had believed that 'learning was power', but as a Conservative his approach had been 'strictly individualist', so that the ideal product of his schooling had been an enlightened workman with a library of Carlyle and Ruskin. However, with the rise of industrial militancy amongst the miners in the village, 'the true leadership in education had passed to other shoulders':

> It had in fact passed to the miners and to the economists among them. They read their Blatchford and Keir Hardie and Bob Smillie; they attended their trade union meetings; and the day came when they elected their first Labour member of parliament, and, with so many other villages in Scotland, joined in the great drive for a Socialist Britain.[24]

The experience of Grierson's father in that small Scottish mining village in the early years of the century had obviously provided a salutary lesson for the young Grierson – one which influenced his attitude to education for the rest of his life. In the world of 'massed bodies' of capital and labour, an educational philosophy based on the teachings of an individualistic literary intelligentsia could not hope to compete with a socialist economic theory grounded in the day-to-day realities of the class struggle. If intellectuals wished to play a continuing part in the historical process, they must find a way of engaging with this new political constituency which was no longer willing to tolerate the hegemony of the Conservative and Liberal middle class.

Clearly there were different ways of responding to this growing separation between the 'traditional' intelligentsia and an emerging 'organic' intelligentsia of the working class. One forum which brought the two groupings together was the Communist Party

which flourished in the period of the Popular Front, increasing its
membership from 7700 in 1935 to 17 700 in 1939.[25] Through the
medium of the Communist Party and organisations such as The
Left Book Club (whose membership had reached 50 000 by
1937),[26] radicalised middle-class intellectuals such as Auden,
Isherwood and Caudwell were drawn into the ambit of a
'counter-public sphere' which seemed to offer the basis for a new
relationship between intellectuals and militant workers. Whatever
their merits or demerits as mass political parties,[27] membership of
political organisations such as the Communist Party and the
Independent Labour Party allowed traditional intellectuals to
rethink their relationship to the militant, self-educated section of
the working class.

Grierson's own preferred solution was to remain independent of
political parties. In common with figures such as Shaw, Wells and
the Webbs, he seems to have viewed himself as the member of an
intellectual caste, whose function was to act as a reforming wing of
the state, offering advice to sympathetic state functionaries and
communicating their policies to the people. ('We, the leaders of the
people and of [sic] the instruments of public opinion', he wrote in
'The Documentary Idea'.[28] It is possible to see his ideal society as an
updated version of the later Hegel's Prussia, or as a Wellsian state
in which a planned, collectivised economy, based on high tech,
would be controlled by an elite of scientists and civil servants.
Although he distanced himself from his father's individualism, he
did not necessarily reject the 'dominie's' drive for cultural and po-
litical hegemony. Grierson may have respected the miners and their
socialism, but there was still more than a touch of Victorian pater-
nalism in his approach to education and, like his father, he ap-
proached his task as one whose role was to 'educate his masters'.
There seems to have been a residual fear (as there was with Shaw,
Wells and the Webbs) that if he and others of his caste lost touch
with 'the masses' the results might be disastrous. Hence his attrac-
tion to a Burnhamite model of state capitalism, in which central
planning, 'public unity' and 'discipline' were preferred over more
'Utopian' models of socialism. As he explained in 'Education and
the New Order':

> I do not believe that Socialism as we have thought of it will come
> at all. That surely was plain when the Workers' Soviets with all
> their Socialist dreams of workers' control in a classless society

were driven out of industrial management in Russia and Republican Spain, and by their own leaders. They were driven out not because Socialism did not represent a high ideal, but because, given the conditions of modern technocracy, workers' self-management represents an unpractical and inefficient one. My view, if any, would be that we are entering upon a new and interim society which is neither capitalist nor socialist, but in which we can achieve central planning without loss of individual initiative, by the mere process of absorbing initiative in the function of planning. I think we are entering upon a society in which public unity and discipline can be achieved without forgetting the humanitarian virtues.[29]

This, rather top-down approach to a reforming politics was obviously rationalised in terms of a particular reading of the development of Socialism, as we can see from the above passage, and the notion that Workers' Soviets and experiments in self-management failed simply because of 'inefficiency' might be contested by anti-Stalinist analyses of Russia or Republican Spain in the Thirties.[30] However, Grierson's negative response to the idea of 'workers' control in a classless society' was not an isolated one, as studies of Russia such as the Webbs' *Soviet Communism: A New Civilisation*[31] demonstrate, and it needs to be understood in relationship to the trajectory of a particular section of the reforming intelligentsia in the Thirties. For this grouping the Thirties was a kind of interregnum, in that it saw, to use Eric Hobsbawm's telling phrase, 'the forward march of Labour halted', albeit in an earlier period than the one to which Hobsbawm is referring.[32] With the debacle of 1931 and Labour's resulting political exile, the working class was in danger of being tempted by what Grierson and others saw as a 'romantic' Socialism which made 'unpractical' demands, such as workers' control of industry. In this context, it was vital that 'responsible' reforming intellectuals should act as a bridge between the organic intelligentsia of the working class and the state, thus preventing further polarization of the political arena and paving the way for a return to social democracy at a later date. It is hardly surprising, then, that Grierson's films did not explore the social and political tensions of the workplace to any great extent (with the exception, perhaps, of the above example from *Coalface*), preferring instead to celebrate the harmony of machine and labourer as the basis for a new 'efficient' order.

DOCUMENTARY AND MASS OBSERVATION: 'THE DRAMA OF THE DOORSTEP'

One way of bridging the gap between different sections of society and building a new political consensus was by documenting the activities of those whose work and leisure had generally gone unrecorded and using the results to break down middle-class stereotypes of the working class. Eric Hobsbawm has pointed out that in the twentieth century 'two linked instruments made the world of the common man [sic] visible as never before and capable of documentation: reportage and the camera':

> 'Reportage' – the term first appears in French dictionaries in 1929 and in English ones in 1931 – became an accepted genre of socially-critical literature and visual presentation in the 1920s, largely under the influence of the Russian revolutionary *avant-garde* who extolled fact against the pop entertainment which the European Left had always condemned as the people's opium. The Czech communist journalist Egon Erwin Kisch, who gloried in the name of *Reporter in a Rush* (*Der rasende Reporter*, 1925, was the title of the first of a series of his reportages) seems to have given the term currency in central Europe. It spread, mainly via the cinema, through the Western *avant-garde*. Its origins are clearly visible in the sections headed 'Newsreel' and 'the Camera Eye' – an allusion to the *avant-garde* film documentarist Dziga Vertov – with which the narrative is intercut in John Dos Passos' (1896–1970) trilogy *USA*, written in that novelist's left-wing period. In the hands of the *avant-garde* Left 'documentary film' became a self-conscious movement, but in the 1930s even the hard-headed professionals of the news and magazine business claimed a higher intellectual and creative status by upgrading some movie newsreels, usually undemanding space-fillers, into the more grandiose *March of Time* documentaries, and borrowing the technical innovations of the *avant-garde* photographers as pioneered in the communist AIZ of the 1920s to create a golden age of the picture-magazine: *Life* in the USA, *Picture Post* in Britain, *Vu* in France.[33]

Although film was an expensive medium, and increasingly so since the advent of sound, it was utilised by organisations outside the entertainment industry who saw the advantages of a medium with a dramatic visual impact and a large audience. (So, for

example, by the mid-Thirties the Conservative Party was employ-
ing film material in its election campaigns.) Documentary films
were cheaper to produce than their fictional counterparts, since, to
put it simply, one was not required to pay actors or construct
scenery. Moreover, the developments in film language initiated by
Eisenstein, Pudovkin, and Vertov made it possible to recycle
footage in different combinations through the device of montage,
again making the whole process cheaper for potential backers.
Grierson and his collaborators at the EMB were not slow in point-
ing this out to their paymasters, with the resulting irony that films
used to advertise the British Empire were increasingly influenced
by the techniques of Soviet revolutionary cinema.[34]

The term 'documentary' had first appeared in French where it
was used to denote a 'travelogue'. In 'First Principles of
Documentary' (1932) Grierson commented that documentary shorts
which used film to explore the natural world had proved popular
with commercial audiences.[35] However, one of the problems of de-
veloping documentary was the conditions of commercial exhibition
which usually dictated the showing of two feature films, so that
there was 'neither space for the short *and* the Disney *and* the maga-
zine', although 'by good grace' some of the renters would 'throw in
the short with the feature'.[36] In Britain, one of the main hurdles was
that certain classes of film had been excluded from quota protection
under the 1927 Cinematographic Act, including those dealing with
current events and the natural world. Hence, the commercial cir-
cuits were, in the main, unwilling to include documentaries in their
programmes, although the first six films made by the EMB (known
as 'The Imperial Six') were sold to Gaumont British and certain
documentaries which had won critical acclaim, such as *Drifters*,
Night Mail and *Song of Ceylon* were given limited commercial
exhibition.

One answer to this problem was to build up a distribution
network outside the commercial circuit and before its collapse in
1933 the EMB was distributing eight hundred films to film clubs,
the YMCA, women's organisations, schools and other educational
establishments, etc. Stephen Constantine notes that a cinema was
opened at the Imperial Institute in London for 'the free showing to
organisations and general public of films from the EMB library', the
annual audience reaching a peak of 357 000 by 1930.[37] However, as
Peter Miles and Malcolm Smith have commented, at a time 'when
commercial cinemas were admitting anything up to 17 millions

every week, it is unlikely that non-theatrical distribution was reaching more than 25 000.'[38]

However, if Grierson and his collaborators were 'largely preaching to the converted', in the form of 'those minority of "film buffs" who made up the audience of the film clubs and who were interested in film as an art form',[39] their films did gain access to a wider audience in the Thirties with the growth of outlets in the labour and co-operative movement. Moreover, it would be historically short-sighted to deny the importance of films such as *Coalface*, *Night Mail* and *Housing Problems* as representations of a changing attitude to the working class in the Thirties. Instead of portraying working people as butts of middle-class humour, British documentaries attempted to show 'the common man' in 'the romance of his calling' (*Industrial Britain*, *Night Mail*, *Coalface*) or the 'intimate drama of his citizenship' (*Housing Problems*).[40] Looking back on these early attempts to celebrate the lives of the 'labouring people', it is not surprising to see that they are characterised by a residual sexism (Grierson's panegyric on the virtues of the 'common man' is reflected in the virtual absence of women from most of these films, with the partial exception of Anstey's *Housing Problems* and Jennings' *Spare Time*) and by what Raymond Durgnat has described as a 'hear-no-evil, speak-no-evil, see-no-evil idyll' of industrial life.[41] Nevertheless, these images of 'ordinary life' seem to have made a lasting impression on sections of the middle class who were aware of the limitations of their existing horizons. As Stuart Hood comments:

> It is difficult to convey to people to whom shots of workers are the routine images of television documentaries the impact of such pictures on audiences in the Thirties; as Grierson records, their appearance on the screen caused spontaneous applause from spectators used to the representation of workers in British feature films, in which, as Ralph Bond, a Communist member of the movement, has explained, 'when workers did appear...they were always the comedy relief, the buffoons, the idiots or the servants'.[42]

Grierson clearly saw the films of the Unit as instruments for 'consciousness-raising' on a variety of social issues and he was particularly keen to make the working class visible to the rest of society. He wrote of the need to record the 'actuality' of 'raw' everyday life, which he claimed would provide 'a more complex and astonishing

material' for films than any of the texts which emerged from the 'studio mind'. Documentary was, then, the 'drama of the doorstep'.[43]

It is possible to uncover the same impulse at work in Mass Observation, an organisation which employed a mixture of reportage and social science surveys as a method for investigating 'mass behaviour' in the Thirties. Mass Observation was founded in 1937 by Tom Harrisson, Charles Madge and Humphrey Jennings. Harrison was an anthropologist who had returned to England after spending three years with the people of Malekula, an island in the New Hebrides, and whose book, *Savage Society* had been published in the Left Book Club series. Madge was a journalist working for the *Daily Mirror* who was also a poet with a wide circle of artistic friends in London. Jennings was a surrealist poet and painter, who was working with Grierson and was to direct the documentary film on leisure, *Spare Time*, for the Film Unit and Mass Observation in 1938–39.[44]

The founders of Mass Observation were keen to develop an 'anthropology' of British customs and rituals by employing mainly voluntary observers in a 'mass science' of British life. As they wrote in a letter to the *New Statesman*, headed significantly 'Anthropology at Home':

> Mass Observation does not set out in quest of truth or facts for their own sake, or for the sake of an intellectual minority, but aims at exposing them in simple terms to all observers, so that their environment may be understood, and thus constantly transformed. Whatever the political methods called upon to effect the transformation, the knowledge of what has to be transformed is indispensable. The foisting on the mass of ideals or ideas developed by men apart from it, irrespective of their capacities, causes mass misery, intellectual despair and international shambles.[45]

The idea was to get the British people to view their culture in a detached, dispassionate manner. So, key icons and rituals were subjected to the same 'objective' assessment as a 'primitive' culture which had just been discovered by an anthropologist in one of Britain's colonies. For example, Mass Observation organised teams of observers to keep detailed diaries of events on the day of George VI's coronation. Crowd behaviour was monitored, people were interviewed about their attitudes to the monarchy, the various festivities such as the street parties were described in detail and

'denaturalised' for the nation. The results were published in a study called *May Twelfth 1937*, which juxtaposed the various reports in a montage without editorial comment, rather like Jennings' film *Spare Time* of 1938, which was also, in part, a product of Mass Observation and which largely eschewed a directive narrative 'voice over' as well.[46]

This 'anthropology' of the British people and their 'social habits' was developed further in studies such as *Britain by Mass Observation* (1939) and *The Pub and the People* (based on surveys conducted in the late Thirties but not finally published until 1943). Three other volumes were also projected and advertised in Chapter 9 of *Britain* 'to be published shortly, by Victor Gollancz', but they were never to appear. (They were: *Politics and the Non-Voter, How Religion Works* and *Blackpool: One Week a Year*.)

Perhaps the most interesting text for the purposes of this study is *Britain*, which has been described by Angus Calder as 'one of the most significant books of that decade [that] has never been fully acknowledged.'[47] It offers a fascinating insight into a variety of 'totemic' activities, from the observance of two minutes silence on Armistice Day to old and newly created folk customs (the traditional 'Kew Yead' festival during the Lancashire Wakes Weeks and the 'Lambeth Walk' of 1938). The latter were obviously amenable to an approach derived from Harrisson's excursions into cultural anthropology, as there were clear parallels between the social function of 'folk rituals' such as dances in a 'primitive' culture and their modern equivalents, such as the 'Lambeth Walk'. However, Harrisson and Madge moved beyond these, more general folk customs to consider a ritual which seemed to register the political tensions of the late thirties in a much more direct way, namely Armistice Day. This was a ceremony which acted both as a generalised human reaction to war and as a specific marker of a particular historical event. Because of this, Madge and Harrisson were able to harness anthropology to address specific changes in historical consciousness, as the following extract demonstrates so vividly:

> The central ceremony at the Cenotaph, attended by the King, has a religious character and thousands of secondary ceremonies take place all over the country at churches, or round consecrated war memorials. Yet the Silence itself is not confined to people with religious beliefs; it also has a national and social significance, and amounts in a sense to a reaffirming of confidence in the motives

which led to this country joining in the Great War. Of course it is possible for anyone to treat the Silence as a personal experience, connected with personal memories, but these almost inevitably join on to wider, less purely individual feelings. To some extent, at any rate, the vast majority are compelled by the circumstances of the Silence to stop in the middle of their own lives and think in terms of their own country and other countries, of war and peace, life and death. From the religious point of view, the Silence is a kind of link between living and dead – like other ceremonies the world over at which the spirits of the dead members of the tribe are thought to return to their former home on earth. But from the secular, non-religious point of view, the Silence is an act of social solidarity, with implications connecting it with this life rather than the life to come. It is on this side that the institution of the Silence is suffering a certain strain. The general attitude towards the Great War has changed. A new generation has grown up. Since 1918 the League of Nations has come into existence and then practically faded out again. The Versailles Treaty has been made and broken. The Great War is less in people's minds than the possibility of the next war. So it is not surprising that on November 11, 1937, a very large number of people felt uneasy about the whole performance. Repeating the same ritual year after year is a way of *stopping* time, of keeping it fixed at some point in the past. This is possible when the point in the past is mythological, like the death of a corn god, but it is trickier when the events are recent enough to have implications in the present, yet long enough past for other events to have changed people's ideas about the first events.[48]

Mass Observers (M.O.) discovered that the ceremony seemed to mean far more to the older generation who had participated in the Great War. For the men, especially, it was a moment to remember 'old comrades' who had fallen at the front. For many of the others, however, particularly the younger generation, the ritual had become a hollow act, so that the Armistice or the Great War went unmentioned. (One observer at a factory in Staines noted that, 'The general impression of the chaps was I think that it was a bit of a nuisance, and to some an embarrassment to stand still'.)[49] Moreover, even though the majority of those surveyed did not seem actively to resist the meanings attached to the ritual (i.e. the notion of honouring the dead), they were increasingly alienated

from official interpretations of the First World War as 'the War to end War': 'Feeling that another war was not distant, many people resented as an imposition and mockery the version of history which the Armistice ceremony seemed to convey.'[50]

According to M.O., this feeling was reinforced by the findings of other surveys around the time of the Munich Crisis, which suggested that whilst a majority of the population still wished for a peaceful solution to the crisis, they were becoming disillusioned with the actions of Chamberlain and the political establishment. (To put it simply, M.O. claimed that their surveys revealed an increasing proportion of the public, especially men, to be concerned that Hitler should not be accommodated at any price, especially after his actions in Czechoslovakia and the Sudetenland – although public opinion was exceedingly volatile and subject to large mood swings.)[51] M.O. concluded that the crisis had thrown up a 'hiatus', 'a hit-and-miss relationship between leader and led, old habit and new',[52] which was not just the product of recent political events, but which suggested more fundamental structural differences in society. Hence those in power would do well to heed the findings of M.O. and listen to public opinion if they wished to survive the next few years and avoid political turmoil:

> For we find constantly that the pattern of society is changing in a way which is seldom noticed as significant, and even less recognised officially by the leaders, but which is nevertheless storing up new tangles and conflicts for the not too distant future....[53]

There are obvious parallels between the aims and methods of Mass Observation and those of the Documentary Film Movement. We have already noted that Grierson was heavily influenced by the American sociologist, Walter Lippmann, whose early study of the media, *Public Opinion* (1924) argued that the 'ordinary citizen' in 'mass society' was increasingly unable to participate in decision making because he/she no longer had access to all the knowledge necessary to make informed decisions. In a mass society people's opinions were only elicited at election times and even then they were subject to the influence of specialist 'opinion makers' who controlled the apparatuses of 'opinion formation'. Lippmann drew largely pessimistic conclusions about the long-term prospects for democracy. As far as he was concerned, the hierarchical divisions between the people and the governing élite were built into the very structure of society, since they were endemic to a mass-mediated

culture. By contrast, Grierson and the founders of Mass Observation saw the media as part of the solution to society's problems, if they could be harnessed in the right way. Film, radio and the printed word could be utilised to give the citizenry better information about their society, so that they could participate in debate which would be informed by 'hard facts', rather than prejudice and rumour. Correspondingly, public opinion could be given a hearing between elections by calling on the services of organisations like Mass Observation. The more society came to know itself through detailed observation of its own demeanour and behaviour, the more existing class barriers would be seen as unnatural inhibitions to effective, rational action. (Hence, the study *Britain* by Mass Observation in 1939 was subtitled *The Science of Ourselves*.[54] Thus, knowledge of 'the actual' was the key to human progress; the main difference between Fascism and democracy was that 'Fascism thrives on fantasy, while democracy has grown up with science and recognition of newly noticed facts.'[55]

This empiricist belief in the transparent nature of 'actuality', and its seemingly all-pervading power, highlights the strengths and weaknesses of the liberal reforming sector of the British intelligentsia in the Thirties. On the one hand, there was a pragmatic approach to social and political problems which did not retreat from the demands of the empirical world into an ethereal realm of pure theory. On the other hand, there was a touching faith in the redeeming properties of 'facts', once they were made known to the society at large, which suggests a measure of political conformism and philosophical naivety. In this they were not alone, as Perry Anderson has argued in his seminal essay, 'Components of the National Culture',[56] for empiricism and pragmatism have been powerful currents of thought in British (especially English) intellectual life since the eighteenth century. Anderson points out that, whereas the European mainland witnessed the birth of critical thought, in the form of dialectical philosophy and the synthesising discipline of sociology, this totalising perspective was largely absent from British intellectual life which favoured the development of 'empirical, piecemeal intellectual disciplines':

Its thinkers were confined by the cramped horizons of their class. They developed powerful sectoral disciplines – notably the economics of Ricardo and Malthus. They advanced the natural sciences – above all evolutionist biology with Darwin. But they

failed to create any general theory of society, or any philosophi-
cal synthesis of compelling dimensions....
British culture never produced a classical sociology largely
because British society was never challenged as a whole from
within: the dominant class and its intellectuals consequently had
no interest in forging a theory of its total structure; for it would
necessarily have been an 'answer' to a question which to their
ideological advantage remained unposed. *Omnia determinatio est
negutio* = the very demarcation of a social totality places It under
the sign of contingency. The British bourgeoisie had learnt to fear
the meaning of 'general ideas' during the French Revolution:
after Burke, it never forgot the lesson. Hegemony at home
demanded a moratorium on them.[57]

However, as Anderson remarks so astutely, the notion of totality
'can never be completely displaced from an industrial society. If it
is suppressed in its natural loci, it will inevitably be displaced into
abnormal or paradoxical sectors. So it has been in Britain.'[58] Hence,
Anderson argues that holistic, totalising thought was displaced into
two channels – the literary criticism of Leavis and the anthropology
of Malinowski and Evans-Pritchard. In the case of the latter, al-
though 'hegemony at home' demanded a moratorium on 'general
ideas', the existence of the Empire allowed the scientific study of
'primitive' social totalities at a safe distance from the domestic
culture:

> British imperial society exported its totalizations, on to its subject
> peoples. There, and there only, it could afford scientific study of
> the social whole. 'Primitive' societies became the surrogate object
> of the theory proscribed at home. British anthropology devel-
> oped unabashedly in the wake of British imperialism. Colonial
> administration had an inherent need of cogent, objective infor-
> mation on the peoples over which it ruled. The miniature scale of
> primitive societies, moreover, made them exceptionally propi-
> tious for macro-analysis as Sartre once commented, they form
> 'natural' significant totalities. British anthropology was thus able
> both to assist British imperialism, and to develop a genuine
> theory – something sociology in Britain was never able to do.[59]

If one accepts the general tenets of Anderson's intellectual
history of Britain, then it does not seem so strange that the erst-
while anthropologist and the employee of the Empire Marketing

Board should have made such an impact on the documentation of British society and its culture in the Thirties. Moreover, Anderson's model offers a way of explaining the political contradictions in the anthropological 'project' which Harrisson and Grierson initiated. On the one hand, Documentary and Mass Observation implied a new 'take' on Britain which relativised notions of 'culture' and, by implication, raised the status of 'ordinary people', particularly the working class. Once it was accepted that British culture was no different in phenomenological terms from that of a 'tribal' society in the New Hebrides, then one could, in theory, dispense with hierarchical notions of 'high' and 'low' art and their class connotations. Analysing the national culture as a set of 'rituals', which were all of equal intrinsic interest, was a major break with an Arnoldian, literary-based cultural tradition, which was inevitably constrained by its commitment to certain canonical forms and practices.

However, this potential advance on one theoretical front was matched by what we can now see as an equally limiting approach to its subject matter, in which the British working class was presented as an object of interest, or concern, by a reforming intelligentsia. As Stuart Hood has noted, Harrisson spoke rather revealingly of studying the 'cannibals of Britain', and Grierson remarked on the need to 'travel dangerously into the jungles of Middlesbrough and the Clyde'.[60] Such statements would seem to indicate that the working class functioned as a 'strange tribe' for the Documentary film makers and Mass Observers (with the exception, perhaps, of individuals who had an intimate knowledge of that background, such as Harry Watt and Ralph Bond).

Hence, there was a rather ambiguous response to the working class, who were presented either as 'victims' of social circumstances (e.g. *Housing Problems*) or 'heroes' whose labour was deified. We can illustrate the latter point if we return to *Coalface*. Here we find that the miners are celebrated for their labouring power in a rather Stakhanovite fashion but, as Colls and Dodd point out, the camera tends to efface their individuality so that they become primitive, sculpted objects.[61] The 'anthropological' gaze of the film camera fetishises the working-class labourer as bodily 'shape' and, hence, maintains a controlling distance for the middle-class observer. In part, this reduction of the working class to physical, labouring bodily matter can be attributed to a middle-class guilt about the trials of the working class and a (perhaps unconscious) tendency on the part of the middle-class intelligentsia to reproduce hege-

monic definitions of mental and manual labour. There is also a
gender dimension to this romanticisation of the miner's physicality,
as Bea Campbell has rightly observed, a male narcissism in which
the miner's body 'is loved... because of its work and because it
works'.[62] But, whatever the inflections of this 'anthropological' dis-
course in *Coalface*, it clearly 'fixes' the working class male as an
object of middle-class interest, rather than the subject or bearer of
knowledge.

There were differences between Mass Observation and the
Documentary Film Movement. The latter was tied much more
closely to the needs of government organisations or private spon-
sors in the commercial sector. The former, by contrast, was sup-
ported in the main by voluntary workers or funds from
entrepreneurs such as the publisher Gollancz, who financed the
Worktown survey on life in Bolton during the latter part of the
decade. (Gollancz had also been involved in commissioning
Orwell's *The Road to Wigan Pier* for the Left Book Club in 1936.)
However, despite these differences in terms of patronage, the 'dis-
cursive field' within which both organisations operated was
already 'given'. So, intellectuals such as William Empson,
Humphrey Jennings and John Sommerfield, who were 'drafted in'
to Bolton, were the products of a particular education and although
they might espouse radical political views, the ingrained assump-
tions which they carried from school and university were not
necessarily designed to challenge the hierarchical cultural arrange-
ments of British society.

The *Worktown* project is an interesting example of the contradic-
tions which are discernible in the 'social rhetoric' of Documentary
and Mass Observation, in that it is possible to pinpoint marked dif-
ferences between the outlook of the largely working-class sample
from the town and their mainly middle-class interviewers. Thus, in
a study of all-in wrestling, which appears in *Britain*, there are two
contrasting accounts of the sport, one by a 'patron' and the other by
Madge and Harrisson who wrote up the survey.[63] The patron's
account runs as follows:

> I think All-in wrestling is the best money worth in any sport. I
> think it is clever and exciting, a real evening sport. Glad that
> there is some thrilling entertainment different than pictures. We
> patrons receive as cheap an evening excitement as it is possible to
> produce.[64]

Harrisson and Madge summarise the appeal of the sport rather differently:

> Free Style Wrestling is so successful because it meets certain needs of the people. It is very similar in this and other respects to the football pools, with which it has three important features in common: it is thrilling, allows dream-wish fulfilment, and gives the feeling of being a member of a group by talking about it. Free Style Wrestling gives excitement, satisfies the sense of adventure; betting does the same. Identification with the wrestler in the ring makes it possible to think one is strong and vigorous and not afraid of an opponent; day-dreams about big prizes can make one believe that one is rich and secure. Both things can't happen in reality, neither will the weaver with the weak lung be ever strong and powerful, nor will the Littlewood better be ever rich, never can those things be achieved in reality; but as they are so situated, the easy way out is identification and day-dreaming, and as the two opportunities provide both, they are used by the 'crowd'. The same is true of the thrill; probably all those who want to be thrilled would not mind indulging their sense of adventure in another way, where more effort and activity is needed, but as there is no chance for it in the ordinary life of a working-class man, what remains is again betting and entertainments like Free Style Wrestling. And about the third common feature, the social common bond; we have shown elsewhere how it is fading out in all spheres of life, the churches losing influence, the political parties with no ideology; what wonder, as human beings are herd animals, that this common bond is taken up wherever it is found in tune with contemporary need and industrial presentation.[65]

Two general points emerge from this discussion of popular culture. First, there is a tendency to view the 'people' as a homogeneous mass or 'herd' whose behaviour is different from that of the individualised intellectual/scientist. D. L. le Mahieu has pointed to the impact of Gustav Le Bon's *The Crowd* [1896] and Wilfred Trotter's *Instincts of the Herd in Peace and War* [1916], between the wars, the latter, especially, having an influence, on 'the leadership of the major political parties, including Labour.'[66] The description of crowd behaviour at the All-In Wresting Match seeks to apply a popularised version of Trotter's social psychology and Freudian psychoanalysis in understanding the 'compensations' and

'wish-fulfilment' which the mass (interestingly conflated with the working class) derives from this form of activity. Behind all this is a notion of the masses as childlike innocents who are easily distracted and manipulated. Moreover, as Angus Calder has commented, this 'theory' of human psychology seems to be given dramatic proof by the politics of the historical moment of 1938/39 – that of Fascist expansion in Europe – when *Britain* is researched and written-up. The conclusions, then, are obvious:

> Unless 'they' are given the right things (which include 'facts'), 'they' are naively vulnerable to the 'hypnotic' appeal of Fascism. It is more urgent that the 'masses' should be well-understood and well-directed than that they should speak for themselves through M-O.[67]

The second observation, which must impress itself on those interested in more recent developments in cultural theory is that, for all their pretensions to scientific objectivity and cultural relativity, here Madge and Harrisson draw on a set of aesthetic categories which make clear, hierarchical distinctions between 'high' and 'low' culture. It is interesting to see how the supposedly dispassionate anthropological approach of Mass Observation, which seems to be based on 'value-free' assumptions about culture, ('human beings are herd animals') actually hides quite traditional views about the relative status of those in the sample and the researchers observing them. Ultimately, the cultural aspirations of a Madge or Harrisson are deemed to be 'higher' than those of the average punter at an All-in Wrestling Match ('probably all those who want to be thrilled would not mind indulging their sense of adventure another way, where more effort and activity is needed, but as there is no chance for it in the ordinary life of the working-class man ...'). One notes the term 'indulge' here and the implied notion that other forms of cultural activity require self-discipline, whereas the working class is hedonistic and chooses to 'gratify' its pleasures in a rather indiscriminate fashion. One is struck also by the phrase, 'it is thrilling, allows dream-wish fulfilment' implying that popular culture is a form of 'distraction', a 'bread and circuses' for the masses, which prevents them from engaging in more 'worthwhile' pursuits.

In *Distinction: A Social Critique of the Judgement of Taste* Pierre Bourdieu argues that the dominant cultural or 'symbolic' realm reproduces social hierarchies by the creation and maintenance of a system of differences based on 'taste'. In the symbolic field, judge-

ments on the merit of a particular art object or cultural activity, which might seem to derive from an autonomous realm of aesthetics, actually function as 'markers' of social class. Symbolic power operates through a division of the cultural field into a 'high' and a 'popular' or 'mass' aesthetic, with the 'disinterested', contemplative approach of the former (a Kantian 'taste of reflection') being preferred over the passion, emotion and hedonism of the latter (a 'taste of sense'):

> The culture which results from this magical division is sacred.... The denial of lower, coarse, vulgar, servile – in a word, natural – enjoyment, which constitutes the sacred sphere of culture, implies an affirmation of the superiority of those who can be satisfied with the sublimated, refined, disinterested, gratuitous, distinguished pleasures forever closed to the profane. That is why art and cultural consumption are predisposed, consciously and deliberately or not, to fulfill a social function of legitimating social differences.[68]

Returning to the passage on all-in wrestling, we can see that Bourdieu's typology does, indeed, seem to operate in the symbolic order of prewar British society. Mass Observation reproduce the archetypal division between a 'mass', whose cultural predilections are those of the 'heart' and who expect culture to address them in a direct, unmediated way, and a 'minority', who are capable of appreciating a more 'difficult', formal representation of the world which does not 'indulge' their senses and makes more demand on the 'mental' faculties. Although Madge and Harrisson seem to be breaking with dominant notions of culture by embracing the pleasures of the 'masses', they still operate with an aesthetic schema which reproduces (albeit, perhaps, at an unconscious level) the dominant conceptions of cultural value.

Ultimately, of course, this is not just a matter of aesthetics or cultural values. In his introduction to the 1986 reprint of *Britain*, Angus Calder makes the important observation that the contradictions of the text are also those of the liberal, reforming intelligentsia at a particular moment in its history.

The concept of a single 'mass-mind' which Madge and Harrisson deploy casually yet confidently, consorts strangely with their statement that:

> Each and every person is automatically a individual, conforming outwardly... but underneath with repressions and furies which are partly 'personal'.

Britain, without resolving it, exposes a contradiction characteristic of the thinking of 1930s intellectuals – who were typically, the heirs of a liberal-individualist tradition in a period of 'mass politics'. Freudianism appeared to offer the chance of a new kind of liberal individualism based on an appreciation of psychological differences between autonomous personalities. Marxism seemed to call on the intellectual to immerse himself (sic) in the 'masses' and the 'struggle'. Harrisson's politics, when he chose to name them, were Liberal (he worked on a volume, never published, for the Liberal Book Club). Madge had been a committed Communist. But both seem to have been relieved to retreat from the dilemma of their generation into the supposedly neutral position of the 'scientist', where consciousness could be neither 'collective' nor 'individual', but 'objective'.[69]

Like their counterparts in the documentary film movement, Madge and Harrisson saw their role as being 'to describe rather than prescribe – not to agitate, but to mediate.'[70] By distancing themselves from the field of social action and by screening out their own subjective relationship to the 'Britain' which they had placed under the microscope, Madge and Harrisson hoped to be able to produce an 'objective' diagnosis based on the facts. But this was to resolve the contradiction between their own individual and collective identities by falling back on an 'autonomous' intellectual practice which refused to examine its own conditions of production and reproduction. As Calder implies, there was a retreat into the notion of the Mass Observer as 'free-floating' intellectual, whose own social function and identity remained uninterrogated. 'The people' as a collective entity, a 'mass', were still 'out there', mysterious, unknown and requiring investigation, whilst the intelligentsia consisted of a group of individuals whose motivations were self-evident and did not require analysis. It was enough, then, to produce a method of investigation which united the individual and social components of human behaviour at a theoretical level, through an abstract fusion of Freudian and Marxist thought – by treating the people as 'masses' with repressed desires which were displaced into activities of 'wish-fulfilment'. Meanwhile, the politics of intellectual life and the relationship of individuals such as Madge and Harrisson to the educational and cultural aspirations of the people (i.e. their own identity as *part* of the people) were, perhaps, insufficiently foregrounded.

CONCLUSION

Traditionally it has been argued that the documentary is a 'window on the world', but it would be more accurate to see it as a prism, refracting the image of reality through the medium of the observer's 'gaze' and the cultural apparatus which he/she serves. In the Thirties, the pictures of 'the people' which emerged from the 'texts' of the Documentary Film Unit and Mass Observation were largely the products of middle-class presuppositions and preoccupations, albeit those of a liberal, reforming intelligentsia. Although there was an intense desire to bridge the socio-cultural gap between the classes, existing attitudes could not be cast off like a worn-out shoe, as Orwell observed so acutely in *The Road to Wigan Pier*.[71]

Nevertheless, the work of the documentary film-makers and Mass Observation marked a significant shift away from a patronising view of 'the people', particularly the working class, towards a more *inclusive* notion of citizenship, which was to form a crucial bridge with the social patriotism of the war and the ultimate victory of Labour in 1945. If they were unable to break with all the inbuilt cultural and political assumptions of the middle class, they did contribute perhaps to the re-education of that sector of British society, by shifting its gaze, from the metropolitan heartland of London's West End and the suburban villas of the Home Counties to other parts of the British Isles and other sections of the community. The 'national voice' which emerged from the films of Grierson's Unit and the pamphlets of M.O. in the Thirties may not have been that of 'the people', pure and unadulterated. (How could it have been, anyway, for 'the people' cannot exist, as Stuart Hall and others have argued, outside the political discourses which 'produce' them.)[72] But it was a voice which demanded a new relationship between the governing élite and the citizenry, between 'the people' and their tribunes, a voice which would prove hard to ignore when war broke out, and which helped to prepare the ground for the eventual construction of the Welfare State.

3

In Search of the People: The Journeys of J. B. Priestley

> Grierson and his young men, with their contempt for big easy prizes and soft living, their taut social conscience, their rather Marxist sense of the contemporary scene, always seemed to me figures representative of a new world, at least a generation ahead of the dramatic film people.... But nearly all documentary films seem to me a very romantic heightening of ordinary life, comparable not to the work of a realistic novelist or dramatist, but to the picturesque and highly-coloured fictions of the romancer.... For plain truth they cannot compete with the printed word.... In short, their very medium compels these young men to be romantic in practice, no matter how realistic they may be in theory.[1]

Like the documentary film-makers whose work and attitudes he admired, J. B. Priestley sought to engage with the social realities of his time. However, his mode of doing so, and the reputation he earned from it, could hardly be more different. On the one side, it would seem, we have 'earnest and enthusiastic' young intellectuals, steeped in *avant-garde* film technique, striving on a subsidised shoe-string to bridge the gap between their own middle-class metropolitan culture and the real lives of the people. On the other, we have the best-selling middlebrow novelist, rooted in the ordinary life of his native Bradford, and addressing huge popular audiences in a style that owed more to Walpole and Meredith than to Eisenstein. Where some observers have seen documentary as Britain's true art cinema, few have even acknowledged Priestley as a serious twentieth-century novelist. Yet in important ways, they were part of the same cultural and political current. Cutting across their technical and aesthetic differences, and their contrasting conditions of production, was a common project: to reunite a fractured nation around a more inclusive conception of itself, one which rested above all on defining and constructing 'the people' as the real Britain. It was a project which transcended cultural distinctions,

and came into its own in the populist social-democratic politics of
the war and postwar.

Priestley was probably the most widely-known English writer of
his time. He was a prolific best-seller, in an age when best-seller-
dom mattered, before the electronic media displaced the printed
word from its central role in the public sphere. The runaway
success in 1929 of his third novel, *The Good Companions,* and a string
of theatrical hits beginning with *Dangerous Corner* (1932), swelled
by a continual flow of essays, reviews, biographies, film-scripts and
radio talks, made him into a prominent public figure, an all-
purpose sage with a broadly-based audience of a kind which today
only television can deliver. Priestley's novels were set in the
present, and he was a habitual commentator on the contemporary
scene. *The Good Companions* and *Angel Pavement* (1930) established
his reputation as a surveyor of English life, while other novels ad-
dressed particular social issues – the mass media and the slump in
Wonder Hero (1933), wartime class relations in *Daylight On Saturday*
(1943) – while non-fiction such as *English Journey* (1934), and the
wartime polemic *Out of the People* (1941), engaged with the 'condi-
tion of England' in documentary and political form. These writings
– probably more so than the documentary films, with their limited
audiences – helped to construct the way people saw the present, of-
fering a framework with which to think through and respond to
historical experience. But they also situated the present historically,
translating recent economic and social change into accessible expe-
riential terms. Though he was never regarded as much of a socialist
writer – too young to be an H. G. Wells Fabian, too old, and in any
case too mainstream, to be of the Auden generation – his reading of
this experience was usually a critical one, and, as a later chapter
will argue, he played an important part in constructing the post-
1940 social democratic consensus.

Finally, Priestley was a Yorkshireman: the one thing everybody
knew about him was that he came from Bradford. The dubious
term 'professional Yorkshireman' could no doubt be used, but only
to alert us to the fact that any identity other than that of male met-
ropolitan public-schoolboy was (and to a degree still is) regarded
in English literary circles as a self-indulgent affectation. Without
being a 'regional writer' as such, Priestley retained his strong re-
gional identity, and accent – both of which, as a Cambridge gradu-
ate well-networked in London literary circles, he could easily have
dropped had he wished to. This identity was thus in a sense both

authentic and carefully chosen, distancing him from metropolitan élites, underwriting his cultural and political populism, and giving him a particular 'take' on England and Englishness.

For all these reasons, Priestley might be considered an obvious port of call for those interested in interwar culture – and especially in the social and political engagement of writers, which is considered to be such a major issue in the 1930s. Yet, in academic terms, he is barely regarded as part of the history of the twentieth-century novel at all, and if he is mentioned in literary surveys, it is only gingerly and in passing.[2] If he is taken more seriously as a dramatist, this may be more of a comment on the poverty of English drama than a mark of Priestley's status. Readers – at any rate, those with any cultural ambitions – have learned to be equally wary, as Richard Hoggart discovered amongst the 1950s working class:

> Others are proud of reading J. B. Priestley and writers such as him, because they are 'serious writers with a message'. Others have learned that Mr Priestley is a 'middlebrow', and only mention him in terms of deprecation. They tend to read bitterly ironic or anguished literature – Waugh, Huxley, Kafka and Greene.[3]

Indeed, the stout-swilling vulgarian Ida in Graham Greene's *Brighton Rock* is damningly identified as a Priestley-reader.[4] Such judgements are confirmed by the tone of some of Priestley's defenders. *The Good Companions*, we learn from the back of its 1962 Penguin reprint, 'has defied the cheap sneers of some highbrows' by going through forty editions and impressions; its 'grand and positive pageant of English life' embraces an 'enchanting cast of characters' as good as any in Fielding or Dickens (including 'probably the most lovable Yorkshireman in all literature'); the whole thing, in short, is 'unforgettable'.[5] Never was a jacket blurb more calculated to warn off the intelligentsia. The message is clear – if you buy this book, hide it: Priestley is middlebrow. To explain these responses, and locate Priestley in British culture, we must begin by exploring this category of the 'middlebrow', before returning to his actual works.

DEFINING THE MIDDLEBROW

The middlebrow is perhaps the least analysed and theorised of cultural categories. Falling as it does between the high achievements

of Art and the raw power and street cred of popular genre fiction, it has never quite been rescued from the immense condescension of the literati.[6] Attempts to define 'middlebrow' in rigorous terms are invariably unsatisfactory. This is because it is not part of a precise critical vocabulary, but emerges from a particular cultural discourse which itself lacks rigour. For 'middlebrow' is very much a word of its time. Unknown to the Victorians, it made its appearance, according to the *Oxford English Dictionary*, in 1928, a coinage from 'highbrow' and 'lowbrow', terms which were imported from the USA before the First World War. This timing is significant. The 1920s saw the explosive growth of a commercial mass culture – radio, cinema, recorded music, the popular press – whose foundations had been laid at the end of the nineteenth century. But the 1920s also saw an apparently opposite cultural shift: the growth of modernism in literature, art and music, all of which, at least at the cutting edge, moved away from the representational forms of the nineteenth century and became 'difficult', marked by formal or stylistic experimentation, and the 'bitter irony and anguish' of the alienated artist.

The emergence of the terms 'highbrow' and 'middlebrow' – partly a direct result of this dual cultural shift, and partly a defensive response to it – marked a new boundary of cultural discrimination, which divided the general educated audience from the high intelligentsia. The Victorians had marked the difference between the 'serious' novel, dealing with weighty themes, and largely read by the middle classes, and the sensational fiction preferred by the masses – just as the oratorio and the parlour ballad were distinguished from the coarse music-hall song. But although in some fields (such as history) academic culture had begun its process of separate development, by and large the middle-class literary culture was still a shared one, open to all educated people, in which many working-class readers could also participate. In the 1920s, however, the educated culture was becoming divided between the professionals and the general readers. In the audiences who – unable to stomach Stravinsky – remained loyal to nineteenth-century romanticism; and in the readers who, finding Joyce, Woolf and Lawrence hard to take, sought the continuance of nineteenth century realism, the 'middlebrow' was born.

A number of different considerations, then, come together in defining middlebrow writing. It is partly defined in terms of what it is not: its eschewal of certain formal and stylistic characteristics of

the highbrow, as well as its avoidance of overtly formulaic popular techniques. It is partly defined by its potential readership: those with literacy and cultural awareness above the basic level assumed by mass popular fiction, but lacking academic literary training. Finally, it is defined by its cultural status, partly ascribed in hostile terms by the developing literary-academic intelligentsia, and partly self-designated (as in the Penguin jacket-blurb). Middlebrow is thus a loose category, defined by a cluster of attributes, rather than a genre like the western or the detective story, defined by distinctive formal characteristics and 'rules' of operation.

From this definition, it is clear that the emergence of 'middle-brow' as a category was closely linked with general cultural changes in the interwar period, which made possible an unprecedented expansion in the production of fiction. Books, of course, have always been commodities. However, in this period their status as commodities underwent significant change, as part of a general intensification in the commodification of culture. The growth of secondary education expanded the market for novels, as well as 'intelligent' non-fiction books, and new publishers (Secker and Warburg, Michael Joseph, Penguin) emerged to produce the novels this new market wanted – categorised now simply as 'fiction', by contrast with the 'literature' produced by highbrow publishers such as Faber, Cape and Hogarth, and the popular genres in which firms like Mills and Boon were now specialising. Middlebrow publishers adopted new promotional and marketing methods – advertising, Book Clubs, mass distribution, and the 'bestseller' as an object of intrinsic interest; in this, they followed the example of the newspaper and magazine press, which was itself an important part of the promotional strategy.[7]

The socio-cultural context in which the middlebrow novel emerged and was defined was crucial in shaping its character. Hostile responses to it from the literary intelligentsia focused both on its alleged aesthetic deficiencies, and on the process of commercialisation which was held responsible for them. Q. D. Leavis's attempt in *Fiction and the Reading Public* to draw a firm line between middlebrow and highbrow fiction was crucial to the project of the Leavises and the *Scrutiny* group to professionalise the activity of literary criticism, and to extend its cultural influence. Leavis argued that the middlebrow 'literary novels' of such as Priestley, Wells, Galsworthy and Hugh Walpole were a kind of fraud. They pretended to be serious novels by adopting a

particular tone and technique, but instead of giving their readers 'the exhilarating shock that a novel coming from a first-class fully-aware mind gives' they delivered only 'the relief of meeting the expected, and being given the desired picture of life', not to mention 'soothing and not disturbing sentiments', 'faked sensibility... insensitiveness to the life around them... lack of discrimination... the functioning of a second-rate mind... the complacent, hearty knowingness of *The Good Companions*, coarse in texture...'. Readers who are flattered and seduced by this fakery are thereby rendered incapable of spotting the real thing when they see it, so that 'the major achievements of contemporary novelists appear to be unknown even by name'.[8]

This state of affairs, the Leavises argued, was the product of a long period of cultural decline, in which industrialisation, urbanisation and commercialisation had fragmented a once-unified culture. Now the supply of literature had become 'an industry subject to the same conditions as the supply of any other commodity', and the middlebrow bestseller was its grotesque product. Even the intelligentsia had been corrupted: reviewers and academics, who should be the guardians of standards, had simply become part of the commercial machine. The 'Walpole-Priestley regime', which supposedly dominated literary London, formed part of a philistine network which embraced Book Clubs, magazines such as the *London Mercury*, and dilettante academics such as Oliver Elton and Lord David Cecil, all hostile to 'the moderns', and promoting the middlebrow conception of culture to a half-educated readership.[9]

Despite the perennial Leavisite call for intellectual rigour in literary studies, all these judgements are *ex cathedra*, and none are supported by any close textual analysis; rather, passages from novels are quoted which are presumed to speak for themselves. Nor does the historical narrative which underpins this critique stand up to any close scrutiny. As Francis Mulhern has commented,

> The trichotomy 'highbrow'/'middlebrow'/'lowbrow' was less an analytic discovery than an evaluative representation of the literary field as seen through the optic of 'culture', not the result of analysis but its unchallengeable presupposition.[10]

But this very dogmatism is significant: the criteria of judgement are never spelt out because their whole point is that readers are supposed to share them already. If they do not, that merely confirms the narrative of historic cultural decline.

The important process going on here is not the close analysis of
novels or history, but what Pierre Bourdieu has described as the
construction of cultural distinction.[11] Categories such as high-
brow/middlebrow/lowbrow are not embedded in the texts to
which they refer, waiting to be drawn out by the acute critic: rather,
they function as elements in a socially constructed system of taste,
in which inequalities of economic and cultural capital are expressed
and reinforced through preferences in everything from music, art
and literature to cars and interior decor. There is nothing intrinsi-
cally sacred about 'legitimate' (or highbrow) culture, and nothing
intrinsically inferior about middlebrow culture (*culture moyenne*) –
as is shown by the fact that, from time to time, 'by one of those
taste-maker's coups which are capable of rehabilitating the most
discredited objects', things may pass from one category to the
other. What makes middlebrow culture middlebrow is not its in-
trinsic qualities, but its significance within this system of taste, and
the kind of people who therefore appropriate it: and in particular,

> the social nature of the petty bourgeois…. It is, quite simply, the
> fact that legitimate culture is not made for him (and is often
> made against him), so that he is not made for it; and that it ceases
> to be what it is as soon as he appropriates it.[12]

Out of this system of discriminations arise distinctive patterns of
taste. Intellectuals, with their high investment in abstract thought
acquired through long education, tend to value the form of an arte-
fact; while popular or middlebrow taste gives more importance to
the content, the thing represented – a beautiful view, a moving
story, an interesting character, a tune. The difference is satirically
encapsulated in a *Punch* cartoon of 1928, cited by George Orwell: a
youthful aspiring writer, asked by a relative what he is going to
write about, replies, crushingly, 'My dear aunt, one doesn't write
about anything, one just *writes*'.[13]

Bourdieu does not offer any history of how the prevailing system
of taste and distinction has developed. However, as we have
argued in the Introduction, there are reasons to see the period
between about 1910 and 1930 as one of profound discontinuity and
cultural crisis, of which the rise of both modernism and commercial
culture formed a part. The commercialisation of culture created
new centres of cultural power (press barons, broadcasting institu-
tions, Hollywood) over which the traditional intelligentsia, for-
merly the guardians of culture, had little if any influence. The new

cultural distinctions – an antagonistic rather than a paternalistic re-
lationship between the serious and the popular, and the wedge
driven between highbrow and middlebrow – meant that even if
cultural capital no longer delivered assured cultural power, it at
least carried unassailable cultural status. Armed with this, the em-
battled intelligentsia could carry the cultural struggle away from
the marketplace, where they had been defeated, and into the insti-
tutions of the state – especially the education system, to which the
Scrutiny group attached such crucial importance. Hoggart's
working-class autodidacts learned soon enough that the 'bitterly
ironic or anguished' works of the moderns carried higher cultural
status than middlebrow 'writers with a message' like Priestley.

Locating Priestley is therefore not just a matter of scrutinising his
works for signs of some formalistic essence of the middlebrow.
Since such categories were a product of the cultural structures and
relations of the time, it is within these structures and relations that
he has to be placed, beginning with that all-important site: the
marketplace.

Priestley's relation to the market was that of a professional writer
who lived by selling his work. On leaving Cambridge (where he
went as an ex-serviceman, with meagre financial resources), he set
out, not to revolutionise the novel or transform the way people saw
the world, but to earn a living with his pen. To this end, he estab-
lished a position for himself in 1920s literary London (where he
was a kind of protégé of Hugh Walpole), working desperately hard
writing essays, reviews, and ultimately novels for most of a decade,
before *The Good Companions* made his name and his fortune.[14] In
Leavisite eyes, as we have seen, he was one of the *apparatchiks* of
the commercial-critical machine. But unlike some of his contem-
poraries, Priestley needed to respect the market in order to make a
living. A 'highbrow' novel, Q. D. Leavis observed, would be lucky
to sell 3000 copies overall; this would hardly keep its author alive
without patronage, an independent income, or a high tolerance for
poverty. Until the later months of 1929, when *The Good Companions*
was selling those 3000 copies every day, Priestley was obliged to
harvest a hard living – not to mention 'anxiety, overwork, constant
strain' – from what salaried academics are pleased to regard as
literary hack-work.[15]

Priestley's relation to the market was a powerful influence on his
work. He himself admitted that he wrote too much, partly out of
necessity. Everything he wrote was written with the expectation of

having an audience, not for himself, his muse, or a literary coterie.
Like other bestsellers of the time, he wrote in a broadly realist style
inherited from the nineteenth century, bypassing the formal inno-
vations of the moderns – although his plays were sometimes more
experimental. Those elements in his work that put it beyond the
highbrow pale – a certain cosiness, a weakness for one-dimension-
ally 'lovable' characters, a penchant for happy endings – undoubt-
edly reflected the taste of his readers. But this was not the whole
story. Popular taste neither dictates nor is dictated to. it is the shift-
ing outcome of a dialectical process in which both audiences and
producers have a stake. Priestley himself, as he points out, never
stuck to a single formula in order to milk the market, but moved
restlessly from one form of novel to another, and from novels to
plays, reportage, autobiography – seeking, he maintains, to realise a
wide range of different ideas and solve the technical problems they
posed.[16] This versatility also had a beneficial effect on his career,
making him a prominent figure across a remarkably broad swathe
of cultural life.

It would have been easy for Priestley, like many 'middlebrows',
to robustly dismiss modernism as pretentious élitism. However, in
Literature and Western Man (1960), he defended his realist practice
on pragmatic rather than populist grounds. While warmly praising
certain modernist writers, especially Proust, Joyce and Virgina
Woolf, he sees their innovations as something of a dead end. Woolf
urged the novelist to record life as 'a luminous halo, a semi-
transparent envelope surrounding us from the beginning of con-
sciousness to the end...'. But, argues Priestley,

> the novel is a very loose, wide form; and the task of the novelist is
> to write as well as he can the kind of novel he wants to write. If his
> fiction is concerned with men in a particular society, and with
> the character of that society, then this highly subjective, interior
> monologue, halo-and-envelope method will not serve his purpose
> at all. In the unending dazzle of thoughts and impressions, society
> disappears, and even persons begin to disintegrate.[17]

Priestley's contemporary Winifred Holtby, author of *South Riding*
(1936), distanced herself from 'art' for similar reasons:

> People who write very rare things like Virginia Woolf have a far
> higher standing than professional journalists like myself. I have
> no illusions about my work. I am primarily a useful, versatile,

sensible and fairly careful artisan. I have trained myself to write quickly, punctually and readably to order over a wide range of subjects. That has nothing to do with art. It has quite a lot to do with politics.[18]

The Marxist theorist, Georg Lukács, defended realism in surprisingly similar terms. Lukacs argues that, contrary to modernist critics, form, style and technique are no more than means to an end, and should be judged by how well they help achieve the intentions of the text. Novels are about people, and people are inseparable from their social and historical context. But modernist fiction presents man as an isolated, asocial being; obsessed with individual consciousness, it uses society and history merely as a static backdrop. Only through realism can a novel present the dialectical relationship between the individual and history, because realism takes 'change and development to be the proper subject of literature.'[19] Once again, the question seems to be whether content or form should take priority, and on this issue the Marxist and the bourgeois realist are of one mind.

In the nineteenth century, literature, and in particular the realist novel, had been a crucial site of public discourse on ideological, political and social questions for an educated middle-class and upper-working-class public. We only have to think of Scott, Disraeli, Dickens, Eliot, Hardy, Kipling, Wells, to name only a few of those who are still remembered, to see how this was so. The power of this literary realism, and its centrality to the bourgeois public sphere, was broken both by social and political changes in the pre-1914 period, and by the rise of literary modernism. Modernism involved more than mere formal innovation: to its critics, it broke with history, abandoned the social purposes of writing, and tried to move the novel into the realm of the subjective and the purely literary. It is often argued that in the 1930s, the supreme decade of 'committed writers', literature shifted back towards an interest in social and political issues.[20] As the example of the 'Auden school' in poetry shows, elements of modernism could be compatible with this shift. The case of the novel is somewhat different. The modernist novel as such had never been particularly strong in England. Even so, critics have tended to discuss the 'writers and politics' theme of the Thirties in terms which reflect the subjectivist preoccupations of modernism. As one critical commentary has put it,

the crisis of the literary in the period is identified as a personal crisis about writing and political commitment. Yet even at this level of analysis, individual crises in the writer's response to political events refer only to male left-wing 'highbrow' writing.[21]

A good example of the approach being criticised here is Peter Widdowson's article 'Between the Acts? English Fiction in the Thirties'.[22] This discusses, usefully and perceptively, how seven novelists – all of accepted literary importance – attempted to break out of the impasse of modernist introspection and 'engage with the social reality of their times'. It seeks to challenge the literary ideology which endorses the closures of modernism and reads the novel in purely individualistic terms. Paradoxically, though, the article's focus on the struggles of individual highbrow writers reproduces that same 'turning-inward' of modernism from which these writers were trying to escape.[23] Widdowson suggests that these struggles reflect the crisis of liberal-bourgeois individualism. But this crisis did not prevent others outside the literary canon, such as Priestley and Holtby, writing books which they and their readers believed 'engaged with the social reality of their times': indeed, it encouraged them to do so. These writers (including the right-wing ones discussed by Alison Light) engaged with the crisis of liberalism on a political level – by exploring British society of the 1930s, not on the aesthetic level – by grappling with literary forms. Both are responses to the crisis of liberalism: it is for posterity and the reader to judge which made the more significant intervention in that crisis.

Since the proof of the pudding is in the eating, we now proceed to examine some of Priestley's actual works in the light of some of the points made in this opening section. We will be looking at three texts produced in 1933–4, all of them addressing the dominant theme of the Slump in a 'realist' manner, but using different narrative forms: *Wonder Hero* (1933), a novel; *English Journey* (1934), which is personalised journalism; and *Sing As We Go* (1934), a film for which Priestley wrote the script.

WONDER HERO

Charlie Habble, a young factory worker from the Midlands industrial town of Utterton, helps to prevent an explosion in the chemi-

cals factory where he works. Owing to the fortuitous presence in Utterton of star journalist Hal Kinney, Charlie is briefly turned into a national hero by the *Daily Tribune*, the mass-circulation newspaper which he himself reads. He is whisked off to London and paraded through a hectic round of promotional events, a by-product of the newspaper circulation wars of the time. There, he encounters the vacuity, decadence and corruption of metropolitan life, and meets Ida Chatwick, winner of a rival paper's beauty contest, who comes from a neighbouring Midlands town, and is hoping to become a film star. On hearing that his aunt is seriously ill, he rushes off to the North Eastern shipbuilding town of Slakeby, devastated and decaying under the impact of the Slump. With the money the newspaper has given him, he is able to help his aunt get the treatment she needs, but he cannot prevent the slow disintegration of her family. While Charlie is in Slakeby, he realises that it was not he who really prevented the explosion, but the Communist agitator, Kibworth, who has now been arrested and is about to be imprisoned for his political activities. Rushing back to London, he tries to sort everything out, but discovers that no one is interested: in two weeks he has become old news, and in any case the *Tribune* will not turn a Communist into a hero. Pausing to give some more of his money to help Kibworth's common-law wife and child, Charlie tracks down Ida, whose cinematic ambitions are in ruins; they fall in love, he gets his old job back, and the couple return to the Midlands together.

Priestley described *Wonder Hero* as a 'polemical, journalistic, social-moral fable', of no lasting value. *English Journey*, he thought, did the job better. Although 'a great many people would read a novel when they would never dream of looking at a piece of social criticism', successful didactic fiction must both satisfy and convince, and 'hasty topical novel-writing' ran the risk of doing neither.[24] Certainly, we can point to technical deficiencies in *Wonder Hero* if we are so inclined, including some rather wooden dialogue too anxious to move the plot on, and a plot too obviously devised to get Charlie to the right places at the right times. Its main structural problem is that the 'Charlie and Ida' narrative, whose resolution concludes the book, is too sketchy and has too little to do with the novel's chief focus of interest – the popular press, and the experience of the Slump.

However, these two themes, nicely contrasted, give the novel a strong enough narrative drive until the last chapter, and the French

director René Clair, who knew a good story, once wanted to make a film of it.[25] The ending apart, the structure of the narrative, driven on by our interest in Charlie's fate (and not much by whether he gets the girl or not), is well-matched to the novel's polemical intent. Charlie's story progresses through his movement between Utterton, London, Slakeby and London again. In the process, the reader is given three contrasting 'samples' of English society – the stable Midlands town only moderately affected by the Slump; the devastated shipbuilding community; and London, which (apart from a chirpy hotel chambermaid) is not encountered as a real place at all, but as a nexus of power, corruption and 'muddle'. These are not just isolated snapshots of contrasting locations: they are connected to each other. It is the connections which both bring about Charlie's extraordinary experiences, and construct the muddled and fractured England which Priestley is trying to show us: and chief among these connections is the baleful role of London.

It is London, in the shape of the popular press, which reaches out its tentacles to Utterton and draws Charlie and Ida into its maw, starting the whole story off, and then spits them out again when they have served their purpose. The mass-circulation press, exposed as shallow and manipulative, is a leading villain of the piece. One of the themes of *Wonder Hero* is the decay of the public sphere that the modern press represents. In the opening scene, Charlie is reading his *Tribune*:

> He had no particular respect for it. Gone was that reverence which his father and grandfather had had for the news-sheet, the printed page. He did not believe every statement it made, nor did he disbelieve. He read it in a curious state of suspended belief or disbelief, the mood of a man at a conjuring entertainment...He felt that it was a grand penny-worth, no matter whether it lied or told the truth.[26]

Later, the cynical journalist Hughson describes his paper as 'not really a newspaper, we're a circus in print, a vaudeville show, a Fun City, a daily comic'.[27] All this, of course, is nothing new, and reflects critiques of the popular press from Northcliffe onwards. But Priestley's point about the *Tribune* is not that it corrupts Charlie: he reads it without ill-effect, and even learns something from his experiences at its hands. The point is that it stops people from learning the things that Charlie eventually finds out by experience. When he is about to set off for Slakeby, Hughson remarks

that 'we don't like putting the spotlight on that part of the country. Your uncle could hardly have lived in a worse place. He's taking you right out of the news'.[28] The truth about Slakeby goes the same way as the truth about the averted factory explosion, and the real character of the persecuted Communist, Kibworth – none of them are newsworthy, so they may as well not exist.

But Priestley's intention is to fill the gap in public understanding which the press has left, and tell the world the truth about 'Slakeby'. The Slakeby chapter, ironically entitled 'This Other Eden', adopts a semi-documentary style, contrasting with the lurid caricature of London's West End which precedes it. There is vivid physical description which could have come out of *English Journey*, and much practical information about the dole system, along with an informed account of the human impact of unemployment on the fictional Adderson family. In this way, *Wonder Hero* is both an intervention in public debate about the Slump, and a critique of the way that public debate is shaped (or not shaped) by the press.

Slakeby's own predicament has itself been inflicted by the tentacles of London. The shipyard, Charlie's uncle has us believe, was doing all right under its original owner, 'old Sturk' – 'a hard old devil', but he 'would never have seen them works closed down'. But when he died his two sons turned it into a limited company, the shares were bought by 'one o' those clever Dicks from London', and everything crashed in the Slump – but not before the two sons had sold out: 'them and their families live down London way – one of 'em's in Parliament, they tell me, Conservative of course – as snug as you like'.[29] The only new buildings in the town are, somewhat improbably, two lavishly-appointed banks: 'If they're on our side, and mucking in wi' us, then they ought to be having a big slump too.... Instead o' that, they're building marble palaces'.[30] The conclusion is not hard to draw.

Charlie has already encountered money-manipulators in London, in the shape of Sir Edward Catterbird, a former civil engineer, whose talent for money-juggling has made him a fortune, but cost him his self-respect and his mental stability (in fact, he goes mad before the end of the book). 'You can't make a big fortune by handling things or ideas,' he tells Charlie, 'you can only do it by manipulating money.... There's a curse on usury and gambling, on all money-spinning'.[31] This curse has also dragged down Lady Catterbird, 'a middle-aged women glittering with jewels, with a face like a whitewashed parrot', whose cocktail party, and subse-

quent attempted seduction of Charlie, marks, along with a lurid
nightclub scene, the nadir of London's moral degeneration.[32] The
nightclub and the party are described in terms of sexual and racial
degeneration: 'young men who were trying to look like girls and
girls who were trying to look like young men',[33] men 'hissing
amiably at one another and smiling and swaying and waving their
delicate white paws',[34] cabaret songs full of dirty jokes, sung by a
consumptive girl and an American described by Hughson (with
Charlie's – and Priestley's? approval) as 'a dirty, conceited,
damned impudent, doped half-caste who ought to be back where
he belongs'.[35]

London, then, is corrupting itself, and ruining the rest of the
country. What is to be done about it all? Communism is no solu-
tion: Kibworth is a sympathetic character in some ways, but basi-
cally a deluded and dogmatic figure of fun. Nor is Fascism: Charlie
ducks out in the nick of time from *Tribune* proprietor Sir Gregory
Hatchland's League of Imperial Yeomen ('out of Militant
Imperialism by Fascism').[36] If we dismiss the nutritional nostrums
of the deranged Colway-Peterson, and the eccentric inventor
Finnigan Otley, we are left with Dr Inverurie, the nearest thing to a
Priestley mouthpiece, who patches up the poor of Slakeby, while
holding forth about the iniquities of the world financial system and
the City of London.[37] Or, we must settle for the individual solution:
a trip to the countryside with poor Aunt Nellie, idyllic precisely
because the trees and the flowers are outside the economic system,
unhurt by the Slump: '"Daisies and buttercups," she cried. "They
haven't gone off the gold standard, have they, Charlie?"'.[38]

Wonder Hero, then, as much as any Auden-school poem, could be
described as a response to the crisis of liberal-bourgeois individual-
ism, seen not through the plight of the artist, but through the expe-
riences of 'ordinary' people. Liberal capitalism, which had once
held things in their proper balance and relation, was breaking
down. Finance, once the servant of productive activity, was becom-
ing its master, an end in itself. Too much power and wealth had
fled to London from the provinces, and in the process not only had
the productive areas of the country become impoverished, but
London itself had been corrupted. The liberal press, once the public
forum in which these matters were weighed and discussed, had
been swamped by commercialism and the egotism of newspaper
barons. No one could claim that Priestley offers a solution to these
problems, or that his account of them is unassailable, but he is

drawing them to people's attention and putting his particular slant on them. For this polemical purpose, the form and structure of *Wonder Hero* is, in principle, well-suited, even if it is not fully realised in practice. In particular, its simplistic plot and characterisation, and its lack of technical innovation, meant that nothing stood in the way of its gaining a broad audience for Priestley's first 'take' on England in the Slump.

ENGLISH JOURNEY

'The London and North Eastern Railway brings you to Priestley's England', proclaimed its adverts in 1932.[39] When the following year Victor Gollancz commissioned J. B. Priestley to tour England and write a book about it, he, like the railway, knew he was playing to the strengths of an established literary traveller. Priestley's first popular success, *The Good Companions* (1929), was picaresque and panoramic: a narrative which was also a journey of discovery. A sample of individuals, uprooted from diverse social and geographical origins, tour around the country in a concert party: the backdrop to their various self-discoveries and narrative resolutions is the discovery of England itself, revealed through a mosaic of small-scale – some have said cosy – local vignettes. *Angel Pavement* (1930) is a London novel, consciously Dickensian in scope; although it 'stays put' geographically, its social vision too is panoramic and all-inclusive, scanning the life of the capital through the fortunes of a City firm and those who work there, from the impoverished junior through the respectable head clerk to their gentlemanly and incompetent boss, all ruined by the machinations of a sinister cosmopolitan con-man. *Faraway* (1932) journeys to the South Pacific in search of paradise; and *Wonder Hero*, as we have seen, is constructed around its protagonist's odyssey from the Midlands to London, the North East, and back again.

English Journey takes up the picaresque and panoramic perspective of *The Good Companions*, *Angel Pavement*'s dark theme of lives disrupted and betrayed, and *Wonder Hero*'s critical investigation of the Slump, but it does so within a different genre. Travel books were a feature of the interwar literary scene. Highbrow writers in the 1920s travelled abroad, seeking to escape from a safe and smug postwar Britain, whose investigation they were happy to leave to the middlebrow, or worse.[40] Master of the domestic travelogue was

H. V. Morton, whose *In Search of England* (1927) went through twenty-three editions by 1936, followed by *In Search of Scotland* (1929) and *In Search of Wales* (1932). Morton's England, like Stanley Baldwin's, was essentially rural, and deeply historical.[41] In *The Call of England* (1928), Morton explicitly set out to explore the urban North and Midlands. But even here, despite some well-observed scenes of business and factory life, his dominant aim was to reclaim the industrial North for 'deep England', through its 'miles of wild and romantic country', and quaint tales of its medieval past; industrialism, one feels, is but a passing phase. Such journeys arrived where they had started out, with a comfortable notion of Englishness reaffirmed by one who had been there, reassuring a readership every bit as anxious about the postwar world as any expatriate novelist. We can sense in such writings a conservative nation, half-consciously beginning the retreat from Empire and world power, seeking its true home in the history and landscape of its native island.[42]

English Journey takes this genre and turns it upside down. Morton in 1928 had had ample opportunity to observe economic distress, but chose not to do so. Priestley is looking for it: the Slump has come, and the adequacy of our national home has been called into question. After a preliminary sortie into the West Country, he braces himself for 'a time of stress': 'I know there is deep distress in the country. I have seen some of it, just had a glimpse of it, already, and I know there is far, far more ahead of me.'[43] Thereafter, the journey proceeds through the English regions in ascending order of economic hardship, from the relatively prosperous Midlands, to his native West Riding, shaken but still standing, to Lancashire amid the collapse of cotton, and finally to the grim North-East, whose apocalyptic landscape of dereliction and despair is followed by a scenic route home through Morton country: York, Lincoln, Norwich and Cambridge. The narrative route is brilliantly contrived: the quiet start in Southampton, Bristol and the bucolic Cotswolds serves to bring in key themes of community, class and work; in Birmingham, Leicester and Nottingham, where things are relatively prosperous, we get Priestley's view of normal factory work and industrial relations; a prolonged stop in his native city establishes a benchmark of autobiographical and historical normality – Bradford in 1914 – before we descend through the increasing chaos and distress of the present to the horrific climax two-thirds of the way through the book, which can only overpower and trivialise

the ancient charm of the 'heritage' route home. If there is a single climactic scene, it takes place in the Durham mining village of Shotton, 'a clutter of dirty little houses' in the shadow of a monstrous, sulphurously smoking tip: a powerful image of physical, social and spiritual desolation, industrial man at the end of his tether, and about as far away from Morton-land as it is possible to get.[44]

The main theme of *English Journey*, of course, is the Slump, whose consequences Priestley describes on the doorsteps of the unemployed in Lancashire, in the derelict shipyards of the Tyne, and in the civic decay of Gateshead and Stockton. These are not just victims of an economic accident: they are places where wealth was created, and from which wealth has been extracted – 'if anybody ever made money in Gateshead,' he remarks, 'they must have taken great care never to spend any of it in the town'.[45] In the shadow of Shotton's great slag-heap, Priestley has a vision of

> all the fine things that had been conjured out of it in its time, the country houses and town houses, the drawing-rooms and dining-rooms, the carriages and pairs, the trips to Paris, the silks and the jewels, the peaches and iced puddings, the cigars and old brandies; I thought I saw them all tumbling and streaming out, hurrying away from Shotton – oh, a long way from Shotton – as fast as they could go.[46]

This is the result of an unjust social system – one which rewards fifty years of service in the Bradford mills with a 5/- pension.[47] In Southampton, he is appalled to learn of the conditions of service on board the luxury ocean liners on which he has sailed, and declares that

> most of us would be willing to give up a little space in the ship and a few items from the menu if we knew that the people waiting on us were being allowed to lead a civilised life.[48]

The political metaphor is clear. But unjust as the system may be, Priestley cannot bring himself to analyse it in class terms. In Newcastle, he encounters Bob, a Communist, whom Priestley admires, but who believes that poverty is a result of class conspiracy, and that 'most people are poor because a few are rich'. Bob cannot see that bosses and managers are men very much like himself, trying to do their best in a 'muddled and wasteful competitive system', but persists in seeing them as exploiters.[49] It may be difficult to see what else but exploiters the people are who smoked

the cigars and drank the brandy that Shotton paid for; but Priestley draws back from Bob's radical response. To him, the Slump is caused by 'muddle', just as it was 'greed and muddle and monstrous cross-purposes' which killed his comrades in the Great War.[50] 'Muddle', in *English Journey* and elsewhere, is Priestley's all-purpose term for the inefficiencies of the system, of which poverty, war and exploitation are by-products. But 'muddle' is something reasonable people should be able to sort out by getting their heads together: class war is part of the problem, not the solution.

Despite his outbreaks of moral indignation, then, Priestley's ideal vision is essentially one of class harmony. It is an idealised version of his prewar Bradford: bosses and men dealing honestly with each other in a spirit of independence, and eschewing the demeaning factory paternalism of such places as Bourneville, with their overtones of deference and untoward loyalty.[51] This is a vision straight from the provincial radicalism of the late nineteenth century, of mill-owners speaking with Northern accents, spurning the trappings of Southern gentility, and addressing their independent-minded workers by their first names: a tradition Priestley himself lived up to when he turned down a knighthood and a peerage later in life. These men – partly mythical, it must be said – were pillars of their community, living amongst the people.[52] Around them grew a thriving civic culture; and in 1933, Priestley found all too often that this civic culture was in a state of decay:

> The richer merchants and manufacturers [of Bradford] no longer live in the city. They work there, but live well outside … throughout the north…the wealthier industrialists are busy turning themselves into country gentlemen and are leaving the cities to the professional, clerking and working classes…. When I was a boy, we had certain wealthy families of manufacturers who came as near to forming an aristocracy as such a democratic community as ours would allow. Now they are gone, and their places have not been taken by other families. That chapter is closed.[53]

Equally, in Hull, cultural life is now run by employees, not employers, the old bourgeois houses have been turned into offices, and even the small repertory theatre has difficulty surviving. In cities like Bristol, on the other hand, where the merchants still live in the town, the civic culture continues to thrive.[54] Priestley's ideal is a revived provincial culture based on local newspapers and the-

atres and orchestras, on rational public debate, self-reliance and
local pride, and above all on co-operation between the classes.
Passing through Norwich, he has a vision of the city as the seat of a
future regional government: dignified and democratic, bringing
politics closer to the people.[55]

The very form of *English Journey* predetermines that local identity
will be one of its main themes. Movement from one place to
another is signalled by differences – economic, cultural, even physi-
cal (north-country 'stocky figures and broad faces' in Sheffield,
Flemish 'long noses and long upper lips and small eyes' in King's
Lynn).[56] But the real local differences are not biological, nor are
they based on some timeless essentialist conception of 'character',
but are formed in networks of economic, political and cultural rela-
tions to which Priestley returns again and again: the Atlantic
economy in Southampton, Bristol or Liverpool, the North Sea con-
nections of the eastern seaboard, the cosmopolitan links of the
textile trade in Bradford and Manchester. These diversities, rooted
in historical experience, are something Priestley values highly. But
threaded through them, and again predetermined by the shape of
his great looping journey, is whatever it is that links us together
and makes us all English.

There are, as we know, a number of versions of this Englishness.
Before the Great War, imperial pride, military glory, the lion
rampant, represented the dominant strain of national identity – the
King and Country that men enlisted for in 1914. What happened to
those men made it impossible in 1933 to sustain unchanged that
particular notion of patriotism: interwar conservatives such as
H. V. Morton opted for a version of 'deep England' rooted in a far
more distant history.[57] Though Priestley rarely wrote about the
Great War at any length, it is a powerful presence in his work, and
never more so than in one of the key episodes in *English Journey*, the
reunion battalion dinner he attends in Bradford.[58] On the face of it,
this event seems out of keeping with the tone and intentions of the
book. When he should be out discovering the England of the
present day, here he is in his home town, among old friends, im-
mersed in his own past life. But this is no idle self-indulgence: the
dinner and what it represents are crucial to the 'England' Priestley
is seeking, and its problematic postwar identity.

For Priestley, as for many others of his generation, the Great War
was a gaping chasm in his autobiography, something lost that
could never be found again. All but one of his childhood friends, he

says, were killed, on the Somme on 1 July 1916. His sense of loss is rooted in concrete experience: suburban streets, boys' games, foolish plans for a future that never came. Now, 'sometimes I feel like a very old man.... I have many vivid dreams, and the dead move casually through them'. It all seems a very long time ago; but Priestley is not yet 40, and it is only fifteen years since the Armistice.

War is the supreme intersection of national history and autobiography: perhaps the only point at which personal and historical trauma fully coincide. It was also, at least until the 'home front' of 1939–45, a gendered experience, simultaneously defining the nation, and defining masculinity in its relationship to the nation. To die for one's country is surely the most serious public act that most men could ever be called on to perform. Yet how impossible to reconcile the solemnity of this sacrifice with the small-scale and unheroic lives of those who offered it. Looking around the room, 'I thought how queer it was that these chaps ... woolcombers and dyers' labourers, warehousemen and woolsorters, clerks and tram-conductors, should have gone out and helped to destroy for ever the power of the Hapsburgs, closing a gigantic chapter of European history.' The heroic and patriotic resonances of the War have all evaporated; its only sustainable meaning now is personal – the trivial shared memories and private jokes of the eight survivors of Priestley's old platoon. Every potentially heroic moment is undermined. The solemn toast to the dead is disrupted by bathos when the regimental march is performed too fast on a tinny piano. Even the surge of emotion for a popular officer underlines the failure of the peacetime world to offer either worthy leadership or a sense of common purpose. In this gathering of men who have proved their manhood, 'alive with roaring masculinity', every prospect of re-asserting that masculinity has been systematically undercut, both by the war itself, and by 'the civilian life to which they returned, a condition of things in which they found their manhood stunted, their generous impulses baffled'. Worst of all are those who could not afford to attend the reunion. They had been 'official heroes', acknowledged by the crowd and by the state, 'while the women and old men cheered...when kings, statesmen, general officers all reviewed us, when the crowds threw flowers', but now 'they could not even join us in a tavern because they had not decent coats to their backs.' Public heroes in wartime, they were now debarred by their private poverty even from the modest public life of a reunion

dinner. Thus has the most resounding and most masculine conception of English nationhood been undermined by individual historical experience.

Gender is not conspicuously addressed in *English Journey*. Priestley's is a masculine world, populated by clubbish, pipe-puffing men of letters, and it is to men that he looks for guidance on his travels. Personal contact is recorded with some seventy people: ten of them are women, and only one of these has anything significant to say. This exception is a Bradford woman, an old friend, who, somewhat startlingly, asks where all the men have gone – the men who used to frequent plays, lectures, political meetings in equal numbers with women, but now seem to have deserted the public scene. What were they doing, sitting at home listening to the wireless? Yes, Priestley reflects, he has heard similar stories in London, 'that in this generation the young men are far more subdued, far less enterprising and ambitious than the girls, who have mysteriously acquired all the dash and virility'. The point once made is then hastily half-withdrawn – perhaps it's just a wild generalisation after all – and Priestley passes on to quiz his next male witness on the state of the nation.[59] But the point will not go away so easily. All Priestley's guides may be men, but what they show him is the collapse of an old masculine world. The Slump has destroyed the heroically male forms of manual labour, the 'Promethean and Vulcanic grandeur' of shipbuilding – 'the real thing, man's work' – and industry itself has become feminised.[60] The 'proper factory…a grim blackened rectangle with a tall chimney at one corner' has been replaced by 'decorative little buildings' along the Great West Road, all glass and chromium plate, which look as if they might sell ice-cream or postcards, but manufacture 'potato crisps, scents, tooth pastes, bathing costumes' for 'an England of little luxury trades'.[61] Middle-class male roles too have been undermined. Businessmen have lost their factories, financiers their money; paternalist mill-owners no longer bestride their communities like colossi, but have either gone bust or departed to the private life of country gentlemen. The aldermanic world of local politics and culture has been shoved aside by centralised government and the new mass media. Above all, in a time of dimly-perceived national decline, no one can any longer believe that the supreme redemption of manhood lies in sacrificial service to the Empire.

In some ways, Priestley finds all this disturbing; in other ways, welcome. The small-scale cultural democratisation of petrol sta-

tions, Woolworth's and the cinema is on the whole welcomed: the clean factories of the Great West Road are gently mocked, but 'what a pleasanter country this would be' if we all could work in them.[62] Even, somewhat surprisingly, the supermarket (or Priestley's attempt to imagine it: 'one clean shed, a decent warehouse') would be better than the fly-blown, inefficient corner shop.[63] The cheap and accessible consumer democracy that is coming about has its roots in the pleasures of the masses, not the luxury of the classes: in 'the democratic and enterprising Blackpool', which declared 'that you were all as good as one another so long as you had the necessary sixpence. Modern England is rapidly Blackpooling itself'. But something has been lost, too. There is a suspicion in the 'new England' of all the vices of 'mass culture': cheapness of quality as well as price, uniformity and the loss of something distinctively English, passive audiences manipulated by business interests.[64] Modern Blackpool is not to his liking as was the old: too much artificiality and Americanisation, replacing authentic plebeian vulgarity.[65] Perhaps, he speculates, a nation which lacks both the vulgarity and the robust civic culture of nineteenth-century England is weak enough to fall prey to autocracy.

Priestley may live in London, but he writes as a Northerner: London, indeed, is the absent centre of his England. It is where he starts out from, but it is rarely described, and is discussed mainly in oblique, bitter terms of its distorting and parasitic relationship with the rest of the country. The last leg of the journey home, through, or rather past, a litany of 'heritage' towns is hurried and dismissive: this is not Priestley's England; Cambridge, where he was a student, made him 'always faintly uncomfortable, being compelled to feel – and quite rightly too – a bit of a lout'; and coming into London, a convenient blanket of fog blots out the approaching metropolis. London he identifies with the City, with world power, but he is a 'Little Englander', hostile to the 'red-faced, staring, loud-voiced' Big Englanders who wanted 'to go and boss everybody about all over the world'.[66] Charlie Habble in *Wonder Hero* says of the Empire, 'if I'd ever seen it ... or if it had ever done anything for me, I expect I'd care about it. As it is, I don't much. They don't up our way. We're not great on the Empire.'[67] This is very much Priestley's view: patriotism is a domestic matter, of taking care of one's own. But taking care of our own is what we have failed to do: for all the taxation and welfare benefits, the nation has as yet no 'real, corporate life', otherwise the North would not be suffering while the City,

which had grown fat on its toil, still prospered. Economic activity, 'can have, I take it, only one object in view, namely, the well-being of people, of actual human beings, and not a few of them here and there but a whole lot of them'.[68] But by this criterion of 'moral economy', were Lancashire, Jarrow, the North East getting their fair share?

Ostensibly searching for England, Priestley actually attempts to redefine it, in democratic, collective, inclusive terms, which were to come into their own, partly through the voice of Priestley himself, in the early 1940s. The need for such redefinition is closely tied up with the loss of the old masculinist England described earlier. Alison Light has argued that during the interwar period, there took place 'a realignment of sexual identities which was part of a redefinition of Englishness', as the prewar aggressive and masculine definition was replaced with something 'at once less imperial and more inward-looking, more domestic and more private ... [a] notion of the English as a nice, decent, essentially private people'.[69] For Light, women were crucial to this retreat into private life, which was both conservative in tone, and embraced new forms of modernity – those encountered through domestic consumption, new forms of leisure, and the kinds of commodities made in Priestley's feminised factories. Culturally, it was conservative 'middlebrow' women writers who led the way: Agatha Christie, Ivy Compton-Burnett, Daphne du Maurier.

This argument is a powerful and persuasive one. It is characteristic of middlebrow fiction to focus down on the ordinary and the everyday, and what better vehicle for the redefinition of Englishness along domesticated lines. But not all these writers were conservative: there was a 'left middlebrow' culture also, whose conception of ordinariness, decency and security focused on the community rather than the inward-looking family: Winifred Holtby (*South Riding*, 1936) was one representative, Priestley another. Repeatedly, his novels deal with the lives of ordinary people, arguing for their dignity and worth, and their entitlement to a better life than the one they were getting. In *English Journey*, we see reflected not just (largely unconsciously) the interwar crisis of masculinity, but also (more overtly) a social-democratic alternative, both to the discredited national self-image of war and empire, and to the conservative domestic retreat. In 1941, Priestley was to ask, 'What is Britain?', and provide the answer, 'Britain is the home of the British people'.[70] The 'home' here is the whole nation, not the

inward-looking suburban microcosm. Nor is the nation seen, in Orwell's oft-quoted image, as a 'family'. A family is a locus of authority: you may be bossed around and exploited there, perhaps sent out into the cold world unfit to cope. Home is where you are sheltered and nurtured, even if you have to do the job for yourself. In the British people's common home, the British people should be taken care of – or rather, should take care of themselves. As if to underline this, *English Journey* closes on an image of opening doors, familiar firelight, home.

SING AS WE GO: PRIESTLEY, GRACIE FIELDS AND THE NATION

Listen to her for a quarter of an hour and you will learn more about Lancashire women and Lancashire than you would from a dozen books on these subjects. All the qualities are there: shrewdness, homely simplicity, irony, fierce independence, an impish delight in mocking whatever is thought to be affected and pretentious.

(J. B. Priestley on Gracie Fields)[71]

The Gracie Fields of literature.

(Robert Graves on J. B. Priestley)[72]

It is the low point of the Slump. Greybeck Mill is closing, and management and workers alike are thrown on to the dole. The future looks bleak. Undaunted, the indefatigable Grace Platt (Gracie Fields), guiding spirit of the mill concert-party, leaves her drunken Uncle Murgatroyd, and sets off on her bike for Blackpool in search of seasonal work. Once there, she is employed variously (and briefly) as a boarding-house waitress, a human spider, a vanishing lady in a magic show, and a singer in a promenade song-plugging establishment. She meets the pretty, innocent and middle-class Phyllis and saves her from a fate worse than death. She also encounters a friendly millionaire, who has a new textile process, and with his help the mill is reopened. Grace becomes welfare officer, and leads the workers back into the mill the same way they left it, singing the rousing and optimistic title song.

What could be more incongruous – and insensitive – than to portray the experience of unemployment in the form of a light-

hearted comedy/musical, full of songs, wisecracks and slapstick routines, and wrapped up with a magical solution which would make Dickens himself blush?

Yet *Sing As We Go* (1934) probably had the widest audience of any single representation of British life in the Slump, and according to its director Basil Dean, in common with all Gracie Fields' early films, it was most popular outside London, in the very areas most likely to be affected by unemployment.[73] Priestley, who was not one to romanticise life on the dole, wrote the script; but *Sing As We Go* was, like any film, a collective production. Basil Dean, head of ATP's Ealing studios – who had directed some of Priestley's stage plays – was producer and director, and as such responsible for bringing Priestley and Fields into the project; Thorold Dickinson, as editor (and 'more than an assistant director'), was partly responsible for the film's distinctive visual style; and, of course, and above all, Gracie Fields, then at the height of her popularity, brought to it her distinctive star persona, for which she was paid about half the film's budget.[74] In considering *Sing As We Go*, then, we pass from the artisan realm of literary production to the industrialised world of mass culture, and from the middlebrow to the unashamedly popular.

Sing As We Go has been one of the most discussed 1930s British films. It is adduced as evidence that, at a time when other studios like Gaumont-British were trying to ape Hollywood and break into the American market (e.g. *Evergreen*, 1934), it was still possible to make distinctively British popular films on a moderate budget. It is praised as a film which in its depiction of everyday working-class life was more true than most to the experience of its audience. But most of all, *Sing As We Go* has been brought into arguments about the foundations of social and political order in this time of economic disruption, and the role of popular culture in the hegemonic process. Thus, for Tony Aldgate, British cinema was

> without much prompting, a ... significant factor in contributing to the remarkable stability of British society during this period. It reflected and reinforced the dominant consensus and sought to generate adherence to the idea that society should continue to remain stable and cohesive as it changed over time.

Sing As We Go, Aldgate argues, reflected and contributed to this stability and consensus through its optimistic assertion that adversity can be overcome by bravery and spirit, and its 'stirring and

patriotic reassurance that all will be well in the end' – expressed in the Union Jacks in the closing scene.[75] For Jeffrey Richards, *Sing As We Go* is a key text in Gracie Fields' transition from regional entertainer to symbol of the nation, personifying consensus and hope: the 'Lancashire Britannia'.[76]

Was *Sing As We Go*, then, an instrument of hegemony? This argument needs to be critically examined on three levels. First, the nature of 'consensus' and 'hegemony' in general, and in the Thirties in particular; second, the meanings of *Sing As We Go* in the context of popular cinema, and its relation to its audience; and finally, the question of 'the nation' and what relation the part Priestley created for Gracie Fields bears to the construction of national identity.

Despite its economic and social problems, and the prevalent images of dole queues and hunger marches, Britain in the 1930s was a relatively stable society, which was never threatened with major political upheaval. However, this stability was not 'remarkable', nor does it need any special ideological explanation. In part, it reflected the fact that the impact of the Slump, though severe in certain regions, was overall not as serious as, for example, in the USA or Germany, and there were important areas of relative prosperity. In part, it was because interwar Britain inherited a stable political and social system. More immediately, the Conservative-dominated National Government, personified by Stanley Baldwin, was successful in neutralising and disempowering potential political alternatives. In particular, following the defeat of the 1926 General Strike, the collapse of the second Labour Government in 1931, and the onset of mass unemployment, the Labour Movement was unable to offer any serious threat to Conservative hegemony, and for reasons specific to British history, the extra-Parliamentary Left, though vocal, was not strong.

It may be doubted, however, whether the stability of political institutions and the tactical success of the governing party are evidence of an all-pervading 'consensus' in British society at this time, still less of an 'expansive hegemony' in which the regime commands enthusiastic popular support. Rather, by comparison with, say, the Edwardian period, when an ebullient popular imperialism was challenged by emergent socialist alternatives – or the 1940s, when determination to win the war combined with an emerging welfarist consensus – the feeling of the Thirties is of a lack of both enthusiasm and alternatives, a dull compulsion on the part of the

poor to put up with things, and a retreat into private life by those who were relatively prosperous.[77] Some historians seem inclined to celebrate the National Government simply because it was stable, as if its very survival refuted the arguments of its critics.[78] However, the government's stability could be said to rest on short-sightedness; it did not tackle the nation's long-term problems, and it led a complacent drift into war. Not without reason, revulsion against Baldwin and Chamberlain and everything they stood for was a cornerstone of the new social-democratic consensus which emerged in the 1940s.

Nor should the optimistic tone and 'happy ending' of *Sing As We Go* and films like it be taken at face value, either as an expression or a construction of political consensus. To do so is to mistakenly compare it with a documentary, or a gritty realist drama: the rules governing the production and reception of musicals are different. As Richard Dyer has argued, the central thrust of the musical, and of popular entertainment generally, is its Utopianism: 'the image of "something better"'. It satisfies because it resolves the problems of everyday life on an imaginary level: replacing scarcity with abundance, exhaustion with energy, dreariness with intensity, manipulation with transparency and fragmentation with community. In this way, entertainment responds to real needs in society, imagining what it would feel like to have those needs satisfied, pointing out how things could be better. At the same time, it defines and delimits what those needs are, ruling some – usually those related to class, race and gender – out of bounds. In general, the needs which the entertainment Utopia addresses are those which capitalism itself promises to meet.[79] This being the case, any musical at any time could be read as an expression or construction of consensus, because it depicts needs being met. But at the same time, by addressing the felt inadequacies of real life, they also embody the non-consensual. Consequently, they can work for their audiences in a complex and contradictory way, few more so than *Sing As We Go*.

The audience of *Sing As We Go*, experienced cinemagoers, know that it is a fantasy, that it has to do with how they wish their world was rather than with how it actually is. Gracie's energy, the intensity and spontaneity of her mad dash through Blackpool, the 'let's all pull together' feel of the climactic scene, and the resolution of intractable problems (the Slump) by luck and an effort of will, these are the stuff of wish-fulfilment, entertaining precisely because they contradict the reality of daily experience. But the audience know

what is happening. For all its optimistic tone, *Sing As We Go* does not hope to convince them that life is perfect, any more than Dracula movies are trying to convince us of the widespread existence of vampirism. *Sing As We Go* and films like it work only because audiences already know life is not perfect. This was well understood by Priestley himself, who replied to his critics by pointing out that the cinema audience needed 'a bit of glamour, an increased tempo, a touch of the fantastic, people who are more vivid than the ordinary run ot folk: in short it demands a bonus somewhere'.[80]

On this basis, we can turn our opening observation about *Sing As We Go* around: what is noteworthy is not so much that the Slump is portrayed in a musical comedy, but that a musical comedy should be set in the Slump. Unusually for a genre which expresses escapism and wish-fulfilment, the film does not whisk us away to a fantasy land, but is set where many of its audience live and work (Greybeck and its mill), and where they take their holidays (Blackpool). This is emphasised by documentary elements in its technique: the location shooting, and the montage sequences for which Thorold Dickinson was responsible. Its central theme, the closure of the mill, is hardly the stuff of romantic fantasy, but a constant reminder of the real world outside. There is a romantic interest, but unlike in most musicals it is not the main focus of the narrative. Nor is there any of the glamorous spectacle which is so central to the Hollywood musical, and British versions of it such as *Evergreen*. In fact, of Dyer's Utopian categories, abundance is the least in evidence in *Sing As We Go* – compared, for example, with the Hollywood Depression musical, *Gold Diggers of 1933*, with its lavish Busby Berkeley production numbers.[81]

The category most in evidence, significantly, is community. While *Gold Diggers*, as the title suggests, deals in individual solutions, the strengths of Greybeck life, endangered by the closure, are portrayed as collective – the mill concert-party, the football team. Unemployment and its reversal are depicted as communal experiences: the owner's son is (implausibly) out of work along with everyone else; the workers march out of the mill and back in again singing together; Grace is a strong individual, but she acts on behalf of others, and at the end she gets the job of welfare officer, the very embodiment of the commonweal. At the crucial narrative high points, we are invited to identify ourselves with the crowd, the collective, rather than with Grace the individual.

This does not, of course, make *Sing As We Go* a radical text. It does, however, make it a contradictory one. If the underlying thrust of all musicals is conciliatory, the imaginary solution of some real problems and the concealment of others, *Sing As We Go* does all this, but it does it in a way which partly undercuts the consensual effect. The film is not just saying 'wouldn't it be great if everyone magically got their job back': in fact, it never actually shows the factory at work (except in a brief opening montage sequence), nor does it dwell on the hardships of unemployment. Its dominant message is, 'imagine how it would feel if we ordinary people could all pull together to solve our problems'. The film's very optimism leads it to emphasise the pulling together rather than the problems. This is not a class message, but a populist one: the subject being addressed (and, in the process, constructed) is 'the people', not 'the working class'. Nevertheless, in the context of the 1930s – rather than, say, the 1940s, when such collectivism came into its own – it is potentially a radical message. It is no coincidence that Priestley, the scriptwriter, was to become a leading spokesman for the new collectivist, social-democratic politics of wartime.

This brings us to the question of the 'Lancashire Britannia'. Gracie Fields is, of course, the dominating presence in the film. Her stature in British culture at the time was also unchallenged and probably unprecedented. From her Lancashire origins, born over a fish-and-chip shop in Rochdale, she swept to West End stardom, and the series of films she made for Basil Dean and ATP in 1931–37 consolidated her position as a universally-adored national phenomenon, who never abandoned – indeed, constantly played up to – her Northern identity.[82] To some extent, it is a truism to say that she represented the nation: after all, national stars are themselves part of what the nation has in common. But for Jeffrey Richards, there is more to it than that. Gracie was not just a symbol of the nation, she embodied its 'spirit and mood', and helped to promote 'consensus, co-operation and national unity': somewhat fancifully, she was the elder sister of the national family, with Stanley Baldwin as father and George V as grandfather. Where the King represented tradition and continuity, and Baldwin the bucolic solidity of a John Bull, Gracie stood for industrial England.[83]

There are, however, a number of problems in the model. The existence of three national figureheads, standing for different conceptions of Englishness, clearly suggests that the nation was a more contradictory unity than Richards' picture of universal consensus

allows. How do these three images fit together, and why do they
not conflict with each other? How on earth could their coexistence
promote consensus rather than conflict? A number of public issues
of the 1930s – among them the Empire, appeasement,
Americanisation, the abdication crisis, the Slump and deindustriali-
sation – raised clear questions about the identity of the nation, po-
tential areas of conflict which were simply unresolved. Far from
representing a strong underlying consensus, Richards' three images
suggest a nation ill at ease with itself, an ideological civil war
threatening to break out.

Nor was Gracie herself an uncontradictory figure. Her three
obvious peculiarities were that she was working class, she was
northern, and she was a woman. In complex ways which we will
not explore here, these three identities interacted to make up
Gracie's familiar public persona. All three were subordinate identi-
ties in the context of the 1930s British society, where the preferred
thing to be was a middle-class, southern male. Thus, although
Gracie herself was by no means an oppositional figure, the poten-
tial was there for audiences to use her for oppositional purposes.
Her popularity in her native Rochdale, and in Lancashire and the
North generally, for example, could be seen as an assertion of a
downtrodden regional identity against the metropolitan centre, to
which those regions had become increasingly subordinated since
the nineteenth-century heyday of the industrial North. Gracie was
loved back home because she had made it without becoming posh:
she could show stuck-up Londoners a thing or two. But of course
(and here the contradictions come round again) 'making it' meant
winning the approval of those very stuck-up Londoners.

When in *Sing As We Go*, Gracie's northern, working-class and
female identity is articulated to the pervasive collectivism of the
script, put there by the Yorkshireman J. B. Priestley (who in many
ways shared her ambiguous cultural positioning), the result cannot
be read as an unproblematic assertion of consensus and national
unity. In fact, *Sing As We Go* contains only one explicit image of the
nation: the Union Jacks in the closing scene, and the most promi-
nent of these is in fact the ATP studio logo; moreover, what this
ending celebrates is not the nation as such, but the people acting to-
gether. If anyone believed the British people should all pull to-
gether it was Priestley, who in *English Journey* and elsewhere
repeatedly bemoaned the creeping privatism of middle-class life,
celebrated the capacity of the northern working class to help each

other out, and called for collective action to solve the nation's problems. But it is important to remember that, in order to pursue these radical reformist politics, it was necessary not to abolish the nation but to redefine it. Priestley's radical populism, closely linked with his northern identity, gave him a strong conception of Englishness, but one radically different from the pomp and circumstance surrounding George V, or the complacent pastoralism of Baldwin. As evidence that these rival images of the nation can conflict bitterly, consider Priestley's comments on the 1937 Coronation:

> So much wealth, so much time, so much energy, could be spared without protest for the crowning of a king, a ceremony with hardly a glimmer of real significance left, an immense empty shell of a function. But to crown at last these people themselves, to ennoble the whole kingdom, where were the wealth and time and energy for this task? Who would, after taking down the bunting and the lights, tear down the streets themselves, and build a nobler, happier, beautiful Britain?[84]

Here, Priestley sets two conceptions of Britain up against one another: 'the people themselves' against the 'empty shell' of the monarchy. Priestley's populist patriotism should be contrasted with other constructions of Englishness: for example, Noel Coward's stage show *Cavalcade* (1931), a patriotic celebration of tradition and hierarchy, which bemoaned the baleful influence of the twentieth century, and inspired its West End audiences to rise and sing the National Anthem.[85] Both Coward and Priestley invoked a conception of 'England' in support of their violently contrasting positions, but it would be wrong to believe that this made them somehow fundamentally the same. Indeed, the opposition between the two patriotisms persisted into the Second World War, when in films such as *In Which We Serve* and *This Happy Breed*, Coward articulated the traditional, class-structured, Churchillian conception of the nation, while Priestley, with his radio *Postscripts*, and his commitment to the radical political movement Common Wealth, was defining the nation in collective, social-democratic terms.

On its release in 1934, *Sing As We Go* was condemned by some critics for its frivolity and lack of realism in depicting the lives of the northern working class. The *Observer*'s C. A. Lejeune asserted that 'we have an industrial north that is bigger than Gracie Fields running round a Blackpool funfair'; and Graham Greene sneered that 'unemployment can always be wiped out by a sentimental

song, industrial unrest is calmed by a Victorian ballad and dividends are made safe for democracy'.[86] Later writers have been correct to rescue the film from this kind of generalised dismissal. However, in interpreting *Sing As We Go* as a straight assertion or construction of national consensus, and drawing the conclusion from this that consensus was what the cinema audiences wanted, they too have overlooked the complexities of popular genres, and the different ways in which their audiences can relate to them. *Sing As We Go's* distinctive mélange of musical comedy, music-hall and documentary, radically different from the classic Hollywood musical; the dominating presence of Gracie Fields, available for articulation in so many directions – class, region, gender, nation; the thread of social-democratic populism which Priestley wove into the script – all these forces are at work to produce a film more packed than most with contradictions and alternative readings. Basil Dean's original conception was to use the great northern writer to produce a script for the great northern star, thus maximising audience appeal. What he got was a film which, while it could be, and was, seen as an escapist comedy, embodied also some of the contradictions of that 'northernness' and its future political possibilities.

4

Narratives of Empire: Journeys from the 'Centre' and 'Periphery'

> To rejoin experience and culture is of course to read texts from the metropolitan centre and from the peripheries contrapuntally.... The great imperial experience of the past two hundred years is global and universal; it has implicated every corner of the globe, the colonizer and the colonized together.
>
> Edward Said: *Culture and Imperialism* (London, 1993), pp. 312–13

In the course of a fascinating 'excavation' of British popular culture, entitled 'Digging for Britain',[1] Dick Hebdige pauses to examine the film *Spare Time*, a short documentary on leisure which was directed by Humphrey Jennings in 1939. Hebdige reflects on the part played by documentary films of the Thirties in projecting a particular image of the working class, filtered through the lens of Griersonian radicalism, which he sees as 'that mixture of the patronizing, the heartfelt and the voyeuristic which speaks not just of times past but of a superseded social order.' With its narrative voice-over, addressing the world in what Hebdige terms 'the clipped patrician accent which is the trademark of the films produced under the aegis of John Grierson at the Empire Marketing Board', *Spare Time* seems to belong to another time and place, a half-forgotten world of cloth caps and pinafores, of brass bands and pigeon-fancying, which bears very little resemblance to the multicultural, hybrid Britain of the nineties.[2]

However, there is a moment in Jennings' film when the narrative of a seemingly homogeneous, corporate working class is arrested and the screen turns into a 'stage', opening-up on a mini-tableau which dramatises the contradictions of British popular culture in the Thirties. Suddenly we are confronted with a children's kazoo band from Manchester, playing 'Rule Britannia'

as they carry the figure of 'Albion' around their makeshift parade-ground, and 'strutting their stuff' in a manner reminiscent of Shirley Temple in *The Good Ship Lollipop*. The scene acts as a kind of epiphany (what Hebdige, drawing on Barthes, refers to as a 'punctum', or disruption of the flow of the narrative) startling the contemporary viewer with its strange mixture of imagery from British imperialism and American popular culture. It is a moment which tends to provoke heated discussion when the film is shown in a teaching context, or as part of a retrospective on the Thirties. For some, like Jennings' co-worker in the documentary film movement Harry Watt, the shot of the kazoo band is a cheap jibe at the expense of the working class. The rather ragged playing of the kazoos and the fact that the children are marching in thin costumes on a chilly day, renders their identification with the glories of 'Britannia' bathetic – an index of the subordination of a once proud, working class culture to the interests of cultural imperialism, both British and American. For Watt and Basil Wright, who both wrote critical reviews of *Spare Time*, Jennings has picked on an easy target in highlighting the supposed second-hand nature of working-class culture and its inferiority.[3] For others, however, Jennings' film does not ridicule the children, but celebrates their creativity in assembling a 'bricolage' of the American marching bands and an inherited imperial imagery, in what is almost a surrealistic comment by the director of *Spare Time* on the contradictions of prewar popular culture.

Hebdige refuses to endorse either side of this argument about Jennings' message in *Spare Time*, concluding that the 'question of a satirical intention as far as Humphrey Jennings is concerned is neither here nor there'.[4] However, he does feel that we can 'surely discount' such an intention 'on the part of the band itself', recalling the 'solemn observance of Empire Day' in the schools of his own childhood, even later in the fifties, which would 'seem to indicate that this is a straightforward affirmation of loyalty to the crown ... albeit one expressed in the "Americanized" accent so typical of a certain kind of British popular culture then as now.'[5] Moreover, as Hebdige observes, it is the solemnity and 'sad-sweet innocence' of the children's act which gives the scene so much poignancy for the contemporary viewer, highlighting the gap between our own age and life in a cotton town before the war, 'before the ignominious bundling off the stage of history of the straight-backed British empire ... and the final death throes of King Cotton.'[6]

Clearly 'Digging for Britain' is not intended to be an elegy for a prewar era of imperial glory. Rather, Hebdige is concerned with tracing the contradictory historical relationship between past and present, both in terms of the changes which have taken place since that little band paraded in front of Jennings' camera and the continuing connections with Britain's imperial legacy in the supposedly 'post-imperialist' age of the nineties. Hence, for Hebdige the feelings of pain and regret evoked by *Spare Time* are partly due to the failure of the social democratic vision of 1945, which was going to deliver so much for those working-class children in the kazoo band and their contemporaries across Britain. A central plank of his argument is that the inability of Labour to sustain a radical programme of change and its demise post 1979 was due to an unwillingness to face up to and deconstruct Britain's imperial legacy. It was this contradictory heritage – embodied in the popular culture which Jennings captured so fleetingly on screen in 1939 – which was to emerge once again to haunt Labour during the Falklands' campaign of 1982 and which effectively rescued Margaret Thatcher from defeat the following election, so that she and her party could go on to dominate the parliamentary politics of the eighties and early nineties.[7]

Hebdige has produced a compelling analysis of imperialism and popular culture in 'Digging for Britain' and the rest of this chapter can be seen as a development of his remarks on *Spare Time*, extending his 'excavation' to a broader stratum of texts from the Thirties. So, we shall be examining two other 'representative' examples of social democratic/left-of-centre discourse – the documentary film *Song of Ceylon* and Orwell's essays on the Empire – in order to show how particular assumptions about the superiority of British culture permeated the thinking of 'radical' intellectuals, even when they were supposedly critical of imperialism. At the same time, this chapter will stress the contradictory nature of that social democratic tradition – an aspect which is, perhaps, somewhat submerged in the rather apocalyptic tones of Hebdige's essay. Hence, Orwell's writings in the Thirties reveal the guilt of an ex-colonial policeman, uncovering the various masks which he had to wear in order to carry out his role as an imperialist functionary. In the novel *Burmese Days* and essays such as 'A Hanging' or 'Shooting an Elephant', there is a clear desire to expose the workings of imperialism and the various disguises which it adopts in order to justify its continuing dominance of those whose culture it attempts to suppress or even erase.

In addition to what might be termed the 'ethical' dimension of British social democracy in the Thirties, we will be examining those critiques of imperialism which appear at the 'periphery', rather than the metropolitan 'centre' of Empire, highlighting the articulation of an alternative, 'emergent' discourse associated with the work of the West Indian writer C. L. R. James and others who attempt to give voice to the concerns of the native populations being ruled in the name of 'civilisation'. It is this tradition of thought and writing which forms an important element in the heritage of contemporary Black and Asian Britons, whose culture Hebdige rightly sees as being so central to the construction of a modern, diverse, pluralistic society. Thus, any 'excavation' of the relationship between culture and Empire in the Thirties must surely embrace this positive critical inheritance, as well as interrogating the more negative dimensions of imperialism and its cultural legacy.

SOCIAL DEMOCRACY AND THE EMPIRE

In the 1930s imports from the colonies and the dominions doubled. The promotion of tea as the national beverage, the British Empire Exhibition at Wembley in 1924 ... and the activities of the Empire Marketing Board all helped to encourage the notion of imperial self-sufficiency. Empire cruises, land settlement in Kenya and the Rhodesias, the overseas expansion of the Scouts and Guides, and, not least, popular literature all helped to promote a more intimate sense of union between Britons at home and those overseas, and it is perhaps indicative of this that at the outbreak of war, in September 1939, more attention was paid to the attitude of the Empire than that of Britain's notional European allies.

> Raphael Samuel: Introduction to *Patriotism: The Making and Unmaking of British National Identity*. Vol. 1 (London: 1989, p. xxiii)[8]

Between the wars propaganda for the Empire constantly emphasised the resources to be obtained from the colonies and dominions in celebrating the extent of Britain's territorial domain. In a study of the Empire Marketing Board, Stephen Constantine quotes from a 'Buy British' broadcast made by the then Prince of Wales in

November 1931, in which the audience were reminded that, 'The British Empire offers you the resources of a quarter of the world.'[9] Constantine also cites a campaign run by the EMB in the late twenties, which claimed that, 'There is nothing the Empire cannot provide, if you encourage it to do so.'[10] And, of course, this did not just include natural resources such as minerals of fruit, but also cheap labour, so that the teachers' notes accompanying the EMB posters sent to schools pointed out that one of the reasons why Jamaica had advantages over every other country in the world for banana cultivation was the abundance of cheap negro labour.[11]

The EMB, which existed from 1926 to 1933, constantly emphasised the interdependence of the British economy and its overseas territories and this was reinforced at an ideological level by the notion that 'the citizens of the Empire at home and overseas constituted a single community' or 'family'.[12] So, there were frequent references to family ties – 'Keep Trade in the Family' and 'Remember the Empire, Filled with Your Cousins' were EMB slogans used in the 1931 economic crisis.[13] However, as Stephen Constantine has pointed out, it was apparent that the roles within the family were defined in a particular way:

> Only the United Kingdom appeared to have a mixed economy, combining industrial production and wealth from agriculture and fishing. Territories in the overseas Empire were categorised solely as primary producers... the images the Board presented strongly suggested that this was the inevitable economic order of the present and of the future in which a natural economic harmony between British and overseas Empire interests existed and would prevail.[14]

Thus, if the Empire was represented as a 'family', it was certainly a hierarchical unit, with the interests of the 'mother country' at the head. And this rank order was justified by the 'undisputed fact' that Britain exerted a 'civilising influence' over the colonial peoples, giving them political and cultural leadership. So, as Branson and Heinemann have observed, when there was a 'moral panic' about the decline of the birthrate in the mid-Thirties, it was represented, first and foremost, as a threat to the future of the Empire. When Neville Chamberlain, then Chancellor of the Exchequer, announced a marginal increase in the tax allowances for those with children in 1935, he justified the change with the accompanying remarks:

I must say that I look upon the continued diminution of
the birthrate in this country with considerable apprehension ...
the time may not be far distant ... when ... the countries of the
British Empire will be crying out for more citizens of the right
breed, and when this country shall not be able to supply the
demand.[15]

But how far did the enthusiasm for the Empire embrace all the
main political tendencies? After all, Neville Chamberlain was a
member of the Conservative front bench which was firmly commit-
ted to the maintenance of the imperial connection. To what extent
did the Labour Party also share this enthusiasm? In the early
Twenties there did seem to be a clear division between the two
parties over economic policy and the Empire. So, when Stanley
Baldwin, the Conservative Prime Minister, announced a programme
of tariff reforms in 1923, to give preferential treatment to foodstuffs
being imported from the Empire, the Labour Party opposed him,
their argument being that this would inevitably lead to price rises.[16]
Yet the Labour front bench, particularly 'Jimmy' Thomas, largely
welcomed the establishment of the EMB in 1926. Moreover, as
Constantine comments: 'It is symptomatic of the consensus support
for imperial strategies by the major political parties that when a
Labour government took office in June 1929 the EMB was preserved
under a new chairman, Lord Passfield (Sydney Webb). He assured
the Board that "the new Government would be no less interested in
the work of the Empire Marketing Board than their predecessors in
office had been. They had every confidence in the work of the
Board."…. There is more than a hint that if imperialism was part of
the dominant ideology, it was not without influence beyond the
confines of industry, commerce, and the Conservative Party: it em-
braced also the hierarchy of the Labour Party.'[17]
 In principle the Labour Party of the Thirties was committed to
the promotion of democratic change in the Empire and it was re-
ceptive to the demands of independence movements, especially
Indian nationalism. Hence it was critical of the National
Government's Government of India Act of 1935, which only gave a
limited measure of provincial self-rule to India and retained federal
control of political and economic affairs firmly in Whitehall.
However, the Labour leadership was careful not to press anti-
imperialist policies and the consensus seemed to be that this was
not a vote-winning issue.[18] Moreover, as Parta Gupta has pointed

out, some of the assumptions underlying Labour's attitude to impe-
rial affairs were not that different from those of the Colonial Office.
Labour shared an imperial world-view to the extent that, 'it divided
the colonial world according to a racial-cultural typology'[19] in
which countries like India, which had 'benefited' from a long
period of British influence, were thought to be ready for some form
of self-government, whilst colonies in Africa and the Pacific were
deemed to be less 'civilised'. So, the composite motion presented to
the Labour Party Conference in 1939, while calling for 'bold mea-
sures of progress in self-government and social advance' as a
general principle, still reaffirmed the extension of imperial mandate
in 'colonies...inhabited by peoples of a primitive culture'.[20]

> The subconscious streak of a racial typology in deciding a politi-
> cal community's fitness for self-government emerged in the dis-
> cussions on the West Indies in the wake of the Abyssinian crisis.
> The committee drafting the 'Demand for Colonies' pamphlet had
> conceded that India and Ceylon were 'recognized to be capable
> of self-government' and if 'claims to colonial territory ... [were]
> to be satisfied' it had to be 'largely in Africa or in the Pacific'. The
> West Indies sub-committee argued that the West Indies should
> also be left out of a mandates scheme for the following reason:
> 'inhabitants are either Europeans or Europeanised Africans,
> speaking English or French. They are British subjects, European
> in culture, language, religion, and industry. No question arises
> of 'Natives'.[21]

Although the Labour Party was critical of the more brutal and
authoritarian aspects of imperial rule, particularly in the area of
employment and labour conditions, it still shared much of the na-
tional consensus about the continuing need for some version of the
British Empire, albeit one moving towards an [eventual]
Commonwealth of equal nation states. Moreover, concerns were
expressed, particularly within the TUC, about the impact of de-
colonisation on British jobs. Whilst the anti-protectionist and anti-
imperialist tradition was still strong in the TUC, by the Thirties it
was coming under increasing pressure as a result of the
Depression. A variation on the theme of imperial protection and
tariff reform was increasingly voiced as an antidote to American
competition and as a way of protecting British industries.

Ernest Bevin is a key figure here because of his ability to mediate
between the TUC leadership and the rank and file membership. At

the TUC Conference of September 1930, Bevin argued that the
tariffs versus free trade controversy had 'no relevance for social-
ists', implying that he was primarily concerned with building up a
Commonwealth of socialist governments which would unite the in-
terests of labour, rather than allowing policy to be decided by
financiers and speculators. However, as Gupta comments, 'under-
lying all this socialist-sounding rhetoric was a nagging fear of the
industrialisation of the Eastern peoples and the development of
tropical resources, which if not controlled and if necessary checked
by European socialists would in course of time affect their long-
term interests.'[22] Bevin's anxieties about the possible effects on
British jobs of independent developing countries, in Africa and
elsewhere, is clearly evident in the following statement at the
conference:

> What I say is this, and I am not afraid of saying it. I know that in
> saying it I shall be described as a friend of the capitalists, but I
> do not care what people say about me ... I sit on a Colonial
> Development Committee under an Act passed by the Labour
> government, and I see the expenditure of millions of pounds
> going on the development of areas where native races have not
> yet begun to be industrialised. You talk about the coal trade.
> Ought there not to be some control against the possible develop-
> ment of coal in Tanganyika and in East Africa, which might
> come into competition with your coal here at a time when the
> world does not want it? ... And when you have settled your
> problem for Europe ... you must see that these areas which are
> still open to be developed are brought under the control of the
> Colonial Office.[23]

Bevin's comments on the need to protect home industries from
competition in the Empire show just how much agreement there
was, between 'left' and 'right', on maintaining that division which
we noted earlier between the developed 'head' of the Empire and
its undeveloped 'children'. On the surface, a centre/right Labour
figure such as Bevin was much less committed to the discourse of
Empire than his Conservative opponents. However, underlying the
'pragmatic' attitude to imperial institutions such as the Colonial
Office was an unwillingness to challenge the institutional under-
pinnings of this discourse and its assumptions about the 'natural'
right of British industry to continue exploiting its access to cheap
raw materials.

DOCUMENTARY AND THE EMPIRE: THE ORIENTALIST DISCOURSE OF *SONG OF CEYLON*

Just how far this consensus on the 'utility' of Empire stretched can be seen from the attitude of a supposed left-of-centre intellectual such as John Grierson, who worked for the Empire Marketing Board after his return from America in 1927. Grierson, who impressed on the EMB the advantages of using film for propaganda purposes, managed to operate quite comfortably within the organisation until its demise in 1933, commenting that: 'the EMB is the only organisation outside Russia that understands and has imagination enough to practise the principles of long-range propaganda.'[24] As the film critic Stuart Hood has noted, 'there is no evidence that he was critical of imperialism; indeed, he wrote, apparently without irony, that in the Twenties "our original command of peoples was becoming slowly a co-operative effort....for the old flags of exploitation it substituted the new flags of common labour."'[25]

This point of view allowed him to describe in curiously naive terms the role of Shell Oil, one of the earliest and richest companies to sponsor industrial documentaries; he saw Shell as 'the greatest of sponsors', because the company saw the full implication of film sponsorship, 'in terms of social welfare and the preaching and teaching of social welfare.' The example he gives of Shell's interest in welfare is instructive. Shell had found that in the Persian Gulf it took two men to lift a bag of cement, 'therefore they (Shell) were in the nutrition business' – and the business, one might add, of seeing that each man could carry his own bag and thus increase productivity and Shell's profits. Such thoughts do not seem to have troubled Grierson, whose approach was purely pragmatic, as is demonstrated by the account by Basil Wright of how Grierson 'gave me some very rusty cans of mostly very old instructional films about cocoa on the Gold Coast (Ghana) and told me "OK. Sell the British public the idea that cocoa comes from one of our great colonies."'[26]

Like Bevin, Grierson had a pragmatic attitude to the Empire and sponsorship of documentaries by an imperial organisation such as the EMB. He and the majority of his co-workers (Rotha is perhaps an exception) seem to have been largely untroubled by any sense of the contradictions between their generally 'progressive' approach to human affairs and the underlying assumptions of an imperialist world order. One way of focusing this issue of the relationship between the documentary film movement and imperial sponsor-

ship is to concentrate on a particular text, in this case Basil Wright's
film *Song of Ceylon*, which was made for the Ceylon Tea Board and
distributed in 1934. It is an interesting case, because it is not a
simple piece of propaganda and yet it reveals the inherent tensions
between the attempt to present a more enlightened picture of the
native peoples on the one hand, and the discursive effects of impe-
rialism on the other.

As we all know, one of the most recognisable significrs of
'Britishness' for advertisers, even in the contemporary world, is still
the 'good old cup of tea'. Thus, in a clever pun, combining the
lexical and the metonymic, television viewers are told that 'Typhoo
put the "T" in Britain', a slogan which recalls the heyday of Empire
and the role of the great trading enterprises, such as Typhoo and
Cadbury, in delivering the products of the colonies to the Home
Country. Between the wars tea was seen as both a key signifier and
material guarantor of 'imperial self-sufficiency', as we can see from
Raphael Samuel's comment on the 'national beverage' in the epi-
graph at the beginning of this section. Hence, it is not surprising
that the Empire Marketing Board should have agreed to finance a
documentary on the Ceylon tea industry as part of its brief of pro-
moting produce form the colonies. Basil Wright, who had already
directed two documentary shorts on the West Indies (*Cargo From
Jamaica* and *Windmill in Barbados*), was sent to Ceylon in 1932 to
make four films on tea production, of which one, *Song of Ceylon*,
has survived. During the course of his sojourn in Ceylon the EMB
ceased to exist, but the commission was taken over by the GPO and
Song of Ceylon helped to establish the international reputation of the
British documentary film movement by winning a prize at the
Brussels International Film Festival of 1935.[27]

Wright won critical acclaim for the poetic content of his film and
the creative integration of sound and vision which seemed to augur
a new ear of stylistic sophistication in the British 'art' cinema. The
following review by Graham Greene, which appeared in the
Spectator in 1934, is worth quoting at length because it summarises
the content and narrative movement of *Song of Ceylon* quite well,
whilst also giving some insight into the critical reception of
Wright's film and its appeal to an influential member of the
literary/critical intelligentsia:

Perfection is not a word one cares to use, but from the opening
sequence of the Ceylon forest, the great revolving fans of palms

which fill the screen, this film moves with an air of absolute certainty in its object and assurance in its method.

It is divided into four parts. In the first, *The Buddha*, we watch a long file of pilgrims climb the mountainside to the huge stone effigies of the god. Here, as a priest strikes a bell, Mr Wright uses one of the loveliest visual metaphors I have ever seen on any screen. The sounding of the bell startles a small bird from its branch, and the camera follows the bird's flight and the notes of the bell across the island, down from the mountainside, over forest and plain and sea, the vibration of the tiny wings, the fading sound.

The second part, *The Virgin Island*, is traditional, leading us away from the religious theme by way of the ordinary route of living to industry. In *The Voices of Commerce* the commentary, which has been ingeniously drawn from a 17th-century travellers' account of the island, gives place to scraps of business talk. As the natives follow the old ways of farming, climbing the palm trees with a fibre loop, guiding their elephants' foreheads against the trees they have to fell, voices dictate bills of lading, close deals over the telephone, announce through loudspeakers the latest market prices. The last reel, *The Apparel of a God*, returns by way of the gaudy gilded dancers in their devil masks to the huge images on the mountain, to a solitary peasant laying his offering at Buddha's feet, and closes again with the huge revolving leaves, so that all we have seen of devotion and dance and the bird's flight and the gentle communal life of harvest seems something sealed away from us between the fans of foliage. We are left outside with the bills of lading and the loudspeakers.[28]

As Greene notes, *Song of Ceylon* is a lyrical depiction of the native Ceylonese and their culture, and there is a timeless air to Wright's film which is reinforced by the focalisation of the narrative through Ronald Knox's description of the island, written in 1680. So it is possible to 'read' the resulting text as being primarily concerned with celebrating the traditional ways of people, as exemplified in the following extract from Knox's travelogue:

But husbandry is the great employment of the people. In this the best men labour; nor is it held any disgrace to work for oneself be it at home or in the fields; but to work for hire with them is reckoned for a great shame, and very few are to be found who will work so.[29]

Set alongside Knox's island paradise, the values and practices of the contemporary world and the Empire seem somewhat alien. As Greene's review implies, when the 'voices of commerce' intervene in section three it is as a cacophony of sounds which might be interpreted as an invading force, disrupting the peace and tranquillity of the island.

Yet there is no evidence that the Ceylon Tea Board expressed any disquiet about the way in which Wright yoked together his shots of traditional Ceylon with the babble of contemporary commerce and perhaps this is not surprising, given the overall interpretative context which is constructed for the viewer by the film. In theory the narrative allows for a critical response to imperialism (or, perhaps more accurately, mercantile capitalism) yet it is arguable that the viewer would be unlikely to come to such a conclusion unless he/she already occupied a radical interpretative position and entertained fundamental doubts about the imperialist project. As Eric Barnouw comments, whilst the film makes clear 'the role of tea as an imperial link', it does so in a subtle way, by putting the Ceylon Tea Board on record as 'fervently admiring the Ceylonese and their culture'.[30] By weaving an almost seamless web of the ancient and the modern (what it describes as 'The Sacred Isle's Harmony of Ancient Faith and Modern bustle') *Song of Ceylon* aestheticises the plight of the Ceylonese workers and places them in what Raymond Durgnat has perceptively described as 'an imperialist pastorale'.[31] Of course, the sensitive viewer may, like Greene, pick up the lurking anxiety in Wright's portrayal of a culture which is in danger of being destroyed if it is contaminated by outsiders ('the gentle communal life of harvest seems something sealed away from us between the fans of foliage. We are left outside with the bills of lading and the loudspeakers'). But this is not the *organising* principle of the narrative and the 'preferred reading' of Wright's film is, as Durgnat remarks, that ultimately 'imperialism brings no disturbances to traditional cultures, introduces no new problems.'[32]

As we have already demonstrated, *Song of Ceylon* is not a simple propaganda exercise on behalf of its imperial sponsors. Rather, it performs its function in an indirect way, by celebrating a world in which two historical eras and two separate cultures can exist side by side. However, the relationship is not one of two equal partners. Ultimately it is the culture of imperialism which is privileged in *Song of Ceylon*, albeit in a discreet manner, since it is the metropolitan centre which produces the intellectuals who can 'appreciate', and have the resources to 'document', the qualities of the Ceylonese

and their culture. And it is the West which is able to 'place' the art and religion of Ceylon on a broader canvas of cultural history, by the authoritative way in which it interpolates Knox's commentary into the narrative discourse of the film, so that the natives are situated within a 'timeless' zone of unchanging beliefs and behaviour (which, of course, is the source of their 'charm').

Despite the undoubted merits of Wright's film, the limits of his ethical liberalism are revealed through an 'Orientalist' discourse which 'fixes' the native culture as an object of western contemplation. In his book *Orientalism*, Edward Said argues that western imperialist cultures have defined their identity by means of a discourse in which the East is represented as the 'other', the obverse of western civilisation: the Orient as the site of despotism and cruelty, but also, the exotic, the transcendental religious experience, etc.[33] Of course, Said is careful not to see Orientalism as a unitary discourse without contradictions, and it is not conceptualised as a 'western imperialist plot' to hold down the East. Nor is it simply the basis for a 'demeaned or denigrated' culture, which reflects ideology in a passive way. Orientalism is viewed by Said as a form of 'dynamic exchange' between individual intellectuals, authors, film-makers, etc., and 'the large political concerns' of imperialism. Hence, the 'internal constraints' which it places upon cultural producers can be 'productive' rather than 'unilaterally inhibiting'.[34] Thus, *Song of Ceylon* can be analysed in terms of the creative tensions which it sets up between Occidental and Oriental cultures. By celebrating the East as a repository of artistic, religious and communal values, it implies that there is a crucial 'absence' in western culture which troubles intellectuals such as Wright. At the same time, in so far as Wright's film is situated within the discursive field of Orientalism, it is bound to reproduce a set of geopolitical relations which are grounded in the power/knowledge hierarchies of western imperialism. Thus *Song of Ceylon* cannot help but contribute to the elaboration of what Said terms a 'basic geographical distinction [the world is made up of two unequal halves, Orient and Occident]'[35] which finally 'overdetermines' the critical project of the film.

ORWELL AND THE CONTRADICTIONS OF THE 'IMPERIALIST PASTORALE'

In part, the 'geographical distinction' which marks the discursive space of *Song of Ceylon* can be located in the representation of the

colonies as an 'imperial pastorale', as Raymond Durgnat implies. This point is taken up by Raymond Williams in *The Country and the City*, when he describes how, in response to poverty and over-crowding back home, the English novel, from the mid-nineteenth century onwards, constructed the Empire as a 'rural idyll' and, hence, an extension of an idealised England:

> The lands of the Empire were an idyllic retreat, an escape from debt or shame, or an opportunity for making a fortune. An ex-panding middle class found its regular careers abroad, as war and administration in the distant lands became more organized. New rural societies entered the English imagination, under the shadow of political and economic control: the plantation worlds of Kipling and Maugham and early Orwell; the trading worlds of Conrad and Joyce Cary.[36]

As Williams points out, in terms which closely resemble Said's description of Orientalism, the mapping of Empire as a new geo-graphical space was 'a dramatic extension of landscape and social relations'.[37] This impulse was still very strong in the Thirties. So, to pick up on a comment made by Orwell in *The Road to Wigan Pier*, the attraction of service out in the Empire for individuals from his own background, the 'lower-upper-middle class', was that they could act out their dreams of belonging to a squirearchy in a way which was simply impossible back in Britain:

> People in this class owned no land, but they felt that they were landowners in the sight of God and kept up a semi-aristocratic outlook by going into the professions and the fighting services rather than into trade. ... It was this that explained the attraction of India [more recently Kenya, Nigeria, etc.] for the lower-upper-middle class. The people who went there as soldiers and officials did not go to make money, for a soldier or an official does not want money; they went there because in India, with cheap horses, free shooting, and hordes of black servants, it was easy to play at being a gentleman.[38]

For those such as Basil Wright, who were members of an intellec-tual faction with a 'social conscience',[39] the Empire offered a differ-ent form of 'compensation' and, like the nineteenth century Romantics, Wright was concerned to project a 'pastoral' alternative to modern industrial society which he found in the traditional life and culture of Ceylon. However, in the case of Wright as well as

the 'hunting, shooting and fishing brigade', it can be argued that the relationship to the colonies was never an 'innocent' one and that the landscape or the indigenous peoples were always 'appropriated' in one way or another. Moreover, it is worth reminding oneself that the idealisation of the indigenous culture which one finds in a text such as *Song of Ceylon* can serve as a veil to cover the socio-economic relationship between coloniser and colonised. In this regard, it is salutary to set Wright's film alongside a passage from Orwell's novel, *Burmese Days*, which appeared in the same year as *Song of Ceylon*, and which throws a rather different light on the relationship of colonisers to colonised in the Empire. The extract is interesting because it records what was probably one of Orwell's own experiences,[40] but refracted through the consciousness of his character Elizabeth Lackersteen, as she encounters Ceylon and the Orient for the first time:

She was going to love India, she knew. She had formed quite a picture of India, from the other passengers' conversation; she had even learned some of the more necessary Hindustani phrases, such as *idher ao, jaldi, sahiblog*, etc. In anticipation she tasted the agreeable atmosphere of Clubs, with punkahs flapping and barefooted, white-turbanned boys reverently salaaming; and *maidans* where bronzed Englishmen with little clipped moustaches galloped to and fro, whacking polo balls. It was almost as nice as being really rich, the way people lived in India.

They sailed into Colombo through green, glassy waters, where turtles and black snakes floated basking. A fleet of sampans came racing out to meet the ship, propelled by coal-black men with lips stained redder than blood by betel juice. They yelled and struggled round the gangway while the passengers descended. As Elizabeth and her friends came down, two sampan-wallahs, their prows nosing against the gangway, besought them with yells.

'Don't you go with him, missie! Not with him! Bad wicked man he, not fit taking missie!'

'Don't you listen him lies, missie! Nasty low fellow! Nasty low tricks him playing. Nasty *native* tricks!'

'Ha, ha! He is not native himself! Oh no! Him European man, white skin all same missie. Ha ha!'

'Stop your *bat*, you two, or I'll fetch one of you a kick,' said the husband of Elizabeth's friend – he was a planter. They stepped

into one of the sampans and were rowed towards the sun-bright quays. And the successful sampan-wallah turned and discharged at his rival a mouthful of spittle which he must have been saving up for a very long time.

This was the Orient. Scents of coco-nut oil and sandalwood, cinnamon and turmeric, floated across the water on the hot, swimming air. Elizabeth's friends drove her out to Mount Lavinia, where they bathed in a lukewarm sea that foamed like Coca-Cola. She came back to the ship in the evening, and they reached Rangoon a week later.[41]

On the one hand, there are clearly a number of similarities with Wright's depiction of Ceylon in the plasticity of the imagery and the tactile, visceral response of the narrative to this feast of colour and sound. At the same time, Orwell is constantly aware of the political relations which underpin the colonist's response to the Orient. What distinguishes this scene from *Song of Ceylon* is the brutal reality of imperialism, which is registered so forcibly in the planter's matter-of-fact threat to the natives and the response of the people themselves who are forced into what Homi Bhabha has termed a discourse of 'mimicry', classifying and regulating themselves as racial inferiors.[42] Moreover, Orwell is concerned to interrogate the consciousness of the imperialist voyeur, in the form of the naive, complaisant Elizabeth, whose main interest in India is the access which it will give her to social status and the lifestyle of the county set which has been denied to her back home in England.

Burmese Days offers an interesting comparison with Basil Wright's documentary because, whereas the latter emphasises the peace and tranquility of the East, Orwell is constantly reminding his reader of the violence engendered by imperialism and its corrosive effects on all those who enter into its services, whatever their motives:

Your whole life is a life of lies. Year after year you sit in Kipling-haunted little Clubs, whisky to right of you, *Pink'un* to left of you, listening and eagerly agreeing while Colonel Bodger develops his theory that these bloody Nationalists should be boiled in oil. You hear your Oriental friends called 'greasy little *babus*', and you admit, dutifully, that they are greasy little *babus*. You see louts fresh from school kicking grey-haired servants. The time comes when you burn with hatred of your own countrymen, when you long for a native uprising to drown their Empire in

blood. And in this there is nothing honourable, hardly even any sincerity. For, *au fond*, what do you care if the Indian Empire is a despotism, if Indians are bullied and exploited? You only care because the right of free speech is denied you. You are a creature of the despotism, a pukka sahib, tied tighter than a monk or a savage by an unbreakable system of taboos.[43]

This oft-quoted passage registers the thoughts of Orwell's hero, Flory, who finally commits suicide because he cannot face a life of loneliness in Burma, once Elizabeth has abandoned him. Flory has socialist leanings and his best friend is a native, Dr Veraswami, so that the narrative seems at first to offer some hope of an alternative to the hierarchical, exploitative relationship between England and its imperial 'subjects'. However, Flory's death and the subsequent ruin of Veraswami leave a pessimistic conclusion which suggests that the Empire is not amenable to reform in this way. Ultimately, it seems that 'blood will flow', although one is not entirely clear about where Orwell stands on the rights and wrongs of a a nationalist uprising. The narrative 'voice' in *Burmese Days*, and essays such as 'A Hanging' or 'Shooting an Elephant', is that of the frustrated liberal imperial functionary, who feels that the Empire cannot last and yet does not believe that the natives have the political will to extract meaningful changes from the 'powers that be'.

In part, Orwell's pessimistic approach to the prospects of anti-imperialism derives from his own rather isolated experience in Burma and his inchoate feelings about the immorality of imperialism as a young colonial policeman in the Twenties.[44] But the nihilism of *Burmese Days* and other writings of the Thirties is also the product of his alienation from what he perceives as a 'parlour socialism' which refuses to face up to the implications of Britain without the Empire. Thus, the provocative essay 'Not Counting Niggers', written in 1939, argues that socialists in Britain have been guilty of 'hypocrisy' in effectively rendering the colonial peoples invisible in their analyses of capitalism:

In a prosperous country, above all in an imperialist country, left-wing politics are always partly humbug. There can be no real reconstruction that would not lead to at least a temporary drop in the English standard of life, which is another way of saying that the majority of left-wing politicians and publicists are people who earn their living by demanding something that they don't genuinely want. They are red-hot revolutionaries as long as all goes

well, but every real emergency reveals instantly that they are shamming. One threat to the Suez Canal, and 'anti-Fascism' and 'defence of British interests' are discovered to be identical ...

The unspoken clause is always 'not counting niggers'. For how can we make a 'firm stand' against Hitler if we are simultaneously weakening ourselves at home? In other words, how can we 'fight Fascism' except by bolstering up a far vaster injustice?

For of course it *is* vaster. What we always forget is that the overwhelming bulk of the British proletariat does not live in Britain, but in Asia and Africa. It is not in Hitler's power, for instance, to make a penny an hour a normal industrial wage; it is perfectly normal in India, and we are at great pains to keep it so. One gets some idea of the real relationship of England and India when one reflects that the *per capita* annual income in England is something over £80, and in India about £7. It is quite common for an Indian coolie's leg to be thinner than the average Englishman's arm. And there is nothing racial in this, for well-fed members of the same races are of normal physique; it is due to simple starvation. This is the system which we all live on and which we denounce when there seems to be no danger of its being altered. Of late, however, it has become the first duty of a 'good anti-Fascist' to lie about it and help keep it in being.[45]

Orwell's rather sweeping, judgemental comments on the perceived faults of other socialists, particularly 'left-wing intellectuals', are renowned and one would not necessarily look to his writings for an unbiased assessment of the Popular Front and its response to either Fascism or the British Empire. Nevertheless, what is noteworthy about Orwell' trenchant critique of the Empire in the Thirties is the way in which he constantly reminds his reader of the injustice and immorality of what he and others have been forced to do in the name of 'Pax Britannica'. Thus, in a letter to Geoffrey Gorer, written in 1937, he comments that, 'We like to think of England as a democratic country, but our rule in India, for instance, is just as bad as German Fascism, though outwardly it may be less irritating.'[46] It is this insistence on 'bringing the Empire back home' to his English readers and reminding them that they are complicit in 'a despotism with theft as its final object'[47] which gives his writing its distinctive 'ethical' tone.

For Orwell, the Empire is not simply an abstract political system, but a form of exploitation with exceedingly tangible effects for

those under its sway. By contrast, even a humane Communist writer, such as Ralph Fox, can still be found quoting, with approval, in his book *The Novel and the People*, Marx's rather insensitive comments on the 'progressive' role of British role in India: 'English interference having placed the spinner in Lancashire and the weaver in Bengal, or sweeping away both Hindoo spinner and weaver, dissolved these semi-barbarian, semi-civilized communities, by blowing up their economical bases, and thus produced the greatest and, to speak the truth, the only *social* revolution ever heard of in Asia.'[48] Whatever Orwell's faults, he does not evince this kind of cold detachment in his response to the Empire. The British invasion of the Indian subcontinent is not simply a necessary precondition for the construction of a new 'mode of production', as an orthodox Marxist such as Fox would tend to imply. Although Orwell is not entirely immune from the Euroethnocentricity which Marx and his followers displayed, he does emphasise the history of the Burmese in *Burmese Days* and the fact that they possess a civilisation 'stretching back and back ... into times when we were dressed in woad.'[49]

Thus, Orwell does not just view the British Empire as the bearer of an economic revolution which laid the foundations for the development of civilisation in a 'semi-barbaric wilderness'. Imperialism may bring benefits, such as an efficient civil service and improved systems of communication, but it is also leads to uncivilised acts which have repercussions for the colonisers as well as the colonised. At one point in *Burmese Days*, Dr Veraswami compliments Flory and his fellow countrymen on their noble motto of 'Hanging Together' which is 'the secret of your superiority to we Orientals'.[50] But in the essay 'A Hanging' we learn that it is not just the intransitive form of the verb which is important for divining the secret of imperialism. The representatives of British power in the East are also required to engage in the act of hanging in a very literal way and it is this coercive aspect of imperialism which will ultimately force the young policeman in Burma to question his role as a representative of 'civilisation'.

At the end of 'A Hanging', Orwell describes the aftermath of the execution of a native, recalling the way in which the British superintendent of the jail had broken normal protocol by inviting everyone to share a bottle of whisky as a means of releasing tension: 'We all had a drink together, native and European alike, quite amicably. The dead man was a hundred yards away.'[51] As Orwell hints,

the macabre irony of this situation, and by implication of imperialism in general, is that it takes an inhuman act such as a hanging to overcome the barriers between the British and their colonial 'subjects'. Earlier on in the narrative, he has already made his reader aware of the fact that the execution had opened his eyes to the futility of capital punishment: 'When I saw the prisoner step aside to avoid the puddle, I saw the mystery, the unspeakable wrongness, of cutting a life short when it is in full tide.'[52] Hence the combination of this insight with the final description of the executioners, united in their 'medicinal' drink, leaves us in no doubt about the nature and limitations of 'Pax Britannica'.

Perhaps one of Orwell's most important contributions to the critique of imperialism, which connects his work with more recent discussions, is his dissection of the persona which the colonial administrator has to adopt in order to 'hold his/her own' with the natives. Seamus Deane has argued that the colonising power does not just create a stereotype of the native as an 'other', whose alien, inferior nature justifies the imperial adventure. The process of stereotyping also affects the colonising power which 'has to create a stereotype of itself as much as it does of others. Indeed, this is one of the ways by which otherness is defined.'[53] Orwell dramatises this process in 'Shooting an Elephant', recalling an episode in his life as an imperial policeman when he was forced to act against his will and better judgement. An elephant, which had gone 'must', had killed a man in its rampaging, but by the time Orwell caught up with it the attack was wearing off and there seemed little point in destroying the animal. However, he realised that the crowd which had gathered expected him to act and that there was no alternative but to act out the role of the colonial policeman:

> They did not like me, but with the magical rifle in my hands I was momentarily worth watching. And suddenly I realized that I should have to shoot the elephant after all. The people expected it of me and I had got to do it; I could feel their two thousand wills pressing me forward, irresistibly. And it was at this moment, as I stood there with the rifle in my hands, that I first grasped the hollowness, the futility of the white man's dominion in the East. Here was I, the white man with his gun, standing in front of the unarmed crowd – seemingly the leading actor of the piece; but in reality I was only an absurd puppet pushed to and fro by the will of those yellow faces behind. I perceived in this moment that

when the white man turns tyrant it is his own freedom that he destroys. He becomes a sort of hollow, posing dummy, the conventionalized figure of the sahib. For it is the condition of his rule that he shall spend his life in trying to impress the 'natives' and so in every crisis he has got to do what the 'natives' expect of him. He wears a mask, and his face grows to fit it.[54]

The strength of 'Shooting an Elephant' comes from Orwell's direct experience of the contradictions of imperialism so that he is able to analyse the absurdity of his role as a 'puppet' in a seemingly meaningless drama. By contrast, the weakness of the essay lies in his inability to inhabit a discourse which articulates the viewpoint of the anti-colonial struggle. Ultimately the monks and students in Burma, who represent a burgeoning nationalism, are still seen from his point of view as a nuisance, a mob threatening the European women in the bazaars and generally making everyone's life difficult. ('in an aimless, petty kind of way anti-European feeling was very bitter. No one had the guts to raise a riot, but if a European woman went through the bazaars alone somebody would probably spit betel juice over her dress.')[55] There is a tendency to displace the blame for the irrationality of the situation on to the native people, so that the deadlock is somehow the fault of the 'gutless' Burmese who are too cowardly to rebel and risk being shot!

Hence there is a self-serving side to Orwell's description of the dilemma which he and his compatriots faced; the natives are still the objects of an 'othering' which allows the reader to empathise with the narrator/Orwell when he confesses that one of his fantasies at this time was to 'drive a bayonet into a Buddhist priest's guts'.[56] Although Orwell's writings of the Thirties have been seen as expressing a growing 'alienation from the imperial ethos'[57], it is an alienation which is ultimately blamed on the ungovernable natives, rather than the irrational nature of imperialism itself. We are still asked to adopt the viewpoint of the frustrated imperial official whose irascibility is assumed to be perfectly understandable to the implied European reader, as the following passage from *Burmese Days* amply illustrates:

Besides you could forgive the European a great deal of their bitterness. Living and working among Orientals would try the temper of a saint. And all of them, the officials particularly, knew what it was to be baited and insulted. Almost every day, when

Westfield or Mr Macgregor or even Maxwell went down the
street, the High School boys, with their young, yellow faces –
faces smooth as gold coins, full of that maddening contempt that
sits so naturally on the Mongolian face – sneered at them as they
went past, sometimes hooted at them with hyena-like laughter.
The life of the Anglo-Indian officials is not all jam. In comfortless
camps, in sweltering offices, in gloomy *dak* bungalows smelling
of dust and earth-oil, they earn, perhaps, the right to be a little
disagreeable.[58]

Orwell was finally compelled to leave Burma in 1927 because he
was faced with an impossible dilemma: how to reconcile his com-
mitment to 'decency' and 'fair play' with a role which forced him to
suppress the rightful demands of the indigenous peoples for self-
determination. For a while he dealt with these contradictions by ex-
ternalising his frustrations in the form of violent outbursts against
the natives, as we have seen, but ultimately he was constitutionally
unable to adopt the authoritarian character armour necessary to
preserve his identity intact as a colonial policeman. Of course the
dilemma was not Orwell's alone, but he suffered it in silence, along
with all those who found themselves to be opposed to the effects of
imperialist rule in the colonies. Clearly the hegemonic discourse of
British imperial culture could not allow for the emergence of alter-
native voices which might have undermined the whole enterprise,
particularly in the face of growing nationalist movements on the
Indian subcontinent and elsewhere.

The narrative of Empire which this experience produced was one
of internal exile and increasing self-alienation. On the surface the
Empire was alive and flourishing, or so the propaganda of the
Empire Marketing Board and other agencies maintained. However,
underneath the mask of certainty and self-control, pressure for
change was building up from those who found it difficult to recon-
cile their commitment to democracy and patriotism in the home
country with a suppression of the same beliefs out in the colonies.
Nevertheless, there were limits to the amount of self-reflection
which intellectuals like Orwell could indulge in whilst pursuing
their roles as imperial functionaries. Ultimately the main diagnosis
of imperialism's ills would emerge in the writings of those new in-
tellectuals being produced out in the colonies themselves, whose
relationship to imperialism was rather different. So, for example,
one of the most articulate summaries of the dilemma faced by colo-

nial emissaries such as Orwell is contained in an essay by the West Indian writer, C. L. R. James, published in 1933:

> The colonial Englishman it is fair to say retains some of the admirable characteristics which distinguish his race at home, but he is in a false position. Each succeeding year sees local men pressing him on every side, men whom he knows are under no illusions as to why he holds the places he does. Pressure reduces him to dodging and shifting. Thus it is that even of that honesty which is so well-recognised a characteristic of the English people – but I shall let an Englishman speak: 'It is difficult', says Mr Somervell, the historian, 'for white races to preserve their moral standards in their dealings with races they regard as inferior.' Should Englishmen of fine sensibility stray into the Colonial Service they find themselves drawn inevitably into the circle of their colleagues and soon discover that for them to do otherwise than the Romans would be equivalent to joining a body of outsiders against their own. Thus it is that in the colonies, to quote an English official in the West Indies, 'such large and intelligent classes of Englishmen come to have opinions so different from those for which the nation has ever been renowned at home.'[59]

The next section is devoted to an examination of James's career in the Thirties as an intellectual whose 'journey', like that of Orwell, is significant for understanding the cross-currents of imperialism in that period and the emergence of future tendencies. Whilst their paths seem never to have actually crossed, both lived in London at some point in the Thirties, both were involved with the Independent Labour Party and Trotskyite politics and both developed trenchant critiques of imperialism. Yet Orwell's essays on the Empire have been widely available since the Thirties, whilst James's voice has only really been heard in recent years, especially since the republication of his major writings in the late Eighties. It would seem appropriate, then, to redress the balance a little and to ask how essays such as 'The Case for West Indian Self-Government', or imaginative fictions such as *The Black Jacobins*,[60] offer a different perspective on the Empire in the Thirties and an illuminating contrast with the Englishman's version of the colonial dilemma, even that of an enlightened Englishman such as Orwell.

C. L. R. JAMES AND THE VOICE OF 'PERIPHERY'

In *Culture and Imperialism*[61] Edward Said describes the history of
imperialism in terms of a journey which has two stages (if one
thinks in chronological terms) or two separate trajectories (to repre-
sent it spatially). On the one hand, there is 'the voyage out' from
the metropolitan centre to the uncharted regions of the world and
the consequent establishment of imperialism, which is re-traced
every time a Forster or an Orwell takes the 'passage' to India,
Africa or the West Indies. On the other hand, set against this
journey/narrative is a different movement, the 'voyage in' to the
Mother Country by colonial intellectuals, which Said sees as pro-
viding the basis for a more critical interaction between colonisers
and colonised, the metropolitan centre and its periphery. Said
argues that, in this second stage of the history of imperialism:

> No longer does the logos dwell exclusively, as it were, in London
> and Paris. No longer does history run unilaterally, as Hegel be-
> lieved, from East to West, or from North to South, becoming
> more sophisticated and developed, less primitive and backward
> as it goes. Instead, the weapons of criticism have become part of
> the historical legacy of empire, in which the separations and ex-
> clusions of 'divide and rule' are erased and surprisingly new
> configurations spring up.[62]

So, the history of modernism in Europe is inextricably linked
with the 'massive infusions of non-European cultures into the met-
ropolitan heartland during the early years of this century', affecting
'the very fabric of a society that believed itself to be homogeneously
white and western.'[63] Moreover, the period between the wars, par-
ticularly the Thirties, is a crucial historical 'moment' in the develop-
ment of this hybrid cultural movement:

> In the interwar period students from India, Senegal, Vietnam and
> the Caribbean flocked to London and Paris; journals, reviews and
> political associations formed – one thinks of the pan-African con-
> gresses in England, magazines like *Cri des nègres*, parties like the
> Union de Travailleurs Nègres established by expatriates, dissi-
> dents, exiles and refugees, who paradoxically work better in the
> heart of the empire than in its far-flung domains, or of the
> invigoration provided movements by the Harlem Renaissance. A
> common anti-imperialist experience was felt, with new associa-

tions between Europeans, Americans, and non-Europeans, and they transformed disciplines and gave voice to new ideas that unalterably changed that structure of attitude and reference which had endured for generations within European culture. The cross-fertilization between African nationalism as represented by George Padmore, Nkrumah, C. L. R. James on the one hand, and, on the other the emergence of a new literary style in the works of Césaire, Senghor, poets of the Harlem Renaissance like Claude McKay and Langston Hughes, is a central part of the global history of modernism.[64]

However, while the impact of writers like Langston Hughes and other members of the Harlem Renaissance has long been recognised as central to the development of twentieth-century American literature, and while the stylistic experimentations of Cesaire are seen as being crucial for an understanding of modern French poetry, the contributions of prewar writers from the colonies of the British Empire – James, Padmore and others – have gone largely unrecorded. Moreover, even when one moves from the realm of artistic production to that of political and social ideas, it is noticeable that cultural historians in the metropolitan centre, including those on the Left, have generally failed to recognise the role of James and other intellectuals as forerunners of an alternative radical tradition of ideas. As Benita Parry has pointed out, 'when E. P. Thompson, Williams, and others, went in search of hidden socialist traditions, they overlooked the leaders of the anti-colonialist independence movements resident in Britain as representatives of this tradition.'[65] Thus, it has taken post-colonialist writers, like the American Paul Buhle and the Palestinian Edward Said, to put James's work on the map of cultural history.[66]

Cyril Lionel Robert James was born in Trinidad on 4th, January 1901, to lower-middle-class parents who were, as Paul Buhle describes them, 'part of a distinctive generation of blacks – the generation which followed the slave emancipation and whose contribution shaped profoundly the future of those small island societies.'[67] His father was a schoolteacher and James recalls that his mother was a passionate reader, so the young man acquired a good deal of the 'cultural capital'[68] needed for the next stage of his voyage 'inward' to the metropolis at an early stage in his life. In addition, the family house was situated next to the cricket ground and James developed a love of the game from an early age, an en-

thusiasm which he was to combine with his commitment to writing in the journalism which he produced for the *Manchester Guardian* in the Thirties.

James began to write imaginative fiction in Trinidad during the Twenties. Stories such as 'La Divina Pastora' and 'Triumph', which focused on the lives of strong, resourceful women from the barrack-yards, were published in local magazines and then reprinted in collections published in London, so James's work was already available to an overseas readership when he emigrated in 1932, even though he was still relatively unknown in England.[69]

On his arrival in England he went to stay with an old Trinidadian friend, the cricketer Learie Constantine, in Nelson, Lancashire, assisting him with his memoirs, published in 1932 as *Cricket and I*.[70] In return, Constantine helped to support James while he wrote *The Life of Captain Cipriani*, the study of a West Indian national hero whose challenge to British rule had exposed the hypocrisies and internal contradictions of colonialism. This was published in 1932 and then brought out the following year in a slightly condensed form as the pamphlet, *The Case for West Indian Self-Government*, produced by Leonard and Virgina Woolf's Hogarth Press.[71]

Learie Constantine was also instrumental in furthering James's career by introducing him to Neville Cardus of the *Manchester Guardian* and James quickly rose to prominence as the first coloured cricketing reporter on an English newspaper.[72] His accounts of the visiting West Indies team revealed the knowledge of an insider who, as Paul Buhle notes, was able to provide his English readers with 'a short education in the material conditions of the game in the Caribbean' and to use that knowledge to further demands for self-determination.[73] But James also developed a more general thesis about cricket which can be seen as offering an original contribution to Marxist cultural theory in its Brechtian concern with building on the strengths of popular art forms:

> James confronted the unwillingness of the other critics, notably Neville Cardus, to designate cricket a fully-fledged art form equal to theatre, opera and dance. To this claim James added a populist amendment: 'What matters in cricket, as in all the arts, is not the finer points but what everyone with some knowledge of the elements can see and feel.'[74]

Like James, Brecht claimed that popular art forms appealed to the 'concrete' knowledge of the people. The German playwright

had argued that 'epic theatre' must break with a high culture model which ruled out the 'practical', 'utilitarian' involvement of the audience. Whereas classical, 'bourgeois' theatre based itself on an aesthetic of 'the finer points', Brecht's socialist drama was designed to involve the audience as 'technical experts', whose 'concrete' knowledge and 'survival skills' would provide the starting point for a revitalised drama. As Benjamin explained in *Understanding Brecht*:

> Epic theatre addresses itself to interested persons 'who do not think unless they have a reason to' ... Brecht's dialectical materialism asserts itself unmistakably in his endeavour to interest the masses in theatre as technical experts, but not all by way of 'culture'. 'In this way we could very soon have a theatre full of experts, as we have sports stadiums full of experts.'[75]

In developing his analysis of cricket as a popular art, James, like Brecht, highlighted the parallels between Greek theatre and modern sport in their joint celebration of the epic, spectacular, communal and public dimensions of human life. Cricket was not just a form of 'distraction' for James, but was representative, as Anna Grimshaw comments, of 'something located much deeper in human experience':

> Cricket was whole. It was expressive in a fundamental way of the elements which constituted human existence – combining as it did spectacle, history, politics; sequence/tableau, movement/stasis, individual/society.[76]

This emphasis on sport and popular art was unusual for a Marxist of the thirties, as even the most original Marxist cultural theorists, such as Christopher Caudwell, tended to view popular culture as an 'opiate' of the people and hence, by implication, non-culture.[77] By contrast, James and Brecht did not restrict their definition of culture to a reworked version of bourgeois high art. To adopt Raymond Williams' memorable phrase, culture was not the activity of a privileged minority, but a 'whole way of life'.[78]

However, what the New Left thinkers, such as Williams, only began to discover in the late Fifties was already a truism for James in the Thirties. In part, this was due to the 'peculiarities' of his own cultural origins and the cross-class appeal of cricket in the West Indies, but his ability to embrace more advanced cultural politics is also the product of his particular relationship to the metropolitan centre. As Paul Buhle has pointed out, it was 'the *distance* estab-

lished between him and England by his birth, colour and circum-
stances' (i.e. as an outsider from the colonies) which 'permitted him
an unashamed attachment to contemporary popular culture from
which British [as American] theoretical Marxism almost invariably
found itself alienated.'[79] (Our emphasis.)

Nevertheless, it would be wrong to imply that James's enthusi-
asm for popular culture was accompanied by a concomitant rejec-
tion of high culture. At school he seems to have imbibed English
and European literature enthusiastically, learning vast chunks of
Shakespeare and Thackeray off by heart. In a later interview he
commented that, 'Everything depended formally upon European
literature, European institutions,' and he refused to disown this
legacy or its positive implications for West Indian culture.[80]
Edward Said has pointed out that for James, 'the world of discourse
inhabited by natives in the Caribbean ... during the 1930s was hon-
ourably dependent upon the West,'[81] and this is perfectly illus-
trated by *The Black Jacobins*, where his hero, Toussaint L' Ouverture,
draws directly on the discourse of the French Encyclopaedists and
the Revolution. At the same time, James's play highlights the weak-
nesses of a man who, as Said remarks, has accepted the 'universal-
ist sentiments propounded by the European Enlightenment' as
literal truths, rather than 'class and history-determined remarks of
interests and groups'.[82] In arguing that the struggle for national
self-determination will need to transcend the rhetoric and practice
of the bourgeois Enlightenment, James registers the historical limi-
tations of this 'honourable dependency' and the requirement for
colonial liberation movements to gain a critical distance from the
Mother Country.

Said has summed up James's position as one of the 'intellectuals
from the colonial or peripheral regions who wrote in an "imperial"
language, who felt themselves organically related to the mass resist-
ance to empire, and who set themselves the revisionist critical task
of dealing frontally with the metropolitan culture, using the tech-
niques, discourses, and weapons of scholarship and criticism once
reserved exclusively for the European.'[83] One of the best examples
of James's discursive duel with metropolitan culture is the essay,
'The Case for West Indian Self-Government', in which he cites a
number of English cultural icons, from Johnson on patriotism as the
'last refuge of the scoundrel' to Julian Huxley on the low level of in-
tellectual debate among colonial officials in Africa, in developing a
scathing analysis of imperialism. James exposes the internal contra-

dictions of a political discourse which celebrates 'the famous English tolerance at home', but which brands as a 'wild revolutionary' any man in the colonies who 'tries to do for his own people what Englishmen are so proud that other Englishmen have done for theirs.'[84] Hence, the tradition of 'Hampden, Chatham, Dunning and Fox, Magna Carta and the Bill of Rights' and the 'Whig tradition in historical writing' becomes in the colonies 'the greatest crime'.[85]

The high point of 'The Case for West Indian Self-Government' is the moment where James reconstructs the 'passage' to the colonies, ostensibly from the viewpoint of the newly arrived English official but actually as narrated by the West Indian intellectual, in the form of an ironic authorial voice:

> On his arrival in the West Indies he experiences a shock. Here is a thoroughly civilised community, wearing the same clothes that he does, speaking no other language but his own, with its best men as good as, and only too often, better than himself. What is the effect on the colonial Englishman when he recognises, as he has to recognise, the quality of those over whom he is placed in authority? Men have to justify themselves and he falls heavily back on the 'ability of the Anglo-Saxon to govern', 'the trustee-ship of the mother country until such time' (always in the distant future) 'as these colonies can stand by themselves', etc. etc. He owes his place to a system, and the system thereby becomes sacred. Blackstone did not worship the corrupt pre-Reform constitution as the Colonial Office worships the system of Crown Colony government.[86]

It is not hard to see that this 'meeting' of the Englishman with his colonial counterpart is rather different from Orwell's representation of the Burmese intelligentsia – the Buddhist monks and the radical students – in 'Shooting an Elephant'. In Orwell's essay the point of view is decidedly that of the frustrated colonial policeman, sickened by the insults to Englishwomen in the bazaars (the 'voice of Amritsar', as Rushdie so vividly describes it)[87] and unable to communicate with the irrational 'mob'. By contrast, in James's essay 'the subaltern speaks' (to quote Giyatri Spivak) albeit through the discourse of European *belle-lettres*.

James's project, in both the imaginative fiction and the essays, seems to be that of bringing the colonial and metropolitan cultures into what Said terms a 'contrapuntal' relationship, as a way of exploring 'overlapping territories' and 'intertwined histories'.[88]

A fascinating illustration of this 'hybrid' discourse can be found in
the play, *The Black Jacobins*,[89] which sets the progressive nationalist
traditions of Europe alongside the indigenous culture of San
Domingo (Haiti) in the late eighteenth century. This works on a
number levels, both political and artistic. So, an example of the po-
litical interdependence of the two traditions is referred to directly at
the beginning of the play, when a white settler berates the French
Revolution for giving free rein to liberationist tendencies which
have spread to the colonies:

> White Man A: Imagine! Only six deputies for San Domingo!
> The States General in France must be crazy.
> White Man B: It was Mirabeau from that black-loving club.
> 'The Friends of the Negro.' He had the effron-
> tery to say that if our blacks could not vote, and
> could be counted in the census, then there were
> mules and horses in France which could not
> vote and could be counted in their census.
> White Man C: So unfair! Everyone knows that animals are
> worth more than blacks.[90]

A short while later, the action shifts to a native speaker address-
ing a crowd from a platform. His speech picks up on the same
theme, but viewed from a diametrically opposed position to that of
the master:

> Speaker: My brothers, I have been running all night to tell you.
> The slaves of the French island of Guadaloupe and
> Martinique are fighting their masters. The white
> slaves in France are fighting their masters. You here
> in Fort Dauphin, you who have toiled in the fields
> and got no reward except lashes with the whip; the
> land belongs to you, your blood and sweat is mixed
> with the earth. You must join your brothers in revolt,
> we must fight ...[91]

From the outset, the play establishes a counter-hegemonic dis-
course of intertwined destinies, which opposes the 'divide and rule'
of colonialism by arguing that the national-popular struggle in both
France and its colonies sets the people *in general* against the 'old
order'. This discursive thread is reinforced on a broader thematic
level by dramatic techniques of various kinds. So, the role of music,
especially song, is important in developing the idea of liberation

and revenge for past wrongs. Early in the Prologue, five slaves are shown in silhouette, digging with pickaxes and singing the following refrain:

Eh! Eh! Bomba! Heu! Heu!
White man – vow to destroy
Take his riches away
Kill them
Every one
Canga Li[92]

This theme of revenge is then echoed by the wife of the plantation owner, albeit unconsciously, when she sings an aria from Mozart's *Don Giovanni* at the beginning of Act One:

I demand revenge of you, your heart demands it,
Your heart demands it.
Remember the wounds in that poor breast,
Recall the ground, covered, covered with blood,
Should the fury of a just anger, of a just anger
Wane in you ...
I demand revenge of you, your heart demands it,
Your heart demands it.
Remember the wounds, recall the blood,
I demand revenge of you, your heart demands it,
I demand revenge of you, your heart demands it ...[93]

Madame Bullet, the plantation owner's wife, seems to be blissfully unaware of the political overtones of Mozart's aria and the way in which she talks about the opera to her servant makes it clear that it is really only a fashionable event for her, part of her tour of Europe which she can recount on her return to San Domingo. However, moments later, one of the leaders of the slave rebellion, Dessalines, bursts into the house and the irony of Madame Bullet's naivety is confirmed for the audience:

Bullet: What are you doing in here, Dessalines?

....

Dessalines: Revolution in France. Revolution in San Domingo. Freedom for slaves. Kill Master. Burn down plantation.[94]

Hence, Mozart's opera and the slaves' chant are not seen as representing opposed traditions, but as enunciations of a developing nar-

rative of human liberation in which 'centre' and 'periphery' are in-
extricably linked. At the same time, the two cultures cannot simply
merge with one another and James makes it clear that the slaves of
San Domingo must establish their own counter-hegemonic strategy,
separate from that of the European revolutionary nationalist move-
ment. This is signalled dramatically at the end of the play, when
Dessalines, who has deposed the original leader Toussaint
L'Ouverture and set himself as Emperor of the island, inadvertently
illustrates the decline of the revolution by insisting on dancing a
minuet in front of emissaries from England. Here, the *ironic* juxtapo-
sition of the two cultures is a visible artistic comment on the ability
of the *ancien régime* to assimilate the rebelliousness of its former
colony and, ultimately, to install a counter-revolutionary regime (as
it has done by this time in Europe – the date is now 1803) if the
native peoples do not break with the trajectory of European history
and the monarchial regression embodied in the Napoleonic order.

So far we have been following the work of James as an individual
colonial intellectual of the Thirties, albeit as the source of an alterna-
tive narrative which has wider 'representative' status. However, we
must be careful to avoid the trap of seeing figures such as Orwell
and James as purely isolated individuals, with a unique insight into
the issues of their time. In this context, it is worth recalling a quota-
tion from Edward Said which was cited earlier in the chapter. In
Culture and Imperialism Said comments on the migration of students
from India, Senegal and the Caribbean to Paris and London in the in-
terwar years, pointing out that this was the period when various
'journals, reviews and political associations' were formed by 'expatri-
ates, dissidents, exiles, and refugees' in the metropolitan centres.[95]

Hence, to comprehend the significance of James's work in the
Thirties is to recognise, as Said remarks, that 'anti-imperialist intel-
lectual and scholarly work done by writers from the peripheries
who have immigrated to ... the metropolis is usually an extension
into the metropolis of large-scale mass movements.'[96] (In James's
case Pan-Africanism, as we shall see.) It is also to understand what
Raymond Williams describes as 'the sociology of metropolitan en-
counters between immigrants' and mainstream groups'. It is these
encounters which, as Williams comments, 'create especially
favourable conditions for dissident groups', both political and artis-
tic.[97] (One thinks, for example, of James's participation in the
Independent Labour Party and Trotskyist politics during his years
in London in the Thirties.)

James's own role as the spokesperson for 'large-scale mass move-
ments' became demonstrably clear after his move to London in
1933. In Nelson he and Constantine had mixed with local people
through cricket and the Labour Party, but they were virtually the
only Blacks in the town.[98] Meanwhile, James was starting to gain a
national reputation through his journalism and he participated in a
programme for the BBC on the centenary of the abolition of slavery
in the West Indies in which he 'acquitted himself with such vigour
that colonial officials complained.'[99] This visibility at the national
level made a move to London the next logical step and here he met
influential figures such as the Black Communist George Padmore
and the nationalist Marcus Garvey.

In the main, James leaned towards the Marxism of Padmore,
rather than the nationalism of Garvey, accusing the latter of having
more in common with fascism than socialism. But although James
was critical of Garvey's 'Back to Africa' movement, he was in no
doubt about the symbolic and practical importance of that conti-
nent for the liberation movement when Mussolini invaded
Abyssinia in 1935. It is arguable that the war in Abyssinia/Ethiopia
was as important for James and other Black activists of the Thirties
as the Spanish Civil War was for their European comrades. To the
Pan-African movement Ethiopia was, as Paul Buhle remarks, the
'symbol of Africa's past greatness, its emperor, Haile Selassie, a
unique monarch upon a throne older and more secure than that of
many European constitutional monarchs.'[100] Yet the rhetoric of
Mussolini, Marinetti and other Fascisti was chilling in its represen-
tation of the Ethiopian tribesmen as natural objects for target
practice. In one of his war-time columns for *Tribune*, Orwell re-
called the way in which Bruno Mussolini, the Duce's son, de-
scribed bombed Abyssinians '"bursting open like a rose", which,
he said, was "most amusing"'.[101] James threw himself into the
defence campaign, helping to found the International African
Friends of Abyssinia, along with other notable exiles, such as Jomo
Kenyatta, George Padmore and Amy Ashwood Garvey.[102]
However, there was little that organisations such as the IAFA
could do to influence the final outcome of the war and the unwill-
ingness of Britain to countenance oil and naval sanctions against
Italy led James to conclude that British imperialism would always
put its interests above those of the native peoples in such a situa-
tion. Hence, in an article written at the beginning of 1936, a few
months before the defeat of Ethiopia, he was already hinting at the

final outcome and the need for Black activists to be sceptical about
the power of liberal opinion in imperialist countries when it came
to issues of national self-interest:

> But British imperialism does not govern only the colonies in its
> own interests. It governs the British people in its own interests
> also, and we shall see that imperialism will win. It will talk a lot
> but it will do nothing for Abyssinia. The only thing to save
> Abyssinia is the efforts of the Abyssinians themselves and action
> by the great masses of Negroes and sympathetic whites and
> Indians all over the world
>
> Mussolini, the British government and the French have shown
> the Negro only too plainly that he has got nothing to expect from
> them but exploitation, either naked or wrapped in bluff. In that
> important respect this conflict, though unfortunate for Abyssinia,
> has been of immense benefit to the race as a whole.[103]

Here, apart from the general tenor of James's comments on impe-
rialism, it is worth noting the reference to an alliance of 'Negroes,
sympathetic whites and Indians' as the basis for long-term action.
James's involvement with the IAFA had strengthened his links
with other black militants, but it had also alerted him to the need
for an international movement of all those struggling for independ-
ence from colonial rule. In particular, his period in London had
brought him into contact with exiles from India, such as the experi-
enced political campaigner Krishna Menon, who was to become a
close friend. Paul Buhle argues convincingly that the movement for
Indian home rule had 'pioneered the anti-imperialist movement in
England' and by the time of James's arrival in London had 'created
a formidable anti-colonial lobby.'[104] Ironically, the metropolitan
centre was to provide a fertile meeting ground for those planning
their liberation in a variety of imperial locations and the example of
one movement was not lost on the others.

If the experience of campaigning around the Abyssinian War en-
couraged James to develop links with individuals in other anti-im-
perialist movements, it also left him increasingly critical of the
Soviet Union and what he saw as a policy of defending 'socialism in
one country', rather than a commitment to international revolution.
Once again, we find fascinating parallels developing between the
political trajectory of the intellectual from the 'periphery' and his
counterpart from the 'centre'. Just as James was increasingly
vociferous in his accusations that the Soviet Union had 'rushed to

send oil to Italy, rather than leading the struggle against imperial-ism',[105] so Orwell's experience of Spain, particularly the suppression of the Trotskyists in the Barcelona Riots of May 1936, also left him a convinced internationalist and an ardent critic of the Popular Front. Both were drawn to the Independent Labour Party as an organisa-tion which was both critical of labourism in the Trade Union move-ment and suspicious of Stalinism in the international arena. However, whereas Orwell's involvement with the ILP was largely that of the sympathetic 'fellow traveller', James worked closely with Fenner Brockway and other leading figures around the Abyssinia campaign, speaking at ILP branches up and down the country.[106]

Although there is no record of James having met Orwell in the Thirties, the latter's increasing interest in Trotskyist analyses of in-ternational politics almost inevitably brought him into contact with James's writings. *World Revolution 1917–1936: The Rise and Fall of the Communist International*, James's Trotskyist critique of the Communist International, was published by Fredric Warburg in 1937 and seems to have circulated quite widely on the anti-Stalinist left. Orwell obviously picked up on James's book after he returned from Spain and in reviewing a study of the Spanish Civil War by Mary Low and Juan Brea, entitled *Red Spanish Notebook*, he noted that 'Mr C. L. R. James, author of that very able book *World Revolution*, contributes an introduction.'[107] It is interesting to think of the black colonial émigré helping the ex-colonial policeman to 'place' his own political experiences in Spain in an international context and Orwell's reference to James adds an intriguing footnote to the history of the Trotskyist left in the Thirties.

Towards the end of the decade the combination of anti-colonial and Trotskyist Politics espoused by James made it increasingly difficult for him to function effectively in Britain and he left for America in 1938.[108] As Paul Buhle comments, 'The Trotskyist posi-tion on war, "Revolutionary Defeatism", had scant prospect in a Britain about to be nearly overwhelmed by Nazi bombs',[109] a fact recognised by Orwell in his own inimitable, if rather dismissive way in the following explanation for his exit from the ILP at the beginning of the war:

> I was for a while a member of the Independent Labour Party, but I left them at the beginning of the present war because I consid-ered that they were talking nonsense and proposing a line of policy that could only make things easier for Hitler.[110]

The war encouraged a 'radical patriotism' which foregrounded the 'citizens' war' at home and this inevitably undermined the position of those, such as James, who espoused radical pacifism or revolutionary defeatism. Moreover, the strategic considerations of the war outside Europe led British anti-imperialists, such as Orwell, to modify their stance on immediate independence for the colonies. Thus, whereas the Orwell of the late Thirties was still placing the Empire on a par with Nazi Germany (see, for example, the essay 'Not Counting Niggers', published in July 1939), by the middle of the war he was questioning the anti-fascism of the Indian nationalists and adopting a patronising tone towards the 'pseudo-Marxist' attitudes of the left-wing colonial intelligentsia.[111]

Of course, Orwell is not necessarily a reliable barometer of left opinion in the war, but his writings at this time may be seen as illustrations of the continuing influence of the Empire and the tendency of those who had been educated in an imperial culture to 'revert to type' at a moment of national crisis. In the end, individuals like Orwell were unable to move beyond an internal self-questioning of their role as imperial functionaries to a position which embraced the liberation movements in the colonies on an equal basis and the war tended perhaps to exacerbate this limited outlook.

Hence, the war brought a temporary halt to the anti-colonialist politics of the prewar period, at least in the metropolitan centre. Nevertheless, the career of James and other emigrés to Britain in the Thirties points to the emergence of a new politics and new narratives which questioned the old assumptions of an eternal hierarchy of racial power embodied in an unending Empire. The work of James and other 'colonial' writers had shown that the stereotype of the Indian, African or West Indian as an inferior 'Other' could be deconstructed by appropriating the discourse of the metropolitan culture and revealing its internal contradictions.

However, standard accounts of the Thirties, even those from a left-wing point of view, still present a picture of Britain in the Thirties as the Archimedean centre of an imperial universe. Looking back now on this period from the vantage point of the present, we need to recast the image of the Thirties, bringing into relief the features of those figures and movements who were in the process of remaking history in a post-colonial mould. For, as Edward Said has commented, the work of contemporary post-colonial writers such as Rushdie, Achebe and Solinka is 'unthinkable

without the earlier work of partisans like C. L. R. James'.[112] We need, then, to challenge the canon of accepted wisdom about the Thirties, as a period in which the only anti-imperialist narratives were written by white radicals, by shifting the spotlight to those accounts which were part of a new, 'emergent' culture of the periphery. Only by adopting this tack can we begin to construct a history which addresses the deeper, continuing relationship between past and present by connecting the narratives of the Thirties, and perhaps more importantly their authors, with the hybrid cultural identify of a post-colonial Britain of the Nineties.

5

'Kept Under by a Generation of Ghosts': The War, the People and the Thirties

Never can a decade have ended with more dramatic finality than did the 1930s. Some time between the declaration of war on 3 September 1939 and the climactic events of May 1940 – the fall of Chamberlain, Hitler's blitzkrieg, Dunkirk – a door slammed: life changed utterly – and, many feared or hoped, permanently. Not surprisingly, then, the autopsies on the Thirties began early. Auden's 'low dishonest decade' still had four months to run when he wrote its over-quoted epitaph. Professional writers, realising how quickly the Thirties had acquired the fascination of a lost past, took up their pens before the corpse was cold. Politicians and broadcasters weighed in. Within months, a process which usually takes years was well under way, and the Thirties were being thoroughly constructed and reconstructed as an object in posterity's imagination.

We might expect that for those enduring wartime privation and danger, the prewar world would take on the rosy glow of nostalgia, a lost world to which one could return in the imagination, and perhaps one day in reality – like the mythical golden summer of 1914. Far from it: wartime Britain had its share of 'escapist' films and novels, but they were mostly set in the distant and romantic past, not in the world which had so recently gone.[1] Few saw fit to romanticise the 1930s – not even those, like Evelyn Waugh, who suspected that they were better than what was to come. Perhaps the nearest we get to a cosily conservative view of the interwar period is Noël Coward and David Lean's saga of lower-middle-class life *This Happy Breed*. But even this film had to distance itself from the events of the Thirties, from unemployment and from ap-

peasement, by showing its essentially Conservative protagonists' discontent with the Baldwin and Chamberlain governments. The Thirties could not escape their guilt. Even before people had formulated any clear ideas of what kind of war this was or how it might end, they were picking over the ruins of the previous decade in search of its causes and meaning. Before too long, this general revulsion against the Thirties turned into one of the key ideological themes of the War: that the nation was fighting not just for King and Country, or even to repel Hitler, but to build a better life than the Thirties had offered.

The imaginary narrative of the First World War had been one of paradise lost and regained: a way of life threatened and then retrieved by sacrifice and victory. The wartime interpellation of the people as patriotic subjects doing their duty ('King and Country', 'Kitchener Needs You', 'What Did You Do in the Great War, Daddy?') did not allow into the mainstream of public discourse any critical perspective on the nature of the war or of the country being fought for. This narrative therefore suppressed vital issues: the fundamental prewar conflicts over class (strikes), gender (women's suffrage), the nation (Ireland), the constitution (the House of Lords); Britain's changing (i.e. declining) role in the world, to which the war was central; the whole question of war aims and postwar reconstruction. In accordance with this narrative and its systematic absences, the Twenties were a period of unresolved conflicts and futile and damaging attempts to return to the world of 1914.

Partly as a result of interwar experience, the dominant narrative of this war was to be different. Immediate prewar history was not idealised: instead, a critical reading of the Thirties prevailed, dominated by two themes. Most prominent, in view of the circumstances, was Appeasement, and prewar governments' failure either to stop Hitler or to adequately prepare for fighting him, which was extended into a general critique of the prewar ruling class. Beneath this was a second theme, also a story of failure – the Slump, and its attendant mass unemployment, poverty, and inequality. These failures were not accidents or mistakes, but moral failures, and failures of the system rather than of weak or incompetent individuals. The Thirties were thus set up to become the first act in a three-act drama. First act: shame, failure and betrayal while the people sleep; second act: danger rouses the people, and their sacrifice and moral courage redeems the national shame (and, incidentally, saves the

nation); finale: everyone marches together into the sunlit uplands of
a better life for all. As in any well-made narrative, each act draws
its meaning from its relation to the others. This is an optimistic nar-
rative, so it needs a negative starting point: the 'devil's decade',
which sharpens the positive prospect of postwar reconstruction;
both together give meaning, practical and moral, to the sacrifices of
wartime. The war is above all a drama of national redemption: the
Thirties stand for everything about the nation that needs to be re-
deemed, and the hero who rises to the occasion is not some charis-
matic national leader – not even Churchill – but the People
themselves. On this reading, it was to be a 'People's War'.[2]

Where did this narrative come from? It undoubtedly owed a lot
to popular memory of the First World War and the years in
between. From at least the late 1920s, that war had been widely un-
derstood as a squalid and unnecessary crime, which partly ac-
counted for reluctance to go to war again during the Thirties. The
postwar betrayal of those who had fought, returning to mass unem-
ployment instead of a land fit for heroes, was particularly noted.
People could well remember, without having to be reminded, that
Thirties politicians had failed either to prevent war or adequately to
prepare for it – something which seems to have been acutely felt
after Dunkirk.

At the same time, the 'People's War' idea was not simply a spon-
taneous response to historical events. Popular memory certainly
taught its lessons, but popular memory is never untouched by the
context of its production or the surrounding political and ideologi-
cal discourses. Should those lessons start to fade, there was no
shortage of publicists and politicians to revive them. Indeed, the
idea of a 'People's War', fought on the basis of equality of sacrifice
and a better life afterwards, could be seen as a deliberate attempt to
build a popular platform from which the war could be won. Even
so, it was not universally approved of by those in power: the gov-
ernment tried to discourage debate about postwar reconstruction
until it proved impossible to do so, and critical voices such as J. B.
Priestley and the *Daily Mirror* were so resented by Churchill and
other Conservatives that efforts were made to silence them:
Priestley's 1941 series of broadcast Postscripts was probably term-
inated on ministerial instructions.[3] Rather than seeing the 'People's
War' as either a myth imposed from above, or a spontaneous
upsurge from below, we should perhaps see it as a product of
conflict and interchange between all those seeking not just to win

the war but to define what it meant and what the postwar world should be like. The success of the 'People's War' in answering these questions marked the new ascendancy of the Left after their relative powerlessness in the Thirties.

THE VIEW FROM 1940: TWO EARLY HISTORIES

Months before the first shoots of the 'People's War' idea began to appear, two books written at top speed at the start of the war began in earnest the work of demolishing the reputation of the previous decade: *The Long Week-End*, by the poet Robert Graves and his co-author Alan Hodge (who was later to become the co-founder of the magazine *History Today*), described as 'A Social History of Great Britain 1918–1939'; and Malcolm Muggeridge's idiosyncratic and deeply pessimistic account *The Thirties*.[4] Both books, interestingly, have been reissued several times since the war. Muggeridge finished his book in December 1939, sitting on his bed in a barrack hut near Aldershot, 'a pseudo warrior in a still pseudo-war', wondering 'whether it was worth while bothering to complete a manuscript which was bound never to be published, and which in any case would almost certainly be destroyed in the holocaust from the air'. Graves and Hodge began work on *The Long Week-End* in March 1940, and completed it at the time of Dunkirk, 'when there was a grave risk that German might soon be spoken in Whitehall'.[5]

Both books were products of the 'phoney war', when nothing much was happening, but the very worst was expected. Both are pessimistic in their account of the Thirties. Muggeridge's book is written in a style familiar to readers of his later works: detached, apocalyptic, sardonic – pitilessly exposing from some lofty vantage-point the ludicrous pretensions of the human race, as they act out the tragi-comedy of their inevitable doom. Powerful and pompous institutions are exposed as empty charades; great events are reduced to farce by being juxtaposed with newspaper trivia; great men are made ludicrous by their own portentous words which later events have rendered absurd. Parliament, collective security, the League of Nations, the Peace Ballot, world conferences on disarmament or economic policy, appeasement, even peace itself – all are so many self-deceiving charades, informed by the great materialist illusion of liberalism, 'progress without tears'. Political leaders are not evil but weak and ridiculous – especially Ramsay MacDonald,

Muggeridge's great comic creation, and the deceitful, but widely trusted Stanley Baldwin. But these leaders merely reflected the character of those whom they led, a populace deceived into materialistic egotism by their loss of faith in higher values, dulled and confused by the messages of the mass media, futilely seeking consolation for the emptiness of their lives in the search for material goods, for useless knowledge, for the illusion of freedom and self-expression. As the decade wears on, as one institution after another is exposed as a hollow shell, apathy and inanition grips the nation, and it supinely awaits its inevitable fate at the hands of its enemies. '*Reductio ad absurdum*, more plausibly than dialectical materialism, may be taken as the principle which provides a key to human affairs.'[6]

Aside from its satirical use of newspaper trivia, *The Thirties* makes foreign and parliamentary politics its main concern, and hardly mentions the Slump, hunger marches or depressed areas, or indeed any aspects of economic and social policy, except occasionally to mock its materialist liberal pretensions. It is essentially a critique of failed leadership, seen as the expression of the deeper moral failings of the nation: the dictators could not be resisted because a nation which believed only in material values had no moral basis for such resistance, no faith, no ideals, to equal the false and fanatical ideals of Nazism. When Chamberlain confronted Hitler in the last act of the prewar farce it was not Good against Evil, but Mammon against Mars, 'expired and upsurging force meeting, like two well-buckets, one on its way down to be filled, one on its way up to be emptied'.[7] It is impossible to imagine Muggeridge discussing 'war aims' or 'postwar reconstruction' in anything but the most bitterly satirical tone. Nor did he anticipate any such reconstruction, when soon afterwards he walked the streets of blitzed London in company with Graham Greene, hailing 'the last bonfire of the last remains of our derelict civilisation'. As his 'Introduction' to the 1967 paperback reissue makes clear, total destruction was his preferred option, and the eventual survival of the system was if anything to be deplored.[8]

All this, of course, is the Muggeridgeian view of the world, which could be, and was, applied to almost any age and place. Its historical interpretation rests on a vague and grandiose 'master narrative' of western decline, seeing all events as simply reflections of this narrative, and disdaining any analysis of specific problems and conflicts. It is a deeply idealist account, in which every event

and action is little more than an expression of the underlying *zeit-geist*. Yet, whatever its faults as a history of the Thirties, it seems to catch the moment of despair which gripped so many intellectuals at the decade's end. In some ways, *The Thirties* is a less angry, yet more satirical and more pessimistic version of Auden's poem '1st September 1939', which deploys similar themes: the windy dishonesty of leaders, the narcotic euphoria of everyday life and the self-deceiving egotism which lies at its heart, the supine, defenceless world awaiting its destruction. What is missing from Muggeridge, however, is Auden's 'affirming flame', the tenuous network of those who wish to resist the 'negation and despair' of the moment.

George Orwell, reviewing *The Thirties* on its publication in April 1940, approved its damning of 'an age when every *positive* attitude has turned out a failure ... a riot of appalling folly that suddenly becomes a nightmare, a scenic railway ending in a torture-chamber'.[9] At about the same time, in a review of *Mein Kampf*, Orwell echoed Muggeridge's account of the moral weakness behind appeasement: socialism and capitalism, he argues, have said to people 'I offer you a good time', but 'Hitler has said to them "I offer you struggle, danger and death", and as a result a whole nation flings itself at his feet'.[10] Nevertheless, for Orwell and others like him, the early despair led on to more positive analysis as the war seemed to open up the possibility of radical change and moral renewal. For Muggeridge, on paper at any rate, the 'negation and despair' seemed to be all he craved.

The tone of *The Long Week-End* is markedly different, but beneath the surface its verdict on the 1930s is not dissimilar – as its title suggests, with its implications of idleness, triviality, time taken out from history. This is a work of popular history which covers the whole interwar period, interspersing a narrative of public affairs with observations on fashion, leisure, everyday life and sensational news stories. While Muggeridge draws on everyday trivia as a support for his analysis, illustrating the depths into which western culture was being drawn, in *The Long Week End* such details do not often connect up with the major narrative, but rather provide a sense of period, and presumably a frisson of recognition for those who lived through them. Typical of this style is Chapter 16, entitled 'Pacifism, Nudism, Hiking'.[11] A fairly straightforward eight-page account of the failure of disarmament in the early 1930s leads naturally to the topic of pacifism, which, we learn, 'had been introduced from Germany at the time of the Weimar Republic ... so had three

other libertarian fashions – sun-bathing, nudism and hiking', and in
no time at all we are in the nudist camp, hiking on the moors, dis-
cussing what hikers wore, what people wore on cruises, and finally
the vagaries of fashion in dress, hair, jewellery and hats. The links
between these things are purely associative, and nothing is really
explained, not even the fashions.

The subtitle of Graves and Hodge's book is 'A Social History of
Great Britain 1918–39', and this is what 'social history' meant, and
perhaps still means, to a large part of the popular historical audi-
ence: the kind of thing scornfully dismissed by serious historians as
'scrapbook history', in which 'profound historical developments
and epiphenomenal trivia jostle together like cards in an unshuffled
pack'.[12] Instead of getting beneath the surface of events, this history
replicates the experience of living through them, opening the *Daily
Mail* over breakfast every morning and scanning its miscellany of
daily doings, from Hitler's speech to the latest thing in hats. In
daily life, of course, the profound and the ephemeral do indeed
jostle together like this, which is why books like *The Long Week-End*
appeal to their readers. An important component of popular
memory is supplied by this sense of 'how it was' – how people
dressed and talked, what kind of things they got up to in their
spare time – which links common everyday experience – 'private
memory', whether first- or second-hand – to a broader and deeper
sense of the changing patterns of social structure and relationships.
If the only way everyday life could be dealt with in 1940 was as a
collection of ephemeral trivia, it was because only the public doings
of powerful men – the narrative of high politics and diplomacy –
were regarded as historically serious. This ideological structuring
of the field of historical knowledge presented a major barrier to
popular understanding; books like *The Long Week-End* merely filled
the gap which was left.

Nevertheless, at the level of public events, *The Long Week-End*
does present a coherent and critical account of the Thirties, written
like Muggeridge's, as the decade was approaching its dramatic
climax. The correspondence between Graves and Hodge while
the book was being written intersperses reports on the progress of
the manuscript with an increasingly gloomy commentary on the
progress of the war, which as events unfold are reflected in the
book's view of the preceding decade.[13]

The overall thesis of the book is a leftish one, critical like
Muggeridge's, but eschewing his nihilism. It tells how the social

revolution promised in the 1920s by the 'revolutionary but apathetic Fighting Forces' was side-tracked by 'The Rest ... the schemers in the Law and Order interest' (Graves to Hodge, 15 May 1940).[14] The Twenties are presented as a decade of hope, of progress, of experimentation, which by the 1930s had sunk into apathy, caution and conservatism, culminating in the failure of both leaders and led to face up to the realities of the world situation. Ramsay MacDonald's vagueness and confusion was matched by Baldwin's stolidity: 'the National Government had been a stroke of political genius – a concentration of all that was lovably stupid of all three parties into a bloc, around the nucleus of the Stupid Party', leaving all 'highly gifted politicians' (Churchill, Lloyd George) in the wilderness. But 'that something was wrong somewhere, whether in the City or Westminster, seemed obvious'. 'The many new light industries that had successfully grown up did not compensate for all the distress caused by the breakdown of the nineteenth-century system. Everyone was aware that the world was changing, and that Britain had to change too. All sorts of plans were produced by every kind of theorist.' But all the plans, polls, surveys and nostrums were too scattered and too small-scale to exercise any influence. Anyway, the climate of opinion was against radical change, and even in matters of fashion, 'the experiments made in the Twenties had long since been abandoned'.[15]

A characteristic of the Thirties in England was an attempt to be reasonable about the confusion into which the new theories of physics, astronomy, sex and economics had plunged thinking people. Things were, it had proved, effectively the same as ever: foot-rules still measured accurately, the stars still twinkled mildly, the Wedding March still pealed out at church weddings.... Neo-Victorianism was a brave new facade to a house whose foundations had been shaken by heavy mechanized traffic. Inside there was a general consensus of opinion: never to do what the Russians had done and the Germans and Italians were doing – pull the house down and build up from new foundations – but to continue patching and rivetting and bracing so long as it would stand. The country was still sound at heart....[16]

The cautious facade concealed a suppressed need for democratisation, for 'government by the people', not 'by representatives of particular interests', a policy based on what people needed and what they thought, 'a closer integration of community needs and

feelings [which] would make class war unnecessary and even impossible'.[17] But even war, it seemed, might not bring this about. On 3 September 1939,

> the country was still sound at heart, the staunch Conservatives felt, as they hurried on, a few minutes late, to Sunday service; and the social revolution, so long averted, would now be made altogether impossible... The Left did not know what to feel or where to go.[18]

Both *The Thirties* and *The Long Week-End*, then, present a pessimistic view of the decade which had just finished, and one which in the end leaves no obvious way in which its failures can be redeemed. As we have noted, this pessimism was far from inevitable, and perhaps some readers would have preferred to see the lost but still familiar past – public figures, events, styles and crazes, 'what it was like' – as a platform for nostalgia rather than for all this gloom and doom. Neither author seems in the least doubt, though, that a critical view of the Thirties is what is called for, which says something about the public mood of 1940. Neither, however, envisages this critical mood turning towards any kind of constructive political response.

PATRIOTISM, WAR AND REVOLUTION: GEORGE ORWELL

'Only revolution can save England, that has been obvious for years', declared George Orwell in an essay published in Autumn 1940, 'but now the revolution has started'.[19] Orwell, like Muggeridge and Graves/Hodge, saw in the 1930s a decade of failure, culminating in the disasters of 1940, which exposed the malaise at the heart of British society. But for Orwell, the war provided the opportunity – indeed, the urgent necessity – of radical change, even revolution, to put things right. The left was starting to work out 'what to feel and where to go'.

The Lion and the Unicorn, written in the Autumn of 1940, is an attempt to reconcile, in wartime conditions, patriotism and an attachment to Englishness with socialism and the need for revolutionary change. England is portrayed as a gentle, tolerant and anti-authoritarian civilisation. However, it was badly run and the wrong people were in charge: 'the most class-ridden country under the sun'. Prewar experience showed that private capitalism had

failed; the war was demonstrating that planning and common effort was possible. Only socialism could win the war, so the war provided the opportunity for a radically different society. English socialism would still be English, its necessary firmness moderated by tolerance and eccentricity, and it would still bear 'the unmistakable marks of our own civilisation'; but private capitalism and the class system, both of which have proved oppressive and ineffectual, would have to go.

Because of its idiosyncrasies, and because of the obsessive attention posterity has paid to Orwell as a writer, *The Lion and the Unicorn* can easily be read merely as a stage in Orwell's personal development, a drift from socialist internationalism into patriotic Englishness. Indeed, to a later generation, grappling with racism and accustomed to problematising all notions of national identity, Orwell's somewhat cosy conception of Englishness does seem rather suspect. But he is not simply asserting that socialists should be patriotic: rather more significant in the context of the moment in which he is writing is the idea that patriots should be socialist – that socialism and revolutionary change belong in the mainstream of British life, not on its fringes, where they had spent the Thirties. *The Lion and the Unicorn* is a product of a public as well as a private moment – the 'revolutionary moment' of Summer 1940, when 'after twenty years of being fed on sugar and water the nation had suddenly realised what its rulers were like, and there was widespread readiness for sweeping economic and social changes'.[20] At such a moment, to be revolutionary was to be patriotic, because revolution could be the only way to win the war: it was the 'old guard', the last survivors of Chamberlain's 1930s, clinging to the old system, whose patriotism was impugned. In this context, Orwell seeks to recapture patriotism from the 'old guard', and restore it to its radical origins; he seeks to redefine English identity to include socialist values of collectivism and co-operation, which the Thirties had marginalised.[21] Orwell thus in some ways prefigures the postwar settlement of 1945, though this achieved neither the classlessness nor the abolition of capitalism which he foresaw in 1940.

Orwell's argument for revolution is founded on a reading of history, a narrative of national – and, particularly, upper-class – decay stretching back to the mid-Victorian era, and reaching its bathetic climax in the 1930s. This ruling class, Orwell argues, once had real functions in life: it owned and controlled productive resources, it formed governments, it ran the Empire. Now, it merely

drew dividends and spent them, while salaried professionals ran
the businesses, and bureaucrats ran the Empire. As a result of this,
by the 1930s,

> the ruling class decayed, lost its ability, its daring, finally even
> its ruthlessness, until a time came when even stuffed shirts like
> Eden or Halifax could stand out as men of exceptional talent. As
> for Baldwin, one could not even dignify him with the name of
> stuffed shirt. He was simply a hole in the air. The mishandling of
> England's domestic problems during the nineteen-twenties had
> been bad enough, but British foreign policy between 1931 and
> 1939 is one of the wonders of the world.[22]

Now, Orwell argues, pressure for socialist change must come
from the people: 'It is time for *the people* to define their war aims.'[23]
But who are 'the people'? It is central to Orwell's argument that
the social structure of the nation has been changing in important
ways during the interwar period. This change he sums up as 'the
upward and downward extension of the middle class ... [which]
has happened on such a scale as to make the old classification of
society into capitalists, proletarians and petit bourgeois (small
property-owners) almost obsolete'. Increased prosperity, though
uneven, has led to 'the spread of middle-class ideas and habits
among the working class', until 'the old-style "proletarian" –
collarless, unshaven and with muscles warped by heavy labour –
... is constantly diminishing in numbers; he only predominates in
the heavy-industry areas of the North of England'. The emergence
of large-scale industry has led to the expansion of administrative,
technical and professional occupations – 'people of indeterminate
social class', increasingly found in the new light-industry areas in
the South-East and around the great towns, living in a new civil-
isation centring round 'tinned food, *Picture Post*, the radio and the
internal combustion engine'.

> To that civilization belong the people who are most at home in
> and most definitely *of* the modern world, the technicians and the
> higher-paid skilled workers, the airmen and their mechanics, the
> radio experts, film producers, popular journalists and industrial
> chemists. They are the indeterminate stratum at which the older
> class distinctions are beginning to break down.

> These are the people who, above all, are going to demand the
> wiping out of existing class privilege, who will learn the unanswer-

able, and thoroughly patriotic, lesson of the war: 'that private capi-
talism ... *does not work*. It cannot deliver the goods'.[24]

Orwell's vision of the future was thus based on a historical narra-
tive in which his perception of Britain in the Thirties played a
central part. It was in the Thirties that the failures of economic and
foreign policy displayed for all to see the long-term decay of the
ruling class. But it was also in the Thirties that new social groups
arose who would form the nucleus of the new socialist Britain: a
Britain that could only come into being from below, from 'the
people':

> The heirs of Nelson and of Cromwell are not in the House of
> Lords. They are in the fields and the streets, in the factories and the
> armed forces, in the four-ale bar and the suburban back garden;
> and at present they are still kept under by a generation of ghosts.[25]

THE 'PEOPLE'S WAR': PRIESTLEY, THE THIRTIES AND THE POLITICS OF RECONSTRUCTION

This war, unlike 1914–18, was not a war of traditional patriotism,
fought for King and Country. No cheering crowds, no eager antici-
pation of military glory, greeted its outbreak: rather, a dull accep-
tance of the inevitable. While there was little substantial resistance
to the war, there was little enthusiasm either. The full-hearted
consent of the British people to the sacrifices that the war effort de-
manded had still to be won. This could only happen if the war was
seen to be properly conducted. But it also required ideological
work: the war had to be seen not just as a grim necessity, but as a
crucial and inspiring component of the character and history of the
nation itself, through which individuals could find their place and
give meaning to their sacrifices.

No Ministry of Information propaganda campaign could invent
out of nothing such a sense of identity and purpose. It had to arise
from the existing culture and its richly varied discourses, ranging
from politicians' speeches, through journalism, broadcasting and
the popular press, to novels, films, stage and radio entertainment
and the ordinary exchanges of everyday life. There was in wartime
an immense appetite for all these discourses. Partly, this was motiv-
ated by a desire to 'escape', to experience something that had no
connection whatever with the war, but it was also inspired by a

need to make sense of what was happening. It was through all these variegated public and private discourses that the dominant 'myths' of wartime emerged, and in the formation of those myths, the first posthumous impressions of the 1930s played a central part.

In essence, as time went on there took shape two versions of what the war meant and how and why it was being fought, and each was important in mobilising the support of the population. Both were formed early in the war, and both persisted into the postwar era as powerful, and to some extent rival, national myths: 'myths', not because they were necessarily untrue, but because their main significance was how they were used in the present, rather than their truth to past reality.

The 'Churchillian' myth portrayed a nation united under its great leader, Winston Churchill. It evoked a thousand years of unbroken history, a national mythology of the Island Race, standing alone against foreign enemies (the Spanish Armada, Napoleon), slow to rouse but proud and heroic in the defence of its native soil, now summoned to face its finest hour, and ready for any sacrifice in the defence of its freedom. This version of the war, with its appeal to history and to patriotism, is heard in Churchill's wartime oratory – as much in its high-flown tone and language as in what it actually says:

> Upon this battle depends the survival of Christian civilisation. Upon it depends our own British life and the long continuity of our institutions and our Empire.... Let us therefore brace ourselves to our duty, and so bear ourselves that if the British Empire and its Commonwealth last for a thousand years, men will still say, '*this* was their finest hour'.[26]

Note the emphasis on timeless unities (Christian civilisation, British life), on history, continuity, duty, the Empire: all delivered in the cadences of a Shakespearian actor, or, perhaps, an Anglican bishop. Note too the lack of any reference to recent history, or to the personal experience of the audience.

The other myth was populist and democratic: the 'People's War'. The war was being fought, not for patriotic duty or past glories, but by and for the common people of England, 'the kindly, decent, patient folk of this country', as J. B. Priestley put it, who deserve so much better than they have had, and for whom 'a nobler framework of life must be constructed' after they had made the sacrifices that war demands.[27] Central to the 'People's War' myth is the need

for equality of sacrifice, and the conviction that things must be made better after the war. Its characteristic voice is the intimate, demotic Yorkshire intonation of Priestley's BBC *Postscript* broadcasts during 1940 and 1941. As he put it in the 'Preface' to the published edition of these broadcasts,

> What really holds the attention of most decent folk is a genuine sharing of feelings and views on the part of the broadcaster... Thus it is useless handing out to most of them a lot of dope left over from the last war. They may not understand this present war, but unlike many official persons, they do know that it is not the last war, that a simple, almost idiotic nationalism will not do, that either we are fighting to bring a better world into existence or we are merely assisting at the destruction of such civilisation as we possess.[28]

The two myths clashed, but were not mutually exclusive: both myths had their part to play in the ideological war effort, and most people probably subscribed to elements of both at one time or another. Each rested on a particular conception of 'Englishness'. The Churchillian version proclaimed the heroism and resolution of the people; while the People's War celebrated their kindliness, tolerance and good sense. Each, also, drew on a particular construction of national history. While the Churchillian myth evoked a long and glorious Island Story, the People's War rested on a more recent, and contentious, narrative which rejected much of that history: the suffering and inequalities of the industrial revolution, which culminated in the mass unemployment of the Thirties; and the greed, decadence and betrayal of the nation's leaders, which led to appeasement and the failure to prepare adequately for war. Thus, while the Churchillian narrative is hardly a narrative at all – rather, a single, continuous state of national being, punctuated by dramatic incidents illustrating what is always-already true about the British Nation – the People's War offered a shorter, more urgent narrative of past, present and future, focusing crucially on the Thirties, and looking to postwar reconstruction for its resolution. Whenever memories of the Thirties, rather than the misty distances of Our Island History, dominated the public mind, thought of postwar reconstruction, with all its radical potential, was never far behind.

We can see from this somewhat simplified typology that it would be the left rather than the Conservatives who would want to

discuss the 1930s during the war. But the rhetoric of politicians and publicists, raking over the embers of the Thirties, and urging people to seek a better life afterwards, worked on something which was already there: a general gut-reaction against the Thirties which developed in the light of the experience of war. This reaction may be encapsulated in three phrases: 'Guilty Men', 'the lessons of war', and 'Never Again!'

Guilty Men was the title of a pamphlet written by three left-wing Beaverbrook journalists, Michael Foot, Frank Owen and Peter Howard, published in early July 1940 in the aftermath of Dunkirk, and selling over 200 000 copies despite being blacklisted by the major distributors.[29] In brilliant satirical mode, it accused those in power during the 1930s, some of whom were still in the new coalition government, of having caused the disasters of 1940 by appeasement and failure to re-arm. It caught a general, post-Dunkirk, public mood of vituperation against Chamberlain, Baldwin and their allies: opinion polls showed that a large majority of people wanted Chamberlain sacked from the coalition government, a view shared by many Conservatives.[30] While the remaining appeasers – 'the old loitering gang' as the *Daily Mirror* called them – were in due course eased out of the government, hostility to those who had held power in the Thirties continued unabated, and broadened out to embrace the ruling class in general, and all that Old Guard encapsulated by David Low's prewar invention 'Colonel Blimp'. 'In the ascendent demonology of the war period,' Paul Addison has said, 'the upper classes were usually to blame because they were rich, because they were obsolete in their ideas, or because they were both.'[31]

As has often been pointed out, Labour leaders could equally well have been damned for opposing rearmament in the Thirties. But this is beside the point, which was the relationship between the decadence of the ruling class – 'neither aristocratic nor democratic, but… an uneasy, posturing plutocracy', as J. B. Priestley put it – and their moral failure to stand up to Hitler, or even in some cases, to resist his attractions.[32] This critique is well summed-up in a savage passage written by Orwell in 1943:

When one thinks of the lies and betrayals of those years, the cynical abandonment of one ally after another, the imbecile optimism of the Tory press, the flat refusal to believe that the dictators meant war, even when they shouted it from the housetops,

the inability of the moneyed class to see anything wrong what-
ever in concentration camps, ghettoes, massacres and undeclared
wars, one is driven to feel that moral decadence played its part as
well as mere stupidity. By 1937 or thereabouts it was not possible
to be in doubt about the nature of the Fascist régimes. But the
lords of property had decided that Fascism was on their side, and
they were willing to swallow the most stinking evils so long as
their property remained secure.[33]

A succession of yellow-jacketed pamphlets produced during the
war years under the imprint of Victor Gollancz continued the
assault: notably *Your MP* (by Tom Wintringham) and *The Trial of
Mussolini* (by Michael Foot), both published in 1944, and both
drawing with devastating polemical effect on the prewar words
and actions of prominent Conservatives.[34] If England was a family,
the experience of the Thirties sustained Orwell's accusation that the
wrong members were in charge, and persuaded people that the
management should be changed.

The experience of war taught other political lessons, about the
potential scope and uses of state power. After a decade of mass un-
employment, which governments had professed themselves pow-
erless to cure, the state now seemed able to do more or less
anything it wanted to in order to win the war. It took massive
powers over both people and property, shifting resources towards
the production of bombs, guns, tanks, ships, aircraft, conscripting
people into the armed forces and industrial work, setting their
wages, hours and conditions, rationing the consumption of scarce
commodities. Prewar governments had spurned talk of economic
planning as the vapouring of crackpots, and insisted on the need
for balanced budgets, defending against violent opposition dole
cuts which would scarcely have paid for a single day of the war
effort. Quite early in the war, people came to see what government
could do to manage the economy and society when the will was
there, and applied the lesson retrospectively to the years of the
Slump. Even before Dunkirk, J. B. Priestley was asking why we
could not 'learn to plan and spend in peacetime as we do in
wartime' – to get rid of the depressed areas, to clear the nineteenth-
century slums.[35] Through wartime experience, the problems of the
Thirties came to be seen as essentially soluble, and Thirties govern-
ments were condemned with increasing fervour for lacking the will
to solve them.

Further, the war was seen, ironically perhaps, to have a positive and egalitarian impact on welfare. Rationing improved consumption patterns for many of the poor. By 1943, some 2.9 million new jobs had been created, many in hitherto depressed industries such as coalmining and shipbuilding. Wage-packets, swollen by overtime, expanded steadily, while incomes from property and salaries were falling. Universal conscription, rationing and taxation – excess profits tax, introduced at 60 per cent, was raised to 100 per cent in the week of Dunkirk – proclaimed equality of sacrifice as the principle of wartime life.[36] Even the BBC shifted away from Reith's paternalist mission to a more democratic agenda, seeking new popular styles for both entertainment and serious programmes.[37] If all these things could be done in wartime, what did this say about the failures of peacetime – and the possibilities of postwar reconstruction?

Troops embarking for D-Day in 1944 asked Ernest Bevin, Trade Union leader and all-powerful Minister of Labour, 'Ernie, when we have done this job for you are we going back on the dole?' Bevin replied, of course, 'No, you are not!'.[38] What is significant about the exchange is not so much Bevin's answer, as the fact that the question was worth asking. In what other war had men enquired about the prospects for postwar employment before going out to fight? Yet by 1944, the question and its answer had the air of a ritual. 'Never Again' – meaning no return to the unemployment and insecurity of the Thirties – had already become the watchword which was to lead the nation out of the war and into the period of reform and reconstruction which followed. It is a slogan about history, about the links between past, present and future. It drew, not only on the remembered experience of the Thirties, but also on the way the meaning of those years was interpreted in the circumstances of wartime.

It is not necessary here to go into the details of the prolonged wartime debate on reconstruction – a debate which the government frequently resented, tried to stifle, but eventually had to accept as a key component of the war effort.[39] It began as a vague urging that the war should be about making things better afterwards: Priestley in his 1940 BBC *Postscripts* frequently referred to 'the breakdown of one vast system, and the building up of another and better one' (21 July), or 'raising at last the quality of our life' (11 August), or marching forward 'not merely to recover what has been lost, but to something better than we've ever known before' (14 July). He had also referred trenchantly to the way returning servicemen were let

down after 1918: 'We did nothing,' he declared, 'except let them take their chance in a world in which every gangster and trickster and stupid insensitive fool or rogue was let loose to do his damnedest' (28 July).[40]

As time went by, the debate, and the proposals arising out of it, became more specific, and the left and centre made the running: 'Colonel Blimp being pursued through a land of Penguin Specials by an abrasive meritocrat, a progressive churchman, and J. B. Priestley', as Paul Addison puts it. The '1941 Committee' including all three categories and chaired by Priestley, put out a nine-point plan for reconstruction, and started contesting by-elections, with some success. In 1942 it merged into a new political party, Common Wealth, whose collectivist socialism also achieved popular support, and won a series of by-elections. But the main landmark in the reconstruction debate was the publication of the Beveridge report at the end of 1942, foreshadowing the postwar extension of the Welfare State. Greeted with misgivings by the government, the Report received 86 per cent approval from the public, sold 635 000 copies, and became the most potent symbol of the desire that the postwar world should be different from the prewar. By-election results and early opinion polls confirmed that this was, and remained, the prevailing popular feeling since even before the Beveridge Report was published.[41]

Whether 'war radicalism' resulted from an upsurge from below or the conversion of an elite is not worth debating. It is clear that both elements were important. The war necessitated the entry into state service of people who had been excluded in the Thirties: not just the political left, but technicians, meritocrats and intellectuals: in Priestley's words,

> youngish technical men of the so-called middle classes, men rarely given final authority, and men already feeling restless and dissatisfied because they were hampered by the incompetence, pedantry, lack of drive of the superior persons from whom they were often compelled to take orders.[42]

At a higher level, the embattled band which represented Thirties 'middle opinion', the supporters of economic planning, came into its own, increasingly dominating not just policy-making but the terms of public political discourse.[43]

But reconstruction talk was not just the effect of 'new men' coming to the fore. It was also a product of the terms on which

popular support for the war had been won. The dominant narrative of the war, as we have seen, depended on a repudiation of the 1930s, and therefore slammed the door on any return to the *status quo ante*. If Churchill spoke for England's timeless glory, the supreme articulator of the 'People's War' narrative was J. B. Priestley – in his radio *Postscripts*, broadcast after the Sunday Nine O' Clock News in 1940–41, in his incarnation as a political figure in the 1941 Committee and Common Wealth, and in his prolific output as journalist, novelist, playwright and screenwriter.

Though the two writers are rarely spoken of in the same breath, and scarcely referred to each other except in passing, Priestley's excoriation of the 1930s, his version of national character, and his views on the conduct of the war and postwar reconstruction, are very close to Orwell's. In these respects, it could be argued, both represent the emerging wartime centre-left consensus. However, Priestley got there first: his critique of prewar British society in *Out of the People* is foreshadowed in some detail – not just the ideas but even the phraseology – in his autobiographical *Rain upon Godshill*, published in 1939 and written when Orwell was still laying plans for underground resistance against a war he believed could only lead to fascism.[44] While Orwell seems to have experienced the early days of the war as a transforming revelation, for Priestley, they confirmed and sharpened the radical populism which he had been developing throughout the Thirties. Moreover, it is Priestley who makes the more convincing champion of 'the ordinary English people', whom Orwell is, one feels, observing from a distance; and, by virtue of his populist style, Priestley is the more convincing public figure. As Graham Greene, who hated Priestley's novels, said at the time, Priestley 'became in the months after Dunkirk a leader second only in importance to Mr Churchill. And he gave us what our other leaders have always failed to give us – an ideology.'[45]

This ideology can accurately be described as a populist one: it took the side of 'the people' against the ruling classes, against the powers that be, against the state – except in so far as the state serves the interests of the people. It was the ruling classes who had got us into the war, but 'the people' – 'the ordinary British folk...whose courage, patience and humour stand like a rock above the dark morass of treachery, cowardice and panic' – who would win it. (*Postscript*, 1 September).[46] Priestley's intimate, Yorkshire tones, contrasting with the BBC's usual officer-class received pronunci-

ation, left no doubt that he too was of the people. He alone of the writers discussed in this chapter could speak of 'you and I – all of us ordinary people' (*Postscript*, 30 June) without inviting derision.[47]

But in order to praise 'the people', we have first to invent them. Precisely because the category seems so transparent, 'the people' is the most slippery of all collectivities. Who are Priestley's 'people'? Certainly not the nation, which exists only to serve their best interests: 'Britain is the home of the British people... Before it is anything else, this country is their home'.[48] Certainly not the working class: the people are not 'members of "classes"... [or] powerful group interests', but 'individuals, here there and everywhere'. In fact, 'We are all the people so long as we are willing to consider ourselves the people' – that is, not as anything 'better'.[49] Classes – meaning, primarily, ruling classes – have been responsible for the failures and betrayals of the past: now it is the turn of democracy, the people, 'free men and women freely co-operating', who will 'lay down the foundations of our new society'.[50] The war has revealed their 'deeply hidden reserves of endurance, patience, courage and goodwill'; now the need is to tap their 'deep reservoirs of creative energy' to construct a new social order.[51] In 'the people', then, Priestley seeks to conjure up a unity based on nothing more than that we are ordinary human beings who live in the same place: but ordinary people, like the 'little ships' he celebrated in his famous Dunkirk *Postscript*, have the capacity for glory, if they are allowed to rise to the occasion and work together.

From his populist democratic standpoint, Priestley unequivocally damns prewar England, and especially its ruling class for failing to do this:

Surely one reason why the twenty years between wars now seem a tragic farce, even here at home, is that during this period we did not change our values but merely cheapened them. It will be remembered as the era of nightclub-haunting princes and gossip-writing peers. The masquerade still went on, though now the costumes were tattered and the masks rotting... No visitor to Britain, seeing the ruined cotton mills and rotting shipyards of the North, the jerry-built bungalows and gimcrack factories of the South, exclaimed in wonder, as men had done once, at the virility, splendour and potent magic of our island life. How much was there here worth preserving?... The nation's mind was else-

where, withdrawn, more than half asleep, charmed and lulled by politicians with a good bedside manner.[52]

The Thirties was a fraudulent period in which the trappings of a traditional ruling class concealed an increasingly centralised power-structure based on mere wealth, and an 'inner ring' of big business, high finance and Tory politics.[53] But it was not the fake England which was fighting the war. 'the England the films are so fond of showing us: the old Hall, the hunt breakfast, the hunt ball, the villagers touching their caps, all the old bag of tricks.' This England could not last a couple of days. 'It is industrial England that is fighting this war, just as it was industrial England, those scores of gloomy towns half-buried in thick smoke, with their long dreary streets of little houses, that produced most of the wealth which enabled this other fancy little England to have its fun and games.'[54] Now the war had revealed the truth: the old life is finished. 'Britain, which in the years immediately before this war was rapidly losing such democratic virtues as it possessed, is now being burned and bombed into democracy'.[55] 'The people feel, obscurely for the most part, the need for great changes. They want to have done with their pre-war life. When they said Goodbye to it, they meant Goodbye.'[56]

Goodbye to all that, then, but Hello to – what? Like Orwell, Priestley believes that a society based on 'property and power' is finished, and a new one, based on 'community and creation', must come about – a new order whose feasibility and rationality is shown by the collectivism and common purpose of wartime (*Postscript*, 21 July 1940).[57] Like Orwell, Priestley saw the war as a democratising force, coming in the nick of time to sweep away the corruption and failure of the Thirties and reveal the true strengths of the English people, 'men and women freely co-operating'. But his assertion that a new order could come, simply, 'out of the people', that established interests would either just disappear or voluntarily make way for it, could only carry conviction at a moment when all fixed points had disappeared and the entire future seemed up for grabs. At least Orwell thought it might be necessary to shoot somebody.[58] In the event, the postwar world, despite its many problems, did feel it had improved on the Thirties, and that the experience of war had something to do with it. Even if Priestley's, and Orwell's, vision of English socialism did not come to pass, there is a sense in which they did get the end of the story right.

CONCLUSION: THE PEOPLE'S PEACE?

The world's roughly made up of two kinds of people. You're one sort and I'm the other. I know we're together now there's a war on, we need to be. What's going to happen when it's over? Shall we go on like this or are we going to slide back? That's what I want to know.

Thus the working-class foreman Charlie, refusing to marry upper-class war-worker Jennifer in the 1943 film *Millions Like Us*.[59] What Charlie wants to know is, 'How does the story end?'

It is a commonplace to suggest that each age has its own stories about the past, constructed with its own purposes in mind. But stories about the past are also, as Charlie recognises, stories about the future. In this chapter we have tried to show how images of the Thirties constructed during wartime were active and deliberate interventions in the present, using the past to suggest how the war should be fought, and what should happen afterwards. Indeed, so pervasive was this three-part narrative of past, present and future that it became almost impossible to say anything serious about the conduct of the war without going on to discuss postwar reconstruction, and impossible to discuss either without falling back on some view of the prewar world.

As a result, the images of the Thirties which wartime discourse bequeathed were very much shaped by their place in the narrative which included the war. For the most part, as we have seen, these were negative images: the Thirties were everything that the postwar world should not be. Only a conservative minority – Waugh, Coward – offered the Thirties as a normality to which we should hope to return. These negative images underpinned an ideal populist conception of how the war should be fought: with full participation, equality of sacrifice, and the promise of a better world afterwards. Many hoped that the war would moderate or end the class system, or even do away with capitalism itself: hopes which again were sustained by raking over the problems which class and capitalism had caused in the Thirties. The dominance of these negative views of the Thirties thus both reflected and helped to constitute the ideological ascendancy of the centre-left during the 1940s. Resolving the narrative in a satisfactory way meant taking a radical view of the future. After the publication of the Beveridge Report in December 1942, and the 1944 White Paper on Employment

Policy, which edged towards a Keynesian strategy for full employ-
ment, such a view seemed well on the way to becoming the new
orthodoxy.[60]

Thus, in the General Election of 1945, all parties were committed
to a full employment policy, the extension of the National
Insurance scheme, and a comprehensive health service. However,
each party manifesto justified these policies by a totally different
account of national history. The Conservatives presented a narra-
tive of timeless national greatness, rooted in 'the character, the
ability, the independence of our people and the magic of this won-
derful island', to be passed down, essentially unchanged, from gen-
eration to generation:

> British virtues have been developed under the free institutions
> which our fathers and forefathers struggled through the cen-
> turies to win and to keep. We of this generation are trustees for
> posterity, and the duty lies upon us to hand down to our chil-
> dren unimpaired the unique heritage that was bequeathed to
> us.[61]

The new welfare policies came as an unconvincing coda to this
Churchillian non-narrative of the always-already true: something
is said about allowing individuals to make the best use of their
gifts, but it is clear that the party has difficulty in justifying radical
change to what we have been told is a unique and unimpaired
heritage.

Labour, as befitted the inheritors of the 'People's War' mantle,
presented a version of the nation's history which was more contem-
porary and more abrasive. The story begins in 1918, when 'the
people lost the peace', and 'the "hard-faced men who had done
well out of the war" were able to get the kind of peace that suited
themselves…. And when we say "peace" we mean not only the
Treaty, but the social and economic policy which followed the
fighting'. On to the 1930s, when industry and government failed
the nation, and millions went through unemployment and insecur-
ity. 'It is not enough to sympathise with these victims: we must
develop an acute feeling of national shame – and act.' The second
War, like the first, was won by 'the high resolve of the people', but
this time 'progressive forces' were able to prevent profiteering,
through rationing, Excess Profits Tax, and government controls.
'With these measures the country has come nearer to making "fair
shares" the national rule than ever before in its history.' Now is the

time to ensure that these gains are not lost: 'We need the spirit of Dunkirk and of the Blitz sustained over a period of years.'[62] The narrative logic is clear, and by now familiar: from the shameful Thirties, through the People's War, to the new postwar order. It was a narrative which, as we have seen, was conceived in the days after Dunkirk, honed through the years of war, and now sought its resolution in peacetime. As everyone knows, Labour won the election. Perhaps it was because they had a better story to tell.

6

From the Devil's Decade to the Golden Age: The Postwar Politics of the Thirties

In contrast to the excessive individualism, the 'devil take the hindmost' philosophy of the nineteenth century, there has developed a sense of collective responsibility, of caring for the human family, in some ways more akin to medieval ideals.... The years between the wars saw the decay of the old Liberal doctrine of *laissez faire*. There began to form in the most impartial minds the idea that some form of effective partnership must be found between the State and those involved in production, distribution, and even exchange.

(Harold Macmillan, 1966)[1]

In these terms, with their echoes of Clause Four of the 1918 Labour Party Constitution, Harold Macmillan, former Conservative Prime Minister, summed up the historical basis of the postwar political consensus, still going strong in 1966, with which his name was perhaps more closely associated than any other. Wartime radicalism had given birth, not to the thoroughgoing revolution which commentators such as Orwell and Priestley had predicted, but to a reformed capitalism, built on the foundations laid by the 1945–51 Labour Government, and continued in principle by the Conservative governments of 1951–64. The basis of this system was a mixed economy, in which certain basic industries and services remained state-controlled; a commitment to full employment as a primary aim of economic management; and the welfare state.

The Conservative government returned in 1951 accepted the essentials of this system (as it had to all intents and purposes since 1944), and riding the postwar consumer boom, presided over an

unprecedented period of popular capitalism, summed up most fa-mously in Macmillan's own (partly apocryphal) slogan 'You've Never Had It So Good'. Between 1951 and 1964, the rate of owner-occupation doubled, the number of cars nearly quadrupled, fridges, telephones, washing-machines and foreign holidays ceased to be middle-class privileges and became part of millions of lives, and throughout that period, unemployment never rose above 2 per cent.[2] Capitalism, which had seemed such a catastrophic failure in the Thirties that many people took its impending demise for granted, now seemed to have been saved, thanks to 'Keynes plus the Welfare State'. Capitalism could deliver; socialism was obsolete; class itself was on the way out. This, in Eric Hobsbawm's words, was 'The Golden Age'.[3]

The postwar settlement, like all great historical turning-points, had a story to tell about where it came from: a story which rested heavily on the contrast between this success-story and the gloomy experience of the Thirties. All political tendencies agreed, though for different reasons, that the Thirties were a bad thing: a class-ridden age of unnecessary poverty and inequality, led by govern-ments who wilfully ignored the possibility of making things better, and ending in an avoidable war caused by failure to stand up to dictators. The only good thing about it was that it showed that things must change. For Macmillan, it was a decade when 'it had become evident that the structure of capitalist society in its old form had broken down...Something like a revolutionary situation had developed'.[4] For the Communist James Klugman, it was a period 'of extreme change and struggle and storm', dominated by a 'sense of impending doom'.[5] For modernising critics of the linger-ing conservatism of British life, the Thirties were too much with us and should be eradicated for good. The sharpest political insult was to accuse your opponent of 'harking back to the Thirties', by invok-ing the politics of class ('waving the cloth cap'), or making a fuss about poverty, which the boom had apparently driven off the polit-ical agenda. Apart from a lingering left-wing nostalgia for a pro-fessed age of commitment and struggle, only the openly reactionary, like the Evelyn Waugh of *Brideshead Revisited* (1945), looked back to the Thirties with any sense of loss.[6]

As we shall see, this unrelievedly negative view of the Thirties started to break up along with the postwar settlement with which it was so intimately linked. In the mid to late 1970s, it became clear that the stark contrast between prewar failure and postwar success

could not be sustained. Opinions about the Thirties among historians started to diverge again, some seeking lessons for a new age of political activism; others emphasising the stability of British institutions through the Slump. Finally, with the coming to power of Margaret Thatcher in 1979, the 'devil's decade' underwent what almost amounted to a rehabilitation, as the last age of true capitalist values.

THE THIRTIES AND POSTWAR HISTORIANS: MOWAT AND TAYLOR

As we have seen, for wartime commentators, the Thirties formed part of a narrative which included the War, and was to be resolved with the coming of peace: a narrative in which, for most people, the Thirties provided the prospective justification for a radical postwar settlement. Historians in the fifties and sixties had the advantage of knowing how the story ended – not with the Utopian revolution envisaged by some early commentators, but with the state-centred welfare capitalism which emerged from the reconstruction plans of 1942–44. This postwar settlement, prefigured in wartime, was regarded as the basis of political and social relations in the ensuing decades, so it is not surprising that postwar historians' views of the Thirties had many affinities with that which prevailed during the war. This becomes evident when we look at two of the earliest general histories of the interwar period: Charles Loch Mowat's *Britain Between the Wars 1918–1940* (1955), and A. J. P. Taylor's *English History 1914–1945* (1965). From these two standard texts, we learn not only what the postwar era thought of the Thirties, but what kind of 'mainstream' history it was thought appropriate to write at this time. In the ensuing decades, it was not only views of the Thirties, but also favoured types of history that were to change radically.

These are 'general histories'. That means that they take as their object of study 'Britain', or 'England' as a whole during a particular period. Their narrative structure is chronological: Taylor describes his book as 'a continuous narrative, though with occasional pauses for refreshment'.[7] Most of the chapters of both books are defined by dates, and they rarely overlap chronologically. It would appear, then, that it is time and place alone, rather than any guiding questions or themes, which define what these books are about. Of

course, we know this is not true: all histories, however 'general', must be selective: but according to what principles? Taylor blandly informs us that 'most themes chose themselves', mentioning the Slump and the two world wars – and as for the rest, 'I chose the subjects which seemed most urgent, most interesting, and with which I was most competent to deal'.[8] Mowat tells us nothing at all about his principles of selection, though this is hardly less helpful. We are clearly in a territory stuffed with hidden agendas and suppressed assumptions, which it is the reader's task to uncover. We could start by asking what this 'continuous narrative' is actually about.

In both books, it is politics which provides the underlying master narrative: politics meaning public events and personalities, Westminster plus elections: there is no analytical history of the state, and little political sociology. Broader themes – social and economic change, living conditions, culture – enter the narrative when they impinge on political events: the Slump, like Hitler, is a problem which politicians have to deal with. Whatever does not fit the master narrative, but is still felt to be important – issues such as housing conditions, culture and mass communication, the growth of leisure and consumer spending – is discussed in what Taylor calls 'pauses for refreshment', 'condition of England' chapters for which the narrative clock is stopped: Chapters 4, 5 and 9 in Mowat, and 5 and 9 in Taylor. By removing these aspects of national life from the main narrative, this method marginalises them, and undermines its own claim to be 'general history', thereby raising questions about the relation of politics and society which it is unable to answer. In 'general history' it is political institutions and leaders, rather than, say, 'British society', which define what 'Britain' is, and constitute the nation as a historical object. But Taylor's 'pauses for refreshment' signal a different view of the nation, embracing other layers of social life. However, because the narrative focus on high politics rarely permits these interconnections to be explored, the contradiction remains unresolved – although some of the most interesting passages in Taylor are precisely those which do touch on these interconnections: for example, between mass communication and politics.[9]

Both books offer a similar narrative of interwar British history. It is a narrative overshadowed by both the past and the future – the Edwardian past of imperial and economic might, the post-1945 future of social democracy and the welfare state. The interwar

period is an interregnum, a postscript or a prelude, a segment of a larger narrative. Contemporaries – politicians, intellectuals, the general public – are seen as either yearning for a pre-1914 Arcadia, or prefiguring a new world that was to come. What none of them were any good at doing was handling the world they actually lived in. The two narratives share the same starting point and the same destination. The story begins with a nation uncertain of itself, living through an age of failure: it ends, in 1940 or 1945, with the nation finding itself, in the realistic hope that some of this failure, at least, can be redeemed. The importance of the Thirties is where they lead to: the 'postwar' world of full employment, the welfare state and the managed economy, in which vain dreams of past glory were finally abandoned, to be replaced by the more modest but wholly honourable objective of making ordinary life secure and pleasant for the mass of the population.

Thus for Mowat, the declaration of war and the summer of 1940 effectively restarts the history of the British people:

> as they awaited the Battle of Britain, they found themselves again, after twenty years of indecision. They turned away from past regrets and faced the future unafraid.[10]

In Taylor's conclusion, 1945 is a similar turning-point, finally banishing the world of 1914:

> Traditional values lost much of their force. Other values took their place. Imperial greatness was on the way out; the welfare state was on the way in. The British empire declined; the condition of the people improved. Few now sang 'Land of Hope and Glory'. Few even sang 'England Arise'. England had arisen all the same.[11]

The endings may be similar, but the routes taken there are somewhat different. For Mowat, the new world was always there in embryo, held back by the moral and intellectual failings of political leaders, and awaiting the shock of war to bring it to birth. For Taylor, the journey to 1945 was less a voyage of national self-discovery than a chapter of accidents, in which deluded and self-deceiving leaders stumbled on the future, thanks partly to occasional nudges from the people.

Mowat's 1930s is essentially the story of the failure of the National Government, and the rise of those who were to become the 'reconstructionists' of 1940–45. With the 1931 election, 'the

humdrum figures of the twenties' were back, and from then onwards, the history of the government was 'one long diminuendo', until it 'shambled its unimaginative way to its fall in 1940'.[12] The government reflected the character of its leading figures: Ramsay MacDonald was a sad, declining figure, courageous enough in his time, but now lacking mental focus; Baldwin an avuncular Everyman, skilled in maintaining the political equilibrium, but indecisive and wholly without vision, 'content to follow events, not to shape them'.[13] Baldwin's successor, Neville Chamberlain, was able enough, but a cold and repellent figure, self-righteous and dictatorial in his manner.[14] Where other nations had 'new and adventurous governments', Britain had the old gang, cautious, conservative and resistant to new ideas: 'in harmony with the national mood', but offering the nation no leadership.[15] In Mowat's story, then, the slump and fascism are merged into one huge composite problem: the government, whose 'limping efforts to conquer unemployment' stem from the same moral and intellectual weakness as its failure to confront Hitler.

As a counterpoint to the narrative of governmental failure, Mowat gives us a second, almost underground narrative – the emergence of an alternative. Citing passages from Orwell's *The Lion and the Unicorn*, and thus linking his analysis clearly with the 1940s, he finds a 'new England' in the growing suburbs and new technological occupations, which symbolise modernity much as did the divorce law reform he discusses on the previous page, and the Odeon cinema architecture eulogised on the next – all part of the 'new social conscience' of the 'restless younger generation'.[16] The gospel of this 'new England' is 'planning', motivated by the modernising spirit and by humanitarian concern for the depressed areas, and inspiring everything from Harold Macmillan's *The Middle Way* (1938) to enthusiasm for the Soviet Five Year Plan, as well as a mass of social surveys and investigations, Penguin Specials, the peace movement, the Left Book Club, Youth Hostels, popular science and left-wing poets.[17]

Yet conscience is roused not just by domestic issues, but also by the rise of fascism. The Spanish Civil War is seen as an all-purpose 'catalyst of political feelings' which politicised the apathetic, and transformed public opinion. Spain not only prefigured the anti-Fascist war that was to come, but as that war was to do, pushed ahead the gathering forces of progress across a whole range of issues.[18] For Mowat, these extremely diverse forces were not a mere

fringe of political extremists, but a unified movement of opinion, prefiguring the wartime coalition, the subsequent Labour government, and, more distantly, the postwar consensus.

On the one side, then, Mowat gives us timid, conservative leaders, lacking vision and moral courage, unable to deal with the problems of the slump and fascism; on the other, the men and women of the future, whose ideas are ignored now, but who will have their day. In the middle lies the nation: confused, demoralised, 'ready for a bold lead, yet apathetic when left without one'.[19] The change when it comes is not an intellectual conversion but a collective moral response. Spain, and revulsion against the 1938 Munich settlement, begin the process of change: but 'the sacrifice of Czechoslovakia was a sin not expiated until Britain had gone through her own lonely ordeal in 1940–1'.[20] Only then could the 'new men' and the rest of the nation come together to make the postwar world. Chamberlain's broadcast of 3 September 1939 announcing the outbreak of war

> was no clarion call: a tired, old man telling of the bitter blow to *his* hopes of peace.... His world was indeed being reduced to ruins; but for the people of Britain a new life would in time begin....[21]

This, in sum, is the Thirties seen from the perspective of William Beveridge and the Attlee Government, through the distinctive lens of liberal moralism.

If for Mowat the politicians were blameworthy, for A. J. P. Taylor they were simply deluded – but so was everyone else. Taylor's approach is not moralistic, but ironical. In this age of illusions, rulers and ruled alike inhabited a world of fantasy and wishful thinking. If events had an underlying pattern, no one knew what it was. If politicians did the right thing it was invariably for the wrong reasons, and if they got what they wanted, it was despite rather than because of the course of action they followed. There are no heroes or villains: all are revealed as victims of their own illusions.

Taylor's 1930s begin not with the formation of the National Government in August 1931, but with its decision the following month to come off the Gold Standard. In this instant, all yearning for the world of 1914 evaporates for ever: but so too does the *raison d'être* of the National Government, which nevertheless carries on for another nine years.[22] Having, by accident, acquired an economic policy, the government now achieved an accidental economic recovery which owed little to their policy. Instead of the hoped-for

revival of the old staple industries, recovery came through in-
creased consumer spending, house-building, and the expansion of
new industries, none of which anybody had planned. Taylor's
suburbs, like Mowat's, are the harbinger of things to come; but
while for Mowat they represent modernism, technology and plan-
ning, for Taylor they are the laboratory of creative consumerism, in
which develop popular tastes and aspirations over which no one
has any control.[23]

Nor do the government's critics escape the ironies of history.
Where Mowat sees in the 'new social conscience' a single move-
ment towards the postwar future, Taylor sees a diffuse collection of
impotent intellectuals and rejected politicians, well-intentioned and
on the right side, but subject to just as many illusions as their oppo-
nents. The aims of the 'planners' conflict, their viewpoints range
wildly from protectionist Toryism to pro-Soviet Marxism, their
various proposals hardly add up to an alternative policy. Even
Keynes offers no solution to the economy's structural problems.[24]
The picture, in other words, lacks the clarity of postwar hindsight:
economic debates 'fumbled in the dark, occupying much time, cre-
ating much passion, leading to little result'.[25] The 'documentary
impulse' – social surveys, documentary film, Mass Observation,
Orwell and Priestley – is not even considered important enough to
mention.

Meanwhile, the extra-Parliamentary left were even more impo-
tent; their consciences roused by mass unemployment, but disabled
by their class background from joining in working-class struggles,
they could only cheer the hunger-marchers from the sidelines. The
Left Book Club and its ilk mobilised intellectuals in spectacular
fashion, but diverted them from mainstream Labour politics. Anti-
fascism was all very well, but in Britain there was not much fascism
to fight. Spain at least gave them 'something real to do', but even
then – in contrast to Mowat's picture of popular mobilisation –
Spain remained 'very much a question for the few, an episode in
intellectual history'.[26]

Taylor's conclusion, that 'England had risen all the same', locates
his viewpoint firmly in the People's War and the postwar consen-
sus. However, where Mowat sees the arrival at 1945 as the product
of social conscience and the activities of progressive intellectuals,
Taylor sees change as coming from below, from forces unrecog-
nised by those who sought to influence events – in particular, from
the aspirations of the people. Taylor's ironical approach to history

forbids him to see welfare capitalism as the outcome of anyone's conscious intentions, though it does not prevent him from seeing it as a good thing. But the focus of his narrative is on high politics, and his irony is reserved for the actors upon that stage. True to his radical heritage (and in contrast with, say, Muggeridge), he treats 'the people' without irony, but his historical method prevents him from analysing who or what they are, or how they come to influence events.

If 'the people', largely offstage, is the idealised hero of Taylor's story, the Fabian-style intelligentsia is the hero of Mowat's. Mowat's view is closest to the mainstream of the subsequent historiography, which linked the 1930s to 1945 through the activities of what Arthur Marwick called 'middle opinion', similar to Mowat's 'new social conscience' – the moulders of the new interventionist consensus of the wartime and postwar periods.[27] Taylor's populism is too vague to offer a coherent alternative to Mowat's Fabian progressivism, not least because the political focus of his narrative prevents him from exploring the social forces at work below; but although he cannot answer the questions he poses, they are still worth asking.

Despite their differences of approach, Mowat and Taylor both present the Thirties in essentially the same narrative light as the wartime commentators discussed in the previous chapter: it is a period whose failures legitimise the postwar political settlement of welfare capitalism. Other historians writing in the 1960s presented a similar picture. Arthur Marwick's *Britain in the Century of Total War* (1968), a book with a more focused argument than most 'general histories', emphasised, alongside the bitterness of the Depression, the emergence of 'forces making for agreement' outside and on the fringes of the major political parties, in particular a revulsion against prevailing economic orthodoxy and a new devotion to economic planning.[28] Robert Skidelsky, in his study of the 1929–31 Labour Government, *Politicians and the Slump* (1967), blamed the government's failure on its preference for economic orthodoxy, and the distant prospect of 'socialism', over 'what might loosely be termed Keynesian policies', as adopted in the USA, Germany, France and Sweden. His later biography of *Oswald Mosley* (1975) partially rehabilitated its subject by presenting him as virtually the only proto-Keynesian in the Labour Cabinet, before he veered into Fascism.[29] In these and other works, the redeeming feature of Thirties politics is seen to be the presence of a minority

whose views prefigured the Keynesian orthodoxy of the postwar period. Even overtly right-wing accounts, such as Robert McElwee's Churchillian popular history of *Britain's Locust Years 1918–1940* (1962) – a book which is resolutely hostile to the Left – approvingly linked the slow moral awakening of the prewar years with the eventual appearance of the Welfare State:

> More and more thoughtful people were finding it impossible to ignore the social disaster which had overtaken the Black areas The gains which had been made in social welfare and security were seen less and less as matters of self-satisfaction, but as a foundation only for a proper system.[30]

APPEASEMENT

It was not only in economic and social policy that the Thirties offered the postwar world lessons in how not to do things. 'Appeasement' is the other charge levelled against the 'devil's decade': the policy, particularly associated with Neville Chamberlain and his Foreign Secretary Lord Halifax, of attempting to keep the peace in Europe by accommodating Germany's desire to revise the punitive Versailles settlement. Through weakness and vacillation, anti-appeasers argued, Britain and her actual or potential allies in the League of Nations failed to prevent Italy, Japan and Germany making a whole series of aggressive gains in the 1930s: from the Japanese attack on Manchuria in 1931 through the Italian invasion of Abyssinia in 1935, Hitler's remilitarisation of the Rhineland in 1936, *Anschluss* with Austria in 1938, and the Munich agreement of the same year which paved the way to Germany's unopposed annexation of Czechoslovakia in 1939. Even in September 1939, despite Britain's guarantees to Poland, the appeasers are presented as reluctant to declare war, still hoping for a peaceful accommodation with Hitler. As a result of failing to stop Hitler earlier, it is argued, Britain went to war from a position of weakness and suffered the trauma of near defeat in 1940–41.

Though it is sometimes treated solely as a foreign policy question, the significance of appeasement to Britain's national self-image since 1939 goes far beyond the province of the diplomatic historian. If few historical issues have aroused such strong feelings, this is because appeasement touches on and links together a

number of highly-charged themes in British history. This can be
seen in the developing reputation of appeasement and the ap-
peasers from the 1940s to the present.

The first wartime responses to appeasement were, of course, uni-
formly, and savagely, hostile. Long before there was any official
mention of postwar reconstruction, anti-appeasement was the basis
of the Churchill coalition, the guarantee that the war would be
fought in earnest, signalled by its leader's semi-mythical reputation
as the 'lone voice' against appeasement. The disasters of May–June
1940 were widely blamed on the appeasers, and post-Dunkirk
public opinion loudly demanded the dismissal from the govern-
ment of Chamberlain and his remaining supporters. After all, what-
ever else may be said about it, appeasement had clearly failed, and
left the nation in almost as perilous a position as could be imag-
ined. Middle opinion could only condemn a policy which made so
many concessions to a loathsome enemy, without even managing
to avoid war. When wartime propaganda, and later the horrific rev-
elation of the death camps in 1945, convinced people that the Nazi
regime was indeed unmitigatedly evil, the sins of the appeasers
seemed all the more unforgivable.

Further left, as we have seen, the 'Guilty Men' thesis damned
prewar Conservatism even more fervently for its failure to stand
up to Hitler than over its tolerance of the Slump. Other Left com-
mentators such as Priestley and Orwell linked appeasement with
the decadent rule of a 'posturing plutocracy', many of whom, it
was implied, were covert (and not-so-covert) supporters of
Fascism. The legend of the 'Cliveden Set', country-house fellow-
travellers with Nazism who supposedly orchestrated appeasement,
retained a strong currency both during the war and well into the
postwar period.[31] In 1945, foreign policy was not an election issue:
there was bipartisan support for the newly-founded United
Nations, and for the joint peace-keeping responsibility of Britain,
the USA and the USSR. Nevertheless, the Labour Party manifesto
reminded voters, in its sole mention of appeasement, 'that in the
years leading up to the war the Tories were so scared of Russia that
they missed the chance to establish a partnership which might well
have prevented the war'.[32] Between the lines of this superficially
mild statement lurks the common left-wing view that appeasement
was not only a mistaken policy, but a symptom of the moral and
political deficiencies of a party and a ruling class, guilty of putting
their own class interests before those of the nation.

Following the war, there was widespread belief in Britain's continuing role as a world power, and, as the Cold War gathered pace after 1948, a deep distrust of the motives of Communist Russia. Memories of how dictators had been appeased in the past reinforced a hard line against Communism: appeasement led to war, not peace. The Berlin airlift of 1948, relieving the Russian blockade, showed that this would not be allowed to happen again. Memories of appeasement also justified a strong line in defence of Britain's crumbling imperial role. In 1956, Anthony Eden, himself an anti-appeaser in the Thirties, justified his disastrous military action against Egypt over the Suez Canal by explicitly evoking the experience of appeasement: Nasser was a dictator who must be stopped in his tracks, or, like Hitler, his ambitions would get out of control.[33] The historical parallel was not universally accepted: evoking the same past, but giving it a directly opposite twist, Michael Foot entitled his polemic against the Suez escapade *Guilty Men 1956*.

By the early 1960s, then, there were clear and strong reasons for both Left and Right to damn the appeasers, and very little basis in contemporary political terms for anyone to defend them. The most widely-read historical account of the time, Martin Gilbert and Richard Gott's *The Appeasers* (1963), was written from a left-wing standpoint, and indeed, as supporters of CND, its authors might well, in a Cold War context, have been judged as 'appeasers' themselves by mainstream opinion of the time.[34] Nevertheless, their book was a great commercial success, and widely translated. Their strong anti-appeasement line was rooted in the anti-Fascism of the Thirties and the wartime 'Guilty Men' critique; the lesson it offered to the 1960s was that fear of Communism should not lead to dishonourable compromises with right-wing dictators. In such a climate, A. J. P. Taylor's *The Origins of the Second World War* (1961) was controversial more for its studiedly amoral approach to international relations than for any rehabilitation it offered to the appeasers. Taylor, characteristically, presents the drift to war as the outcome of muddle and miscalculation on the part of the allies, and Hitler as a determined pragmatist rather than a man with an evil plan. All moral arguments for opposing the spread of the Nazi regime are perversely disregarded, even in 1938–39 when they were arguably a key factor in turning public opinion against Chamberlain. Nevertheless, Taylor presents an unflattering portrait of the appeasers, and his account of events could perfectly well underpin an anti-appeasement critique.[35]

We can see, then, that in the 1950s and 1960s condemnation of appeasement was an element in the construction of the postwar consensus, legitimating the wartime coalition and the bipartisan Cold War foreign policy that followed. But the fact that it could also support a left-wing critique of that policy, and for Gilbert and Gott could illustrate the pitfalls of untoward anti-Communism, suggests how broad and complex was the historical resonance of appeasement. It could evoke conventionally patriotic notions of national honour, and the Churchillian image of the British bulldog standing up to all-comers. At the same time, it recalled an older, Gladstonian principle that morality rather than pragmatism should be the guiding light of foreign policy, and that we should not on any account get close to dictators. It validated the ascendancy in the Conservative party of Churchill's aristocratic paternalism over Chamberlain's Midlands business ethic, and thus helped support the 'one nation' Toryism of Harold Macmillan (another Thirties anti-appeaser). But it was also part of a left-wing critique of that patrician class, not only incompetent, but putting their own class interests before those of the nation. In Harold Wilson's modernising rhetoric of 1963–4, the prelude to Labour's return to power, appeasement was not mentioned; but his demolition of the 14th Earl of Home (himself a man of Munich) carried distinct overtones of the 'Guilty Men' thesis of twenty years earlier.

It was in the late 1960s that the starkly anti-appeasement orthodoxy which had held sway since the 1940s began increasingly to be questioned. Donald Watt, one of the first of the 'revisionists', suggested in 1965 that the opening of more official and private papers in the future would lead to a more sympathetic view of appeasement as a rational and coherent policy, rather than the work of fools or knaves.[36] In 1967, the period of secrecy for official documents was reduced from fifty years to thirty, and a flood of historical work on 1930s foreign policy ensued. As Watt had predicted, this new work took a far more complex and balanced attitude to appeasement than had hitherto prevailed.[37] Historians now came to emphasise the weakness of Britain's position in the 1930s. Bereft of allies by the isolation of both the USA and the USSR, Britain and a somewhat wobbly France were seeking to fill a power-vacuum which was too large for them. Britain had world imperial interests to defend, which were threatened by Japan in the Far East; the Empire was beset by politico-military problems, and the independent Dominions were reluctant to enter a European war. Militarily, Britain had been seri-

ously weakened since 1918, and because the manufacturing base had been so badly damaged by the Depression, rapid rearmament would either be impossible or economically too risky to contemplate (as the Treasury advised). To cap it all, public opinion was, it is argued, generally favourable to appeasement until after Munich, when the damage, if any, had been done. In short, Britain was not in a position to contemplate war in the late 1930s, especially when her interests were not directly threatened. Appeasement could thus be seen as a rational response to the situation.

Historians tend to attribute changing views on appeasement to the greatly increased availability of primary sources – memoirs and government documents – especially after 1967: this is in accordance with their professional ideology, according to which all readings of the past must be rooted in verifiable evidence, rather than in changing currents of opinion. It is doubtful, though, whether new documentation was required to sustain any of the 'revisionist' points listed in the previous paragraph. What was surely significant about the revisionist view was not so much its changed verdict on appeasement, as the way in which it shifted the perspective from which appeasement was to be judged. The wartime and postwar critique condemned the Chamberlain government for failing (for one reason or another) to fulfil the nation's duty – whether to its allies, to political principle and international morality, or simply to its own best interests. Whether Britain in 1937–9 was actually in a position to fulfil any of these supposed duties was rarely if ever questioned. By the late 1960s, historians were coming instead to judge appeasement against the realities of Britain's declining power, and in that context finding it far more excusable. As Paul Kennedy put it in 1981, appeasement could be seen as 'a natural policy for a small island-state gradually losing its place in world affairs, shouldering military and economic burdens which were increasingly too great for it'.[38]

From a 1990s perspective, indeed, it is sometimes startling to discover just how many moral and military burdens both left and right in the postwar era believed Britain could shoulder. The 1940s–1960s critique of appeasement, and its implicit belief that Britain not only should but could have 'stopped Hitler', starts to seem less like a healthy moral revulsion against national decadence, and more like part of a national conspiracy of self-deception about the realities of Britain's world position – a self-deception which was to cost the nation dear in the second half of

the century, and in which the left, with its moralistic critique of
foreign policy, was just as complicit as the imperialist right. At
the same time as the revisionist view of appeasement was becom-
ing dominant, Harold Wilson's Labour Government was grap-
pling (or, rather, failing to grapple) with the problems of Britain's
hollow, world-power pose, in the shape of an overvalued pound
and expensive military commitments east of Suez, which helped
to undermine the government's modernising strategy.[39] Seen from
this point of view, the changing historiography of appeasement is
part of the painful (and overdue) revaluation of Britain's world
role since the 1960s; and appeasement itself should be inserted
into a new narrative, one which has preoccupied historians and
the public more and more since that time – the narrative of
national decline.[40]

THE THIRTIES AND THE POSTWAR LEFT

> The Labour Government has ensured full employment and fair
> shares of the necessities of life. What a contrast with pre-war
> days! In those days millions of unwanted men eked out their
> lives in need of the very things they themselves could have made
> in the factories that were standing idle ... Whatever our Party,
> all of us old enough to remember are in our hearts ashamed of
> those years. They were unhappy years for our country and our
> people. They must never come again.
>
> (Labour Party Manifesto 1950)[41]

In these terms, the Labour Government presented itself to the elec-
torate for re-election in 1950 and 1951. Its case was firmly based on
a clear historical agenda which is recognisably that of 1940–45: the
Thirties were the Tory bad old days of high unemployment and
poor welfare provision; Labour's postwar settlement had banished
those evils, but once let the Tories back in, 'with their dark past,
full of bitter memories for so many of our people ... [and] they
would take us backward into poverty and insecurity' (1951 Labour
Party Manifesto).[42] 'Ask Your Dad' was a Labour election slogan,
posters displayed pictures of hunger-marchers, and four out of five
Labour election broadcasts in 1950 explicitly raised the spectre of
the Slump.[43] Labour was asserting its ownership of the postwar

welfare capitalist order, against opponents tarred with the brush of a bitter history.

This historical appeal was not altogether unsuccessful. Labour polled well in 1950 and retained power despite losing some ground from 1945. In 1951, the party received its highest vote ever, in both absolute and percentage terms, but lost office thanks to the vagaries of the electoral system – and also because the Conservatives, so mistrusted in 1945, had rebuilt their support at the expense of the Liberals. The return of the Conservatives to power did not have the consequences predicted by their opponents. Far from relapsing into the 'poverty and insecurity' of the Thirties, the nation in the early 1950s embarked upon the greatest mass consumer boom in its history, participating in the boom conditions which were affecting all capitalist economies at this time. The Conservatives accepted the legacy of the postwar settlement: rationing and the other economic controls of postwar austerity were dismantled (a process which Labour had, in fact, begun), but full employment and the welfare state remained in place, and Keynesian techniques of economic management were used to sustain a high-wage, consumer-orientated economy.

In the process, the Left lost control of the historical agenda which it had wielded so confidently in 1950 and 1951. The Conservatives had no need to rehabilitate the memory of the 1930s: their own record showed that they were no longer the party of 'poverty and insecurity'. Now it was the Labour Party which was saddled with a grim past: the memory of postwar austerity and the economic crisis of 1947. As a Conservative poster of 1955 put it: 'queues, controls, rationing: don't risk it again'.[44] On the basis of this revision of the historical agenda of 1940–51, the Conservative government was re-elected with increased majorities in 1955 and 1959.

Although Labour continued to poll significantly better than at any time before 1945, and never came near the electoral disasters of the 1980s, the party's situation stimulated a huge amount of discussion and analysis during the 1950s and early 1960s. It was not just the loss of three General Elections which attracted all the attention: Labour had stopped growing and was on a plateau, but it was certainly not experiencing a 'persistent and accelerating electoral decline' as some commentators suggested.[45] The problem was that history, which at one time seemed to guarantee a movement towards socialism – so that after the 1951 defeat, Labour commentators confidently expected the new government to fail – seemed

now to be moving in directions which led away from Labour's traditional goals. Socialism, its opponents argued, was unnecessary; capitalism had solved its own problems. People preferred individual prosperity to collective action through the state. Class was not only divisive but out of date. Now it was the Left who were accused of living in the past, even of feeling nostalgia for the days of the hunger-marches, when at least the evils of capitalism could be clearly seen.

Debate on Labour's electoral failure focused on the political and social changes which had taken place between the 1930s and the 1950s. In her contribution to *Must Labour Lose?* (1960), based on a survey commissioned by *Socialist Commentary* after the 1959 General Election, Rita Hinden argued that:

> capitalism is not what it was: everyone has learnt that some degree of state intervention is necessary; everyone understands something of the techniques of planning. Everyone knows that a democratic society will tolerate no repetition of the economic history of the thirties.

Labour could therefore no longer rely on the spectre of the Thirties to mobilise its vote. Nor could it rely on class loyalty, 'at a time when a drift away from old class allegiances has begun'. In the interwar years, 'circumstances tended to weld the workers together politically as a class The dominant theme, then, of what was best in the working-class ethos was solidarity and mutual help; it was the dominant theme of socialism as well.'[46]

> One has only to cast the imagination back to those days to appreciate the extent to which things have changed. The majority of workers are no longer condemned to a constant struggle for a minimum of security ... strong trade unions and full employment have revolutionised the position of most. Large groups of manual workers have higher earnings than white-collar workers or than sections of the middle class. They are cushioned by the provisions of the welfare state; their children have educational opportunities beyond the dreams of their parents. They now have opportunities for leisure, for enjoyment of most of the good things of life.[47]

Moreover, Hinden argued, changing occupational structure had brought the decline of the old-style manual worker and increased opportunities for social mobility. 'There is an increasing fluidity in

our society The day is gone when workers must regard their station in life as fixed.' All these things were held to militate against the kind of class appeal on which the Labour Party had risen to power. Hinden therefore advocated a political programme mobilising not the interests of the workers as a class, but cross-class impulses of 'generosity and social responsibility'.[48]

Other labour 'revisionists' deployed similar historical contrasts. Anthony Crosland in *The Future of Socialism* (1956) declared that British capitalism had changed so much since the war, under the impact of Keynes and the Welfare State, that it was doubtful if it could be called capitalism any longer. From the Industrial Revolution to the postwar era 'the atmosphere was one of constant industrial tension, often verging on class war', but now 'this heavy, lowering atmosphere has largely lifted ... the militant language of class-war, the terminology of revolt and counter-revolt, is itself passing out of usage.'[49]

'Revisionists' within the Labour Party in the 1950s thus supported their analysis of postwar historical change with a new reading of the Thirties. Where the social democrats of 1940–51 had seen the Thirties as a period of poverty and suffering, demonstrating the need for the welfare state and full employment, for the 1950s revisionists they were a time of strong class-consciousness and acute class conflict, whose postwar decline showed the redundancy of the politics of class.

The concrete historical reference involved in this construction was vague in the extreme: Crosland imagined that there must have been 'bitter coal strikes' in the 1930s (there weren't), and from Hinden's analysis the reader might easily assume that the Thirties were the high tide of working-class Labour support: in fact, working-class Conservative voting was still strong in many areas up to 1945, and Labour got significantly more votes in the supposedly classless Fifties (average 46 per cent) than in the four prewar elections (average 34 per cent).[50] In implying that 1945–51 marked the high tide of the politics of class, Hinden and Crosland overlooked the wartime cross-class discourses of 'the people' – very similar to Hinden's 'generosity and social responsibility' – which laid the foundations of the 1945 election victory (see Chapter 5). Clearly, this reworking of the Thirties was not prompted by a close study of the historical facts. Rather, the revisionists were seeking to establish a narrative of historical change which showed that, by contrast with the class-ridden Thirties, the welfare-capitalist modern world was

becoming classless and non-ideological. To sustain this narrative, the Thirties had to be firmly established as a 'red decade'.

The 'Conservative enemy'[51] against which this narrative was directed lay not just on the left, but in Britain's archaic, class-ridden and inefficient society and institutions, too little touched by the welfare state and the postwar boom – too much, in fact, what they had been in the 1930s. Criticism and mockery gathered pace in the late 1950s and early 1960s, feeding into Harold Wilson's 'classless' modernising rhetoric of the 1964 General Election.[52]

The Labour revisionists were 'optimists' about postwar society. They regarded material problems as solved for the foreseeable future, and in foreign policy they tended to take an anti-Communist line and favour the American alliance. 'Pessimists' who regarded postwar capitalism with mistrust tended to favour unilateral disarmament and a neutralist foreign policy. The two major fault-lines on the political left thus largely coincided. As middle-class radicalism started to revive at the end of the 1950s with the growth of the Campaign for Nuclear Disarmament, producing the first major wave of public demonstrations since the Thirties, memories of earlier left-wing struggles were sharpened. The new Left adopted a similar construction of the 1930s as the revisionists, though for different reasons. The same people who in the 1940s would have decried any return to the Thirties now began to see them as a golden age of political commitment and a strong working-class culture, by contrast with the apathetic and conformist Fifties.

This political contrast between the Thirties and the Fifties is vividly expressed in Arnold Wesker's play *Chicken Soup with Barley* (1958).[53] In three acts, set in 1936, 1946–7 and 1955–6, the play shows the decline in class-consciousness and political commitment through the lives of a working-class family. From a starting-point of active engagement in the anti-Fascist struggle, over the decades the family loses its political activism, its links with the wider community, and its own internal cohesion – a decline which is explicitly linked with the trivialisation of mass culture and the loss of community solidarity caused by rehousing. The view of the Thirties presented in *Chicken Soup with Barley*, with its emphasis on activism and betrayal, is similar to that found in left-wing histories such as Noreen Branson and Margot Heinemann's *Britain in the Nineteen Thirties* (1971). Where the play selects the viewpoint of an atypical politically active working-class family to portray the Thirties as being essentially 'about' class solidarity and political commitment,

Branson and Heinemann give particular prominence to activist episodes such as the Invergordon Mutiny of 1931, and the struggle against Mosley's fascists – rather than, say, the solid popular support for the National Government – and emphasise the role of the Communist Party at the expense of the Labour Party and the mainstream Trade Union movement. Any viewpoint on the decade is, of course, a selective one; Wesker's serves to underline his particular narrative of the decline of political commitment and class solidarity from the Thirties to the Fifties, a marked reversal of the 'upwards' political narrative, leading from Slump to Socialism via the People's War, espoused by an earlier generation.

Wesker's pessimistic view of the impact of mass culture on the working class is part of a wider concern with working-class culture, expressed in novels, plays, films and sociological studies, and motivated by a profound anxiety about historical change and in particular a deep suspicion of modern popular culture.[54] The key text of this period is undoubtedly Richard Hoggart's *The Uses of Literacy* (1957). This study of the old 'lived culture' of the working class with which Hoggart himself grew up in the interwar years, and the effects upon it of commercial mass culture, offers another narrative of decline – this time a cultural one, in which politics is present, if at all, only by implication. The strengths and weaknesses of *The Uses of Literacy* have been widely discussed.[55] Its particular importance is that it was one of the first studies of the changing working class to investigate culture as a site of historical change, rather than seeing the class (as Wesker's play rather tends to do) primarily through its political and trade union activities – its 'active minority' as Hoggart labels them. The book is at its best in its account of the 'old' working-class culture: a dense and complex world of shared meanings, which does not yield to simple preconceptions about class or values. Where it is least convincing is in its presentation of the new forces which are bearing down upon this culture and, Hoggart fears, turning it into something less valuable, 'unbending the springs of action': here the simplicities of the 'mass culture' critique abound, and precise observation is too often replaced by a kind of generalised sneering.[56] Perhaps this is partly because Hoggart was writing at a very early stage of postwar cultural change, before mass consumption, commercial TV, and youth culture had really taken off. Certainly his later study of 'Changes in Working-Class Life' (1961) shows much greater understanding of the subtleties and contradictions of postwar cultural change, and

relates it more convincingly to changes in material circumstances, economic relations, and gender roles.[57]

In *The Uses of Literacy*, however, Hoggart's view is that, while the 'new' may be materially better than the 'old', in cultural terms it is unequivocally worse:

> at present the older, the more narrow, but also more genuine class culture is being eroded in favour of the mass opinion, the mass recreational product, and the generalised emotional response The old forms of class culture are in danger of being replaced by a poorer kind of classless, or by what I was led earlier to describe as a 'faceless' culture, and this is to be regretted.[58]

This is a historical dichotomy: the past against the present, the Thirties against the Fifties, with the former sitting in judgement on the latter. As always, the danger of this kind of argument, an occupational hazard of cultural critics which Hoggart does not always avoid despite his own warnings against romanticism, is that the 'old' is lifted out of history and turned into an idealised universal, always preferable to the new. In the nineteenth century, the evils of industrial civilisation were contrasted with a mythical rural elysium which had gone before; in the twentieth, F. R. Leavis and others judged the modern world against an eternal 'organic society', which had only recently disappeared.[59] There are moments in *The Uses of Literacy* when the old working-class culture seems to become another such lost world, an entity without social-historical determinants or external influences, unified and uncontradictory, always and everywhere the same, and thereby denied its real historical specificity. At such moments, the narrative of social change is coarsened into a nostalgic dichotomy between 'then' and 'now'. The moment between the publication of *The Uses of Literacy* (1957) and E. P. Thompson's *The Making of the English Working Class* (1958) is crucial: Hoggart and Thompson began the investigation which was to historicise and problematise the idea of working-class culture, but even so the image of a lost working-class authenticity helped to distance many on the left from postwar social and cultural changes, convincing them that material gains had been bought at an excessive spiritual, cultural and political cost. Like their predecessors, they defined their own era by contrast with the Thirties, but in a much more equivocal way. The Thirties still stood for mass unemployment and Fascism, and no one to the left of Evelyn Waugh wanted

to go back to them. But at least they also stood for an age of au-
thenticity and commitment, as against the shallowness, apathy
and materialism of the Fifties. In these changing images of the
Thirties, we can see how the Left lost control of the postwar settle-
ment it had done so much to initiate, and of the historical agenda
that had underpinned it.[60]

THE THIRTIES IN THE SEVENTIES: THE BREAKDOWN OF CONSENSUS

Although for three decades after the war, the Thirties were continu-
ally being redeployed and reworked by writers and politicians of
all kinds, using narratives of the past to gain some purchase on the
present, it was only in the 1970s that they became the subject of
bitter dispute among historians. The event which reopened debate
about the period was the publication in 1977–78 of John Stevenson
and Chris Cook's *The Slump*, and so we will consider this book's
argument in some detail.[61]

Stevenson and Cook wrote as historical revisionists, seeking to
modify or reverse prevailing views and images of the 1930s, which
they represented as uniformly negative: the 'hungry Thirties', the
'wasted years', the 'long weekend', and, inevitably, the 'low, dis-
honest decade'. While not denying that the Thirties were for many
people 'a time of great hardship and suffering', the grim picture of
mass unemployment needed to be balanced by that of 'another
Britain, of new industries, prosperous suburbs and a rising
standard of living', which established the basis for the postwar eco-
nomic boom. Quoting among others J. B. Priestley and A. J. P.
Taylor, they presented this contrast as the 'paradox' of the Thirties,
the 'two sides' of national life that 'do not add up'.[62]

Stevenson and Cook were particularly anxious to dispel the
image of the Thirties as an era of political instability and extrem-
ism: a time of hunger marches, Communist poets, and Fascists in
the street. In fact, they argue, neither Fascism nor Communism
made any real popular headway, and 'one of the most remarkable
features of the political condition of Britain in the Thirties' was the
absence of a 'major leftward swing', or of any other sustained mass
protest.[63] The long-term unemployed, concentrated in the de-
pressed areas, were too demoralised to protest, while for those in
work, living standards were actually getting better. British society

remained conservative, insular and cohesive, hostile to militancy and violence, whether of Left or Right. 'Moderate opinion', acting 'within the circles of conventional politics' was able to correct grievances without anyone having to take to the streets, and the Jarrow hunger marchers were the only ones to make any lasting impact, because they obeyed the rules, co-operated with the authorities and disclaimed any political intentions.[64] In short, despite left-wing fantasies that capitalism was tottering on its foundations in the face of 'epic and widespread struggle', the system worked.[65]

For an academic history book, *The Slump* attracted an unusual degree of public attention. It was widely reviewed in the broadsheet press, and *The Guardian* published a lengthy summary of its 'controversial' and 'unexpected' findings.[66] On the face of it, this is not easy to explain. Although *The Slump* claimed to challenge academic orthodoxy, this is not usually enough to earn acclaim outside academic circles. Moreover, as the authors themselves acknowledged, much of their argument was already common currency among historians. The idea that the Thirties was, among other things, a time of economic recovery had, as they said, been 'long recognised' by economic historians, ranging from Sidney Pollard in 1962, to the more recent work of Aldcroft and Richardson. In their first chapter, they were able to produce in support of their thesis a whole string of witnesses, stretching from J. B. Priestley, Seebohm Rowntree, the Pilgrim Trust and George Orwell in the Thirties, to postwar historians such as Mowat, Taylor and Skidelsky.[67] Significantly, they did not mention by name, still less quote, a single authority who took a different view. Indeed, Chapter 1 of *The Slump* mustered so much support for the authors' 'revisionist' position that it actually undermined it: how can you be a revisionist if the orthodoxy under attack does not actually exist?

The rest of the book fails to resolve these doubts. Chapters 3 to 5, for instance, deal with the impact and experience of unemployment. Their argument is detailed and compelling, drawing substantially on contemporary surveys to support the view that mass unemployment aggravated problems of poverty, poor housing and ill health in the depressed areas, and that prevailing financial orthodoxy prevented the state from either offering adequate relief, or tackling the underlying structural problems.[68] These chapters have been criticised for relying on outside investigators, and not drawing on the testimony of the unemployed themselves.[69] However – unfortunately for a book which claims to be challeng-

ing accepted orthodoxy – these chapters do not dramatically con-
tradict what people already thought was the case: they are filling
out an already-familiar picture. There is a half-hearted attempt to
stir up controversy by arguing that unemployment did not cause
poverty, but merely aggravated it: something which had been
overlooked, we are told, because 'a number of writers' had used
unemployment 'as the spearhead of a general attack upon social
conditions and the political system'.[70] Unfortunately, we are not
told who any of these writers are, or what they said, nor is it made
clear why it would help their political aims to overstate the level of
cyclical poverty and understate that of endemic poverty (if any-
thing, the contrary would seem to be the case). The whole business
is very confusing.

The reader bent on finding a controversy at all costs might think
it worth comparing *The Slump* with Noreen Branson and Margot
Heinemann's *Britain in the Nineteen Thirties* (1971), a left-wing
account which Stevenson and Cook consider representative of the
prevailing orthodoxy. Surprisingly, we find few disagreements
between the two accounts of the 'condition of England'. Branson
and Heinemann stress the existence of 'Growing Communities'
(Chapter 5) as well as 'Industrial Graveyards' (Chapter 4).
Alongside discussion of poverty and unemployment, we learn
about the suburban housing boom (Chapter 13) and new, 'con-
sumerist' patterns of living and leisure (Chapters 16 and 17).
Certainly, the 'new England' is not a land of unrelieved joy: the
book is critical of working conditions in the new industries, of sub-
urban jerry-building, and of the lack of social cohesion and ameni-
ties in the growing communities. But it is made perfectly clear that
in material terms at any rate, many people's living standards were
rising. If this is the prevailing orthodoxy, it seems to embrace the
'two Englands' thesis without too many misgivings.

We find more differences between the two books in their hand-
ling of politics, though even here, there is much common ground.
Both acknowledge the importance of the moderation of Labour and
Trade Union leaders in damping down the effects of political ac-
tivism; both attach significance to the growth of a new consensus
on planning and social reform, and to the popular feeling of 'Never
Again' at the end of the decade.[71] At the same time, as any reader
can detect, the two books exist in different political worlds. For
Branson and Heinemann, it is the 'great crusades and great radical
movements of dissent', from the Invergordon Mutiny through the

National Unemployed Workers' Movement, to anti-Fascism, which are of supreme importance.[72] The main political legacy of the Thirties is the 'conscious growth of anti-Fascist and democratic feeling', around 'mass issues on which millions of people were involved in some kind of protest action', undermining 'deference and respect for one's superiors', and making possible the Labour victory of 1945.[73] At the heart of this 1930s political mobilisation we find the extra-Parliamentary left, and particularly the Communist Party. When victories are won – for example, the containment of Mosley (Chapter 19) – the rank and file and their (usually Communist) leadership take the credit; when campaigns fail, it is the reformist and collaborationist leaders of the mainstream Labour movement who are usually to blame (see, for example, Chapter 8). For Stevenson and Cook, Communists are little more than a minority of trouble-makers, and extra-Parliamentary action is often discussed in terms of 'violence'. Such extremism is contained by the political system, backed up by a strong popular consensus, and political change comes not from the streets and the barricades, but through the conversion of 'middle opinion', and, in due course, through the ballot box. For Branson and Heinemann, though, extra-Parliamentary action is crucial in pushing on the pace of historical change at a time when the official political system has failed to respond to the nation's problems.

In fact, we seem to have found our elusive controversy. Critics of *The Slump* picked up mainly on its account of the impact of unemployment.[74] In doing so, they were responding to the book's rhetoric rather than to its substantive argument. The book presented itself, in provocative style, as a refutation of the 'hungry Thirties myth', and therefore, by implication, as denying the existence of mass suffering; in fact, its contents, though not immune to the criticisms of 'pessimists', show that the Thirties were quite hungry enough for very many people. It is not in its account of social conditions, but in its reading of their political consequences that the motivating argument of *The Slump* is to be found, as signalled by its subtitle 'Politics and Society during the Depression'. The message is that the system works. Despite all the threats of destabilisation which the Thirties posed – mass unemployment, Fascism, Communism – the essential continuity, stability and good sense of the nation were maintained. Change was indeed necessary, but it came in good time and in good order through the existing political channels. Political mobilisation outside these channels may

have been spectacular, but it was unnecessary – if anything, part of the problem (albeit a very minor part) rather than part of the solution. If the political system could achieve all that was required of it, no one need take to the streets to achieve things that were going to happen anyway. Consequently, no one should look back to the Thirties as a politically heroic age, or see its reputation for activism as an example to be followed when the country once again fell prey to political and social divisions.

What orthodoxy, then, was *The Slump* seeking to refute? Not that of historians, whose picture of events and conditions in the Thirties was largely confirmed. Partly that of the general public: as Howkins and Saville conceded, 'popular belief, including the understanding of many within the British labour movement, has accepted the mythology of crisis and unrelieved depression'.[75] Though the historiographical materials had long been available to construct a different picture, no one had seen fit to do so; as we have seen, the dominant postwar narrative served too many different ideological interests to be easily shifted, and what historians think only matters when other people decide that it does.

In fact, however, the message of *The Slump* was mainly directed at those on the Left, who, finding themselves in a renewed period of crisis and conflict, drew the analogy between the 1970s and that earlier age of political activism, the Thirties. In the series of crises and upheavals beginning in 1973–74, the end of the postwar period was announced. Globally, economic disruptions – inflation, rising energy prices and the onset of industrial recession – put an end to the consumerist optimism of the 1950s and 1960s. Internally, Britain experienced a period of ideological and political turmoil, in which both major parties lost public confidence, and both far left and far right seemed to be gathering support. There was a revival of Marxism among the intelligentsia, and the Communist veteran James Klugman, addressing an academic audience in 1977, suggested that this heralded a new period of political commitment, similar to the 1930s.[76] By 1974, says Kenneth Morgan, the 'cohesive civic culture' which had sustained Britain during and after the war was visibly crumbling; 'there seemed to be fewer agreed norms and values to which the community would respond'. Faith in Keynesian economic management, the welfare state and all kinds of social planning was rapidly ebbing. Public life became more confrontational, strikes more violent, streets and even football grounds more dangerous. 'There was not much left of the solidarity of the

forties and fifties, let alone the "Dunkirk spirit".' The fall of the
Heath government in the miners' strike of 1973–74, declares
Morgan, announced 'the erosion of an ethical system ... now with-
ering away in confusion and doubt'.[77] The ethical system in ques-
tion was the postwar consensus: its final *coup de grâce* was the
election of the Thatcher government in 1979.

In some respects, the Thirties had been reborn: rising unemploy-
ment, bitter strikes, violent demonstrations, radicalised intellectu-
als People had stopped believing in the postwar solutions. The
narratives of the Thirties which had sustained and been sustained
by the various currents of postwar opinion were no longer opera-
tive, because the end of the story had been changed: affluence and
security would not last for ever. The beginning of the story, too,
would need looking at again, and some of its unresolved contra-
dictions sorting out. This was the political moment at which *The
Slump* was published. There was no mention in its pages of the
turmoil of the 1970s. Nevertheless, readers did not have to look far
for its contemporary relevance: this, not its historiographical inter-
est, is what put it on the front page of the *Guardian* review section.
The Slump was not, as some of its critics have unfairly implied, an
apologia for mass unemployment, paving the way for Thatcherism.
Rather, its tone was liberal. It told a story in which the middle-
ground reformers, not the political activists, got things right;
patient work through the system achieved more than direct action;
and economic disruption did not necessarily spell political up-
heaval. In the left narrative of historians like Branson and
Heinemann, taking to the streets was the right way to respond to a
crisis, and had brought about real change: Thirties activism paid
off. While in the Fifties this was mere nostalgia – old soldiers' tales
– in the Seventies it had become dangerous romanticism. *The
Slump*'s liberal narrative argued against this left romanticism as
much as against the orthodoxies of historians or the misconceptions
of popular opinion.

ON YOUR BIKE TO BRIDESHEAD? THATCHERISM
AND THE THIRTIES

In the event, it was neither the extra-Parliamentary left nor the
social-democratic centre-left which received the inheritance of the
Seventies, but a reborn and rearticulated version of the Thirties

laissez-faire philosophy which Macmillan in 1966 thought had gone for good. In this new climate, the Thirties were up for grabs: either a lost age of stability and certainty which Thatcherism would restore, or a dreadful warning of the direction in which the nation was being led.[78] 'Optimist' and 'pessimist' historians did battle over the Thirties, as they once had over the Industrial Revolution, and it really did become an issue whether or not unemployment was bad for people, something which no one in the Fifties or Sixties had considered doubting. The debate became openly political, though both sides denied political motivation. 'Optimists' complained that they had been labelled as Thatcherites, while at the same time accusing 'pessimists' and the journals who published their work of deliberately 'present[ing] the Thirties in an unfavourable light in order to delegitimise Thatcherism'.[79]

Indeed, it was in the moment of Thatcherism that the Thirties, fleetingly, almost achieved a good press at last. The new regime of 1979 came to power buoyed up by a historical narrative which completely reversed that of the postwar period. The welfare state was no longer the solution, but the problem. The state-protected postwar era was one of flabbiness and decline, culminating in the self-indulgent excesses of the Sixties. What the country needed was a stiff dose of Victorian Values, transplanted from the very decade, the 1930s, when they had, allegedly, last held sway – when Norman Tebbit's father, we were told, had got on his bike to look for work, instead of leaning on the state. Along with the rehabilitation of the Thirties as an age of robust self-reliance came the soft-focus discourse of 'heritage' which all but silenced the modernising critiques of the Sixties: the past was now a good place to visit. Suffused in nostalgia, Granada TV's version of *Brideshead Revisited*, written by Waugh as an explicit attack on all 1945 stood for, was hailed as British television's crowning achievement; and a Wigan Pier heritage centre opened, complete with George Orwell pub, but celebrating 1900 rather than 1937 (though it is doubtful whether there was now any effective difference). Standing up to the dictators in Churchillian fashion, Margaret Thatcher used the Falklands War to rub out the bad memories of Munich and Suez, symbolically reversing a whole century of declining power, and bequeathing to her successor an imaginary England of warm beer, cricket and suburbia which, he professed to believe, could 'survive unamendable in all essentials'.[80] Who would have thought the Thirties would have their hour of glory so late in the day?

7

Pennies from Heaven: Revisiting the Thirties as Popular Culture

'The song is ended but the melody lingers on'
Arthur Parker in *Pennies from Heaven*

INTRODUCTION: NARRATING THE PAST

One of the main arguments of this book has been that the past is not simply a given body of facts, which presents itself to us fully formed, but that it is also a construct and, hence, the product of present concerns as well as past events. We have examined the way in which different interpretations of the Thirties have emerged since the end of that decade, highlighting the relationship between those historical narratives and the context in which they were produced and received. Clearly the deliberations of historians have been shaped by, or formed in reaction to, the dominant concerns of their own epoch. At the same time, historians' interpretations of a decade such as the Thirties may contribute to current debates about the nature and identity of British society, by plotting the continuities or disjunctures between past and present and, by implication, proffering lessons to be learned for the future.

Thus, in the last chapter we commented on the way in which Cook and Stevenson's book, *The Slump*, was taken up as part of a broad debate about Britain's political and economic crisis in the mid-seventies. Cook and Stevenson's 'revisionist' thesis received quite a wide coverage in the 'quality' press when it appeared in 1977, with the result that it reached a public beyond the groves of academe. On the one hand, *The Slump* was one more addition to a long-running internal debate among historians about the Thirties. On the other hand, it has been seen by its opponents as contribut-

ing to a shift in the political climate of the mid-Seventies and pro-
ducing effects beyond the normal confines of academic history.
Roger Bromley has argued that Cook and Stevenson's book was 'a
politically conservative act of memory', which addressed the 'inse-
curity of the present' by setting up an analogy between past and
present in which it was implied that, just as the crisis of the Thirties
had been overcome, so also would its successor of the Seventies
prove to be a temporary affair.[1] The connection between past and
present was articulated as a developing trajectory of historical
'progress', in which the inherently stable political and economic in-
stitutions of British society were able to survive and rejuvenate
themselves, through the struggle against temporary adversity and
'extremisms' of the left and the right. The lesson to be learned from
the past was that the centre-ground of British politics would hold
once again, just as it had in the crisis forty years previously.

In developing his critique of 'revisionist' narratives, Roger
Bromley implies that the rhetorical power of books like *The Slump*
derives as much from the form of the narrative as the content. The
narrative movement is triggered off by an irruption of disorder into
the essentially stable world of British society. However, the slump
is shown to be a 'mere interlude among chapters of "progress"'[2]
and, hence, 'an accidental, and temporary, *interruption* of the path
of capitalist development.'[3] Since the narrative is shaped and
guided by its journey to the homeland of the present ('the route to
now') it derives its meaning from the extent to which the past is
able to act as a pretext for a present in which the forces of radical
critique have been revealed as false prophets by 'history' itself.

Bromley argues that the form of this narrative structure is gov-
erned by the need to recover the continuity between past and
present and, thereby, to validate the hegemonic concerns of the con-
temporary social order. This process is also visible in those imagina-
tive and autobiographical reconstructions of the interwar period
which are the main focus of *Lost Narratives*. As Bromley notes:

> The work, because retrospective, will impose a teleological
> framework upon the 'remembered' The writer's present view
> of previous experiences and past emotions forms the referential
> context of these 'memoirs', what Cynthia Hay calls the patterned
> forms of distortion or schematization. The accounts are retrospec-
> tively edited to fit a particular frame of values – in most cases
> 'traditionalist'.[4]

In a detailed examination of a number of commercial autobiographies and popular romance stories based on the interwar period, Bromley demonstrates that they tend to foreground the biography of an 'individualised subject', the 'survivor', who 'made it', despite demoralising conditions, and who lived to tell the tale.[5] The economic crisis is seen in terms of broken relationships which are precipitated by the loss of male identity in the wake of unemployment. However, the image of the 'wasted years' gives way to one of 'empowerment' of the female subject and this displaces the more generalised economic crisis on to a specific, domestic breakdown which is solved through the individual (often entrepreneurial) action of the heroine. 'Coherence' and 'continuity' are restored, particularly at the level of 'spiritual' values, and the material economic crisis is pushed into the background in favour of a 'moral regenerative' narrative. Bromley sums up the whole process at the level of narrative form by concluding that the diachronic, developing axis of the narrative foregrounds a 'days of hope' theme, whilst the 'hard times' are 'part of a synchronic grasp only.'[6]

Clearly the narratives of a novelist like R. F. Delderfield, or Helen Forrester, are rather different from those of historians such as Cook and Stevenson. The popular romance is not required to test its discourse against the empirical reality of the period it is describing, except in terms of the authenticated 'experience' of the individual author/narrator or reader. Moreover, the novel is 'licensed' to create a fictional universe which extrapolates from and transforms objective reality through the medium of the imagination. Nevertheless, it is possible to identify parallels between the popular narratives analysed by Bromley and the historical narrative of the Thirties in Cook and Stevenson's *The Slump*. In both cases there is a diachronic movement which is driven by a teleological thrust forwards to the 'progressive' state of post-war Britain. (What Cook and Stevenson call 'the peaceful revolution which transformed British society in the middle years of the twentieth century'.)[7] The Thirties appears as 'a mere interlude among chapters of "progress"'.[8] The accent is placed on the survivors (individual in the case of the novels; institutional and collective in the case of the 'revisionist' historical narratives) whose resilience and powers of recovery laid the foundations for the 'rising prosperity of the second half of the twentieth century.'[9] It seems then that the way in which historians have constructed their narratives of the Thirties might be illuminated through comparisons with fictional narratives

based on the same period. Although the discursive rules and proto-
cols differ, as we have already pointed out, there are, notwithstand-
ing, certain similarities, both in form and content.

Up to now we have been examining the neglected role of narra-
tive forms in shaping historians' constructions of the Thirties.
Correspondingly, there is the question of how historical source ma-
terial is used by fictional writers in revisiting the past and what
notion of 'history' is posited by their narratives. The rest of this
chapter will be devoted to an exploration of the relationship
between history and fictional representations of the Thirties by fo-
cusing on Dennis Potter's *Pennies from Heaven*. We will be examin-
ing the dramatic strategies which Potter adopts for revisiting the
Thirties as a site of historical 'memory' and we will be asking
whether his approach to the interpretation of the past/present
relationship might have any bearing on the study of non-fictional
histories of the Thirties as well.

PENNIES FROM HEAVEN

Pennies from Heaven (1978), *The Singing Detective* (1986) and *Lipstick
on Your Collar* (1993) form what Graham Fuller has described as 'a
trilogy about the mediating effects of popular culture in, respec-
tively, Thirties, Forties and Fifties England.'[10] *Pennies*, set in 1935,
the year of Potter's birth, is concerned with the career of a travel-
ling song-sheet salesman, Arthur Parker. Arthur's search for a life
which will match the idyllic world of the popular songs he sells
takes him across the country in a picaresque journey away from
suburbia and his sexually-inhibited wife, into the arms of an infant
school teacher from the Forest of Dean (Potter's birthplace). The
plot is, in some ways, an English version of the American 'road
movie', with the innocents turning into criminals, *à la* Bonnie and
Clyde, as their desires conflict with dominant social codes. Thus the
narrative might be seen as a fairly straightforward tragic comment
on the failure of Depression England, as Eileen, the school teacher,
ends up a murderer and Arthur is hanged for a murder which he
has not committed. However, the coda delivers a more optimistic,
upbeat finale, in which Arthur 'escapes' the gallows and is trans-
ported to Hammersmith Bridge to be reunited with Eileen in sym-
bolic union. As Arthur comments: 'The song is ended but the
melody lingers on'. The ending rescues the tarnished anti-hero

Everyman from perdition through a device which refuses the 'realistic' limitations of the here and now in a manner reminiscent of Gay's *Beggar's Opera* and its Brechtian successor. In this sense, *Pennies* is as much an allegory or fable as it is a 'realistic' representation of Thirties' England, since it sets out to explore the 'myths' of the period as much as the 'objective reality'. Potter has made this clear in an interview with Graham Fuller:

GF: To be very literal about *Pennies from Heaven*, there seems to be no kind of moral order, inasmuch as Arthur is hanged for a crime he didn't commit.

DP: No, but he had committed various crimes, and it was like a lurid melodrama in that sense. But also, he comes back at the end. And it was showing how a simple and weak man nevertheless drew strength from what were simple and weak myths. It was the power of the mythologies, really, that I was dealing with ...

There was a feeling, at the end, that *Pennies* was a parable, a kind of morality tale in which the music and Arthur's weaknesses were the engines. The only good thing about Arthur, even though he was an adulterer and a liar and was weak and cowardly and dishonest, was that he really wanted the world to be like the songs, as he explained them, or tried to explain them in his less than articulate way. There was something that he was responding to, and although it was cheap and banal and all those things, he nevertheless had that part of himself that was responding to a myth of a kind, which was wanting the world to be better than he was. He couldn't quite manage it, but it was at those moments when he came alive. Those were the moments that were a kind of epiphany for him, a kind of blessing, even though he was made to suffer for it. When you have an inadequate set of beliefs, or if it's too flimsy to bear the weight, it will collapse, and it collapsed upon him. But the yearning for it was important.[11]

In *Pennies* Potter seems to be implying that it is not possible to use drama to document history without interrogating the very process by which historical memories are produced and reproduced in a mass-mediated culture. So, for example, he makes considerable use of popular songs from the Thirties, sung by Al Bowlly and other 'crooners' of the era but mimed by the actors to camera. These songs are not

presented simply as a decorative device, a form of background de-
signed to aid the realistic effect of the drama by providing period
'feel'. Rather, they become a crucial medium for articulating those
hidden fears and desires which constitute the suppressed imaginary
universe of the characters. At the same time, these songs function like
dreams in 'censoring' the realm of personal desire and containing it
within a discourse of sentimentality. For example, 'when at the outset,
Arthur's amorous advances are rebuffed by his pretty but cold and
socially ambitious wife, he slips into "The Clouds Will Soon Roll
By"'.[12] Thus, Potter makes it clear that in order to unlock the
'meaning' of the Thirties, one must examine it from the 'inside', focus-
ing on the contradictory way in which reality was imagined in and
through popular culture, rather than just the means by which it was
documented, at the level of newsreels or contemporary histories.

Apart from using Arthur's songs as a way of exploring the
Utopian dimensions of popular culture, Potter employs them as
devices to disturb the 'illusionist' nature of realist drama. Thus, he
will cut from a moment of intense dialogue to a comedy review
routine and the conventions of 'classic realism',[13] based on 'well-
rounded' characters and interpersonal conflicts, are suddenly dis-
pensed with. The characters become emblematic, rather than unique
individuals, as the actors on screen turn into singers in a popular
review or chorus (an effect reminiscent of Joan Littlewoood's *Oh!
What a Lovely War*). This 'estrangement effect' is clearly intended to
involve the viewer in a more active process of engagement with the
image on the screen, thereby encouraging a questioning, interroga-
tive attitude to the reality being relayed. So, the history of the
Thirties is seen as a set of representations which activate the cultural
memory of the viewer and the meaning of the drama is the outcome
of a creative dialogue between text and audience.

Thus *Pennies* can be seen as operating on two levels. First, there is
the reminder that the Thirties can only be conveyed to us through
mediations and, hence, that it is never a 'transparent' experience
which can simply be tapped by the dramatist and made available to
the audience. Second, there is the implication that the 'reality' of
any historical period is constituted both at the level of objective
structures and subjective consciousness. Thus it is crucial that the
songs be lip-synched, rather than sung by the actors, because
Potter's play is not just a musical in which the songs are emotional
amplifications of the action. Rather, *Pennies* comments on the im-
portance of popular song as a component in the construction of

identity on an everyday level – a crucial part of the subject's
imaginary universe.

'… THAT ENGLISH THING OF WANTING TO GO TO CHICAGO…'

A central theme in *Pennies* is the attraction of American populai
culture for British audiences, particularly the working class, in the
Thirties. A number of writers have commented on the raw, 'class-
less' connotations of American films and popular novels and their
appeal on this side of the Atlantic to an audience starved of positive
images of working-class life. As critics such as Ken Worpole have
noted, what attracted British audiences to the thrillers of Dashiell
Hammett, or Warner Brothers gangster films of the Thirties, was
the language and milieu of the American popular culture.[14] Dennis
Potter recognises this in his own background. In the interviews
with Graham Fuller he comments that: 'There is some sense in
which I have been Arthur Parker myself, attempting to escape
some of those rigidities of the English class system through demotic
popular drama.'[15] One of the attractions of going to Hollywood in
the early eighties and making a musical out of *Pennies* was that 'it
(Hollywood) was American culture, and therefore I was tapping
some part of my own mind.'[16] In particular, the direct contact with
American popular culture was important for exploring the 'roots'
of *Pennies* itself:

> There is a sense in which I wanted to take the musical back to its
> origins, i.e. the American musical, because that is what it is in
> Arthur's head. He had that English thing of 'wanting to go to
> Chicago', and there's the way he uses the word 'Chicago', almost
> like a touchstone.[17]

Thus, an important component of *Pennies* is the way in which
American popular culture acts as an antidote to 'the rigidities of the
English class system' for Arthur Parker and his creator. At the same
time, Arthur's weaknesses and sentimentality are also interpreted
as the product of an influence which is somehow 'alien' to the in-
digenous English culture. This 'external' factor is negatively coded
as 'Americanisation' and anxieties about its effects have been
central to the critical discourse of English intellectuals on both the
Left and the Right, as we have already seen. The ambiguity engen-

dered by the resulting cultural encounter is captured vividly in the following exchange between Potter and Graham Fuller:

GF: ... Your stance on America is double-edged.

DP: Yes, it is ambivalent. I am aware ... that America was a rewriting of the book, if you like. It was the New World and all that means. It has a genuinely populist culture, even though the other salesmen – expressing their English prejudice, which is both anti-Semitic and hierarchical – say to Arthur Parker in *Pennies*, 'Those songs? Come on Arthur. They're just written by Jew boys in green eyeshades.' But strip away that offensive way of putting it and, literally, that populist culture can be the result of someone sitting in an office, thinking, 'Does this work? Does that work? Will they like it in Peoria?' But it wasn't saying, 'Is this culture? Am I right?' It's a case of 'There's the goods, do you want to buy them?' which few Europeans would say about their culture. I don't want to see European culture reduced to that, but neither do I want to see European culture ignore it. That's the ambivalence.[18]

This 'ambivalence' is discernible in a range of European attacks on 'Americanisation', from the Thirties onwards. Thus, George Orwell argued that the stability of British popular culture was being unhinged by the 'anonymous life of the dance halls and the false values of the American film.'[19] Similarly, the German cultural critic, Theodor Adorno, who emigrated to the United States in the Thirties, described jazz, particularly 'swing', as a form of 'kitsch' which 'diverted' the listener from any critical engagement with his/her society:

Jazz is a form of manneristic interpretation. As with fashions what is important is show, not the thing itself; instead of jazz itself being composed, 'light music', the most dismal products of the popular-song industry, is dressed up.[20]

To a certain extent, Potter seems to share these misgivings about commercial popular culture and its putative malign effects, particularly the 'Americanised' variety. At one point in the interviews with Fuller, he refers to Arthur's belief in the songs as 'simple-minded'[21] and Arthur can be seen as a character who is merely symptomatic of the desire to escape the harshness of the Depression through fantasy. In that sense, the project of *Pennies*

might be interpreted as a fictional rendering of Richard Hoggart's
critique of mass culture in *The Uses of Literacy*, with Arthur being vi-
sualised as the precursor of those postwar teenagers who were
'living to a large extent in a myth-world compounded of a few
simple elements which they [took] to be those of American life.'[22]

It is not hard to see why Potter should have adopted this stance.
Like a number of figures of his generation, he was a writer with
left-wing sympathies whose attitude to popular culture was
influenced by the Leavisite/Hoggartian vein of cultural criticism.
Hence, if one refers *Pennies* back to the moment of its author's intel-
lectual formation, it is not surprising to find that it espouses a
version of 'Left-Leavisite' thought which is unable to deal with
many of the complexities of popular culture. However, if this were
all that *Pennies* amounted to, it would only have curiosity value as a
text which reflected certain attitudes associated with the Fifties and
early Sixties. What makes *Pennies* interesting is that there is a di-
mension of the text which does treat Arthur's songs as more than
mere escapism and thereby transcends Left-Leavisite critiques of
popular culture. Thus, in the interviews with Fuller, Potter empha-
sises the Utopian dimensions of the songs and the way in which
they function as 'latter-day psalms':

> There's a huge gap, obviously, between the psalms and those
> songs, but their function is not dissimilar. It's the idea of the
> world shimmering with another reality, which is what 'Button
> up your Overcoat' or 'Love is Just around the Corner', or 'Down
> Sunnyside Lane' are saying with their cute tink-tink syncopa-
> tions. They are both ludicrous and banal, reducing everything to
> the utmost simplification, but also, at the same time, saying, 'Yes,
> there is another order of seeing, there is another way, there is
> another reality.'[23]

POPULAR CULTURE AND THE 'EDUCATION OF DESIRE'

One way of explaining the ambiguous presentation of Thirties'
popular culture in *Pennies* would be to see it standing on the cusp
between Left-Leavisite thought and a more positive conceptualis-
ation of 'the popular'. The mid-Seventies witnessed something of a
sea-change in cultural theory, with increasing attention being paid
to the 'pleasures' of popular culture. This allowed critics and

writers to revisit the Thirties – the era of dance bands, Hollywood and the musical – in a less guilty, less inhibited manner. 'Entertainment' was re-examined as a concept which might have positive connotations, as seen for example in Richard Dyer's influential 1977 essay 'Entertainment and Utopia'[24] and there are interesting parallels between Dyer's rehabilitation of the American musical and the side of *Pennies* which celebrates Thirties' popular song.

In 'Entertainment and Utopia' Dyer argues that Busby Berkeley's Thirties' musicals embody a 'Utopian sensibility' which celebrates qualities such as 'abundance', 'energy', 'intensity' and 'community', thereby offering an implied criticism of a society based on 'scarcity, exhaustion, dreariness, manipulation and fragmentation.'[25] Perhaps Potter's nonconformist religious background would prevent him from embracing wholeheartedly the aesthetic dimension of Dyer's 'Utopian sensibility', with its accent on sexual 'abundance' and 'excess'. Thus, in Potter's schema the songs of Bowlly and Co. are appropriated within a latter-day version of William Morris' socialism, as people's 'hymns' or 'psalms'. Nevertheless, Potter does attempt to engage with the Utopian dimension of popular song, as demonstrated by the following extract from the interviews with Fuller:

> Singing is in line of descent from the psalms, a way of puncturing reality, the ordered structure of things as they are. As soon as we start to sing, dance, remember, things are not as they are. We are no longer just gathering in the hay, as it were. It's a weird thing to do – a non-animal thing to do. The angel in us.[26]

Taking the discussion one stage further, it is possible to see *Pennies* as a drama which highlights the historical importance of the Thirties as a decade when the 'education of desire'[27] was increasingly the province of mass-mediated popular culture. That is why it would be futile to read *Pennies* in the form demanded by Philip Purser when he castigates it for its lack of 'realistic' content:

> the real stumbling-block is that Potter's objective England of 1935 is not really any more substantial than the dream world of the songs. It is drawn not from life but from superficial associations with which the Thirties are lumbered. It was a good decade for murder, so there are a couple of murders. Prostitution flourished. Tory MPs were corrupt hypocrites clinging to their military rank.

Head waiters put jumped-up diners in their place. Buskers enter-
tained the cinema queues. You get the feeling of time and place
assembled from Great Western Railway posters, old Sunday
papers and the novels of Patrick Hamilton.[28]

There are two ways of responding to Purser's criticisms which
get to the heart of this chapter and the theme of our book as a
whole. First, Potter would be naive if he were claiming to be meas-
uring the 'dream-world' of his songs against an unproblematic,
pre-given 'objective reality' of the Thirties. What would that
'reality' look like anyway to the writer of the mid-Seventies, con-
structing his interpretation of the Thirties *post hoc* and relying on
the narratives of others for his representation of the past? Of
course, *Pennies* is 'derivative' (whether of Patrick Hamilton, or
Sunday newspapers, does not really matter) for how could it be
anything else? The point is, surely, to be aware of this fact and to
make it clear to others in your practice. Second, Purser is missing
the point entirely in implying that Potter has distorted the 'object-
ive reality' of the Thirties by seeing it through the filter of
'superficial associations'. Potter is actually trying to draw our at-
tention to the role of these 'associations', as mediated through
popular culture, in constructing our images of the past. What
Roland Barthes would call the 'mythology' of the Thirties is as im-
portant as the 'objective reality' in explaining both how the decade
appears to us now and how it was experienced by the historical
'actors', the Arthur Parkers of the time. After all, in an era of news-
paper circulation wars, dramatic headlines and stories about
murders or political corruption were, perhaps understandably, the
staple diet of the popular press. They are, therefore, not irrelevant
in reconstructing the 'cultural landscape' of the period and we
might ask Philip Purser why the 'feeling of time and place' should
not be 'assembled' from these and similar sources.

This is not to argue that Potter presents the past simply as a 'text'
or 'discourse'. Thus we would claim that his approach to the inter-
pretation of the Thirties is different from those stylistic appropri-
ations of bygone eras which Fredric Jameson characterises as 'retro'
culture. In *Postmodernism, or the Cultural Logic of Late Capitalism*,
Jameson argues that in the 'nostalgia' or 'retro' films of the last two
decades, 'the history of aesthetic styles displaces "real" history'. By
italicising the notion of 'real' history, Jameson implicitly acknowl-
edges the limitations of the position adopted by writers like Purser

who see 'objective' reality and history as entities which pre-exist
and pre-determine the sphere of representations in a simplistic
manner. Nevertheless, he is concerned about 'pastiches' of the past
as style and commodity and what he terms the 'aesthetic colonisa-
tion' of periods such as the Thirties. ('Witness the stylistic recupera-
tion of the American and Italian 1930s in Polanski's *Chinatown* and
Bertolucci's *Il Conformista*, respectively.'[29]) For Jameson, the 'stylis-
tic recuperations' of a period such as the Thirties, through Art Deco
design and the loving concentration on various 'period' signifiers,
are indices of a culture in which

> the past as 'referent' finds itself gradually bracketed, and then
> effaced altogether, leaving us with nothing but texts.[30]

We would argue that this is not the 'cultural logic' which under-
pins Potter's *Pennies*, and that he does not share a 'retro' approach
to the past. In the interviews with Fuller he makes it clear that he is
opposed to what he describes as 'a twee, Technicolor version of the
so-called past', and he is not interested in nostalgia as a 'means of
forgetting the past, of making it seem cosy, of saying, "It's back
there – look how sweet it was."'[31]

> An ache for what cannot be reclaimed is technically infantilism.
> The past isn't safely tucked away. Psychoanalysis or your own
> memory will tell you that what made you in the wider sense –
> your own culture, your own language, your own communality
> which you shared with your forebears – is actually shaping the
> future, too. It's people without a sense of the past who are alien-
> ated and rootless, and they're losers; they lose out.
> To make any political statemant you first of all have to know
> who and what you are; what shaped your life, what is possible
> and what isn't. That's not nostalgia. That's a kind of grappling
> with the past – an ache for it, perhaps, sometimes a contempt for it.
> But the past commingles with everything you project forward.[32]

Hence, Potter's appropriation of Thirties' popular culture is not
explicable as a form of stylistic 'pastiche', even as played out in the
knowing humour of postmodernism. Lurking behind his affection-
ate excursion into the past is a desire to recapture that 'historical
reality' which has been suppressed from 'popular memory' and
which might be recalled through a process of association. Here
'nostalgia' can be a powerful tool and an antidote to those organ-
ised, institutional forms of 'forgetting':

But you can use the power of nostalgia to open the past up and make it stand in front of you. This is why I use popular songs. Often the initial reaction is, 'Oh, how sweet to hear that thing again!' but then the very syncopations can bear in things that have been knocked away by the present and that are important, that tell you what you are, why you are doing what you are doing, and why every act that a person does has some significance. The ripples never quite die away.[33]

Seen from this point of view, Potter's 'ideological project' in *Pennies* has something in common with Jim Allen's *Days of Hope* and other radical political dramas of the seventies.[34] In both cases there is a concern with tapping those experiences and memories which belong to the 'structure of feeling' of a particular historical moment, but which have been lost or censored subsequently by the 'selective tradition' of socio-cultural transmission and 'recall' (those institutionalised forms of historical, cultural, literary thought, etc. which act as the official public 'memory' of society). However, whereas Jim Allen returns to the 'golden age' of militant working-class politics (in his case, 1916–26), celebrating the blossoming of the political consciousness of a former soldier and his transformation into a revolutionary Communist, Potter takes a rather different tack and explores the consciousness of an apolitical, unheroic 'little man' in the Thirties. This contrast is interesting, as the majority of radical writers and critics have tended to revisit the Thirties as the moment of political 'commitment' and a maturing Communist Party. Hence, one might have expected Potter to continue in this vein by recovering the lost memory of political struggle in the Thirties and making it available to a contemporary audience.

There are a number of ways of explaining this departure from the dominant practice of radical drama in the Seventies. Potter has always argued against overt didacticism in drama, stressing that it should try to capture politics in 'the wider sense' and not just be used to 'write a political essay'.[35] But, perhaps more importantly, he is concerned to explore consciousness at the cultural, rather than the directly party political level. By focusing on a figure such as Arthur Parker he is able to break with the tradition of political art which represents the working class purely in terms of its political life and ignores those struggles which are enacted on the terrain of popular culture.

In embarking on this exploration of popular culture, Potter should not be seen just as simply correcting an 'imbalance' in the treatment of working-class life, by drawing our attention to an area which has, hitherto, been neglected by radical dramatists. Rather, he is implying that it is the very existence of popular culture, in its modern, capitalist, mass-mediated form, which poses the crucial problems for socialist writers and critics – problems which cannot be wished away by the appeal to a politically autonomous working class, with its own separate cultural traditions. For, as Stuart Hall has argued, the whole 'remaking' of the working class, from the 1880s onwards, is inextricably bound up with the growth of a commercial popular culture:

> Everything changes – not just a shift in the relation of forces but a reconstitution of the terrain of political struggle itself. It isn't just by chance that so many of the characteristic forms of what we now think of as 'traditional' popular culture either emerge from or emerge in their distinctive form, in that period.[36]

It is for this reason that Hall is against privileging the 1930s as a period of 'heroic' political struggle, which somehow transcends the dynamics of modern capitalism by producing an independent, anti-capitalist working-class culture:

> I suspect there is something peculiarly awkward, especially for socialists, in the non-appearance of a militant, radical, mature culture of the working class in the 1930s when – to tell you the truth – most of us would have expected it to appear. From the viewpoint of a purely 'heroic' or 'autonomous' popular culture, the 1930s is a pretty barren period.[37]

There are some drawbacks to the way in which Hall formulates the issues here and we might want to argue that the tone is rather too polemical, particularly in the phrase 'a pretty barren period'. Nevertheless, the general point is valid and it is one that helps us to understand Potter's project in *Pennies*. We would claim that Potter's return to the Thirties is important, precisely because he does not adopt a naively romantic attitude to the culture of the working class. Arthur's consciousness is not formed within an autonomous world of popular culture. Instead, the songs in *Pennies* function as what Tony Bennett and James Donald call 'tokens' in the struggle for cultural hegemony between the dominant and popular classes.[38] For, as we have shown earlier, in Potter's dramas

popular songs are seen both to articulate an aching desire for Utopian alternatives to the 'here and now', whilst simultaneously functioning to contain and censor that longing within the bounds of 'common sense'.

Thus, Arthur's songs must be seen as part of a broader popular culture in which meanings are not fixed in advance, but are the result of contestation and struggle. For much of the time this struggle seems to be going against a radical or nonconformist outlook and Arthur's accommodation to the *status quo* is reflected in the 'escapist' use which he makes of the lyrics to brighten up his life. (In this sense, he might be seen as an example of that *petit bourgeois* mentality which novelists such as Hans Fallada and Alfred Döblin explored in the latter days of the Weimar Republic.)[39] At the same time, *Pennies* seems to imply that meanings can be altered through resistance and struggle. This is highlighted, as Philip Purser has noted, by 'the way in which certain songs are used more than once, or used in opposite contexts by different parties.' Hence, 'in one really surrealist instance the mysterious "Accordian Man" whom Arthur ... meets on the road leads a workhouse ensemble of sleeping tramps through "Serenade in the Night".'[40] What has been presented as a straightforward love song turns into a strange and poignant comment on adversity with bizarre, unnerving overtones. This is a moment when the culture does show signs of a 'heroic' potential for resistance, albeit not in the more straightforward 'political' sense which seems to lie behind Stuart Hall's understanding of the term.

It is worth noting here that Potter's fictional reconstruction of the Thirties by means of its popular culture does not just approach the period through its characteristic forms and artefacts. The songs are obviously central, but so also is the role of Arthur as a representative of the culture industries. He is a salesman, peddling sheet music to shops at a time when, despite the growth of the phonograph industry, 'songs were still to a large extent "consumed" from sheet music.'[41] Stuart Hall has argued that to write a history of popular culture, without taking into account the 'institutions of dominant cultural production', is 'not to live in the twentieth century'.[42] Thus, it is appropriate that Arthur is at the sharp end of the music industry, playing his part in the capitalisation of leisure between the wars. At this level his fictional role is clearly defined in functional terms and we do not need to make any recourse to psychological realism to interpret his 'character': he rep-

resents the impact of the twin apparatuses of Tin Pan Alley and Hollywood on popular music in the Thirties. This process has been charted elsewhere and can only be dealt with in summary form here.

By the 1930s Tin Pan Alley, the professional song-writing industry, was well-established in Britain, in London's Denmark Street. Indeed, Iain Chambers points out that professional 'plugging', to persuade artists to adopt particular songs and make them hits, was already an accepted practice by the early Twenties:

> 'Yes, We Have No Bananas', the rage of 1923, involved many hands in Tin Pan Alley and quoted numerous tunes; it was then 'plugged' and promoted until it became a 'hit'. It was a clear indication of the new realities in cultural production that had been established, at least in Britain and the United States, by the early twentieth century.'[43]

Through the 1920s British commercial popular music, in the form of music hall and its successor 'variety', was increasingly overtaken by American dance music – ragtime, jazz, etc. – and by the early Thirties the hegemony of the American music industry was well-established. Some of the songs which Arthur promotes in *Pennies* are played on the sound-track by artists such as Lew Stone, Jack Johnson and others whose dance bands reproduced American 'swing' for British audiences in the large West End dance halls, or on the BBC during the Thirties. Many of the dance bands were fronted by 'crooners' like Al Bowlly, who adopted a style of singing which had emerged in the States and had been promoted on both record and film:

> Alongside the success of US-derived dance music was the rise of the solo singer or 'crooner'. The individual emotionalism of the crooning style – 'the world of the private nightmare', as Richard Hoggart once acidly described it – was again of American origin. Rudy Vallee and Bing Crosby were the famous initiators, and later Frank Sinatra the most acclaimed practitioner. In Britain there was Denny Dennis, Al Bowlly, Peggy Dell and Evelyn Dall. Anglicized tones were maintained by the more restrained 'Englishness' of the British dance bands But undoubtedly the most influential image among these new musical styles was that provided by Hollywood in the 1930s with the arrival of sound film and the musical These films provided an insight into

another world: a world of relaxed male singers, elegant dancing, smooth sounds and stylized glamour.[44]

Thus Arthur is employed by a new culture industry which combines American popular song with the Hollywood musical to project what Chambers describes as 'a fantastic and seductive translantic imagery'.[45] Arthur's identity is bound up with a world of songs which represents a symbolic and stylistic alternative to the rigidities of traditional class and gender politics in England. Hence Chicago, Rio and other settings associated with the music of the dance hall and the musical connote a world of sexual 'diversion' and romance. At the same time, he is employed by an industry which is organised to make profit and which 'incorporates' all those who work for it, from music executives down to dance-band musicians and song-sheet salesmen. (Potter experienced this at first hand when he tried, unsuccessfully, to resist the attempts by Hollywood executives to turn *Pennies* into a straightforward musical, which inevitably removed some of the critical edge of the original.)

As we have already commented, Potter does not accept these tensions and contradictions at face value, but explores them in a critical manner by setting the Utopian content and style of the songs against the everyday reality of Arthur's existence at home and on the road. This juxtaposition of elements is crucial for understanding Potter's 'project' in *Pennies* and the standpoint from which he approaches the past. On one level, his point of entry into the Thirties is via the mechanism of an empathic identification with the dream world of the songs, so that the audience is invited to share the 'pleasures' which the images and sounds create. On another level, it is clear that 'we' (the mid-Seventies audience) are bound to have a particular 'take' on the Thirties and that the relationship to the past is not 'innocent'. That is why *Pennies* is constructed as a 'home-made musical' (Potter)[46] in which the conflict between fantasy and reality is foregrounded. By contrast, MGM's version of Potter's drama revolves around huge 'production numbers', so that fantasy invades and conquers quotidian reality precisely by turning it into a Hollywood musical. Moreover, the contrast between the 'domesticity' of Arthur's world and the larger Utopian realm of the songs functions as a metonymic representation of the wider power relations between British and American culture which are firmly established by the Thirties and have proved to be so contentious ever since.

CONCLUSION

In 'Notes on Deconstructing "The Popular"' Stuart Hall claims that 'many of the real difficulties (theoretical as well as empirical) will only be confronted when we begin to examine closely popular culture in a period which begins to resemble our own, and which is informed by our own sense of contemporary questions.'[46] On this basis, he argues that the period of 1880 to 1920 is more important than that of the 1930s, since the former witnessed the 're-making' of working-class culture under the influence of popular imperialism, resulting in 'that containment of popular democracy on which "our democratic way of life" today appears to be so securely based.'[47] By contrast, the Thirties seems to represent something of a blind alley for Hall, since it can only register an absence – the non-appearance of that 'heroic' popular culture which socialist critics might have expected from this period of political radicalisation and commitment. Hence, Hall concludes, 'It isn't by chance that very few of us are working in popular culture in the 1930s.'[48]

Whilst we share Hall's reservations about naive romantic constructions of working-class and popular culture, we would argue that his rejection of the Thirties as a period which might 'resemble our own' is perhaps somewhat premature. After all, the Thirties is the period which witnesses the establishment of Hollywood and the American music industry as important influences on English popular culture. Thus, we would consider it entirely appropriate for Potter to begin his long investigation of 'the mediating effects of popular culture'[49] in this period, for many of the lineaments of the post-War culture, which Potter examines in *The Singing Detective* and *Lipstick on Your Collar*, particularly the contradictory impact of American popular culture on popular consciousness, are also discernible in the Britain of the Thirties.

In his final interview with Melvyn Bragg, Potter commented on the complex, mediated relationship between popular culture and history which was at the heart of dramas such as *Pennies from Heaven*:

MB: What about bringing in popular songs, as you did with *Pennies from Heaven*?

DP: ...I wanted to write about the way popular culture is an inheritor of something else. You know that cheap songs, so-called, actually do have something of the Psalms of David

about them. They do say the world is other than it is. They
do illuminate. This is why people say, 'Listen, they are
playing our song.' It's not because that particular song ac-
tually expresses the depth of the feelings that they felt
when they met each other and heard it. It is that somehow
it re-evokes and pours out of them yet again, but with a dif-
ferent coating of irony and self-knowledge.[38]

This exchange sums up all that is innovative and compelling
about *Pennies from Heaven* as an interrogation of popular culture in
the Thirties – an attempt to construct a 'popular memory' of that
decade which is adequate to the contradictions of the era. On the
one hand, there is the commitment to the Utopian dimension of
culture which leads Potter to acknowledge the formative role of
American popular culture in the experience of his own and subse-
quent generations, as an important alternative to a class-ridden, es-
tablishment English culture. On the other hand, he realises that
popular culture does not simply offer alternative truths which have
been suppressed by a hegemonic social and cultural order. The
popular songs of the Thirties might have had 'something of the
Psalms of David about them', but they were also mediations of a
reality in which they were complicit. Part of their truth lay in the
discrepancy between the idealised images of life which they pro-
jected and the day-to-day experience of their listeners in an
England of the Depression. Life was never really quite like that!

Thus we would argue that the project of *Pennies from Heaven* is to
explore the ambivalent relationship between popular culture and
popular consciousness in the context of the Depression. Potter's
play highlights the role of American popular culture as the reposi-
tory of alternative values to those of a staid, hidebound prewar
English establishment and, as Potter emphasises in that last,
poignant interview, the popular songs 'illuminate' Arthur's world
by transforming it in line with his desires for a world that is 'other
than it is', so that the Great Western Road can appear to be bathed
in the light of the 'Prairie Moon'. At the same time, in its use of in-
novative dramatic techniques *Pennies From Heaven* constantly con-
fronts the viewer with the mediated nature of these alternative
representations of reality and the fact that they are ultimately
someone else's constructions, the products of a fast-developing
(largely American-owned) culture industry. Thus, what might, at
first sight, seem to be a nostalgic return to the Thirties is actually a

powerful plea for a politics which is able to unite the Utopian dimensions of popular culture with a critical 'irony and self-knowledge'.

Finally, it is interesting to note that Potter chooses to focus on the figure of the 'little man' as a way of exploring the Thirties, a theme which was to prove quite prescient, given the accession of Margaret Thatcher to power in the year following the screening of *Pennies from Heaven*. With Potter's drama one already has, perhaps, an inkling that the era of postwar social democracy was over for a while and that the narratives of the New Right were about to gain the ascendancy. Thatcherism mobilised a different 'memory' of the Thirties and the Depression, accentuating the resilience of a 'Great Britain' of individual, entrepreneurial citizens, rather than collectivities. In the next chapter we explore *The Remains of the Day*, a narrative which attempts to explain the relevance of the Thirties for the present in terms of Conservative values, thus highlighting the extent to which the political and cultural climate has shifted since the Seventies. At the same time, Ishiguro's novel and the Merchant/Ivory film adaptation of *The Remains of the Day* reveal continuities with Potter's drama in terms of their concern with the consciousness of the apolitical 'little person' and his/her desire for self-fulfilment. Moreover, we would argue that Ishiguro returns to the Thirties as the moment of inspiration for a re-emergent social democracy. Thus his novel celebrates a 'Britishness' which is not coterminous with social hierarchies, but which articulates an alternative, democratic narrative of social and national identity to that which emerged in Thatcherism and the 'authoritarian populism' of the Eighties.

8

'A Feeling for Tradition and Discipline': Conservativism and the Thirties in *The Remains of the Day*

Conservatives are not xenophobic. We are patriotic.
> Michael Portillo, Secretary of State for Employment, in his speech to the Conservative Party Conference: 12 October 1994

In order to combat Fascism it is necessary to understand it, which involves admitting that it contains some good as well as much evil.... Everyone who has given the movement so much as a glance knows that the rank-and-file Fascist is often quite a well-meaning person – quite genuinely anxious, for instance, to better the lot of the unemployed. But more important than this is the fact that Fascism draws its strength from the good as well as the bad varieties of conservatism. To anyone with a feeling for tradition and discipline it comes with its appeal ready-made.
> George Orwell: *The Road to Wigan Pier* (Harmondsworth: 1970. First published in 1937), p. 137

The year 1989 witnessed the publication of Kazuo Ishiguro's novel, *The Remains of the Day* and the tenth anniversary of Margaret Thatcher's Conservative government. At first sight there might seem to be little in common between the two events. Ishiguro's narrative focuses on life in an aristocratic country house before and after the Second World War, finishing in 1956. The novel offers a retrospective view of the English upper class of the prewar period, especially the Thirties, as seen through the eyes of a devoted butler, Stevens, whose employer, Lord Darlington, flirts with Fascism. At the same time, this 'Upstairs/Downstairs' narrative explores Stevens' repressed sexuality and his inability to engage in a relationship with the housekeeper of Darlington Hall, Miss Kenton.

Hardly the stuff of Eighties' entrepreneurial Conservatism one might think, and it would surely be futile to draw any parallels between Ishiguro's 'nostalgic story of lost causes'[1] and the confident, upbeat world of Thatcherism which was more concerned with making history in the present than dwelling on the past.

Yet, as a number of commentators have argued, Thatcherism was able to constitute itself as a hegemonic political discourse in the Eighties by virtue of its ability to colonise the past as well as dominate the present. Hence the period of the Thirties was recalled as a moment when traditional Conservative values, centring on the individual and the family, held sway, as against a period such as the Sixties, when the 'nanny state', trade unionism and 'permissiveness' threatened to undermine individual initiative and destroy the fabric of the nation. In the rhetoric of the New Right the Thirties became associated with 'order', 'discipline' and 'security', rather than economic crisis and political uncertainty. So, as Andy Croft has pointed out, whereas the Labour Party warned against a return to the Thirties, Mrs Thatcher appealed for a return to that decade for inspiration. 'Her response to the riots of 1981 was to recall (quite wrongly) that the unemployed never rioted during her childhood – the 1930s. Norman Tebbitt's attitude to the unemployed was characterised by his wheeling on his father's ghost 'an unemployed man who went out on his bike looking for work, rather than relying on the dole'.[2]

Hence there may be some point in comparing Ishiguro's 'nostalgic story of lost causes' and the New Right's attempt to restate 'lost' conservative values at a time of political change and uncertainty. In both cases there is an attempt to address national identity in a post-imperial age by returning to what might be seen as the high point of Empire in the Thirties; both concern themselves with the preoccupations of the apolitical 'little man' and his 'natural' ties with conservatism. In this chapter we will be examining the representation of notions such as 'order', 'tradition' and 'service' in *The Remains of the Day*. We will be considering the criticisms which have been levelled at the novel, and the Merchant/Ivory film adaptation, as a representation of 'Englishness' which subscribes to a heritage version of history in its presumed celebration of an old prewar order based on the aristocracy. In response to these criticisms, we will be arguing that both book and film constitute more than a nostalgic reverie – 'a lament for lost grandeur', as one critic has put it.[3] Rather, *The Remains of the Day* highlights the contradictions of a rigid, stratified social order which puts duty and obedience to the nation above

demands for social equality and emotional expression. Thus, al-
though it uses the Thirties as a touchstone for debates about English
values, *The Remains of the Day* adopts a radically different perspec-
tive from the anti-permissive rhetoric of the New Right.

At the same time, we shall see that *The Remains of the Day* does
not associate discourses of the right exclusively with negative
values. As Orwell commented in *The Road to Wigan Pier*, even
Fascism draws on 'the good as well as the bad varieties of conser-
vatism' and the portrayal of a figure such as Lord Darlington is de-
signed to highlight the 'positive' side of Fascism and the reason
why it might have appealed to 'honourable' members of the estab-
lishment in the Thirties. Thus our discussion of *The Remains of the
Day* will touch on the relationship between 'patriotism' and 'xeno-
phobia', and the way in which the more 'accepted' member of this
pairing in conservative discourse may metamorphose into its less
respectable relation, particularly at moments of political crisis.
Hence, we will argue that the project of Ishiguro's novel is not to
present the past nostalgically, as a 'foreign country' to which we
can never return. To the contrary, his concern is to explore the rela-
tionship between the Thirties and the present as possibly analogous
periods in history, to the extent that they are both moments when
conservative discourses of 'people' and 'nation' are seen to be
coming under increasing pressure.

The narrative of Ishiguro's novel is related in the first person,
from the viewpoint of the butler at Darlington Hall, Stevens, who
ponders the changes which have taken place since he took up
service. Although the core of the novel is concerned with the
Thirties, the diegetic time actually stretches from the aftermath of
the First World War to 1956. (In the film it is somewhat different,
with the inter-war period being confined to the Thirties.) At the
opening of the novel in the 'present' of 1956, Darlington Hall has
just changed hands, the old Lord having died without an heir and a
new American owner, Farraday, having taken his place. Stevens,
who has been working hard to get the Hall into something resem-
bling its old state, but with greatly reduced staff, has been given
time off by his new employer and told to take the car and 'drive off
somewhere for a few days'.[4]

At first Stevens is loath to leave the house and he does not take
kindly to Farraday's implied criticism of his isolation from the rest
of England and life in general. Farraday's comment: 'You fellows,
you're always locked up in these big houses helping out, how do

you ever get to see around this beautiful country of yours?' is met with the rather stiff reply that: 'It has been my privilege to see the best of England over the years, sir, within these very walls.'[5] However, he warms to Farraday's offer after receiving a letter from the former housekeeper, Miss Kenton, who had left the Hall in 1936 to marry another butler, Mr Benn, but is now in the process of separating from her husband. Stevens sees a chance of recruiting his old housekeeper again, although we soon suspect that this is not the only object of his journey and that he also hopes to be able to make up for the mistakes of the past by acknowledging his real feelings for her, which he had suppressed when they had served together at the Hall, so that she will not be forced into leaving again.

As Stevens prepares for his journey, it becomes clear that Farraday is right and that the butler is very much a period piece, who is out of touch with postwar England. The clothes he takes with him, such as the suit passed on to him in 1931 by Sir Edward Blair, help to indicate this in the novel and the film is even more direct, with his American master telling him that he and the car (a prewar Bentley in the film) 'belong together'. In a playful conceit, Ishiguro has Stevens preparing for the journey by consulting 'the relevant volumes of Mrs Jane Symons's *The Wonder of England*'[6] (that author being a fictitious character who has visited Darlington Hall in the Thirties). The butler concludes that although the august Mrs Symons's work was written during the Thirties, 'much of it would still be up to date – after all, I do not imagine German bombs have altered our countryside so significantly' – a statement which acts as a witty, but also rather wistful comment on his hermetically-sealed existence at the Hall. (This is 1956, of course, over ten years after the cessation of hostilities!)

'THE WONDER OF ENGLAND'

Stevens' journey takes him across the rural landscape of South-West England, from Darlington Hall near Oxford, via Salisbury, to his eventual destination in Cornwall, where Mrs Benn now lives. The journey takes on mythical dimensions as it turns into a 'quest' to rescue Mrs Benn (or 'Miss Kenton', as Stevens insists on calling her) from what she has referred to in her letter as a life of 'emptiness' and what he suspects may be cruel treatment at the hands of her husband. Moreover, it is a search for the values which are asso-

ciated with what Patrick Wright terms 'Deep England' – a 'real' and discursive entity composed of both the landscape and the 'ancestral nation'.[7]

Thus, at the start of the quest Stevens is hailed by an archetypal old rustic, who informs him that if he climbs a nearby footpath, he will be able to enjoy one of the best views in England. Stevens follows the old man's advice and duly spies a 'marvellous view' of a typical 'rolling' landscape, which undulates 'gently' and contains the traditional markers of English rural life – sheep and 'the square tower of a church'. It is this view which sets him in 'a frame of mind appropriate for the journey before me'[8] and which 'remains' with him at the end of the day when he rests in Salisbury:

> And yet tonight, in the quiet of this room, I find that what really stays with me from the first day's travel is not Salisbury Cathedral, nor any of the other charming sights of this city, but rather that marvellous view encountered this morning of the rolling English countryside. Now I am quite prepared to believe that other countries can offer more obviously spectacular scenery... but I will nevertheless hazard this with some confidence: the English landscape at its finest – such as I saw this morning – possesses a quality that the landscapes of other nations, however more superficially dramatic, inevitably fail to possess. It is, I believe, a quality that will mark out the English landscape to any objective observer as the most deeply satisfying in the world, and this quality is probably best summed up by the term 'greatness'.... We call this land of ours *Great* Britain, and there may be those who believe this is a somewhat immodest practice. Yet I would venture that the landscape of our country alone would justify the use of this lofty adjective.
>
> And yet what precisely is this 'greatness'? Just where, or in what, does it lie? I am quite aware that it would take a far wiser head than mine to answer such a question, but if I were forced to hazard a guess, I would say that it is the very lack of obvious drama or spectacle that sets the beauty of our land apart. What is pertinent is the calmness of that beauty, its sense of restraint. It is as though the land knows of its own beauty, of its own greatness, and feels no need to shout it. In comparison, the sights offered in such places as Africa and America, though undoubtedly very exciting, would, I am sure, strike the objective viewer as inferior on account of their unseemly demonstrativeness.[9]

In *On Living in an Old Country* Patrick Wright argues that to be an ideological subject of Deep England is 'above all to have been there – one must have had the essential experience... one must have experienced that kindling of consciousness which the national landscape and cultural tradition prepare for the dawning national spirit.'[10] Stevens' articulation of an aesthetics (and, by implication, a politics) of 'restraint', which is somehow ingrained in the very contours of the landscape, is central to this notion of an *inherently* superior 'Deep England'. Moreover, it is this 'England' which forms the ideological core of British identity, as Stevens implicitly recognises, and which supposedly reveals itself to its 'natural' subjects in a quasi-mystical fashion, particularly at moments of crisis.

Stevens' own 'epiphany' on the Oxfordshire hills comes at a time of crisis and potential renewal for both himself and the nation. This is 1956, the year of Suez, when Britain has to decide whether it wants to continue deluding itself that it is still a 'great' imperial nation, or finally step on to the threshold of the post-imperial world. (Suez is never invoked directly in the novel, but it forms a shadowy presence off-stage and one of the figures Stevens encounters on his travels, Dr Carlisle, speaks in favour of independence for the colonies.) Since this is a moment of crisis, it is also the point at which the 'false consciousness' of Deep England is potentially at its strongest and we see this obliquely with Stevens' 'discovery' of his national identity. On one level, it might seem as if the ideal of 'restraint' would be appropriate to the moment, in guiding Britain away from aggressive, interventionist action. In fact, this ideal really functions as an ideology, as Edward Said has pointed out, providing the 'civilised' veneer of decorum at the heart of the Empire in England, which is then the rationale for continuing rule overseas.[11] Thus, as long as individuals such as Stevens embrace an ideology of '*Great* Britain', their celebration of 'restraint' can only serve to suppress any criticism of imperialism, rather than offering an alternative course of action. This is why it is important for Stevens to discover at the end of the novel that his commitment to 'restraint' was a form of false consciousness at the level of his own personal history, and it is this discovery which supersedes the false epiphany at the beginning, offering a different interpretation of his identity and, by implication, 'Englishness' itself.

One way of interpreting Stevens' moment of insight on the Oxfordshire hills would be to argue that he is experiencing and

'reading' England through the eyes of Thirties' Conservatism.
Cultural historians such as Martin Wiener and Patrick Wright[12]
have pointed out that the quest for the 'real' England was one of
the established tropes in the public culture of the immediate
prewar years. However, 'England' spoke to commentators in dif-
ferent ways: as the industrious working-class in documentary film,
the radical populace in Priestley's fiction and journalism, or the
ancient land of rural tradition:

> If this is a time when an upper-class idealisation of 'tramping'
> coexists uneasily with hunger marches, homelessness and unem-
> ployment, it is also the time of Baldwin's 'England': a kind of
> Conservative government by aspic which... was clearly advo-
> cated in its 'historical' dimension by Arthur Bryant, the 'anti-
> materialist' Tory who made such a rousing case for the preserva-
> tion of rural England and who spoke of 'the spirit of the past' as
> that 'sweet and lovely breath of Conservatism'.[13]

In *English Culture and the Decline of the Industrial Spirit*, Martin
Wiener explores this Conservative appropriation of England's past
in some detail, citing a series of BBC talks by Arthur Bryant in
1933–34 on the subject of the 'national character' as an example of
the way in which the yeoman farmer was seen as 'the common an-
cestor of nearly every Englishman'.[14] Although industrial capital-
ism had intervened to create a new set of social relations (and,
incidentally, the modern Tory Party), Conservatives such as Bryant
and Baldwin still looked back to pre-industrial England for their
inspiration. So, one finds the best-selling novelist Philip Gibbs re-
minding his readers of the continuity and timelessness of English
rural life at the height of the Abdication Crisis:

> England is not to be judged by the monstrous ant heap called
> London or by the tabloid press which panders to the lowest
> common denominator of mob psychology. There is still the
> English countryside, where life goes on traditionally in old farm-
> steads and small villages. There are the cathedral cities where
> time stands still, and where there is tranquillity of mind. In the
> old market towns the young farmers who come in with their
> sheep and cattle belong to Hardy's England, and their minds
> follow the same furrows. Their blood is the same. Their charac-
> ter has not been changed much by modern fretfulness and
> 'nerves'.[15]

Of course, there were various inflections of this idealised 'Deep England' in Conservative ideology. On the one hand, there was Stanley Baldwin's sentimental celebration of the landscape as a set of unchanging visceral and aesthetic experiences:

> The sounds of England, the tinkle of the hammer on the anvil in the country smithy, the corncrake on a dewy morning, the sound of the scythe against the whetstone, and the sight of a plough team coming over the brow of the hill, the sight that has been seen in England since England was a land, and may be seen in England long after the Empire has perished and every works in England has ceased to function, for centuries the one eternal sight of England.[16]

Set against this comforting Conservative vision of rural England was the more 'robust', vitalistic version of the myth in Fascist ideology. Here the 'healthy' English yeoman was contrasted with the 'degenerate', cosmopolitan stock associated with 'Jewish' capitalism or Bolshevism:

> Taken to extremes, the discontent with urban industrialism and nostalgia for Old Rural England could nurture fascist-like political sentiments…. Rawdon Hoare, returning from fourteen years in the Empire, found England in 1934 decadent, with pacifism and hedonism rife and Americanization in full swing. The countryside was being destroyed by unregulated urban expansion directed by land speculators, often Jewish… Oswald Mosley denounced the transformation of 'Merrie England' into a 'sweatshop and slum' – 'the green beloved country becomes the playground of the stockjobber.' Mosley contrasted the 'virile country stock' and the 'yeomen of England' with the degenerate urban figure of the 'long-haired intellectual.'[17]

'DIGNITY'S NOT JUST SOMETHING FOR GENTLEMEN!'

We shall be returning to the relationship between Thirties Fascism and Conservative myths of 'Deep England' at a later stage in our analysis of The Remains of the Day. However, it is important to point out at this stage, if it is not already clear, that Ishiguro does not espouse this ideology himself. In fact, he highlights the limitations of Stevens' unreconstructed prewar conservatism by bringing him

face to face with the social-democratic politics of the new postwar
Britain in a crucial encounter towards the end of his journey. When
the unwordly butler runs out of petrol near a small village in
Devon, he is put up by a sociable couple. Stevens' arrival in the
village is an excuse for people to drop in on his hosts, the Taylors,
and soon he is engaged in a discussion about definitions of the
English gentleman. Mr Taylor comments that Stevens is obviously
a 'true gentleman', although he finds it difficult to explain what he
means in precise terms.

> It's not just the cut of your clothes, nor is it the fine way you've
> got of speaking. There's something else that marks you out as a
> gentleman. Hard to put your finger on it, but it's plain for all to
> see that's got eyes.[18]

When asked to expand on Taylor's intuitive definition, Stevens
replies rather pompously that, while it is 'hardly for me to pro-
nounce upon qualities I may or may not possess,... the quality
being referred to might usefully be termed "dignity"'.[19] Because he
has never been questioned on this definition before and as it seems
to satisfy most of the assembled company, Stevens sees 'little point
in attempting to explain this statement further'.[20] However, he is
challenged by one of the villagers, Harry Smith, who maintains that
dignity is not just something 'gentlemen' have, but that it is a
quality 'every man and woman in this country can strive for and
get.'[21] Smith goes on to deliver a peroration on the rights of the
English citizen which registers the continuing impact of 'war radi-
calism' and the changes which have been wrought in the conscious-
ness of the villagers since the Thirties:

> Dignity's not just something for gentlemen... That's what we
> fought Hitler for, after all. If Hitler had had things his way, we'd
> just be slaves now.... That's what we fought for and that's what
> we won. We won the right to be free citizens. And it's one of the
> privileges of being born English that no matter who you are, no
> matter if you're rich or poor, you're born free and you're born so
> that you can express your opinion freely, and vote in your
> member of parliament or vote him out. That's what dignity's
> really about, if you'll excuse me, sir.[22]

Later on, after he has gone to bed, Stevens reflects on Harry
Smith's speech. He feels that there is 'surely little in his statements
that merits serious consideration' and yet the villager's argument

has obviously disturbed him. Smith's commitment to a participatory democracy has challenged Stevens' deferential Conservatism and he responds by commenting that it is 'far too idealistic, too theoretical, to deserve respect.'

> Up to a point, no doubt, there is some truth in what he says: in a country such as ours people may indeed have a certain duty to think about great affairs and form their opinions. But life being what it is, how can ordinary people truly be expected to have 'strong opinions' on all manner of things – as Mr Harry Smith rather fancifully claims the villagers here do? And not only are these expectations unrealistic, I rather doubt if they are even desirable. There is, after all, a real limit to how much ordinary people can learn and know, and to demand that each and every one of them contribute 'strong opinions' to the great debates of the nation cannot, surely, be wise. It is, in any case, absurd that anyone should presume to define a person's 'dignity' in these terms.[23]

In order to prove his point, Stevens recalls an episode at Darlington Hall in the mid-Thirties, when his master had been entertaining one night and the butler was called in to 'replenish refreshments'. One of the guests, Mr Spencer, had used the opportunity to demonstrate the futility of universal suffrage by interrogating Stevens on a number of technical questions about politics and economics, such as whether the currency problems in Europe would be improved if the French and the Russians concluded an arms agreement. Because Stevens was 'unable to be of assistance in this matter', Spencer felt able to claim that parliamentary democracy was irrelevant in a modern world of increasing specialisation and complexity:

> 'You see, gentlemen,' Mr Spencer said, turning to the others, 'our man here is unable to assist us in these matters.'
> This brought fresh laughter, now barely suppressed.
> 'And yet,' Mr Spencer went on, 'we still persist with the notion that this nation's decisions be left in the hands of our good man here and to the few millions others like him. Is it any wonder, saddled as we are with our present parliamentary system, that we are unable to find any solution to our many difficulties? Why, you may as well ask a committee of the mother's union to organize a war campaign.'[24]

Stevens' own response to this distasteful episode makes it clear that he did not experience anything more than a 'slightly uncomfortable situation' and he assumes that the reader will 'no doubt agree that any decent professional should expect to take such events in his stride.'[25] Moreover, he avers that whereas the ideas of people like Spencer may seem 'odd' and 'unattractive' there is still 'an important element of truth in these things':

> Of course, it is quite absurd to expect any butler to be in a position to answer authoritatively questions of the sort Mr Spencer had put to me that night, and the claim of people like Mr Harry Smith that one's 'dignity' is conditional on being able to do so can be seen for the nonsense it is. Let us establish this quite clearly: a butler's duty is to provide good service. It is not to meddle in the great affairs of the nation. The fact is, such great affairs will always be beyond the understanding of those such as you and I, and those of us who wish to make our mark must realize that we best do so by concentrating on what *is* within our realm; that is to say, by devoting our attention to providing the best possible service to those great gentlemen in whose hands the destiny of civilization truly lies.[25]

However, by this stage in the narrative it is obvious that Stevens' disquisition on the 'natural' order of politics is hardly likely to convince an impartial reader. His ritual humiliation at the hands of the sardonic Spencer, and Lord Darlington's unwillingness to check his obnoxious guest, highlight the insidious appeal of authoritarian politics to a section of the establishment in the Thirties. By this time Darlington has become a 'Fellow Traveller of the Right'[26] and the following day he justifies Stevens' ordeal at the hands of Spencer as follows:

> 'It really was quite dreadful. But you see, Stevens, Mr Spencer had a point to prove to Sir Leonard. In fact, if it's any consolation, you did assist in demonstrating a very important point. Sir Leonard had been talking a lot of that old-fashioned nonsense. About the will of the people being the wisest arbitrator and so on. Would you believe it, Stevens?'
> 'Indeed, sir.'
> 'We're really so slow in this country to recognize when a thing's outmoded. Other great nations know full well that to meet the challenges of each new age means discarding old, some-

times well-loved methods. Not so here in Britain. There's still so many talking like Sir Leonard last night. That's why Mr Spencer felt the need to demonstrate his point. And I tell you, Stevens, if the likes of Sir Leonard are made to wake up and think a little, then you can take it from me your ordeal last night was not in vain.'[26]

Darlington's flirtation with Fascism is not just confined to abstract debate about the presumed demerits of parliamentary democracy and the need for a corporate state. Although Stevens is concerned to reject the charges of anti-Semitism which were subsequently levelled at his master, it transpires that there is a skeleton in the cupboard. Stevens is forced to admit that the 'absurd allegations' against his lordship may stem from an episode in the summer of 1932, when Lord Darlington fell under the influence of Mosley's blackshirts and, as a consequence, 'entirely untypical incidents took place at Darlington Hall.'[27] One of these 'minor' incidents had been the sacking of two Jewish maids which Darlington had justified in terms of the 'safety and well-being of my guests.'[28]

Reflecting on his response to this incident back in the narrative 'present' of 1956, Stevens acknowledges that the reader may be rather dismayed by Darlington's actions, especially in view of the fact that 'the Jewish issue has become so sensitive of late.'[29] Although he does not mention the concentration camps and the trials of war criminals, Stevens' rather clumsy reference to the changed historical context does indicate that he has some awareness of the enormity of Darlington's decision to sack the maids. Moreover, Stevens remembers that he had doubts about the morality of the decision at the time and he claims that 'my every instinct opposed the idea of their dismissal.'[30] Nevertheless, there was never any doubt in his mind that loyalty to his master naturally took precedence over the human rights of the Jewish maids:

> my duty in this instance was quite clear, and as I saw it, there was nothing to be gained at all in irresponsibly displaying such personal doubts. It was a difficult task, but as such, one that demanded to be carried out with dignity.[31]

The terrible irony of Stevens' reference to 'dignity' in this context and the hollowness of his concept of duty (echoing Adolf Eichmann's defence at his trial for mass murder?) contrast with Miss Kenton's humanitarian response to the dismissals. She has no

doubts about the immoral implications of the decision, arguing that it is 'a sin as any sin ever was one' and stating that she will 'not continue to work in such a house' if the maids are forced to leave.[32] Miss Kenton represents a different discourse, then, that of a Christian humanitarian creed which is shocked by Fascism. However, she is not able to break away from Darlington Hall and she is bitterly disappointed at her inability to stand up for the maids, feeling that she has betrayed them in a cowardly fashion. Her climbdown is seen to be the product of her economic insecurity as a woman 'in service' since she has no alternative means of support, being unmarried. Hence, this dramatic vignette functions as a reminder of the connections between gender and politics in the Thirties on two levels. On the one hand, Stevens is unable to combat the unjust actions of his master because his own identity has been colonised by a military discipline which equates the 'dignity' of the servant with blind obedience to a patriarchal order. By contrast, Miss Kenton is imprisoned in a different, but no less insidious manner. She is aware of the need to resist Darlington's inhuman directive but, as an isolated woman, she does not possess the material or political means for effecting such a rebellion. Thus, in a sober, but also exceedingly subtle fashion Ishiguro's narrative explores vital questions about the doctrines of Fascism and Conservatism, as well as their relationship to the underlying discourse of patriarchy at a moment of economic and political crisis.

APPEASEMENT AND COUNTRY-HOUSE FASCISM

One of the important dimensions of both the novel and the film of *The Remains of the Day* is that they break with the idea that Britain in the Thirties was protected from the political storms of Europe by a governing class which was deaf to the siren appeal of Fascism. In fact, through the character of Darlington, and to a lesser extent Stevens, the narrative explores the genesis and development of 'country house Fascism' in some detail. Of course Darlington is a fictional character and hence a condensation of certain political traits. Nevertheless, he is clearly a composite figure based on actual individuals, such as Edward VIII and various 'right-wing Fellow Travellers' amongst the aristocracy of the thirties. Hence, anyone who is acquainted with Richard Griffiths' book *Fellow Travellers of the Right* or Robert Benewick's *The Fascist Movement in Britain* will

recognise the similarity between Darlington's statements on the 'malaise' of Britain and the views of figures who were associated with right-wing mouthpieces such as the *Saturday Review* or *Link* in the Thirties.[33]

In his study of British apologists for Nazi Germany, Richard Griffiths argues that it is possible to discern a 'variety of motivation' in the responses whose beliefs were 'in tune with the basic nature of Nazism'. On the other hand, there were those whose motives were 'of the highest':

> Some prominent figures emerge from this study as men of high principle and integrity, who were led into admiration for Germany not by any other factors but by all that was best in them – a concern for the condition of the working man, a belief in spiritual lead, or a propensity to see the best in everyone and everything.[34]

Thus, like Orwell in the epigraph from *The Road to Wigan Pier*, Griffiths is concerned to emphasise the appeal of Nazi Germany to the 'well-meaning person' who was 'genuinely anxious... to better the lot of the unemployed'. Moreover, Griffiths highlights the way in which pro-German sentiment could still flourish after the advent of Nazism because of a long-standing guilt about the effects of the Versailles Treaty, which had virtually wrecked the German economy in the early Twenties. Thus, in *The Remains of the Day* Lord Darlington feels dishonoured by Versailles and the deleterious impact of reparations on Weimar Germany. Darlington is concerned to right the wrongs of Versailles, which are dramatised in vivid form through the fate of a friend, Herr Bremann, who commits suicide when he is bankrupted by hyperinflation. The English aristocrat argues that he fought the war 'to preserve justice in this world', not to take part in 'a vendetta against the German race' and he tells Stevens that: 'It does us great discredit to treat a defeated foe like this. A complete break with the traditions of this country.'[35]

Sentiments like these were important in encouraging pro-German feeling, even after 1933, and Ishiguro's exploration of the character of Darlington helps to show how difficult it is to disentangle the issue of pro-Fascism from that of appeasement. Griffiths demonstrates this well in his account of the Anglo-German Group, which was set up late in 1933 under the chairmanship of Lord Allen of Hurtwood, including pacifists and figures to the left of centre, as well as more conservative and right-wing elements.[36] Griffiths

points out that the legacy of Versailles was crucial in maintaining
the support of those Englishmen and women who were increas-
ingly dismayed about Hitler's tactics in Germany and yet retained
their commitment to Anglo-German peace. Hence, one finds a
Labour member of the Group, Lord Noel-Buxton, writing the fol-
lowing letter to *The Times* in July 1933:

> However much we, with our English tradition, see to deplore in
> the German situation, we must admit that the Allied policy since
> the War is mainly responsible for the abnormal psychology of
> today. Would it not perhaps be produced in similar circum-
> stances in other countries with a degree of violence at least as
> great? What would be our own state of mind in a parallel situ-
> ation if, following defeat by Germany, we had been deprived of
> food so that the children died of hunger; if four years after the
> war Yorkshire had been occupied and a reign of terror estab-
> lished; if till four years ago Kent and Surrey had been garrisoned
> by Negro troops from Africa; if our late enemies' promise to
> disarm were entirely unredeemed? Would we have kept our
> heads and preserved our standards of tolerance?[37]

For Noel-Buxton, Allen and other members of the Anglo-German
Group, the advent of Fascism in Germany was primarily attribut-
able to the acts of the Allies after the First World War. Many of
them were keen to distance themselves from the internal politics of
the Nazi regime, but they argued that the general cause of peace in
Europe must override the particular problems raised by violations
of human rights in Germany. Thus Lord Allen claimed that he had
'always denounced the discriminatory restraints imposed upon
Germany by the Versailles Treaty' and 'could not feel it right to
change his views because there was a change in the German
regime.'[38] As Griffiths comments, for Allen, Noel-Buxton and many
others, 'Nazi excesses' were 'the result of Allied actions in the post-
war period.' Hence, the only long-term solution was what Arthur
Marwick has described as the 'dual programme' of the peace-
makers of the Thirties: 'legitimate grievances must be met by ap-
peasement, illegitimate ambitions faced by collective security.'[39] By
a series of 'personal initiatives', including visits to Hitler, figures
like Allen hoped to be able to bring Germany back into the fold of
the League of Nations and this optimism guided their actions until
well after Munich.

Thus, we might see the fictional character of Lord Darlington as the embodiment of an 'honourable' version of appeasement which influenced a section of the political establishment during the Thirties. However, there are also aspects of his response to the economic and political crisis which tie him in with the more authoritarian approach of politicians like Mosley. In this, he can be compared with Lord Rothermere, whose paper the *Daily Mail* ran an article entitled 'Hurrah for the Blackshirts' on 15 January 1934 but who moved away from Mosley's British Union of Fascists after the violence of the Olympia Rally of 7 June in the same year. Like Rothermere, Darlington is unwilling to be directly associated with Mosley once the 'ugliness of his movement' has become apparent.[40] However, we have already seen that he accepts the need to dispense with universal suffrage and although he is not presented as a Nazi sympathiser he does seem to be keen on 'strong leadership':

'Here we are in the midst of a continuing crisis. I've seen it with my own eyes when I went north with Mr Whittacker. People are suffering. Ordinary, decent working people are suffering terribly. Germany and Italy have set their houses in order by acting. And so have the wretched Bolsheviks in their own way, one supposes. Even President Roosevelt, look at him, he's not afraid to take a few bold steps on behalf of his people. But look at us here, Stevens. Year after year goes by, and nothing gets better. All we do is argue and debate and procrastinate.... Look at Germany and Italy, Stevens. See what strong leadership can do if it's allowed to act.'[41]

Richard Griffiths' study of right-wing Fellow Travellers suggests that Edward VIII was, similarly, drawn to authoritarian politics as a way of solving the economic crisis of the Thirties and dealing with the plight of the depressed areas. Griffiths concludes that Edward was an 'armchair politician' and hence was 'unlikely to have thought of dictatorship in real terms'.[42] Nevertheless, he 'chafed at the restrictions of constitutional monarchy and, in the view of at least one of his German interlocutors, wished eventually "to concentrate the business of government on himself."'[43] Towards the end of 1936, his close confidant 'Chips' Channon was writing in his diary that Edward was 'going the dictator way' in being 'against too much slip-shod democracy'.[44] Even after his abdication in December 1936, Bruce Lockhart was reporting the view of the German Embassy that Edward would return as a 'social-equalising

King', at the head of an 'English form of Fascism' in alliance with Germany.[45]

In *The Remains of the Day* Ishiguro explores the appeal of Fascism to what might be generously described as an 'honourable, but confused' aristocracy and monarchy in the mid-Thirties. By the end of the narrative Darlington is shown to be the 'amateur' politician, much like Edward, doomed to isolation and social exile. Yet the 'inevitability' of this development is, perhaps, more obvious with the benefit of hindsight than in 1936, when it was not clear that Edward was going to abdicate, or that a version of the Fascist *coup d'état* might not happen in Britain. Richard Griffiths comments that at the time of the abdication 'rumours of dictatorship or governmental overthrow were rife'.[46] Thus, Sir John Reith was able to write on 6 December 1936: 'I suppose anything might happen in the country now; it might be the end of the monarchy, or we might have the King as a sort of dictator...'[47] It is one of the merits of *The Remains of the Day* that it highlights the currency and domestication of such authoritarian ideas among the establishment of the Thirties and the way in which a particular, English 'country house' version of Fascism might have come to power, given different circumstances.

DUTY AND THE RENUNCIATION OF DESIRE

Apart from being a study in the politics of the interwar period, *The Remains of the Day* is also an archetypal, pre-Sixties British romance story about the renunciation of 'desire', *à la Brief Encounter*.[48] So, although Mrs Benn's letter at the beginning suggests that she might be on the point of leaving her husband, when Stevens finally meets up with her in Cornwall she reveals that she cannot return to Darlington Hall after all. It seems that she has come to the realisation that her husband still needs her and, perhaps more importantly, her daughter has announced that she is expecting a baby. Hence, Mrs Benn's 'rightful place' is clearly with her family and in this sense *The Remains of the Day* is 'of a piece' with the classical narrative concerns of the period, since fate intervenes to drive home the lesson that the commitment to 'home' and 'duty' will always outweigh the seductions of 'passion' and 'pleasure'. We feel the tragedy of Stevens' life, especially when he breaks with decorum to tell us that 'my heart was breaking', and the pathos of

their last moments together is heightened by the desolation of saying goodbye in a bus shelter in the rain. (One could hardly get more archetypically English than that!) Nevertheless, the awful logic of the situation must be obeyed: Stevens had missed his moment before the war and he is right not to press his claims on Mrs Benn. Instead, he must do the 'decent thing' and let her go:

> 'You're very correct, Mrs Benn. As you say, it is too late to turn back the clock. Indeed, I would not be able to rest if I thought such ideas were the cause of unhappiness for you and your husband. We must each of us, as you point out, be grateful for what we do have. And from what you tell me, Mrs Benn, you have reason to be contented.... You really musn't let any more foolish ideas come between yourself and the happiness you deserve.'[49]

However, *The Remains of the Day* is a study in the suppression of desire, as much as its renunciation. Thus, one might argue that it transcends the limitations of a drama such as *Brief Encounter*, since it is more concerned with tracing the socio-psychological origins of re-pressed desire than with plotting the social impossibility of extra-marital relationships. We come to understand that Stevens has constantly subordinated his own need for affective and emotional contact to the demands of his 'calling'. So, when his father is dying the son is too preoccupied with events of high diplomacy in the dining-room to stay and he actually misses his father's death. Since the Hall is hosting a peace conference, he feels that it is his duty to return to the dining-room and minister to those who are making 'History'. Even when he is in the presence of his father's corpse, he suppresses his own grief and thinks of one of the guests, Monsieur Dupont, asking the doctor to attend to the Frenchman's bruised feet! Recounting this episode to the reader, Stevens is untroubled by the brusque way in which he dealt with his father's demise. Instead, he congratulates himself on the 'dignity' which he displayed in the face of the crisis: 'For all its sad associations, whenever I recall that evening today, I find I do so with a large sense of triumph.'[50]

This suppression of natural emotions is highlighted by Stevens' failure to respond to Miss Kenton's romantic overtures, even though it is clear that they have much in common. Prizing his own repressed notions of 'privacy' and 'decorum' above the chance of libidinal happiness, Stevens effectively drives her from his parlour one evening when she becomes too 'familiar'. Thus, this paragon of

'dignity' is actually a rather troubled figure, whose search for meaning in life is constrained by a deep attachment to patriarchal order. In this sense, his emotional state might be seen as typifying a more general socio-psychological disorder which could erupt in the form of a pathological, fascistic violence if it were blocked by history. Of course, Stevens is no Fascist, but his code of restraint and the suppression of his instinctive doubts about the dismissal of the Jewish maids highlight a disturbing inability to question the logic of a political order which is in danger of lurching towards fascism.

WITNESSES TO HISTORY

Apart from seeing *The Remains of the Day* as a general study in 'repression', it can also be viewed as a 'historical novel' about the Thirties. Here we need to have recourse to Georg Lukács' classic study of the same name which offers a useful typology of the genre, particularly in relationship to the question of characterisation.[51] Lukács points out that writers such as Scott and Balzac portray the 'typical' features of a historical age by creating characters whose psychology and 'inner motives' register the 'historical necessities' and central conflicts of that era. At the same time, these characters are not mere cyphers, but 'representative' figures who are 'individualized down to their smallest human peculiarities'.[52] Thus they are 'typical' in the sense that they are more than a mere reflection of the statistical norm of their class or social group – an 'average' member of the proletariat, or whatever. They are *condensations* of historical forces, whose individual traits of character are 'brought into a very complex, very live relationship with the age in which they live'.[53]

Lukács' model of the historical novel posits two main character types. First, there is the 'world-historical' figure (in Scott's case, a character such as Ivanhoe or Rob Roy) who is typically the leader of a 'contending' class or popular movement. Standing alongside this hero and mediating his actions, is the 'middle of the road' character, such as Waverley, whose narrative function is to take the reader by the hand and lead him/her into the presence of the 'great heroes' of history:

what is the connection between Scott's ability to portray the historical greatness of an important figure and the minor composi-

tional role which the latter (i.e. the 'middle of the road' character) plays? Balzac understood this secret of Scott's composition. Scott's novels, he said, marched towards the great heroes in the same way as history itself had done when it required their appearance. The reader, therefore, *experiences* the historical genesis of the important historical figures... (Our emphasis.)[54]

How, then, might this model be applied to *The Remains of the Day*? On the one hand, Lukács' rather triumphalist notion of history as an independent force, 'marching' towards the 'world-historical' figures and producing the heroes to fit the hour, would probably get short shrift from most contemporary thinkers. And this would seem to be true of Ishiguro as well, for the meaning of 'history', if it resides anywhere, is not to be found with 'world historical' figures, either of the establishment or radical 'contending' movements. Indeed, it is important for Stevens to discover that history in this form is something of a chimera. If he learns any lesson from the past it is that he and others of his class were deluded into thinking that they should serve 'great men' when they should have been discovering the potential for making history within themselves.

At the same time, Ishiguro's narrative explores major political issues of the Thirties, such as appeasment and Fascism, by drawing on the documented history of the period to present a gallery of types, fictional and real, who occupy the 'centre stage' of high politics and in this sense *The Remains of the Day* might be seen as a contemporary reworking of the historical novel. So Darlington Hall is the gathering place for figures such as Lloyd George, Keynes, Wells, Mosley, Ribbentrop, etc. and Lord Darlington is himself manifestly a composite character, as we have already noted, based on Edward VIII and various fellow-travelling aristocrats of the Right. Moreover, we observe these figures, and are witness to the genesis of 'country-house Fascism', through the eyes of the 'middle of the road' character, Stevens. The latter functions as what Lukács, following Hegel, terms a 'maintaining individual', whose psychology and everyday existence is crucial for understanding the basis on which historical movements come to power, even if they are no longer led by the 'world historical individuals' of the nineteenth century novel:

'Maintaining individuals' is Hegel's all-embracing term for men in 'civil society', it describes society's uninterrupted reproduction

through the activity of these individuals. The basis is formed by the personal, private, egoistic activity of individual human beings. In and through this activity the socially general asserts itself. In this activity the 'maintenance of moral life unfolds itself'.[55]

Stevens does not just 'maintain' the existing social order by providing his services as a butler. He also reproduces it at an ideological level through his internalisation of a code of 'dignity' and 'restraint' which he continues to uphold, even when figures such as Lord Darlington threaten to undermine civil society and democratic government by embracing Fascism. In this way, Ishiguro fuses the personal with the political, showing how the existence of Fascism as a form of 'high' politics is ultimately grounded in the 'private, egoistic activity' of an individual such as Stevens. Hence, *The Remains of the Day* can be seen as an important study of the 'authoritarian personality', answering Etienne Balibar's call for 'an analysis of the role of sexual repression in the structure of "authoritarian" institutions.'[56] (This is, of course, the negative obverse of historical development as registered in the work of a novelist such as Scott, who is writing at a moment when bourgeois nationalism has a progressive historical role. There the 'maintaining individuals' provide the support for democratic popular nationalist movements, rather than Fascist politics.)

LIVING IN AN OLD COUNTRY?

A number of critics have attacked *The Remains of the Day*, particularly the Merchant/Ivory film, for presenting a 'nostalgic' picture of life in the England of the Thirties.[57] This is an important criticism but one which is difficult to answer if the definition of nostalgia is not made clear and precise. Fredric Jameson has pointed out that nostalgic narratives do not just sentimentalise the past, but revisit it in a certain way, through stylistic devices as well as content.[58] Whereas the historical novel explored the past through the medium of multi-layered characters, nostalgia novels or films represent historical periods through the medium of stylised decor (the Twenties as Art Deco or the Thirties as social realism, etc.). The characters in these fictions are primarily stereotypical illustrations of a world which we already know and recognise from previous narratives. They function as passive exemplifications of a stereotypical pre-existent knowledge of

the past – the 'flapper' as the icon of the Twenties or the 'rugged pro-
letarian' as typification of the Thirties. Thus Lukács' 'world histori-
cal' figures are replaced by historical 'generations' or 'periods' as the
central figures of the narrative. In effect, we no longer go in search of
a knowledge which is to be discovered through the medium of char-
acterisation. Rather, we consume what we already 'know' in a com-
forting, uncritical fashion.

There may be a case for arguing that the Merchant/Ivory film of
The Remains of the Day falls prey to nostalgic conventions of these
kinds at certain points in the narrative. So, when Stevens and the
rest of the household are preparing Darlington Hall for the interna-
tional peace conference, the 'production values' of the film are
clearly visible in a rather sumptuous celebration of life 'below stairs'
in a country mansion of the Thirties.[59] At this moment Darlington
Hall is turned into a museum for a 'heritage' view of history (the
basting of fowl on the spit in the kitchen, the sharpening of knives
by a wonderful old rotating machine, etc.) and the montage of activ-
ities is accompanied by the voice-over of Stevens, addressing the
servants on the need to demonstrate to the foreign guests that 'they
are in England, where order and tradition still prevail.' Thus, the
collective enterprise of preparing the metonymic 'house' for the
peace conference seems to recall a stereotypical 'golden age' of
the Thirties when sectional interests were supposedly subordinated
to the project of securing Britain's pre-eminence in the world.

The film has also been criticised for failing to break with stereo-
types at the level of characterisation. So, Geoffrey Macnab has
argued that it is full of 'lookalikes', such as Oswald Mosley,
Chamberlain, etc.[60] and James Fox's rendering of Lord Darlington
is, perhaps, somewhat difficult to distinguish from roles in other
films where he plays the role of the 'stiff upper lip' aristocrat.
However, Ruth Prawer Jhabvala's script incorporates many of the
major scenes and speeches from the novel and the film captures the
uneasy and troubled atmosphere of Ishiguro's narrative. The 'plea-
sures' of the country house turn to ashes as the viewer is forced to
contemplate the inhumanity of Darlington's decision to sack the
Jewish girls and the possibility that they may be deported back to
Nazi Germany. Stevens' sense of pride at being his master's right-
hand man is revealed as a form of self-delusion when he is humili-
ated by Spencer. The contrast between the glittering banquet for the
diplomats and old Mr Stevens' 'cell' at the top of the house is chill-
ingly reinforced by the latter's lonely death. Finally, Anthony

Hopkins' portrayal of Stevens manages to capture the plight of the emotional and political cripple who is unable to escape the prison of his authoritarian, other-directed personality.

Hence it would be wrong to conclude, as Macnab does, that Merchant/Ivory use a novel which is 'set safely in the past' to indulge in a 'nostalgic' celebration of Englishness. In fact, both novel and film offer a compelling analysis of the 'genteel Fascism' of the thirties and its relationship to that form of paternalistic Conservatism which has been such a dominant strain in English political life. *The Remains of the Day* is not a 'lament for lost grandeur', as Macnab maintains, but an interrogation of English ideology at a moment of acute crisis. It explores the confusions of a political establishment which was in danger of drifting into Fascism whilst clinging on to values such as 'honour' and 'decency'. Above all, it manages to capture that contradictory mixture of loyalty and lost opportunities which characterised the life of the servant class before the war. Thus what might be seen, from a superficial reading, as a nostalgic celebration of a 'golden age' of English history, is actually a subtle study of the insidious pleasures of 're-straint' and the sacrifices which it exacts.

'THE REMAINS OF THE DAY': EMERGENT DISCOURSES OF THE THIRTIES AND NINETIES

Both the film and novel of *The Remains of the Day* conclude with a coda which 'wraps up' the narrative and points the way forward, after Stevens' final encounter with Miss Kenton/Mrs Benn. In the film, Ruth Prawer Jhabvala's script has a final scene in which Stevens and his new American master release a pigeon which has become trapped in the house. This action symbolically reinforces our sense of the butler as an individual who is left alone with his memories, 'ensnared' in an old house which is half-covered in dust sheets and whose best moments lie in the bustle and drama of Lord Darlington's prewar gatherings. For Stevens himself there is the re-alisation that he has lost 'Miss Kenton' for good and so the mood is one of personal tragedy and stoicism, a feeling which is reinforced by the final aerial shot of the house as the camera draws away from the scene of Stevens' 'entombment'.

In the novel, however, the coda is handled rather differently. Ishiguro does not actually deliver Stevens back to the house, al-

though it is clear that the butler is reconciled to his return. Rather, we are presented with Stevens' thoughts on what he has learned from his journey through England and his encounter with its people. Sitting on a bench on the pier he falls into conversation with a retired man who remarks that for a great many people the evening is the best part of the day. Stevens recognises that this observation is meant to be taken figuratively as well as literally (they are both looking at a beautiful sunset) and he begins to ruminate on what the 'evening' of his own life holds in store. At first, this moment of contemplation leads to a sense of emotional exhaustion; he tells his companion that he has given his best years to Lord Darlington and that the future is very much downhill:

'The fact is, of course,' I said after a while, 'I gave my best to Lord Darlington. I gave him the very best I had to give, and now – well – I find I do not have a great deal more left to give.'[61]

His sense of emotional weariness is compounded by a feeling that he has been unable to make anything of his life and, in particular, an awareness that he belonged to a class that was always subservient and failed to act on its own behalf. Thus, while Lord Darlington had 'the privilege of being able to say at the end of his life that he made his own mistakes',[62] Stevens cannot even claim this compensation:

'His lordship was a courageous man. He chose a certain path in life, it proved to be a misguided one, but there, he chose it, he can say that at least. As for myself, I cannot even claim that. You see, I trusted him, I trusted I was doing something worthwhile. I can't even say I made my own mistakes. Really – one has to ask oneself – what dignity is there in that?'[62]

It is clear that Stevens is in danger of suffering a nervous breakdown as his character armour is pierced by the traumatic realisation that the past was a hollow sham in which he played the part of the gullible fool. However, he is 'rescued' by his good-humoured companion who tells him that his attitude is 'all wrong' and that he musn't 'keep looking back all the time'.[63] Stevens remains on the bench after the man has departed, resolving to 'make the best of what remains of my day'[64] and soon afterwards the pier lights are switched on, provoking laughter and merriment amongst the crowds strolling around. He realises that many of the people conversing are actually strangers and he is curious 'how people can

build such warmth among themselves so swiftly.'[65] At first he thinks they are 'simply united by the anticipation of the evening ahead', but then he fancies that it has more to do with the 'skill of bantering' and he comes to the conclusion that 'in bantering lies the key to human warmth.'[66]

In view of the events which have taken place, both at the level of high politics and Stevens' own personal life, this might seem a rather low-key response, especially compared with the bleak ending of the film. Nevertheless, it is in keeping with the project of Ishiguro's novel as a reflection on the more general historical lessons which need to be learned from a contemplation of the past, rather than a study in personal tragedy. What some have interpreted as a nostalgic 'heritage' narrative is actually a sophisticated disquisition on national identity and the place of Britain in the modern world. Stevens has come to realise that his stiff-necked approach to life, which lost him Miss Kenton, is part of an old order which has gone and that he needs to 'lighten up'. This chimes with the experience of meeting Harry Smith and being forced to acknowledge a democratic alternative to his own authoritarian notions of politics and 'dignity'. Like Priestley, Ishiguro seems to be implying that Britain should not be identified with a hierarchical world of empty traditions and routines, but the independence and humour of the 'common people'.

Hence, *The Remains of the Day* can be seen as a 'restrained', but considered discourse on the need for a different interpretation of the prewar past, than that of Thatcherism and the Conservative politics of the eighties. It is interesting to note that Stevens' relationship with his American employer is not a mini version of the Thatcher–Reagan 'special relationship', with its emphasis on the continuing domination of the old and new empires of the west. Instead, Farraday's intervention encourages Stevens to embark on a journey of discovery which leads to a more inclusive, democratic concept of the nation and this is, of course, in keeping with the best traditions of American and British history. If Britain has a 'greatness', it is not embodied in the 'immutable values' of a 'Deep England', or the xenophobic Falklands fever of the Eighties. Rather, it is to be found in a return to those *social* values which are bound up with the emergent socialist and social democratic discourses of the Thirties and which were to prove so instrumental in constructing a Britain based on fairness, equality and human solidarity after 1945.

Notes

1 INTRODUCTION: A DECADE UNDER CONSTRUCTION

1. Cf. Eric Hobsbawm, *The Age of Extremes: The Short Twentieth Century 1914–1991* (London: 1994); and Giovanni Arrighi, *The Long Twentieth Century* (London: 1994).
2. The following account is largely based on Francis Mulhern, *The Moment of Scrutiny* (London: 1979) pp. 3–10; Tom Ryall, *Alfred Hitchcock and the British Cinema* (London: 1986), esp. Chapter 2; and Stuart Hall, 'Culture and the State', Open University course U203 *Popular Culture* Unit 28 (Milton Keynes: 1982) pp. 28–37.
3. Noel Annan, 'The Intellectual Aristocracy', in J. H. Plumb (ed.), *Studies in Social History* (London: 1955).
4. Mulhern, op. cit., pp. 9–10.
5. T. W. Heyck, *The Transformation of Intellectual Life in Victorian England* (London: 1982).
6. J. B. Priestley, *Rain Upon Godshill* (London: 1939) pp. 83–4.
7. Quoted in Ryall, op. cit., pp. 75–6.
8. Ken Worpole, *Dockers and Detectives* (London: 1983) Chapter 2, 'The American Connection'.
9. P. Scannell and D. Cardiff, *Social History of British Broadcasting* vol 1 (London: 1991); James C. Robertson, *The British Board of Film Censors: Film Censorship in Britain, 1895–1950* (London: 1985).
10. Mulhern op. cit.; F. R. Leavis, *Mass Civilisation and Minority Culture* (Cambridge: 1930); F. R. Leavis and Denys Thompson, *Culture and Environment* (London: 1933). For European parallels, see Ortega y Gasset, *The Revolt of the Masses* (London: 1932; orig. pub. Spain 1930), and the work of Theodor Adorno and other members of the Frankfurt School.
11. Julian Symons, *The Thirties: A Dream Revolved* (London: 1960).
12. Heyck, op. cit. Chapter 5. On present discontents see, for example, Keith Jenkins, *Re-thinking History* (London: 1991).
13. Richard Johnson *et al.* (eds), *Making Histories: Studies in History-writing and Politics* (London: 1982) pp. 206–15.
14. Kieran Egan, 'Mythical and Historical Reference to the Past', *Clio* (1973).
15. Johnson *et al.*, op. cit., p. 207; Luisa Passerini, 'Work. ideology and consensus under Italian fascism', *History Workshop Journal*, 8 (1979) 82–108.
16. G. R. Elton, *The Practice of History* (London: 1967) p. 86.
17. Walter Benjamin, *Illuminations* (London: 1970) p. 265.
18. For example, in C. L. Mowat's *Britain Between the Wars* (London: 1955), 75 per cent of the chapter on 1931–35 is devoted to domestic issues; this falls to 26 per cent for 1935–37 and only 9 per cent for 1937–40, when attention to foreign affairs increases proportionately.

19. See, for example, ibid., p. 586.
20. A. J. P. Taylor, *English History 1914–45* (Oxford: 1965), pp. 315–17.
21. Jeffrey Richards, *The Age of the Dream Palace: Cinema and Society in Britain 1930–1939* (London: 1984).
22. Roland Barthes, *Image-Music-Text*, ed. Stephen Heath (London: 1977), p. 79.
23. Noreen Branson and Margot Heinemann, *Britain in the Nineteen Thirties* (London: 1971).
24. Julian Symons, *The Thirties: A Dream Revolved* (London: 1960).
25. Franco Moretti, *The Way of the World* (London, 1987).
26. John Stevenson and Chris Cook, *The Slump: Politics and Society during the Depression* (London: 1977).
27. Charles Loch Mowat, *Britain Between the Wars* (London: 1955), p. 657.
28. Hayden White, *Metahistory: The Historical Imagination in Nineteenth Century Europe* (Baltimore: 1973), and *Tropics of Discourse: Essays in Cultural Criticism* (Baltimore: 1978).
29. For a critique of the drift towards 'universalism' in Hayden White's work and that of other 'New Historicists', see F. Jameson, *The Ideologies of Theory, Vol. 2: Syntax of History* (London: 1988) and H. J. Kaye, *The Education of Desire* (New York: 1992).
30. Hobsbawm, op. cit., Part Two.
31. Jeffrey Richards, *Visions of Yesterday* (London: 1973); Alison Light, *Forever England: Femininity, literature and conservatism between the wars* (London: 1991).
32. See J. Symons, op. cit., V. Cunningham, *British Writers of the Thirties* (Oxford: 1989) and S. Hynes, *The Auden Generation* (London: 1976).
33. V. Cunningham, op. cit., p. 467.
34. H. V. Morton, *In Search of England* (London: 1927).
35. J. B. Priestley, *English Journey* (Harmondsworth: 1977), p. 389.
36. R. Durgnat, *A Mirror for England: British Movies from Austerity to Affluence* (London, 1970), p. 119.

2 REPRESENTING THE PEOPLE: THE DOCUMENTARY FILM MOVEMENT AND MASS OBSERVATION IN THE THIRTIES

1. W. H. Auden, 'Spain' (1937), repr. in R. Skelton (ed.), *Poetry of the Thirties* (Harmondsworth: 1964), pp. 133–6.
2. G. Orwell, 'Inside the Whale' (1940), in *Collected Essays, Journalism & Letters. Vol 1* (ed. S. Orwell & I. Angus), (Harmondsworth: 1970), pp. 540–78.
3. P. Bourdieu, op. cit., p. 150.
4. For the origins of this term, see S. Hall, 'The Social Eye of *Picture Post*', in *Working Papers in Cultural Studies*, No. 2 (Spring 1972), pp. 71–120.
5. W. H. Auden, 'A Communist to Others' (1933), repr. in R. Skelton, op. cit., pp. 54–9.
6. F. Mulhern, *The Moment of 'Scrutiny'* (London: 1979), p. 9.

7. See A. C. H. Smith, *Paper Voices* (London: 1975), Chapter 3.
8. S. Constantine, 'Bringing the Empire Alive', in J. M. MacKenzie (ed.), *Imperialism & Popular Culture* (Manchester: 1986), pp. 192–231.
9. Ibid., p. 204.
10. Ibid. D. L. Le Mahieu makes the following comments on the ideology of 'Englishness' which Tallents sought to inculcate in his audience: 'Tallents recorded his views on government and public relations in *The Projection of England*, a slim elegantly produced volume of urbane patriotism published in 1932 Perhaps not surprisingly, the "England" which Tallents believed that the government ought to "project" consisted almost exclusively of southern, upper-class institutions, diversions and attitudes; like many civil servants and members of his class, he believed his own tastes to be the most natural and characteristic of his country.' *A Culture for Democracy* (Oxford: 1988), p. 167.
11. J. Grierson, 'The Course of Realism' (1937), in F. Hardy (ed.), *Grierson on Documentary* (London: 1979), p. 78.
12. See A. Kuhn, '"Independent" Film-making and the State in the 1930s', in *Edinburgh '77 Magazine*, no. 2, esp. pp. 51–2.
13. See S. Hood, 'The Documentary Film Movement', in J. Curran & V. Porter (eds), *British Cinema History* (London: 1983), p. 104.
14. J Grierson, in F. Hardy (ed.), op. cit., p. 43.
15. See esp. E. Sussex, *The Rise and Fall of the British Documentary* (London: 1979).
16. R. Colls & P. Dodd, 'Representing the Nation: British Documentary Film, 1930–45', in *Screen*, Vol. 26, No. 1 (Jan.–Feb., 1985), pp. 21–33.
17. J. Grierson (1932), in F. Hardy (ed.), op. cit., p. 39.
18. J. Grierson in F. Hardy (ed.), op. cit., p. 207.
19. This paragraph draws on Alan Lovell's discussion of Grierson's ideas in A. Lovell & J. Hillier, *Studies in Documentary* (London: 1972).
20. J. Grierson (1941) in F. Hardy (ed.), op. cit., p. 126.
21. Ibid.
22. Grierson uses the term 'historical process' in 'Education and the New Order' in a manner quite reminiscent of orthodox Marxism. Indeed, one could argue that his approach is a rather crude application of historical determinism and that he fails to operate with the sort of discriminations found in the work of a sophisticated Marxist thinker such as Caudwell, as the following passage demonstrates: 'But I emphasize the first and main point which is that we grasp the historical process and not bother about recriminations or moral strictures. Men are all fools of history, even the greatest and best of them' (op. cit., p. 127).
23. Ibid., p. 126.
24. Ibid., pp. 125–6.
25. See J. Stevenson & C. Cook, *The Slump* (London: 1979), p. 290.
26. Ibid., p. 139.
27. Stevenson & Cook argue that while Communism 'undoubtedly became more influential in intellectual circles ... it had little appeal for the great mass of the electorate.' (Ibid., p. 144 and rest of Chapter VIII)

For an alternative view, emphasising the appeal of Communism to the unemployed and industrial militants, see N. Branson & M. Heinemann, *Britain in the Nineteen Thirties*, op. cit., esp. Chapters 3 & 8.

28. J. Grierson, in F. Hardy (ed.), op. cit., p. 115.
29. Ibid., p. 127.
30. See, for example, C. L. R. James, *World Revolution 1917–1936: The Rise and Fall of the Communist International* (London: 1937).
31. S. & B. Webb, *Soviet Communism: A New Civilisation?* (London: 1935; reissued without the question mark in 1937). The Webbs, who were not champions of workers' control, applauded Stalin's attitude to trade unionism in Russia. For a trenchant critique of their position, see D. Caute, *The Fellow-Travellers: A Postscript to the Enlightenment* (London: 1973).
32. Hobsbawm's essay refers to the postwar period, up to the late seventies. See 'The Forward March of Labour Halted?', *Marxism Today* (September 1978).
33. E. Hobsbawm, *Age of Extremes: The Short Twentieth Century* (London: 1994), p. 192.
34. Stephen Constantine points out that 'Grierson arranged for EMB staff to see, among other things, the classic Soviet propaganda films like *Turksib*, *Earth* and *Battleship Potemkin*. By 1933 he was to write, with some exaggeration: "the EMB is the only organisation outside Russia that understands and has imagination enough to practise the principles of long-range propaganda. It is not unconscious of the example of Russia."' Constantine, op. cit., p. 209.
35. J. Grierson in F. Hardy (ed.), op. cit., p. 36.
36. Ibid.
37. S. Constantine, op. cit., p. 210.
38. P. Miles & M. Smith, *Cinema, Literature & Society: Elite & Mass Culture in Interwar Britain* (London: 1987), p. 184.
39. Ibid.
40. J. Grierson in F. Hardy (ed.), op. cit., p. 84.
41. R. Durgnat, *A Mirror for England* (London: 1970), p. 118.
42. S. Hood, in J. Curran & V. Porter (eds), op. cit., p. 108.
43. J. Grierson in F. Hardy (ed.), op. cit., p. 63.
44. For introductions to Mass Observation, see J. Richards & D. Sheridan (eds), *Mass-Observation at the Movies* (London: 1987); V. Cunningham, *British Writers of the Thirties* (Oxford: 1989), esp. Chapter 10; T. Jeffrey, *Mass-Observation: A Brief History*, Occasional Paper 55 (Centre for Contemporary Cultural Studies, University of Birmingham: 1978); A. Calder & D. Sheridan (eds), *Speak for Yourself: A Mass-Observation Anthology 1937–49* (London: 1984); S. Laing, 'Presenting "Things As They Are": John Sommerfield's *May Day* and Mass Observation', in F. Gloversmith (ed.), *Class, Culture & Social Change* (Brighton: 1980), pp. 142–60. For Jennings' *Spare Time* and Mass Observation, see A. W. Hodgkinson & R. E. Sheratsky, *Humphrey Jennings: More Than a Maker of Films* (Hanover & London: 1982).
45. Cited in J. Richards & D. Sheridan, *Mass-Observation at the Movies*, op. cit., pp. 2–3.
46. See A. W. Hodgkinson & R. E. Sheratsky, op. cit., pp. 40–3.

47. A. Calder, 'Introduction' to *Britain by Mass-Observation* (arranged and written by T. Harrison & C. Madge) (London: 1986; first published in 1939), p. vii.
48. Ibid., pp. 199–200.
49. Ibid., p. 205.
50. Ibid., pp. 208–9.
51. Ibid., esp. pp. 97–103.
52. Ibid., p. 113.
53. Ibid.
54. See cover of 1939 Penguin edition.
55. *Britain by Mass-Observation* (1988 edn), p. 113.
56. P. Anderson, 'Components of the National Culture', in A. Cockburn & R. Blackburn (eds), *Student Power* (Harmondsworth: 1969), pp. 214–86.
57. Ibid., pp. 225 and 263–4.
58. Ibid., p. 263.
59. Ibid., pp. 264–5.
60. S. Hood, op. cit., p. 107.
61. R. Colls & P. Dodd, op. cit., p. 24.
62. B. Campbell, *Wigan Pier Revisited: Poverty and Politics in the Eighties* (London: 1984), pp. 97–8.
63. *Britain by Mass-Observation* (1986 edn), pp. 114–38.
64. Ibid., p. 136.
65. Ibid., pp. 137–38.
66. D. L. Le Mahieu, *A Culture for Democracy*, op. cit., p. 108. Trotter's book is also cited in the bibliography of Christopher Caudwell's *Illusion & Reality* (London: 1937; repr. London, 1966), p. 311.
67. A. Calder, 'Introduction' to *Britain by Mass-Observation*, op. cit., p. xiv.
68. P. Bourdieu, *Distinction: A Social Critique of the Judgement of Taste* (London: 1986), pp. 6–7.
69. A. Calder, op. cit., pp. xiv–xv.
70. Ibid., p. xv.
71. G. Orwell, *The Road to Wigan Pier* (London: 1937; repr. Harmondsworth, 1962).
72. Hall argues that 'the people' do not exist in a pristine, preconstituted form, simply awaiting articulation: '"The people" is after all, also a discursive figure, a rhetorical device, a mode of address. It is open to constant negotiation, contestation and redefinition. It represents as a unity what are in fact a diversity of different positions and interests.' (S. Hall & D. Held, 'Citizens and Citizenship', in S. Hall & M. Jacques (eds), *New Times: The Changing Face of Politics in the Nineties* (London: 1989), p. 183.

3 IN SEARCH OF THE PEOPLE: THE JOURNEYS OF J. B. PRIESTLEY

1. J. B. Priestley, *Rain Upon Godshill* (London: 1939), pp. 81–3.
2. Valentine Cunningham's substantial *British Writers of the Thirties* (Oxford: 1988), for example, mentions only one of Priestley's novels,

and that in passing – but, ironically, it is mentioned in terms that assume the reader is familiar with it – p. 267. This is not untypical.

3. Richard Hoggart, *The Uses of Literacy* (London: 1957), p. 309 (ref. to Penguin edition, Harmondsworth: 1958).

4. Graham Greene, *Brighton Rock* (Harmondsworth: 1970; orig. pub. London: 1938), p. 42.

5. J.B. Priestley, *The Good Companions* (Harmondsworth: 1962), back cover.

6. But see Alison Light, *Forever England. Femininity, Literature and Conservatism Between the Wars* (London: 1991); and CCCS English Studies Group, 'Thinking the Thirties', in *1936: the Sociology of Literature*, vol. 2 (Essex: 1979), ed. Francis Barker, *et al.*

7. This account draws on CCCS English Studies Group, op. cit., pp. 11–12.

8. Q. D. Leavis, *Fiction and the Reading Public* (London: 1932), pp. 36–8, 74–5. See also Francis Mulhern, *The Moment of Scrutiny* (London: 1979), pp. 38–41.

9. F. R. Leavis, 'What's Wrong with Criticism?', and 'The Literary Racket', in *Scrutiny*, vol. I, no. 2, September 1932. See also Leavis, *Mass Civilisation and Minority Culture* (Cambridge: 1930), and the discussion in Mulhern, op. cit., pp. 118–20.

10. Mulhern, op. cit., p. 38.

11. P. Bourdieu, *Distinction* (London: 1979).

12. Bourdieu, op. cit., p. 327.

13. George Orwell, 'Inside the Whale', *Collected Essays etc.* (London: 1968) vol. 1, p. 557.

14. J. B. Priestley, *Margin Released* (London: 1962), pp. 139–81.

15. Q. D. Leavis, op. cit., p. 79; Priestley, op. cit., pp. 182–3.

16. Priestley, op. cit., p. 184.

17. J. B. Priestley, *Literature and Western Man* (London: 1960), pp. 425–6. We note but do not pursue the begged question of whether 'persons' are integral 'givens' as Priestley seems to assume.

18. Quoted in 'Recent Developments in English Studies at the Centre', in S. Hall *et al.* (eds), *Culture, Media, Language: Working Papers in Cultural Studies 1972–9* (London: 1980), p. 255.

19. G. Lukács, *The Meaning of Contemporary Realism* (London: 1963), pp. 17–35.

20. See e.g. Orwell, 'Inside the Whale' (1940), *Collected Essays etc.* vol. 1, p. 559; and Cyril Connolly, *Enemies of Promise* (Harmondsworth: 1961; orig. pub. 1938), p. 85.

21. CCCS English Studies Group, op. cit., p. 7.

22. Peter Widdowson, 'Between the Acts? English Fiction in the Thirties' in Jon Clark, *et al.* (eds), *Culture and Crisis in Britain in the Thirties* (London: 1979), pp. 133–64.

23. Op. cit., p. 134.

24. Priestley, *Margin Released*, pp. 188–9.

25. J. B. Priestley, *Rain Upon Godshill* (London: 1939), pp. 186–7.

26. J. B. Priestley, *Wonder Hero* (London: 1933) p. 7.

27. Ibid., p. 288.

28. Ibid., p. 197.
29. Ibid., p. 222.
30. Ibid., p. 225.
31. Ibid., p. 181.
32. Ibid., p. 154.
33. Ibid., p. 172.
34. Ibid., p. 168.
35. Ibid., p. 152.
36. Ibid., p. 106.
37. Ibid., pp. 229–35.
38. Ibid., p. 239.
39. F. R. Leavis, 'What's Wrong with Criticism?', *Scrutiny*, vol. 1, no. 2, September 1932, p. 143.
40. Paul Fussell, *Abroad: British Literary Travelling Between the Wars* (Oxford: 1980); Valentine Cunningham, *British Writers of the Thirties* (Oxford, 1988), pp. 226–40, Chapter 11; Light, op. cit., pp. 6–7.
41. Stanley Baldwin, *On England* (London: 1926).
42. For 'deep England', see Patrick Wright, *On Living in an Old Country* (London: 1985), esp. pp. 81–7.
43. J. B. Priestley, *English Journey* (Harmondsworth: 1977; orig. pub. 1934), p. 63.
44. Ibid., pp. 315–17.
45. Ibid., p. 285.
46. Ibid., p. 317.
47. Ibid., p. 186.
48. Ibid., pp. 20–1.
49. Ibid., pp. 282–3.
50. Ibid., p. 159.
51. Ibid., pp. 95–6. For Priestley's view of pre-1914 Bradford, see *Margin Released* Part One, and the novel *Bright Day* (London: 1946).
52. For a historian's view of factory-town paternalism, see Patrick Joyce, *Work Society and Politics* (Brighton: 1980).
53. Priestley, *English Journey*, pp. 187–8.
54. Ibid., p. 35.
55. Ibid., pp. 356–7.
56. Ibid., pp. 149, 353.
57. H. V. Morton, *In Search of England* (London: 1927); see also Patrick Wright, op. cit.
58. Ibid., pp. 158–66.
59. Ibid., pp. 191–2.
60. Ibid., p. 293.
61. Ibid., p. 10.
62. Ibid.
63. Ibid., pp. 21–2.
64. Ibid., pp. 376–7.
65. Ibid., pp. 249–55.
66. Ibid., p. 390.
67. Priestley, *Wonder Hero*, p. 111.
68. Priestley, *English Journey*, p. 324.

69. Light, op. cit., pp. 8–11.
70. J. B. Priestley, *Out of the People* (London, 1941), p. 45.
71. *English Journey*, p. 240.
72. Robert Graves and Alan Hodge, *The Long Weekend* (London: 1985; orig. pub. 1940), p. 298.
73. Basil Dean, *Mind's Eye* (London: 1973), p. 210.
74. Rachel Low, *Film Making in 1930s Britain* (London: 1985), p. 160; see also Jeffrey Richards, *The Age of the Dream Palace* (London: 1984), pp. 181–2; Tony Aldgate, 'Comedy, Class and Containment: The British Domestic Cinema of the 1930s', in J. Curran and V. Porter (eds), *British Cinema History* (London: 1983), pp. 257–71; Marcia Landy, *British Genres: Cinema and Society, 1930–1960* (Oxford: 1991), pp. 337–8; Andrew Higson, *Waving the Flag: Constructing a National Cinema in Britain* (Oxford: 1995), Chapter 4.
75. Tony Aldgate, op. cit., pp. 270–1. For a similar argument, see Peter Miles and Malcolm Smith, *Cinema, Literature and Society: Elite and Mass Culture in Interwar Britain* (London: 1987), pp. 28–9.
76. Richards, op. cit., pp. 169–90. This argument is also followed by Patrick Joyce, *Visions of the People* (Cambridge: 1991), pp. 320–6.
77. Tony Bennett and James Donald, 'Postscript to Block 2', Open University Course U203, *Popular Culture*, Block Two (Milton Keynes: 1981), Part Two, pp. 79–85. See also A. J. P. Taylor, *English History 1914–1945* (Oxford: 1965), pp. 316–17, on the disjunction between public and private life.
78. E.g. Richards, op. cit., pp. 173–6.
79. Richard Dyer, *Only Entertainment* (London: 1992), pp. 17–34.
80. Quoted in Richards, op. cit., p. 189.
81. Dyer, op. cit., pp. 26–8.
82. Gracie Fields, *Sing As We Go* (London: 1960); Muriel Burgess and Tommy Keen, *Gracie Fields* (London: 1980); Jeffrey Richards, 'Gracie Fields: the Lancashire Britannia', *Focus on Film* 33 (1979) 27–35; Joyce, op. cit.
83. Richards, op. cit., p. 172.
84. J. B. Priestley, *Rain Upon Godshill* (London: 1939), p. 41.
85. Cole Lesley, *The Life of Noel Coward* (London: 1976), p. 144. Significantly, the film of *Cavalcade* (1933) was made in Hollywood, with an American director, and was very successful with American audiences: Coward's England is invariably more successful at the box-office, world-wide, than Priestley's.
86. Quoted in Richards, op. cit., p. 188.

4 IMPERIAL JOURNEYS: NARRATIVES FROM THE 'CENTRE' AND 'PERIPHERY'

1. D. Hebdige, 'Digging for Britain' (first published 1987; repr. with an introduction, 1992) in D. Strinati & S. Wagg (eds), *Come on Down? Popular Media Culture in Post-War Britain* (London: 1982), pp. 336–77.

2. Ibid., p. 341.
3. See A. W. Hodgkinson & R. E. Sheratsky, *Humphrey Jennings: More than a Maker of Films* (Hanover & London: 1982), pp. 40–3.
4. Hebdige, op. cit., p. 343.
5. Ibid., p. 344.
6. Ibid., p. 344.
7. Ibid., pp. 338–41. See also P. Gilroy, *There Ain't no Black in the Union Jack* (London: 1987).
8. R. Samuel, *Patriotism: The Making and Unmaking of British National Identity. Vol. 1* (London: 1989), p. xxiii.
9. S. Constantine, '"Bringing the Empire Alive": The Empire Marketing Board and imperial propaganda, 1926–33', in J. M. Mackenzie (ed.), *Imperialism and Popular Culture* (Manchester: 1986), p. 208.
10. Ibid., p. 215.
11. Ibid., p. 215.
12. Ibid., p. 217.
13. Ibid.
14. Ibid.
15. Cited in N. Branson & M. Heinemann, *Britain in the Nineteen Thirties* (St Albans: 1973), p. 183.
16. See S. Constantine, op. cit., p. 197.
17. Ibid., p. 199.
18. See P. Gupta, *Imperialism & the British Labour Movement* (London: 1975), p. 227.
19. Ibid., p. 266.
20. Ibid., p. 260.
21. Ibid., pp. 260–1.
22. Ibid., p. 154.
23. Ibid., pp. 153–4.
24. Cited in S. Constantine, op. cit., p. 209.
25. S. Hood, 'The Documentary Film Movement', in J. Curran & V. Porter (eds), *British Cinema History* (London: 1983), p. 104. The quotation from Grierson can be found in F. Hardy (ed.) *Grierson on Documentary* (London: 1946; repr. 1979), p. 49.
26. Ibid.
27. See S. Hood, op. cit., p. 102.
28. G. Greene, Review of *Song of Ceylon* in *The Spectator* (1934). Cited by P. Rotha in *Documentary Diary* (London: 1973), pp. 125–6.
29. B. Wright (dir.), *Song of Ceylon* (1934).
30. E. Barnouw, *Documentary: A History of the Non-Fiction Film* (Oxford: 1974), p. 93.
31. R. Durgnat, *A Mirror for England: British Movies from Austerity to Affluence* (London: 1970), p. 119.
32. Ibid.
33. E. W. Said, *Orientalism* (Harmondsworth: 1985), *passim*.
34. Ibid., p. 14.
35. Ibid., p. 12.
36. R. Williams, *The Country and the City* (St Albans: 1975), p. 337.
37. Ibid.

38. G. Orwell, *The Road to Wigan Pier* (Harmondsworth: 1962; first published by Left Book Club, 1937), p. 108.
39. Raymond Williams points out that the reforming middle class relate to those 'beneath' them *as a matter of conscience*: not in solidarity, nor in affiliation, but as an extension of what are still felt as personal or small-group obligations'. This form of 'social conscience', which Williams sees as 'consensual, from the right wing of the Labour Party through the Liberal Party to a few Liberal Conservatives', needs to be distinguished from 'the "social consciousness" of a self-organizing subordinate class.' (See 'The Bloomsbury Fraction', in *Problems in Materialism and Culture* (London: 1980), pp. 155–6.)
40. Writing in *Time and Tide* in 1940, Orwell recalled 'the first sight when I set foot on the soil of Asia – or rather, just before setting foot there':

 The liner I was travelling in was docking at Colombo, and the usual swarm of coolies had come abroad to deal with the luggage. Some policemen, including a white sergeant, were superintending them. One of the coolies had got hold of a long tin uniform-case and was carrying it so clumsily as to endanger people's heads. Someone cursed at him for his carelessness. The police sergeant looked round, saw what the man was doing, and caught him a terrific kick on the bottom that sent him staggering across the deck. Several passengers, including women, murmured their approval.' ('Notes on the Way', *Time and Tide* (3 March 1940), cited in B. Crick, *George Orwell: A Life* (Harmondsworth: 1982), p. 600.

41. G. Orwell, *Burmese Days* (Harmondsworth: 1989; first published in 1934), pp. 98–9.
42. See *The Location of Culture* (London: 1994), Chapter 4.
43. G. Orwell, op. cit., pp. 69–70.
44. See the famous passage in *The Road to Wigan Pier*, where Orwell recounts a conversation with a stranger on a train in Burma:

 Half an hour's cautious questioning decided each of us that the other was 'safe'; and then for hours, while the train jolted slowly through the pitch-black night, sitting up in our bunks, with bottles of beer handy, we damned the British Empire.... It did us both good. But we had been speaking forbidden things, and in the haggard morning light when the train crawled into Mandalay, we parted as guiltily as any adulterous couple (op. cit., p. 127).

45. G. Orwell, 'Not Counting Niggers', in *Adelphi* (July 1939), reprinted in *Collected Essays, Journalism & Letters, Vol. 1*, op. cit., pp. 434–7.
46. Ibid., p. 318.
47. G. Orwell, *Burmese Days*, op. cit., p. 68.
48. R. Fox, *The Novel and the People* (London: 1979; first published 1937), p. 146.
49. G. Orwell, *Burmese Days*, op. cit., p. 107.
50. Ibid., p. 152.
51. G. Orwell, 'A Hanging', in *Adelphi* (August 1931), reprinted in *Collected Essays, Journalism & Letters, Vol. 1*, op. cit., p. 71.

52. Ibid., p. 68.
53. S. Deane, 'Introduction' to T. Eagleton, F. Jameson, E. Said, *Nationalism, Colonialism & Literature* (Minneapolis: 1990), p. 12.
54. G. Orwell, 'Shooting an Elephant', in *New Writing*, No. 2 (Autumn 1936), reprinted in *Collected Essays, Letters & Journalism, Vol. 1*, op. cit., p. 269.
55. Ibid., p. 265.
56. Ibid., p. 266.
57. J. M. Mackenzie, 'Introduction' to *Propaganda & Empire* (Manchester: 1985), p. 10.
58. G. Orwell, *Burmese Days*, op. cit., p. 32.
59. C. L. R. James, 'The Case for West Indian Self-Government' (1933), in A. Grimshaw (ed.), *The C. L. R. James Reader* (Oxford: 1992), p. 53.
60. C. L. R. James, *The Black Jacobins* (1936), op. cit., pp. 67–111.
61. E. Said, *Culture and Imperialism* (London: 1993).
62. Ibid., p. 295.
63. Ibid., p. 292.
64. Ibid., pp. 292–3.
65. B. Parry, 'Overlapping Territories and Intertwined Histories', in M. Sprinker (ed.), *Edward Said: A Critical Reader* (Oxford: 1992), p. 42. In making this point, Parry draws on Timothy Brennan's book, *Salman Rushdie and the Third World: Myths of the Nation* (New York: 1989).
66. Said, op. cit.; P. Buhle, *C. L. R. James: The Artist as Revolutionary* (London: 1988; repr. 1993).
67. A. Grimshaw: 'Introduction' to *The C. L. R. James Reader* (Oxford: 1992), p. 2.
68. This term was coined by Pierre Bourdieu. See esp., 'Symbolic Power', in D. Gleeson (ed.), *Identity and Structure: Issues in the Sociology of Education* (London: 1977).
69. See Grimshaw, op. cit., p. 3.
70. See Buhle, op. cit., pp. 39–42.
71. Reprinted in *The C. L. R. James Reader*, op. cit., pp. 49–62. James had already come into contact with Bloomsbury on his arrival in England, when he had attended a lecture given by Edith Sitwell and had impressed her with his knowledge of modern art. See the essay, 'Bloomsbury: An Encounter with Edith Sitwell', in *The C. L. R. James Reader*, ibid., pp. 43–8.
72. P. Buhle, op. cit., p. 43.
73. Ibid.
74. Op. cit., p. 127.
75. W. Benjamin, 'What is Epic Theatre?', in *Understanding Brecht* (London: 1973; unpubl. manuscript from the 1930s), p. 4.
76. A. Grimshaw, op. cit., p. 2.
77. 'The modern thriller, love story, cowboy romance, cheap film, jazz music or yellow Sunday paper form the real *proletarian* literature of today.... This art, universal, constant, fabulous, full of the easy gratifications of instincts starved by modern capitalism, peopled by passionate lovers and heroic cowboys and amazing detectives, is the religion of today, as characteristic an expression of proletarian ex-

224 *Notes*

ploitation as Catholicism is of feudal exploitation. It is the opium of the people;' C. Caudwell, *Illusion and Reality* (London: 1966; first publ., 1937, p. 107).

78. See R. Williams, *The Long Revolution* (Harmondsworth: 1965), p. 63.
79. P. Buhle, op. cit., p. 42.
80. Ibid., p. 3.
81. E. Said, op. cit., p. 297.
82. Ibid.
83. Ibid., p. 293.
84. *The C. L. R. James Reader*, op. cit., p. 53.
85. Ibid.
86. Ibid., p. 52.
87. S. Rushdie, *Imaginary Homelands* (London: 1992), p. 103.
88. E. Said, op. cit., p. 337.
89. *The Black Jacobins* (1936) is a revised version of the play, *Toussaint L'Ouverture* and is reprinted in *The C. L. R. James Reader*, op. cit., pp. 67–113. James cast Paul Robeson in the title role when the play opened at the Westminster Theatre in 1936. It was envisaged that James and Robeson would alternate as Toussaint, but political differences (Robeson's sympathies for the Communist Party versus James's Trotskyism) conspired against the collaboration, although they remained personal friends (see Buhle, op. cit., pp. 56–7).
90. *The Black Jacobins*, op. cit., p. 70.
91. Ibid., pp. 70–1.
92. Ibid., p. 69.
93. Ibid., pp. 71–2.
94. Ibid., p. 72.
95. E. Said, *Culture and Imperialism*, op. cit., p. 292.
96. Ibid., p. 294.
97. R. Williams, *Culture* (1981), cited in Said, op. cit., p. 294.
98. See P. Buhle, op. cit., p. 40.
99. Ibid.
100. Ibid., p. 55.
101. G. Orwell, *Collected Essays, Journalism and Letters, Vol. 3*, op. cit., p. 213. Perhaps it is worth noting that this brutality towards the Ethiopians is not just characteristic of Italian Fascism. Humphrey Carpenter notes the impact of clerical Fascism on the attitude of Evelyn Waugh, whose reports on the Ethiopian War for the *Daily Mail* were almost equally obnoxious. Waugh commented that Hailie Selassie's mind was 'pathetically compounded of primitive simplicity' and that the Ethiopians possessed 'a low... culture... marked down for destruction'. See H. Carpenter, *The Brideshead Generation: Evelyn Waugh and His Generation* (London: 1990), p. 285.
102. P. Buhle, op. cit., p. 55.
103. 'Abyssinia and the Imperialists', *The Keys*, Vol. 3, No. 5 (1936); repr. in *The C. L. R. James Reader*, op. cit., pp. 63–6.
104. P. Buhle, op. cit., p. 54.
105. Ibid., p. 50.
106. Ibid., pp. 49–50.

107. G. Orwell, *Collected Essays, Vol. 1*, op. cit., p. 321.
108. Initially, James went on a lecture tour for the American Trotskyist Socialist Workers Party, but he stayed in the USA until 1953. See A. Grimshaw, op. cit., pp. 8–17 and P. Buhle, op. cit., Chapter 3.
109. Buhle, op. cit., p. 62.
110. G. Orwell, *Collected Essays*, Vol. 2, op. cit., p. 39.
111. Ibid., p. 481.
112. E. Said, op. cit., p. 293.

5 'KEPT UNDER BY A GENERATION OF GHOSTS': THE WAR, THE PEOPLE AND THE THIRTIES

1. Tony Aldgate and Jeffrey Richards, *Britain Can Take It: British Cinema in the Second World War* (Oxford: 1986).
2. Angus Calder, *The People's War: Britain 1939–45* (London: 1969).
3. Paul Addison, *The Road to 1945* (London: 1975), p. 119; Asa Briggs, *The War of Words* (Oxford: 1973), p. 322; J. B. Priestley, *Margin Released* (London: 1962), pp. 216–17.
4. Robert Graves and Alan Hodge, *The Long Week-End: A Social History of Great Britain 1918–1939* (London: 1940; references to 1985 edition); Malcolm Muggeridge, *The Thirties: 1930–40 in Great Britain* (London: 1940; refs to 1967 edition).
5. Muggeridge, op. cit., pp. 7–9; Graves and Hodge, op. cit., p. 6.
6. Muggeridge, op. cit., p. 194.
7. Ibid., p. 293.
8. Ibid., p. 13.
9. G. Orwell, *Collected Essays, Journalism and Letters* (London: 1968), vol. 1, p. 585.
10. Ibid., vol. 2, p. 29.
11. Graves and Hodge, op. cit., pp. 265–80.
12. G. Stedman Jones, 'History in one Dimension', *New Left Review* 36 (1966), p. 48.
13. Paul O'Prey (ed.), *In Broken Images: Selected Letters of Robert Graves 1914–1946* (London: 1982), pp. 293–5.
14. Ibid., p. 293.
15. Graves and Hodge, op. cit., pp. 331, 308, 395, 377.
16. Ibid., p. 304.
17. Ibid., p. 403.
18. Ibid., p. 454.
19. Orwell, op. cit., vol. 1, p. 591.
20. Ibid., vol. 2, p. 67.
21. Cf. Hugh Cunningham, 'The Language of Patriotism 1750–1914', *History Workshop Journal* 12 (1981) 8–33.
22. Orwell, op. cit., p. 89.
23. Ibid., pp. 118–19.
24. Ibid., pp. 98–9.

25. Ibid., p. 133.
26. BBC radio broadcast, 18 June 1940.
27. J. B. Priestley, BBC radio broadcast, 'A New English Journey', 23 April 1940.
28. J. B. Priestley, *Postscripts* (London: 1940), p. vii.
29. 'Cato', *Guilty Men* (London: 1940).
30. Addison, op. cit., pp. 107–11.
31. Ibid., pp. 132–3.
32. J. B. Priestley, *Out of the People* (London: 1941), p. 105.
33. Orwell, op. cit., vol. 2, p. 366.
34. 'Cassius', *The Trial of Mussolini* (London: 1943); 'Gracchus', *Your MP* (London: 1944).
35. J. B. Priestley, BBC radio broadcast, 'A New English Journey', 23 April 1940.
36. Addison, op. cit., pp. 56, 116, 130–1.
37. David Cardiff and Paddy Scannell, 'Radio in World War II', Open University course U203, *Popular Culture*, Unit 8 (Milton Keynes: 1981).
38. Addison, op. cit., p. 242.
39. Addison, op. cit.; Calder, op. cit.
40. Priestley, *Postscripts*, pp. 33, 36, 42, 53.
41. Addison, op. cit., Chapter 8; Arthur Marwick, *Britain in the Century of Total War: War, Peace and Social Change 1900–1967* (London: 1968), pp. 308–15.
42. Priestley, *Out of the People*, pp. 106–7.
43. Addison, op. cit., pp. 16–20.
44. J. B. Priestley, *Rain upon Godshill* (London: 1939), Chapter 13; Orwell letter to Herbert Read, 5 March 1939, *Collected Essays, etc.*, vol. 1, pp. 424–6.
45. *Spectator*, 13 December 1940, quoted Addison, op. cit., p. 119.
46. Priestley, *Postscripts*, pp. 64–5.
47. Ibid., p. 19.
48. Priestley, *Out of the People*, p. 45.
49. Ibid., pp. 10, 13, 33.
50. Ibid., p. 110.
51. Ibid., p. 103.
52. Ibid., pp. 105–6.
53. Ibid., p. 25.
54. Ibid., pp. 31–2.
55. Ibid., p. 77.
56. Ibid., p. 10.
57. Priestley, *Postscripts*, pp. 36–7.
58. George Orwell, 'The Lion and the Unicorn', *Collected Essays etc.*, vol. 2, p. 126.
59. Quoted in Robert Murphy, *Realism and Tinsel: Cinema and Society in Britain 1939–49* (London: 1989), p. 59.
60. Addison, op. cit., Chapter 9.
61. F. W. S. Craig, *British Parliamentary Election Manifestos* (London: 1975), pp. 122–3.
62. Ibid., pp. 123–7.

6 FROM THE DEVIL'S DECADE TO THE GOLDEN AGE: THE
POSTWAR POLITICS OF THE THIRTIES

1. Harold Macmillan, *Winds of Change* (London: 1966), pp. 2–3.
2. Arthur Marwick, *British Society since 1945* (Harmondsworth: 1982),
Chapter 7.
3. Eric Hobsbawm, *Age of Extremes: The Short Twentieth Century
1914–1991* (London: 1994), p. 223.
4. Macmillan, op. cit., p. 283.
5. James Klugman, 'The Crisis of the Thirties: A View from the Left', in
Jon Clark *et al.* (eds), *Culture and Crisis in Britain in the Thirties*
(London: 1979), pp. 13–15.
6. For the 'postwar consensus' and its collapse, see Dennis Kavanagh
and Peter Morris, *Consensus Politics from Attlee to Thatcher* (Oxford:
1989); and for a more detailed treatment of the history of the postwar
years, K. O. Morgan, *The People's Peace: British History 1945–1990*
(Oxford: 1990).
7. A. J. P. Taylor, *English History 1914–1945* (Oxford: 1965), p. vi.
8. Ibid.
9. Ibid., pp. 307–8 and 315–17.
10. Charles Loch Mowat, *Britain Between the Wars, 1918–1940* (London:
1955), p. 657.
11. Taylor, op. cit., p. 600.
12. Mowat, op. cit., pp. 412–13.
13. Ibid., p. 535.
14. Ibid., pp. 634–5.
15. Ibid., p. 413.
16. Ibid., pp. 522–3.
17. Ibid., pp. 461–3, 525–31.
18. Ibid., pp. 577–80.
19. Ibid., p. 470.
20. Ibid., p. 620.
21. Ibid., p. 649.
22. Taylor, op. cit., pp. 297–8.
23. Ibid., Chapter 10.
24. Ibid., pp. 354–5.
25. Ibid., p. 355.
26. Ibid., pp. 347, 395–6.
27. Arthur Marwick, 'Middle Opinion in the Thirties: Planning, Progress
and Political "Agreement"', *English Historical Review*, LXXIX (1964)
285–98; Arthur Marwick, *Britain in the Century of Total War. War, Peace
and Social Change 1900–67* (London: 1968), Chapter 5; Paul Addison,
The Road to 1945 (London: 1975).
28. Marwick, *Britain*, pp. 242–55 (reference to 1970 Penguin edition).
29. Robert Skidelsky, *Politicians and the Slump* (London: 1967), and *Oswald
Mosley* (London: 1975).
30. Robert McElwee, *Britain's Locust Years, 1918–1940* (London: 1962),
p. 252.

31. Addison, op. cit., p. 133; Richard Griffiths, *Fellow Travellers of the Right: British Enthusiasts for Nazi Germany 1933–1939* (Oxford: 1983).
32. F. W. S. Craig (ed.), *British General Election Manifestos 1900–1974* (London: 1975), p. 130.
33. Lord Avon, *Facing the Dictators* (1962) pp. 431, 465.
34. See the discussion in Donald Watt, 'The Historiography of Appeasement', in A. Sked and C. Cook (eds), *Crisis and Controversy, Essays Presented to A. J. P. Taylor* (1976).
35. Watt, op. cit.; Paul Kennedy, 'Appeasement', in G. Martel (ed.), *The Origins of the Second World War Revisited* (London: 1986).
36. D. C. Watt, 'Appeasement: the Rise of a Revisionist School', *Political Quarterly* (1965).
37. Watt, 'The Historiography of Appeasement'; Kennedy, 'Appeasement'; K. Robbins, *Appeasement* (London: 1988).
38. Quoted in P. Kennedy, 'Appeasement', *History Today*, October 1982, p. 53.
39. Morgan, op. cit., Chapter 7, 'Labour Blown off Course, 1964–1967'.
40. For a brief survey of the many works on this theme, see Alan Sked, *Britain's Decline: Problems and Perspectives* (1987).
41. Craig, op. cit., p. 153.
42. Craig, op. cit., p. 176.
43. H. G. Nicholas, *The British General Election of 1950* (London: 1951), pp. 213, 241.
44. Quoted in S. Laing, *Representations of Working-class Life 1957–64* (London: 1986), pp. 10–11.
45. Laing, op. cit., p. 4.
46. Mark Abrams and Richard Rose (eds), *Must Labour Lose?* (Harmondsworth: 1960), pp. 103–4.
47. Ibid., p. 105.
48. Ibid., p. 107.
49. Anthony Crosland, *The Future of Socialism* (London: 1956), pp. 32–3.
50. Crosland, op. cit., p. 32. Election figures from Andrew Thorpe, *Britain in the Era of the Two World Wars* (London: 1994), and Alan Sked and Chris Cook, *Post-War Britain: a Political History* (Harmondsworth: 1979).
51. Cf. Anthony Crosland, *The Conservative Enemy* (London: 1963).
52. Morgan, op. cit., Chapter 6. See, among others, Hugh Thomas (ed.), *The Establishment* (London: 1959); Michael Shanks, *The Stagnant Society* (Harmondsworth: 1961); Anthony Sampson, *The Anatomy of Britain* (London: 1962); Arthur Koestler (ed.), *Suicide of a Nation?* (London: 1963); Rex Malik, *What's Wrong with British Industry?* (Harmondsworth: 1964); Perry Anderson, 'Origins of the Present Crisis', *New Left Review* 23 (1964) 26–54; Harold Wilson, *The New Britain* (Harmondsworth: 1964).
53. Arnold Wesker, *The Wesker Trilogy* (London: 1964).
54. See, among others, Laing, op. cit.; John Hill, *Sex, Class and Realism: British Cinema 1956–63* (London: 1986); Chas Critcher, 'Sociology, cultural studies and the post-war working class', in J. Clarke *et al.* (eds), *Working Class Culture. Studies in history and theory* (London: 1979).

55. E.g. Laing, op. cit. Chapter 7; Critcher, op. cit., pp. 17–20.

56. Richard Hoggart, *The Uses of Literacy* (London: 1957): see, for example, the account of 'Juke Box Boys', pp. 246–50.

57. Richard Hoggart, 'Changes in Working-class Life', in *Speaking to Each Other*, vol. 1 (London: 1970).

58. Hoggart, *Uses of Literacy*, p. 343.

59. E.g. F. R. Leavis and Denys Thompson, *Culture and Environment* (London: 1930). For criticism of cultural nostalgia, see Raymond Williams, *The Country and the City* (London: 1973), Chapter 2, and Raymond Williams *Culture and Society* (London: 1958).

60. For a discussion of some of these political issues, see Nick Tiratsoo, 'Popular politics, affluence and the Labour Party in the 1950s', in Anthony Gorst *et al.* (eds), *Contemporary British History 1931–1961* (London: 1991).

61. John Stevenson and Chris Cook, *The Slump: Politics and Society during the Depression* (London: 1977). The basic argument of the book was rehearsed in John Stevenson, 'Myth and Reality: Britain in the 1930s', in Alan Sked and Chris Cook (eds), *Crisis and Controversy: Essays in Honour of A. J. P. Taylor* (London: 1976).

62. Stevenson and Cook, op. cit., pp. 4–5.

63. Ibid., pp. 143, 190.

64. Ibid., pp. 184, 188, 193.

65. Ibid., p. 166.

66. *The Guardian*, 28 January 1978.

67. Stevenson and Cook, op. cit., p. 5.

68. These issues are explored in greater detail in John Stevenson's *Social Conditions in Britain Between the Wars* (Harmondsworth: 1977), and *British Society 1914–45* (Harmondsworth: 1984).

69. Alan Howkins and John Saville, 'The Nineteen Thirties: a Revisionist History', in *Socialist Register 1979*, ed. Ralph Miliband and John Saville (London: 1979), pp. 89–100.

70. Stevenson and Cook, op. cit., pp. 92–3.

71. Ibid., pp. 142–4, 282; Noreen Branson and Margot Heinemann, *Britain in the Nineteen Thirties* (London: 1971), pp. 300–3, 350–1.

72. Ibid., p. 29.

73. Ibid., pp. 350–1.

74. See the criticisms of Stevenson and Cook in Howkins and Saville, op. cit.; and the survey of subsequent debate in Andrew Thorpe, *Britain in the 1930s. The Deceptive Decade* (Oxford: 1992). Nigel Gray, *The Worst of Times: An Oral History of the Great Depression in Britain* (London: 1985) addresses this version of 'revisionism: see the author's Introduction and the Preface by Richard Hoggart.

75. Howkins and Saville, op. cit., p. 90.

76. Klugman, in Clark *et al.* (eds), op. cit., p. 36.

77. Morgan, op. cit., pp. 352–7.

78. See Roger Bromley, *Lost Narratives. Popular Fictions, Politics and Recent History* (1988) for an analysis of some of these reworkings.

79. Andrew Thorpe, *Britain in the 1930s* (1992), p. 4. Representative of 'pessimists' are Charles Webster, 'Health, welfare and unemployment

230

Notes

during the Depression', *Past and Present*, 109 (1985), 204–30; and M. Mitchell, 'The effects of unemployment on the social condition of women and children in the 1930s', *History Workshop Journal* 19 (1985), 105–127; and of 'optimists', J. M. Winter, 'Unemployment, nutrition and infant mortality in Britain 1920–50', in Winter (ed.), *The Working Class in Modern British History* (London: 1983).

80. Quoted in Patrick Wright, 'Wrapped in the tatters of the flag', *The Guardian*, 31 December 1994, p. 25.

7 *PENNIES FROM HEAVEN*: REVISITING THE THIRTIES AS POPULAR CULTURE

1. R. Bromley, *Lost Narratives: Popular Fictions, Politics and Recent History* (London: 1988), p. 10.
2. Ibid., p. 29.
3. Ibid., p. 9.
4. Ibid., p. 38.
5. Ibid., p. 29.
6. Ibid.
7. J. Stevenson & C. Cook, *The Slump* (London: 1979), p. 282.
8. Bromley, op. cit., p. 29.
9. Stevenson & Cook, op. cit., p. 5.
10. G. Fuller (ed.), *Potter on Potter* (London: 1993), p. 81.
11. Ibid., pp. 87–8.
12. P. Purser, 'Dennis Potter', in G. W. Brandt (ed.), *British Television Drama* (Cambridge: 1981), p. 185.
13. For a summary and critique of 'classic realism', see C. MacCabe, 'Realism and the Cinema: Notes on some Brechtian Theses' (*Screen*, 1974), repr. in *Theoretical Essays* (Manchester: 1985), pp. 33–57.
14. See K. Worpole, *Dockers and Detectives* (London: 1983).
15. Fuller, op. cit., p. 109.
16. Ibid.
17. Ibid.
18. Ibid. p. 108.
19. G. Orwell, *Collected Essays, Journalism and Letters*, Vol. 4 (Harmondsworth: 1970), p. 127.
20. T. Adorno, 'Perennial Fashion – Jazz', in *Prisms* (London: 1967), p. 122.
21. Fuller, op. cit., p. 87.
22. R. Hoggart, *The Uses of Literacy* (Harmondsworth: 1958), p. 248.
23. Fuller, op. cit., p. 86.
24. First published in *Movie* in 1977 and reprinted in S. During (ed.), *The Cultural Studies Reader* (London: 1993), pp. 271–83.
25. Ibid., pp. 277–8.
26. Fuller, op. cit., p. 86.
27. We have taken this phrase from the American historian, Harvey J. Kaye. See his collection of essays with that title (New York: 1992).
28. Purser, op. cit., p. 187.

29. F. Jameson, *Postmodernism, or the Cultural Logic of Late Capitalism* (London: 1992), p. 19.
30. Ibid., p. 18.
31. Fuller, op. cit., p. 22.
32. Ibid., pp. 22–3.
33. Ibid.
34. For the debate on *Days of Hope*, see T. Bennett *et al.* (eds), *Popular Television and Film* (London: 1981), Part IV.
35. G. Fuller, op. cit., p. 25.
36. S. Hall, 'Notes on Deconstructing "The Popular"', in R. Samuel (ed.), *People's History and Socialist Theory* (London: 1981), p. 229.
37. Ibid., p. 231.
38. T. Bennett and J. Donald, 'Postscript to Block 2': *Open University. U203 Popular Culture*. Block 2 Units 7 & 8. (Milton Keynes: Open University, 1981), p. 84.
39. See J. Willett, *The New Sobriety: Art and Politics in the Weimar Republic* (London: 1978).
40. Purser, op. cit., pp. 186–7.
41. D. Harker, *One for the Money: Politics and Popular Song* (London: 1980), p. 42.
42. Hall, op. cit., p. 231.
43. I. Chambers, *Popular Culture: The Metropolitan Experience* (London: 1986), p. 133.
44. Ibid., p. 137.
45. Ibid.
46. Fuller, op. cit., p. 85.
47. 'An Interview with Melvyn Bragg. Channel 4, March 1994', in D. Potter, *Seeing the Blossom. Two Interviews and a Lecture* (London: 1994), pp. 19–20.

8 'A FEELING FOR TRADITION AND DISCIPLINE': CONSERVATISM AND THE THIRTIES IN *THE REMAINS OF THE DAY*

1. Quote from the dust-jacket of the 1990 edition of *The Remains of the Day* (London).
2. A. Croft, *Red Letter Days* (London: 1990), p. 23.
3. G. Macnab, Review of *The Remains of the Day* in *Sight and Sound*, 51/12 (December 1993).
4. *The Remains of the Day*, p. 3.
5. Ibid., p. 4.
6. Ibid., p. 11.
7. See P. Wright, *On Living in an Old Country* (London: 1985), esp. pp. 81–7.
8. *The Remains of the Day*, p. 26.
9. Ibid., pp. 28–9.

10. P. Wright, op. cit., p. 85.
11. See E. Said, *Culture and Imperialism* (London: 1993).
12. See M. J. Wiener, *English Culture and the Decline of the Industrial Spirit 1850–1980* (Harmondsworth: 1985; first published Cambridge, 1981)
13. P. Wright, op. cit., pp. 104–5.
14. Cited in M. Wiener, op. cit., p. 75.
15. Ibid.
16. Cited in P. Wright, op. cit., p. 82.
17. M. Wiener, op. cit., p. 107.
18. *The Remains of the Day*, p 185.
19. Ibid.
20. Ibid.
21. Ibid., p. 186.
22. Ibid.
23. Ibid., p. 194.
24. Ibid., p. 196. It is worth noting that Spencer's speech is exceedingly close to an article by 'Beachcomber' (the Catholic convert J. B. Morton who wrote a column for the *Daily Express*) entitled 'Sleeping England', in *Everyman*, 3 November 1933. The latter argued that: 'The machinery of parliamentary government, which works clumsily and laboriously, is incapable of dealing with the kind of crisis we are facing today.... You might as well expect a Mother's Meeting to conduct a military campaign. Let anybody suggest that what we need is the strong leadership of one man – a king for preference, or else a dictator – and at once he will be told that the English would not stand for it! – we who stand for every kind of humbug and state interference under the sun.' (See R. Griffiths, *Fellow-Travellers of the Right* (London: 1980), p. 47). Ishiguro seems to have drawn on this article for both Spencer's diatribe and Darlington's comments on the need for 'strong leadership'. (See below, note 41).
25. *The Remains of the Day*, p. 199.
26. Ibid., p. 197.
27. Ibid., p. 146.
28. Ibid., p. 147.
29. Ibid., p. 148.
30. Ibid.
31. Ibid.
32. Ibid., p. 149.
33. R. Griffiths, op. cit.; R. Benewick, *The Fascist Movement in Britain* (London: 1972).
34. R. Griffiths, op. cit., p. 3.
35. *The Remains of the Day*, pp. 73 and 71.
36. R. Griffiths, op. cit., pp. 111–12.
37. Cited in R. Griffiths, pp. 149–50.
38. Ibid., p. 150.
39. A. Marwick, *Clifford Allen, the Open Conspirator* (London: 1964), p. 155. Cited in Griffiths, p. 150.
40. *The Remains of the Day*, p. 151.
41. Ibid. p. 198.

Notes

42. Griffiths, op. cit., p. 243.
43. Ibid., p. 242.
44. Cited in Griffiths, p. 242.
45. Griffiths, p. 273.
46. Ibid., p. 242.
47. Ibid.
48. *Brief Encounter* (1945), scripted by Noël Coward and directed by David Lean. Raymond Durgnat recalls seeing the film in the mid-Sixties at the Baker Street Classic: 'the audience in this usually polite and certainly middle-class hall couldn't restrain its derision and repeatedly burst into angry, exasperated laughter.... Not since *The Entertainer* on its general release have I known an audience so convulsed by loathing of a film.... When the lovers were shamed out of consummation by the man's creepy smarmy friend (Valentine Dyall) – "I'm not angry with you – just disappointed", it seemed suddenly, that these two had never been lovers at all; they were both too sick to be. Indeed, *Brief Encounter* is the *locus classicus* of, is, surely, *the* renunciation drama...'. *A Mirror for England: British Movies from Austerity to Affluence* (London: 1970), p. 180. For a reassessment of *Brief Encounter* which rates the cinema of 'restraint' much more highly, see Richard Dyer's article, 'Feeling English' in *Sight and Sound*, 16. 3 (March 1994), pp. 16–19. Dyer makes out a powerful case for the emotional understatement of films such as *Brief Encounter* or the recent *Shadowlands*, where 'feeling is expressed in what is not said or done, and/or in the suggestiveness of settings, music and situation' (p. 17). Unfortunately, Dyer fails to recognise the strengths of *The Remains of the Day* in this regard, adjudging it to be a 'lifeless' costume film about 'emotionally inexpressive people' (p. 19).
49. *The Remains of the Day*, pp. 239–40.
50. Ibid., p. 110.
51. G. Lukács, *The Historical Novel* (London: 1962; reprinted 1989).
52. Ibid., p. 47.
53. Ibid.
54. Ibid., pp. 38–9.
55. Ibid., p. 39.
56. E. Balibar, *Masses, Classes, Ideas* (London: 1994), p. 179.
57. See esp. Macnab and Dyer, op. cit.
58. F. Jameson, *Signatures of the Visible* (New York & London: 1992), pp. 217–29.
59. In the novel this fictional conference takes place in 1923, following an actual International Peace Conference held in Italy in 1922, which had 'succeeded in producing only bitterness and confusion' (see p. 75). Understandably, the film brings the conference forward to the thirties in order to compress the dramatic time and to highlight the tension between appeasement and anxieties about German re-armament.
60. Macnab, op. cit.
61. *The Remains of the Day*, p. 242.
62. Ibid., p. 243.
63. Ibid.

64. Ibid., p. 244.
65. Ibid., p. 245.
66. Ibid.

Bibliography

(Place of publication is London, unless otherwise stated.)

Abrams, M. & Rose, R. (eds), *Must Labour Lose?* (Harmondsworth: 1960).

Addison, P., *The Road to 1945* (1975).

Adorno, T., *Prisms* (1967).

Aldgate, T., 'Comedy, Class and Containment: The British Domestic Cinema of the 1930s', in Curran, J. & Porter, V., (eds), *British Cinema History* (1983).

Aldgate, T. & Richards, J., *Britain Can Take It: British Cinema in the Second World War* (Oxford: 1986).

Anderson, P., 'Origins of the Present Crisis', *New Left Review* 23 (1964).

Anderson, P., 'Components of the National Culture', in Cockburn, A., & Blackburn, R., (eds) *Student Power* (Harmondsworth: 1969).

Annan, N., 'The Intellectual Aristocracy', in Plumb, J. H. (ed.), *Studies in Social History* (1955).

Avon Lord, *Facing the Dictators* (1962).

Baldwin, S., *On England* (1926).

Balibar, E., *Masses, Classes, Ideas* (1994).

Barnouw, E., *Documentary: A History of the Non-Fiction Film* (1974).

Barthes, R., *Image–Music–Text* (ed. S. Heath) (1977).

Benewick, R., *The Fascist Movement in Britain* (1972).

Benjamin, W., *Illuminations* (1970).

Benjamin, W., *Understanding Brecht* (1973).

Bennett, T. *et al.* (eds), *Popular Television and Film* (1981).

Bennett, T. & Donald, J. 'Postscript' to Open University, U203 *Popular Culture*, Block 2, Units 7 & 8 (Milton Keynes: 1981).

Bergonzi, B., *Reading the Thirties* (1978).

Bhabha, H. K., *The Location of Culture* (1994).

Bourdieu, P., 'Symbolic Power', in Gleeson, D., (ed.), *Identity and Structure: Issues in the Sociology of Education* (1977).

Bourdieu, P., *Distinction: A Social Critique of the Judgement of Taste* (1984).

Brandt, G. W. (ed.), *British Television Drama* (1981).

Branson, N. & Heinemann, M., *Britain in the Nineteen Thirties* (St Albans: 1973).

Briggs, A., *The War of Words* (Oxford: 1973).

Bromley, R., *Lost Narratives* (1988).

Buhle, P., *C. L. R. James: The Artist as Revolutionary* (1988).

Burgess, M. & Keen, T., *Gracie Fields* (1980).

Caesar, A., *Dividing Lines: Poetry, Class and Ideology in the 1930s* (1991).

Calder, A., *The People's War* (1969).

Calder, A. & Sheridan, D. (eds), *Speak for Yourself: A Mass Observation Anthology, 1937–49* (1984).

Campbell, B., *Wigan Pier Revisited: Poverty and Politics in the Eighties* (1984).

Cardiff, D. & Scannell, P., 'Radio in World War II', Open University U203 *Popular Culture*, Unit 8 (Milton Keynes: 1981).

Carpenter, H., *The Brideshead Generation: Evelyn Waugh and his Generation* (1989).

'Cassius', *The Trial of Mussolini* (1943).

'Cato', *Guilty Men* (1940).

Caudwell, C., *Illusion and Reality* (1937).

Caudwell, C., *Studies in a Dying Culture* (1938).

Caute, D., *The Fellow Travellers: A Postscript to the Enlightenment* (1973).

CCCS English Studies Group, 'Thinking the Thirties', in Barker., F. *et al.* (eds), 1936. *the Sociology of Literature* (University of Essex: 1979).

CCCS English Studies Group, 'Recent Developments in English Studies at the Centre', in Hall, S., *et al.* (eds), *Culture, Media, Language* (1980).

Chambers, I., *Popular Culture: The Metropolitan experience* (1986).

Clark, J., *et al.* (eds), *Culture and Crisis in Britain in the Thirties* (1979)

Clarke, J. *et al.* (eds), *Working Class Culture. Studies in history and theory* (1979).

Colls, R. & Dodd, P., 'Representing the Nation: British Documentary Film, 1930–45', in *Screen*, Vol. 26, No. 1 (Jan–Feb. 1985).

Connolly, C., *Enemies of Promise* (1938; repr. 1961).

Constantine, S., '"Bringing the Empire Alive". The Empire Marketing Board and imperial propaganda, 1926–33', in J. M. Mackenzie (ed.), *Imperialism and Popular Culture* (Manchester: 1986).

Craig, F. W. S., *British General Election Manifestos 1900–1974* (1975).

Crick, B., *George Orwell: A Life* (Harmondsworth: 1982).

Croft, A., *Red Letter Days: British Fiction in the 1930s* (1990).

Crosland, A., *The Future of Socialism* (1956).

Crosland, A., *The Conservative Enemy* (1963).

Cunningham, H., 'The Language of Patriotism 1750–1914', *History Workshop Journal* 12 (1981).

Cunningham, V., *British Writers of the Thirties* (Oxford: 1989).

Dean, B., *Mind's Eye* (1973).

Deane, S., 'Introduction' to Eagleton, T., Jameson, F., & Said, E., *Nationalism, Colonialism and Literature* (University of Minnesota: 1990).

Durgnat, R., *A Mirror for England: British Movies from Austerity to Affluence* (1970).

Dyer, R., 'Entertainment and Utopia', *Movie 24* (Spring 1977).

Dyer, R., *Only Entertainment* (1992).

Egan, K., 'Mythical and Historical Reference to the Past', *Clio* (1973).

Elton, G. R., *The Practice of History* (1967).

Fields, G., *Sing As We Go* (1960).

Fox, R., *The Novel and the People* (1937: repr. 1979).

Fuller, G., (ed.), *Potter on Potter* (1993).

Fussell, P., *Abroad: British Literary Travelling Between the Wars* (Oxford: 1980).

Gassett, O. Y., *The Revolt of the Masses* (1932; orig. publ. Spain: 1930).

'Gracchus', *Your MP* (1944).

Graves, R. & Hodge, A., *The Long Weekend* (1940: 1985 paperback edn).

Gray, N., *The Worst of Times: an Oral History of the Great Depression in Britain* (1985).

Gloversmith, F., (ed.), *Class, Culture and Social Change: A New View of the 1930s* (1980).

Greene, G., *Brighton Rock* (1938).

Griffiths, R., *Fellow-Travellers of the Right* (1980).

Grimshaw, A. (eds), *The C. L. R. James Reader* (Oxford: 1992).

Gross, J., *The Rise and Fall of the Man of Letters* (1980).

Gupta, P., *Imperialism and the British Labour Movement* (1975).

Hall, S., 'The Social Eye of *Picture Post*', in *Working Papers in Cultural Studies*, No. 2 (University of Birmingham, Spring, 1972).

Hall, S., 'Notes on Deconstructing "The Popular"', in R. Samuel (ed.), *People's History and Socialist Theory* (1981).

Hall, S., 'Culture and the State', Open University U203 *Popular Culture* Unit 28 (Milton Keynes: 1982).

Hall, S. & Jacques, M. (eds), *New Times* (1989).

Hardy, F. (ed.), *Grierson on Documentary* (1979).

Harker, D., *One for the Money: Politics and Popular Song* (1980).

Hebdige, D., 'Digging for Britain', in Strinati, D. & Wagg, S. (eds), *Come on Down? Popular Media Culture* (1992).

Heyck, T. W., *The Transformation of Intellectual Life in Victorian England* (1982).

Higson, A., *Waving the Flag: Constructing a National Cinema in Britain* (Oxford: 1995).

Hill, J., *Sex, Class and Realism: British Cinema 1956–63* (1986).

Hobsbawm, E., *Age of Extremes: The Short Twentieth Century 1914–1991* (1994).

Hodgkinson, A. W. & Sheratsky, R. E., *Humphrey Jennings: More than a Maker of Films* (Hanover & London: 1982).

Hoggart, R., *The Uses of Literacy* (1957; Harmondsworth: 1958).

Hoggart, R., 'Changes in Working-Class Life', in *Speaking to Each Other*, Vol. 1 (1970; Harmondsworth: 1973).

Holtby, W., *South Riding* (1936).

Hood, S., 'John Grierson and the Documentary Film Movement', in Curran, J. & Porter, V. (eds), *British Cinema History* (1983).

Howkins, A. & Saville, J., 'The Nineteen Thirties: a Revisionist History', in *Socialist Register 1979* (ed. Miliband, R. & Saville, J.), (1979).

Hynes, S., *The Auden Generation* (1976).

Ishiguro, K., *The Remains of the Day* (1989; repr. in paperback, 1990).

James, C. L. R., *World Revolution. 1917–36* (1937).

James, C. L. R., *The Black Jacobins*, in Grimshaw, A. (ed.), (1992).

Jameson, F., *The Ideologies of Theory, Vol. 2: Syntax of History* (1988).

Jameson, F., *Postmodernism, or the Cultural Logic of Late Capitalism* (1992).

Jameson, F., *Signatures of the Visible* (1992).

Jeffrey, T., 'Mass Observation: A Brief History', *Occasional Paper*, No. 55 (Centre for Contemporary Cultural Studies, University of Birmingham: 1978).

Jenkins, K., *Re-thinking History* (1991).

Johnson, R., *et al.* (eds), *Making Histories: Studies in History-writing and Politics* (1982).

Joyce, P., *Work, Society and Politics* (1980).

Joyce, P., *Visions of the People* (Cambridge: 1991).

Kavanagh, D. & Morris, P., *Consensus Politics from Attlee to Thatcher* (Oxford: 1989).

Kaye, H. J., *The Education of Desire* (New York: 1992).

Kennedy, P., 'Appeasement', *History Today* (October 1982).

Kennedy, P., 'Appeasement', in Martel, G. (ed.), *The Origins of the Second World War Revisited* (1986)

Klugmann, J., 'The Crisis of the Thirties: A View from the Left', in Clark, J. *et al.* (eds), (1979).

Koestler, A., (ed.), *Suicide of a Nation?* (1963).

Kuhn, A., '"Independent" Film-making and the State in the 1930s', in *Edinburgh '77 Magazine, No 2 History Production/Memory* (1977).

Kuhn, A., 'British Documentary in the 1930s and "Independence"', in Laing, S., 'Presenting "Things as They Are"', in Gloversmith F. (ed.), (1980).

Laing, S., *Representations of Working-Class Life 1957–64* (1986).

Landy, M., *British Genres: Cinema and Society. 1930–60* (Oxford: 1991).

Leavis, F. R., *A Selection From 'Scrutiny'.* 2 vols (Cambridge: 1969).

Leavis, F. R., *Mass Civilisation and Minority Culture* (1930).

Leavis, F. R., & Thomson, D., *Culture and Environment* (1933).

Leavis, Q. D., *Fiction and the Reading Public* (1932).

Le Mahieu, D. L., *A Culture for Democracy* (Oxford: 1988).

Lesley, C., *The Life of Noël Coward* (1976).

Lewis, J., *The Left Book Club: An Historical Record* (1970).

Light, A., *Forever England: Femininity, Literature and Conservatism between the Wars* (1991).

Lovell, A. & Hillier, J., *Studies in Documentary* (1972).

Low, R., *Film Making in 1930s Britain* (1985).

Lucas, J. (ed.), *The 1930s: A Challenge to Orthodoxy* (1978).

Lukács, G., *The Meaning of Contemporary Realism* (1963).

Lukács, G., *The Historical Novel* (1962; repr. 1989).

MacCabe, C., 'Realism and the Cinema: Notes on Some Brechtian Theses', *Screen* (1974), reprinted in *Theoretical Essays: Film, Linguistics, Literature* (Manchester: 1985).

Mackenzie, J. M., (ed.), *Propaganda and Empire* (Manchester: 1985).

Macmillan, H., *The Middle Way* (1938).

Macmillan, H., *Winds of Change* (1966).

Macnab, G., Review of 'The Remains of the Day', in *Sight and Sound*, 51/12 (Dec. 1993).

Macpherson (ed.), *British Cinema: Traditions of Independence* (1980).

Madge, C., & Harrisson, T., *Britain by Mass Observation* (1939; repr. 1986).

Malik, R., *What's Wrong with British Industry?* (Harmondsworth: 1964).

Marwick, A., 'Middle Opinion in the Thirties: Planning, Progress and Political "Agreement"', *English Historical Review* (1964).

Marwick, A., *Britain in the Century of Total War* (1968: Harmondsworth: 1970).

Marwick, A., *British Society since 1945* (Harmondsworth: 1982).

McElwee, R., *Britain's Locust Years, 1918–1940* (1962).

Miles, P. & Smith, M., *Cinema, Literature and Society: Elite and Mass Culture in Interwar Britain* (1987).

Mitchell, M., 'The effects of unemployment on the social condition of women and children in the 1930s', *History Workshop Journal* (1985).

Moretti, F., *The Way of the World* (1987).

Morgan, K. O., *The People's Peace: British History 1945–1990* (Oxford: 1990).

Morton, H. V., *In Search of England* (1927).

Mowat, C. L., *Britain Between the Wars* (1955).

Muggeridge, M., *The Thirties: 1930–40 in Great Britain* (1940; 1967 edn).

Mulhern, F., *The Moment of 'Scrutiny'* (1979).

Murphy, R., *Realism and Tinsel: Cinema and Society in Britain 1939–49* (1989).

Newton, K., *The Sociology of British Communism* (1969).

Nicholas, H. G., *The British General Election of 1950* (1951).

O'Prey, P., (ed.), *In Broken Images: Selected Letters of Robert Graves 1914–1946* (1982).

Orwell, G., *Burmese Days* (1934; paperback edn, Harmondsworth: 1989).

Orwell, G., *The Road to Wigan Pier* (1937; paperback edn; Harmondsworth, 1962).

Orwell, G., *Collected Essays, Journalism and Letters* 4 vols (Harmondsworth: 1970).

Passerini, L., 'Work, ideology and consensus under Italian fascism', *History Workshop Journal*, 8 (1979).

Pawling, C. & Perkins, T., 'Popular Drama and Realism: the Case of Television', in Page, A., (ed.), *The Death of the Playwright?* (1992).

Potter, D., *Pennies From Heaven* (BBC I: 7 March–11 April 1978).

Potter, D., *Seeing the Blossom: Two Interviews and a Lecture* (1994).

Priestley, J. B., *The Good Companions* (1929; Harmondsworth: 1962).

Priestley, J. B., *Angel Pavement* (1930).

Priestley, J. B., *Wonder Hero* (1933).

Priestley, J. B., *English Journey* (1934; Harmondsworth: 1977).

Priestley, J. B., *Rain Upon Godshill* (1939).

Priestley, J. B., *Postscripts* (1940).

Priestley, J. B., *Out of the People* (1941).

Priestley, J. B., *Bright Day* (1946).

Priestley, J. B., *Literature and Western Man* (1960).

Priestley, J. B., *Margin Released* (1962).

Richards, J., 'Gracie Fields: the Lancashire Britannia', *Focus on Film* 33 (Summer, 1979).

Richards, J., *The Age of the Dream Palace: Cinema and Society in Britain 1930–1939* (1984).

Richards, J. & Sheridan, D., (eds), *Mass Observation at the Movies* (1987).

Robbins, K., *Appeasement* (1988).

Robertson, J. C., *The British Board of Film Censors: Film Censorship in Britain, 1895–1950* (1985).

Rotha, P., *Documentary Diary* (1973).

Rushdie, S., *Imaginary Homelands* (1992).

Ryall, T., *Alfred Hitchcock and the British Cinema* (1986).

240 *Bibliography*

Said, E., *Orientalism* (Harmondsworth: 1985).
Said, E., *Culture and Imperialism* (1993).
Sampson, A., *The Anatomy of Britain* (1962).
Samuel, R. (ed.), *Patriotism: the Making and Unmaking of British National Identity*, 3 vols (1989).
Scannell, P. & Cardiff, D., *Social History of British Broadcasting, Vol. 1 (1991)*.
Shanks, M., *The Stagnant Society* (Harmondsworth: 1961).
Sked, A., *Britain's Decline: Problems and Perspectives* (1987).
Sked, A. & Cook, C. (eds), *Crisis and Controversy. Essays Presented to A. J. P. Taylor* (1976).
Sked, A. & Cook, C., *Post-War Britain: a Political History* (Harmondsworth: 1979).
Skelton, R. (ed.), *Poetry of the Thirties* (Harmondsworth: 1964).
Skidelsky, R., *Politicians and the Slump* (1970).
Skidelsky, R., *Oswald Mosley* (1975).
Smith, A. C. H., *Paper Voices* (1978).
Spender, S., *The Thirties and After: Poetry, Politics, People 1933–75* (1978).
Sprinker, M., *Edward Said: A Critical Reader* (1992).
Stedman Jones, G., 'History in One Dimension', *New Left Review* 36 (1966).
Stevenson, J., *Social Conditions in Britain between the Wars* (Harmondsworth: 1977).
Stevenson, J., *British Society 1914–45* (Harmondsworth: 1984).
Stevenson, J. & Cook, C., *The Slump: Society and Politics during the Depression* (1977).
Sussex, E., *The Rise and Fall of the British Documentary* (1979).
Symons, J., *The Thirties: A Dream Revolved* (1960; revised edn, 1975).
Taylor, A. J. P., *The Origins of the Second World War* (1961).
Taylor, A. J. P., *English History, 1914–1945* (1965).
Thomas, H., *The Establishment* (1959).
Thorpe, A., *Britain in the 1930s: The Deceptive Decade* (Oxford: 1992).
Thorpe, A., *Britain in the Era of Two World Wars* (1994).
Tiratsoo, N., 'Popular politics, affluence and the Labour Party in the 1950s', in Gorst, A., *et al.* (eds), *Contemporary British History 1931–1961* (1991).
Watt, D. C., 'Appeasement: The Rise of a Revisionist School', *Political Quarterly* (1965).
Watt, D., 'The Historiography of Appeasement', in Sked, A. & Cook, C. (eds), (1976).
Waugh, E., *Brideshead Revisited* (1945).
Webb, S. & B., *Soviet Communism: A New Civilisation* (1937).
Webster, C., 'Health, Welfare and Unemployment during the Depression', *Past and Present* (1985).
Wesker, A., *The Wesker Trilogy* (1964).
White, H., *Metahistory: The Historical Imagination in Nineteenth-Century Europe* (Baltimore: 1973).
White, H., *Tropics of Discourse: Essays in Cultural Criticism* (Baltimore: 1978).
Wiener, M. J., *English Culture and the Decline of the Industrial Spirit 1850–1980* (Harmondsworth: 1985).
Willett, J., *The New Sobrierty: Art and Politics in the Weimar Period* (1978).
Williams, R., *Culture and Society* (1958).

Williams, R., *The Long Revolution* (Harmondsworth: 1965).

Williams, R., *The Country and the City* (St Albans: 1975).

Williams, R., *Politics and Letters* (1980).

Williams, R., *Problems in Materialism and Culture* (1980).

Williams, R., *The Politics of Modernism* (1989).

Wilson, H., *The New Britain* (Harmondsworth: 1964).

Winter, J. M., 'Unemployment, nutrition and infant mortality in Britain 1920–50', in Winter (ed.), *The Working Class in Modern British History* (1983).

Wood, N., *Communism and British Intellectuals* (1959).

Worpole, K., *Dockers and Detectives* (1983).

Wright, P., *On Living in an Old Country* (1985).

Wright, P., 'Wrapped in the Tatters of the Flag', *Guardian Weekend* (31 Dec. 1994/1 Jan. 1995).

Index